The Annotated Mona Lisa

A CRASH COURSE IN ART HISTORY FROM PREHISTORIC TO THE PRESENT

Carol Strickland
and John Boswell

Book Designer: Barbara Cohen Aronica
Assistant Designer: Jan Halper Scaglia
Cover Designer: Rich Rossiter
Photographic Researcher: Toby Greenberg
Managing Editor: Patty Brown

A John Boswell Associates Book

Andrews McMeel
PUBLISHING®

In memory of my Mother and Father, Rebecca and John Colclough

To the families in New Orleans and Memphis, thanks for your encouragement.
And to Sid, Alison, and Eliza, special gratitude for your enthusiasm when it began
to seem the adage "Vita brevis est, ars longa" was all too true.

—C.S.

Abbreviations used in text:
MMA Metropolitan Museum of Art
MoMA Museum of Modern Art
Whitney Whitney Museum of American Art
NG National Gallery of Art

Andrews McMeel Publishing
a division of Andrews McMeel Universal
1130 Walnut Street, Kansas City, Missouri 64106

www.andrewsmcmeel.com

ISBN: 978-1-4494-8213-8

17 18 19 20 21 SDB 10 9 8 7 6 5 4 3 2 1

Library of Congress Control Number: 2017931253

Typeset in Simoncini Garamond and Futura by TAW, Inc., Wilton, Connecticut

PHOTO CREDITS

CONTENTS

INTRODUCTION: HOW TO LOOK AT A PAINTING x

THE BIRTH OF ART: PREHISTORIC THROUGH MEDIEVAL 2
Roots of painting, sculpture, architecture established.

PREHISTORIC ART: THE BEGINNING 4
Art begins c. 25,000 B.C. with first surviving sculpture, cave paintings, huge stone monuments for rituals.
Stonehenge

MESOPOTAMIA: THE ARCHITECTS 6
First cities built with mammoth temples called ziggurats and palaces lined with bas-relief sculpture.
The pyramid form through the ages

EGYPT: THE ART OF IMMORTALITY 8
Tomb art developed with wall paintings; statues conforming to rigid conventions for 3,000 years; colossal architecture (pyramids) constructed.
Paintings, Sculpture, Mummies, Pyramids, Tutankhamen's Tomb

GREECE: THEY INVENTED A LOT MORE THAN THE OLYMPICS 12
Striving for ideal beauty results in sculpture, architecture, vase painting with balance, proportion, harmony; style called "Classical" because it set standard for technical perfection.
Vase painting, Sculpture, Architecture, Greek art styles

ROME: THE ORGANIZERS 16
Empire produces realistic portrait sculpture, idealized busts of emperors, engineering wonders like aqueducts and arenas based on arch, vault, dome.
Greek vs. Roman styles, Architecture, Sculpture, Colosseum, Pompeii

PRE-COLUMBIAN ART OF THE AMERICAS: NEW WORLD ART WHEN IT WAS STILL AN OLD WORLD 20
Native Americans create stylized human and animal forms in ceremonial objects.
Mound-Builders, 20th-century adaptations

AFRICAN ART: THE FIRST CUBISTS 22
Religion shapes art of wooden masks, elongated sculpture; semiabstract forms influence modern art.
Influence of Tribal Art

THE MIDDLE AGES: THE REIGN OF RELIGION 24
Spiritual art to inspire religious devotion replaces lifelike portrayal.

GOLDEN AGE OF BYZANTINE ART 24
Icons, Mosaics, Hagia Sophia

ROMANESQUE ART: STORIES IN STONE 26
Giotto, Romanesque vs. Gothic styles, Illuminated Manuscripts

GOTHIC ART: HEIGHT AND LIGHT 28
Architectural Terms, Sculpture, Stained Glass, Tapestry

THE REBIRTH OF ART: RENAISSANCE AND BAROQUE 30
Artists rediscover how to represent human figure realistically, overcome technical limitations.

THE RENAISSANCE: THE BEGINNING OF MODERN PAINTING 32
Classic art reborn due to breakthrough discoveries like anatomy and perspective; influence spreads from Italy throughout Europe.
Four Technical Breakthroughs, early Renaissance Masters, Masaccio, Donatello, Botticelli

THE ITALIAN RENAISSANCE 34
Heroes of the High Renaissance, Leonardo, Michelangelo, Raphael, Titian, Architecture

THE NORTHERN RENAISSANCE 40
Italian vs. Northern renaissance styles

THE RENAISSANCE IN THE LOW COUNTRIES 40
Van Eyck, Bosch, Bruegel

THE GERMAN RENAISSANCE 42
Holbein, Dürer, Graphic Arts

MANNERISM AND THE LATE RENAISSANCE 44

THE SPANISH RENAISSANCE 45

BAROQUE: THE ORNATE AGE 46
Grandiose art approaches theater with spotlight effect, emotional appeal.

ITALIAN BAROQUE 47
Caravaggio, Gentileschi, Bernini,
Borromini, Tiepolo

FLEMISH BAROQUE 50
Rubens, Van Dyck

DUTCH BAROQUE 52
Still life, Landscape, Ruisdael, Hals,
Rembrandt, Vermeer, Old Masters

ENGLISH BAROQUE 57
Hogarth, Art of Social Criticism,
Gainsborough, Reynolds, Royal Academy,
St. Paul's Cathedral

SPANISH BAROQUE 60
Velázquez's influence

FRENCH BAROQUE 62
La Tour, Poussin, Claude, Versailles

ROCOCO 64
Watteau, Boucher, Fragonard,
Interior Design, Gaudí

THE NINETEENTH CENTURY: BIRTH OF THE "ISMS" 66
*France dominates art leadership for next 200 years as
styles come and go.*

NEOCLASSICISM: ROMAN FEVER 68
Greek and Roman forms revived.

FRENCH NEOCLASSICISM 69
David, Ingres, Odalisques through the ages

AMERICAN NEOCLASSICISM 72
Peale, Copley, Stuart

GOYA: MAN WITHOUT AN "ISM" 74
Nonconformist denounces human hypocrisy.

ROMANTICISM: THE POWER OF PASSION 76
*Interest in exotic subjects born; goal of art to express
emotion.*

FRENCH ROMANTICISM 76
Géricault, Delacroix, Neoclassic vs.
Romantic styles, Artist's Palette

ENGLISH ROMANTICISM 79
Constable, Turner

AMERICAN ROMANTICISM AND GENRE PAINTING 81
Cole, Bierstadt, Church, Bingham

REALISM 83
*New view of art's function arises; artists show
life of streets without retouching reality.*
Daumier, Bonheur

FRENCH REALISM 84
Courbet, Corot, Millet

AMERICAN REALISM 85
Homer, Eakins, Whistler, Sargent, Harnett

ARCHITECTURE FOR THE INDUSTRIAL AGE 89
*Architects renounce past styles; buildings reflect
new technology.*
Crystal Palace, Eiffel Tower, Arts and Crafts
Movement

ART NOUVEAU 91
Decorative style of flowing lines opposes Machine Age.
Beardsley, Tiffany

BIRTH OF PHOTOGRAPHY 92
*New art form born; captures world with
unmatched accuracy.*
Inventors: Niépce, Daguerre, Talbot,
Types of Photography, Impact on Painting

IMPRESSIONISM: LET THERE BE COLOR AND LIGHT 96
*French artists paint outdoors to record changing
effects of light, launch art revolution.*
Hallmarks of Impressionists' Styles, Landmark
Paintings, Manet, Monet, Renoir, Degas, Cassatt,
Morisot, Pissarro, Graphic Arts, Japanese
Woodblock Prints

RODIN: FIRST MODERN SCULPTOR 110
Rodin brings sculpture into modern era.

POST-IMPRESSIONISM 112
*French painters blaze trails by using color to
express emotion and simulate depth.*
Hallmarks of Post-Impressionists' Styles, Seurat,
Toulouse-Lautrec, Cézanne, Gauguin, Van Gogh

EARLY EXPRESSIONISM 123
Form and color distorted to convey feelings.
Munch, Modersohn-Becker

SYMBOLISM 124
Artists turn to subjective imagery, fantasy.
Rousseau, Redon, Ryder

THE BIRTH OF MODERN ARCHITECTURE **126**
New functions demand new forms; skyscraper invented.
 Sullivan

THE TWENTIETH CENTURY: MODERN ART **128**
Art styles shift each decade; trend toward nonrepresentational art increases.

FAUVISM: EXPLODING COLOR **130**
French painters warp color to express subjective response rather than object's appearance.
 Vlaminck, Derain, Dufy, Rouault

TWENTIETH-CENTURY SCULPTURE: A NEW LOOK **133**
Sculpture simplified into abstract symbols.
 Brancusi, Modigliani

TWIN TITANS OF THE TWENTIETH CENTURY: MATISSE AND PICASSO **134**
Matisse simplifies, Picasso fractures forms.
 Matisse, Picasso

CUBISM **138**
Picasso, Braque overthrow Renaissance perspective, splinter form to show simultaneous views of object.
 Analytic Cubism, Synthetic Cubism: Gris, Léger

MODERNISM OUTSIDE OF FRANCE **139**
New concept of art spreads: less concerned with subject or outside world, more concerned with color, line, shape.

FUTURISM **139**
 Boccioni

CONSTRUCTIVISM **140**
 Tatlin, Malevich, Popova

PRECISIONISM **141**
 O'Keeffe

EXPRESSIONISM **142**
 Die Brücke, Kollwitz, Kirchner, Nolde, Der Blaue Reiter, Kandinsky, Klee, "Degenerate" Art

MONDRIAN: HARMONY OF OPPOSITES **145**
Mondrian devises purely geometric art.

MODERNIST ARCHITECTURE: GEOMETRY TO LIVE IN **146**
International Style develops sleek, simple forms.
 Gropius, Mies van der Rohe, Le Corbusier, Wright

DADA AND SURREALISM: ART BETWEEN THE WARS **148**
Dada defies logic; Surrealist artists explore world of dreams and unconscious.
 Duchamp, Arp, Schwitters, Miró, de Chirico, Ernst, Chagall, Dalí, Magritte

PHOTOGRAPHY COMES OF AGE **152**
Photography reflects trends with both surreal and geometric compositions.
 Man Ray, Atget, Cartier-Bresson, Stieglitz, Weston, Lange

AMERICAN ART: 1908–40 **154**
American Realists focus on social concerns, daily life.
 Ash Can School, Sloan, Bellows, American Scene Painters, Benton, Wood, Hopper, Social Realism, Bearden, Social Protest Art

ABSTRACT EXPRESSIONISM **158**
Action painters smash art tradition, create first U.S. movement to influence world art.
 Gorky, Pollock, de Kooning, Kline, Hofmann, Still, Motherwell

FIGURAL EXPRESSIONISM: NOT JUST A PRETTY FACE **162**
Artists seek visceral effect by distorting figures.
 Dubuffet, Outsider Art, Bacon, Kahlo

POST-WAR SCULPTURE **164**
Nonrepresentational sculptors experiment with varied materials and forms.
 Moore, Calder, Smith, Bourgeois, Nevelson

COLOR FIELD **166**
Americans rely on fields of color to convey message of art.
 Rothko, Newman, Frankenthaler, Louis

THE TWENTIETH CENTURY: CONTEMPORARY ART **168**
Experimentation continues as styles, materials, techniques change rapidly.

HARD EDGE **170**
Artists use large geometric shapes to show how colors interact.
 Albers, Noland, Kelly, Stella

PRE-POP ART **172**
Recognizable objects return to art.
 Rauschenberg, Johns

POP ART 174
Consumer culture permeates art.
 Lichtenstein, Warhol, Oldenburg, Segal, Op Art

MINIMALISM: THE COOL SCHOOL 177
Artists strip sculpture to simplest elements, pure form without content.
 Judd, Andre, Flavin, LeWitt, Morris, Serra

CONCEPTUAL ART: INVISIBLE VISUAL ART 178
Idea rather than art object dominates.
 Process Art, Environmental Art, Performance Art, Installations

CONTEMPORARY ARCHITECTURE 180
Post-Modern triumphs with return to historical references.
 Pei, Johnson, Beaubourg, Graves, Gehry, Venturi, Survey of Architecture

PHOTOGRAPHY: WHAT'S NEW 184
Realism and fantasy both evident.
 Abbott, Bourke-White, Adams, Street Photography, Uelsmann, Baldessari

PHOTO-REALISM 187
Painting imitates the camera.
 Estes, Flack, Close, Hanson

NEO-EXPRESSIONISM 188
Powerful subject matter revived.
 Beuys, Kiefer, Clemente, Baselitz, Basquiat

THE NEW BREED: POST-MODERN ART 190
Multiple styles with social criticism common.
 Appropriation Art: Schnabel; Photography-Derived Art: Kruger, Sherman, Longo; Narrative Art: Fischl; Graffiti Art: Haring; Political Art, Post-Modern Sculpture, End of the Millennium

CONTEMPORARY ART 195
Styles multiply in global, high-tech world before returning to high-touch tradition of studio craft.

VIDEO AND NEW-MEDIA ART 195
 Viola, Barney, Hill, Oursler, Wearing, Aitken, Neshat

PHOTO-BASED IMAGERY 196
 Photography as documentation: Bernd and Hilla Becher, Gursky, Struth, Ruff, Goldin, diCorcia; Photography as invention: Simpson, Wall

A SINGULAR SENSATION: YOUNG BRITISH ARTISTS 196
 Hirst, Jake and Dinos Chapman, Ofili

CONCEPTUAL ART CONTINUES 198
 Cattelan, Gilbert and George, Baldessari

AFRICAN ART: THE NEW WAVE 198
 Kentridge, Shonibare, Amer, Mukomberanwa, Sidibé, Udé

INSTALLATIONS BECOME IMMERSIVE ENVIRONMENTS 199
 Turrell, Hatoum, Kabakov

TEAMWORK: COLLABORATIVE ART 199
 Guerrilla Girls, Komar and Melamid, Christo and Jeanne-Claude

LATIN-AMERICAN ART 199
 Gonzales-Torres, Muniz, Salcedo, Orozco, Bedia, Kuitca

CONTEMPORARY SCULPTURE 200
 Bontecou, Coyne, Booker, Whiteread, Goldsworthy, von Rydingsvard, Kapoor, Guo-Qiang

RETURN TO FIGURATIVE ART 201
 Neo-Expressionism: Polke, Colescott, Doig, Mehretu; Political: Walker, Marshall, Rockman; Figurative Painting: Peyton, Owens, Sillman, Currin, Yuskavage, Richter

THE LINE BLURS: CRAFT-DERIVED ART 201
 Fiber art; ceramic: Voulkos, Takaezu, Woodman

ARTISTS 'TOON IN: CARTOON-INFLUENCED ART 201
 Murray, Torimitsu, Nara, Murakami

NEW LEIPZIG SCHOOL OF PAINTING 202
 Rauch, Loy, Weischer, Eitel, Schnell, Kalaizis

THE TWENTY-FIRST CENTURY: STATE OF THE ART 203
Globalized, hybridized art expands; anything goes as installations spread and social-practice, participatory art snags viewers.

OUTSIDER ART COMES INSIDE THE CANON 204
Self-taught artists once marginal, now mainstream.
 Dial, Singleton, Traylor, Harvey, Tolliver, Hunter

NEO-POP 204
Subversive twists on commercial imagery blur line between celebration and satire.
 Koons

CALIFORNIA CULTURE 205
Spotlight shifts to Golden State.
Ruscha, Diebenkorn, Thiebaud, Celmins, Saar,
DeFeo, Irwin, Asawa, Conner, Thater, Bradford

PERFORMANCE AND PARTICIPATORY ART 206
Artists engage viewers with interactive projects.
Abramović, Jonas, Gonzales-Torres, Eliasson,
Hamilton, Sehgal, Ono, Tiravanija, Mingwei,
Gates, Yangjiang Group

ACTIVIST ART OPENS EYES AND MINDS 207
The power of passionate polemics.
Ai Weiwei, Chin, Pussy Riot, Brookner, Mary
Miss, Bruguera, Laderman Ukeles, Frazier, Lowe,
Reyes

INSTALLATION ART 208
A hodgepodge of ideas.
Sun Yuan and Peng Yu, Sachs, Hammons,
Boltanski

ASIAN ART TAKES THE WORLD STAGE 210
*China's New Wave, Cynical Realism, contemporary;
Japan's Gutai.*

PHOTOGRAPHY SHINES: FROM ABSTRACT TO EXACT 211
Burtynsky, Salgado, Opie, Morell, Eggleston,
Christenberry, Wang Qingsong

BIG IDEAS: NEW SCULPTURE 213
Thinking outside the white box.
Barlow, Paine, Salcedo, Butterfield, Plensa,
Gormley, Long, Altmejd, Cave

FIGURE AND FORM: PAINTING MAKES A POINT 215
Distorted portraits add psychological drama.
Freud, Auerbach, Dumas, Tuymans

**ABSTRACT PAINTING:
SCULLY'S WINDOWS ON THE WORLD 216**
Geometric abstraction with tactile, painterly quality.

NEW MEDIA ART: HIGH-TECH TRUMPS HIGH-TOUCH 217
Artists byte off new domain.
Rist, Fitch and Trecartin, Arcangel, Cortright

ECO-ART: IT'S NOT EASY BEING GREEN 218
Save our planet.
Ballengée, Allora and Calzadilla, Huyghe

INDEX 219

INTRODUCTION:
HOW TO LOOK AT A PAINTING

Like music, art is a universal language. Yet, even though looking at most works of art is a pleasurable enough experience, to appreciate fully what's going on requires certain skills and knowledge. In *The Annotated Mona Lisa* 25,000 years of art history have been condensed into 232 pages in order to quickly provide some of the necessary skills and knowledge.

The Annotated Mona Lisa also presents this essential information as simply as possible, with a minimum of technical jargon but with a wealth of anecdote and biographical asides to lend a human dimension to the world of art. Timelines, summaries, and comparison charts appear throughout the book to help the reader absorb and retain important points.

Yet, while many of the critical tools for forming independent aesthetic judgments are provided here, ultimately, the reward comes in using these tools to draw your own conclusions about why a particular painting touches or moves you, or even why it doesn't. The more time spent in museums and galleries, the more rewarding the act of encountering art becomes.

Géricault, "The Raft of the Medusa," 1818–19, Louvre, Paris.

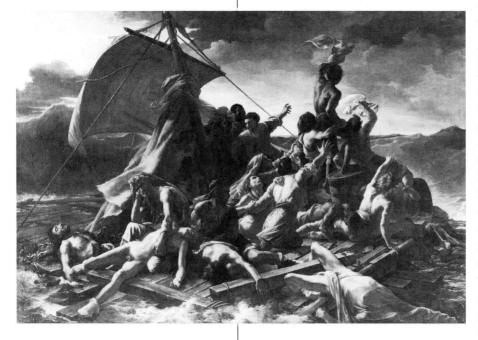

There is a world of difference between viewing a work of art and really seeing it — the difference between sight and insight. When I began to research this book, I already knew a great deal about art, had taught it in American culture courses, loved it, and spent much time in museums and galleries. But after two years of total immersion in art history, I found my experience of looking at paintings and sculpture totally transformed. My increased knowledge led to enriched, stimulating, give-and-take engagement with art. It was like switching from passively watching a film in a foreign language to actively debating in one's mother tongue. I hope my experience will be a microcosm for readers, who will also appreciate art in direct proportion to the amount of knowledge they bring to it.

Choosing one example from the book, "The Raft of the Medusa" by Théodore Géricault (see p. 76), here's how one might go about analyzing a painting using several traditional criteria:

COLOR, COMPOSITION, MOOD, AND LIGHTING

"The Raft of the Medusa" portrays victims of a shipwreck, adrift on the sea without food or water, at the moment they signal to a distant ship. The painter chose to represent a dramatic moment — the instant when survivors regain hope of rescue — but he conveyed their desperate situation through an array of painterly devices. Géricault used the full range of painter's tools — color, composition, mood, and lighting — to convey his theme of man's struggle against nature.

1. COMPOSITION. Géricault divided the scene into two overlapping triangles. The triangle at left, defined by the mast and two ropes, includes the dead and dying. The triangle at right, whose peak is the standing man waving a shirt, is composed of dynamic figures, with arms outstretched to indicate their surging hopes. The placement of this triangle at far right, the direction of glances, gestures, and arrangement of drapery all contribute to the effect of forward thrust and direct the viewer's eye to the focal point of the figures frantically waving.

2. MOVEMENT. Géricault created the impression of motion through contrasting the postures of his figures. The picture as a whole seems to surge upward from the prone figures at lower left to the upper right, with its concentration of sitting and reaching figures. The waving man at the peak of the right triangle is the climax of this mood of rising hope and advancing motion.

3. UNITY AND BALANCE. To prevent the two triangles — one of despair, the other of hope — from splitting the picture into unrelated halves, Géricault overlaps the triangles, with transitional figures appearing in both. An arm cuts across the rope (the strongest line of the left triangle) to point to the peak of the main triangle and unify the two halves. The two off-center triangles also lean in opposite directions, each balancing the other.

4. COLOR AND LIGHT/DARK CONTRAST. Géricault painted the storm clouds and cresting waves dark to create a menacing mood. The horizon — where the rescue ship is located — is bright, like a beacon of salvation. The extreme light/dark contrasts throughout the painting imply the alternating emotions of hope and hopelessness.

5. MOOD. Jumbled lines of the writhing bodies suggest a mood of turbulence, in keeping with Géricault's theme of titanic struggle against the elements.

When looking at any works of art, the viewer should consider elements like these, which artists use to create their intended effects. The more profound the thought, feeling, skill, and invention an artist puts into his or her work, the more it unfolds to an alert spectator. Appreciating art is a gradual, never-ending endeavor, which is why art from all eras still engages and enriches us.

—Carol Strickland

The Birth of Art: Prehistoric Through Medieval

Art was born around 25,000 years ago, when the subhuman Neanderthal evolved into our human ancestor, Cro-Magnon man. With greater intelligence came imagination and the ability to create images in both painting and sculpture. Architecture came into being with the construction of ritual monuments.

For thousands of years, as civilizations waxed and waned, these three art forms — painting, sculpture, and architecture — embodied the ambitions, dreams, and values of their cultures. Although early artists are anonymous, most of what we know about their societies comes from the art they left behind. Ruins of Mesopotamian ziggurats and bas-relief sculpture, as well as Egyptian pyramids, testify to complex civilizations. Greek art reached a pinnacle of beauty as respect for the individual flourished in Athens, and Roman relics attest to the might of the greatest empire in the ancient world.

Artists became increasingly accomplished in representing the human figure in realistic space until the Middle Ages, when art changed radically. With the triumph of Christianity, interest in the body and the world plummeted. Stylized painting and sculpture existed only to teach religion and adorn cathedrals — the true masterpieces of the Middle Ages.

From 25,000 B.C. to A.D. 1400, the history of art is not a story of progress from primitive to sophisticated or simple to complex — only a story of the varied forms the imagination has taken in painting, sculpture, and architecture.

WORLD HISTORY		ART HISTORY
	25,000–20,000 B.C.	Venus of Willendorf sculpted
	15,000–10,000	Cave paintings created
Asians migrate across Bering Strait land bridge into Americas	11,500	
Urbanization begins; writing invented	3500–3000	
	2610	Imhotep, first recorded artist, builds pyramid
	2150	Ziggurat at Ur constructed
	2000	Stonehenge erected
Tutankhamen reigns	1361–1352	
First Olympiad held	776	
	742–706	Sargon II builds Royal Palace
	650	Wall reliefs sculpted at Nineveh
	c. 650	Freestanding sculpture developed
Athenians establish democracy	600	
	500 B.C.–A.D.200	African sculpture begins
Pericles rules Athens	450–429	
	448–432	Parthenon built
	c. 350	Amphitheater at Epidaurus, Greece, built
Alexander the Great conquers known world	332	
Romans build first highway	312	First aqueduct built
	190	Nike of Samothrace sculpted
	80	Pompeii mosaics created
Octavian proclaims self Emperor Augustus; 150-year Pax Romana begins	27	
Rome burns, Nero blamed	A.D. 64	
Pompeii destroyed by volcano	79	
	82	Colosseum opens
	118–25	Pantheon constructed
Greece absorbed into Roman empire	146	
	300–900	Mayans create Classic culture
Roman empire divided; Byzantine era begins	395	
Visigoths sack Rome	410	
Theodoric founds kingdom in Ravenna	493	
Justinian reigns; Byzantine Empire flowers	527–65	
	532–37	Hagia Sophia built
	547	Ravenna mosaics executed
	600–800	Irish monks illuminate manuscripts
Mayan civilization collapses	900	African bronze sculpture made by lost-wax casting method
	1000–1200	Romanesque churches built
	1200–1500	Gothic style reigns
Marco Polo goes to China	1271	
Crusaders capture Constantinople	1305	Giotto paints frescoes in Padua
Aztecs found Mexico City	1325	
Black Death epidemic wipes out one-third of Europe	1347–50	Icons dominate Byzantine art
Incan empire in Peru begins	1438	
Constantinople falls; Byzantine Empire collapses	1453	
Columbus discovers New World for Europeans	1492	
Spain conquers Montezuma, king of Aztecs	1519	
Champollion deciphers hieroglyphics	1821	
	1922	Carter discovers Tut's tomb

PREHISTORIC ART: THE BEGINNING

Although human beings have been walking upright for millions of years, it was not until 25,000 years ago that our forebears invented art. Sometime during the last glacial epoch, when hunter-gatherers were still living in caves, the Neanderthal tool-making mentality gave way to the Cro-Magnon urge to make images.

The first art objects were created not to adorn the body or decorate the cavern but out of an attempt to control or appease natural forces. These symbols of animals and people had supernatural significance and magic powers.

SCULPTURE. The oldest surviving art objects are sculptures made from bone, ivory, stone, or antlers. These were either engraved (by incising an outlined figure with a sharp tool), carved in deep relief, or fully rounded three-dimensional sculptures.

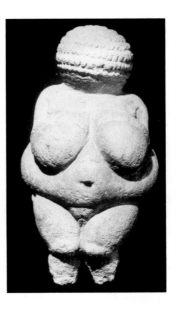

VENUS OF WILLENDORF

c. 25,000–20,000 B.C., Museum of Natural History, Vienna. *This tiny female statuette is one of the earliest known human figures. With its enormous breasts, protruding belly, and stylized round head, the sculpture is more a cluster of spheres than an individualized woman. It was probably a fertility fetish, symbolizing abundance.*

CAVE PAINTING. The first "paintings" were probably made in caves approximately 15,000 years ago. These pictures of bison, deer, horses, cattle, mammoths, and boars are located in the most remote recesses of the caves, far from the inhabited, sunlit entrances. Archeologists speculate artists created the animal images to guarantee a successful hunt. Many are portrayed pierced with arrows, and gouges in the rock indicate cave-dwellers may have flung spears at the painted game.

HORSE

Cave Painting at Lascaux, France, c. 15,000–13,000 B.C.

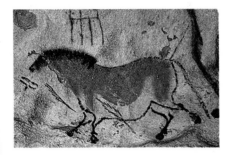

To create these images, cave artists used charcoal to outline irregularities in the walls of caves that suggested forms from nature. Bulges in the rock implied bulk, and tonal shading with earth-tone pigments lent contour and perspective. The "paints" used were chunks of red and yellow ocher ground into powder and applied with brushes or blown onto the surface through hollow bones. Drawings were often superimposed randomly, perhaps because new images were necessary before each hunt. The images — almost entirely animal figures — were represented in two-dimensional profile and seem to float in space, with no hint of background surroundings.

A PREHISTORIC TREASURE TROVE: DISCOVERY OF CAVE ART

In 1879, Marcelino de Sautuola took his small daughter with him to explore the Altamira Caves in northern Spain. Since the ceiling was only a few inches above his head, he did not notice what was immediately above him. From the youngster's lower perspective, however, she spotted marvelous beasts that appeared to cavort on the cave roof. Although de Sautuola was sure the paintings were prehistoric, skeptical archeologists pronounced them forgeries. It was only after the French discovered similar paintings, partially obscured by millennia-old mineral deposits, that the Altamira drawings were pronounced authentic. Today they are recognized as one of the most spectacular finds in art history.

The other major site of cave paintings in Lascaux, France, was also discovered by accident. In 1940, two French boys were out for a walk when their dog suddenly disappeared. They found him in a hole leading to a cave covered with thousands of engravings and paintings. Sealed in the dry underground chambers, the paintings had survived virtually intact for more than 17,000 years. Once hordes of visitors tramped through the cave, however, moisture and carbon dioxide accumulated underground, and fungi crept up the cave walls, concealing the images. Since 1963, the caves at Lascaux have been closed to the public.

FIRST ARCHITECTURE. Once the glaciers receded, the climate grew more temperate, and the Paleolithic (or old stone) period was replaced by the Neolithic (new stone) age. Early human beings emerged from caves to become herdsmen and farmers, and, with a now secure food supply, they began crafting the first monumental "sculpture." As early as 5000 B.C., colossal architecture of massive, upright stones appeared. These took three basic forms: the dolmen, consisting of large, vertical stones with a covering slab like a giant table; the menhir, or single stone set on its end (the largest is 164 feet long, weighing 350 tons); and a cromlech, or circular arrangement of stones, such as Stonehenge.

STONEHENGE: ENGLAND'S FIRST ROCK GROUP. In the Middle Ages, this mysterious group of stones was believed to be either the creation of an ancient race of giants or conjured by Merlin the Magician, who allegedly transplanted it from Ireland. Actually, it seems to be an accurate astronomical calendar. The outer ring consists of trilithons, or Π-shaped rocks like gigantic doorways. Next comes a ring of smaller upright stones like cemetery gravemarkers, then a horseshoe of carefully finished trilithons, 13'6" high. Isolated from these concentric circles is a heel-stone, marking where the sun rises in the East at the summer solstice.

At Carnac, in the French province of Brittany, rows of thousands of megaliths (large, unhewn boulders up to 12' high) stretch for several miles, a dozen or so abreast in parallel lines. Local legend has it that these rows represent columns of Roman soldiers, changed to stone by the resident saint. More likely, they were associated with worship of the sun or moon.

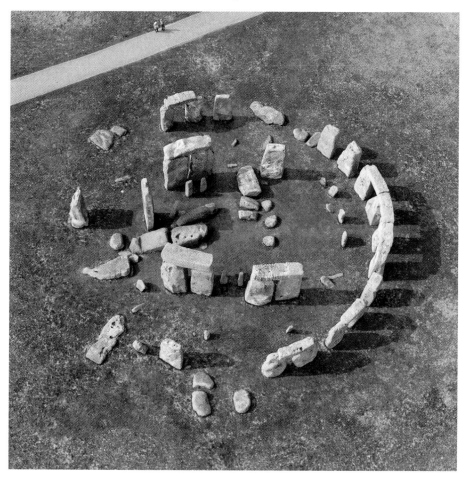

Stonehenge, c. 2000 B.C., 97' diameter, Wiltshire, England.

THE EASTER ISLAND MONOLITHS: HOW THEY DID IT

Anyone who has ever observed the construction of a modern building, aided by bulldozers, huge cranes, and hydraulic lifts, can't help but wonder how prehistoric men managed to erect their monoliths. In the case of Stonehenge, apparently hundreds of men dragged stones weighing up to 50 tons for 24 miles.

The most detailed knowledge we have of megalith construction comes from Easter Island, where descendants of the prehistoric people who created the 30-foot-tall statues demonstrated their ancestors' techniques. First, using crude stone picks, they quarried a giant statue from the crater of an extinct volcano. Next they lowered it to the base of the volcano, where they set it upright in a hole to finish carving and polishing. One hundred eighty natives then moved the 25-ton statue, encircled with a padding of reeds, cross-country by hauling it with ropes on a wooden sledge. Now all they had to do was get it upright and raise it onto its six-foot-high base. How'd they do it? Using two poles or levers they raised the massive carving a few inches off the ground, then inserted rocks underneath the raised side. They repeated this process over and over again, using more and more rocks until voilà! it stood upright. It took approximately one year to carve a statue and two weeks to erect it. At one time, more than 600 of the gigantic figures stood sentry on this tiny Pacific island.

MESOPOTAMIA: THE ARCHITECTS

"The navel of the world" is what King Nebuchadnezzar called his capital city of Babylon. This premier city was the cradle of ancient art and architecture, as well as the site of both the Hanging Gardens and Tower of Babel.

Biblical writers saw the magnificent, 270-foot-high Tower of Babel as an emblem of man's arrogance in trying to reach heaven. The Greek historian Herodotus described it as a stack of eight stepped towers, with gates of solid brass and 120 lions in brightly colored, glazed tiles leading to it. A spiral stairway wound around the exterior, mounting to the summit where an inner sanctuary contained an elaborately adorned couch and gold table. The Babylonians claimed this was the chamber where their god slept.

The Hanging Gardens, one of the Seven Wonders of the Ancient World, was similarly grandiose. It consisted of a series of four brick terraces, rising above the Euphrates River, with lush flowering shrubs and trees spilling over the city. Some believe Mesopotamia was the site of an even more famous historical garden — the garden of Eden.

As far back as 3500 B.C., the Sumerians, the original inhabitants of this area, mastered irrigation and flood control to create a fertile oasis amid the sandy plains of what is now Iraq. In their settlements of the Tigris and Euphrates valley, they also invented the city-state, formal religion, writing, mathematics, law, and, to a large extent, architecture.

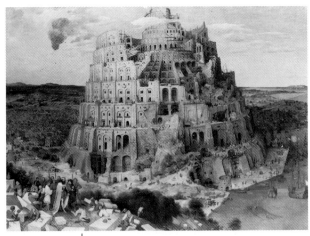

Bruegel the Elder, "Tower of Babel," 1563, Kunsthistorisches Museum, Vienna.

THE FIRST URBAN PLANNERS. Using sun-dried brick as a basic building block, the Mesopotamians devised complex cities centered around the temple. These vast architectural complexes included not only an inner shrine but workshops, storehouses, and residential quarters. For the first time, life was regularized, with division of labor and communal efforts, such as defense and public works projects.

The Palace of Sargon II above Nineveh covered 25 acres and included more than 200 rooms and courtyards, including a brilliantly painted throne room, harem, service quarters, and guard room. It stood on a 50-foot-high, man-made mound above the one-square-mile city. Towering above the elevated palace was a ziggurat (a stepped pyramid-shaped tower). This vast brick temple consisted of seven 18-foot-high stories, each painted a different color. The ziggurat's immense height reflected the belief that the gods dwelled on high. It was destroyed around 600 B.C.

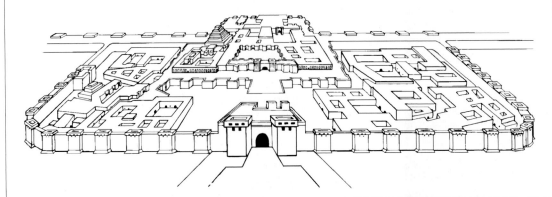

Artist's rendering: "Citadel of King Sargon II," c. 742–706 B.C., Iraq.

THE PERENNIAL PYRAMID

The pyramid shape recurs throughout history and in diverse cultures, many of which have thought the shape itself had magic powers. Man-made landmarks like Mesopotamian ziggurats or flat-sided Egyptian pyramids dominated their landscapes, creating a visual effect as stunning as the amount of effort required to build them. The Mayan stepped pyramids of Mexico's Yucatán peninsula and I. M. Pei's glass entrance to the Louvre in Paris are but two examples of the pyramid shape of different times in different cultures. Is it merely coincidence that the pyramids of Mesopotamia, the cradle of architecture, have served as a symbolic shape for twentieth century architects?

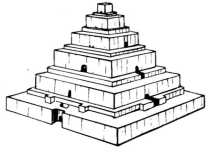

The Ziggurat

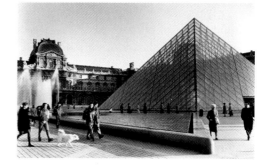

I. M. Pei's Glass Pyramid, the Louvre

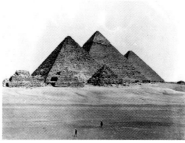

Pyramids of Giza

BAS-RELIEF SCULPTURE. Besides architecture, the predominant art form of Mesopotamia was bas-relief sculpture. Combined with wedge-shaped cuneiform writing, scene after scene of these wall carvings scrupulously detail military exploits.

Another favorite theme seen in bas-reliefs was the king's personal courage during hunting expeditions. At a typical hunting party, servants would goad lions to fury, then release them from cages so the king could slaughter them. "The Dying Lioness" portrays a wounded beast, paralyzed by arrows. The figure's flattened ears and straining muscles convey her death throes with convincing realism.

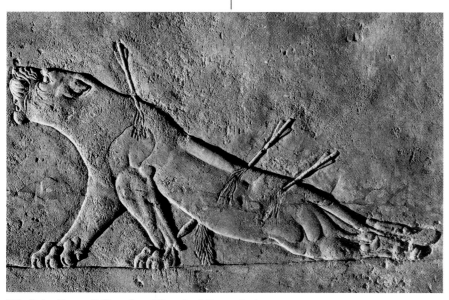

"The Dying Lioness," Nineveh, c. 650 B.C., British Museum, London.

EGYPT: THE ART OF IMMORTALITY

Considering Egyptian society's obsesssion with immortality, it's not surprising that Egyptian art remained unchanged for 3,000 years. Their overriding concern was assuring a comfortable after-life for their rulers, who were considered gods. Colossal architecture and Egyptian art existed to surround the pharaoh's spirit with eternal glory.

In the pursuit of permanence, the Egyptians established the essentials of a major civilization: literature, medical science, and higher mathematics. Not only did they develop an impressive — albeit static — culture, but, while elsewhere lesser civilizations rose and fell with the regularity of the Nile's annual floods, Egypt sustained the world's first large-scale, unified state for three millennia.

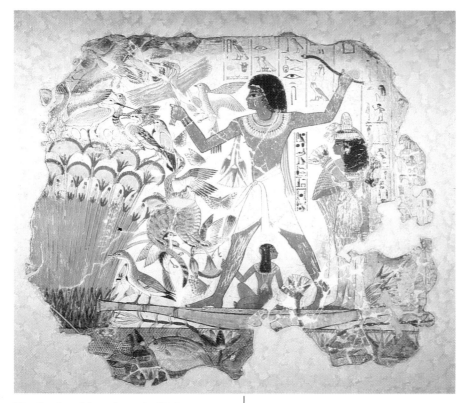

"Fowling Scene" from the tomb of Nebamun, Thebes, c.1450 B.C., British Museum, London. *Egyptian art, built on rigid formulas, was static.*

Much of what we know about ancient Egypt comes from the surviving tombs. Since Egyptians believed the pharaoh's ka, or spirit, was immortal, they stocked the tomb with every earthly delight for it to enjoy in perpetuity. Wall paintings and hieroglyphics were a form of instant replay, inventorying the deceased's life and daily activities in minute detail. Portrait statues provided an alternative dwelling place for the ka, in case the mummified corpse deteriorated and could no longer house it.

Sculpture and paintings followed a rigid formula for representing the human figure. In acres of stone carvings and drawings, the human form is depicted with a front view of the eye and shoulders and profile view of head, arms, and legs. In wall paintings, the surface is divided into horizontal bands separated by lines. The spare, broad-shouldered, narrow-hipped figure wears a headdress and kilt, and stands rigidly, with arms at his side, one leg advanced. The size of a figure indicated rank, with pharaohs presented as giants towering over pygmy-size servants.

Since statues were intended to last eternally, they were made of hard substances like granite and diorite. Whether standing or seated, they included few projecting, breakable parts. The pose was always frontal and bisymmetrical, with arms close to the torso. Human anatomy was usually, at best, an approximation.

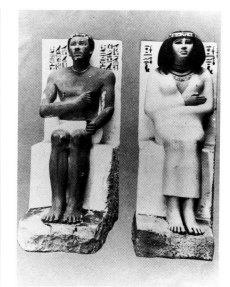

"Prince Rahotep and Wife Nofret," 2610 B.C., Egyptian Museum, Cairo. *These limestone sculptures are typical of the motionless, impassive poses of Egyptian portrait statues.*

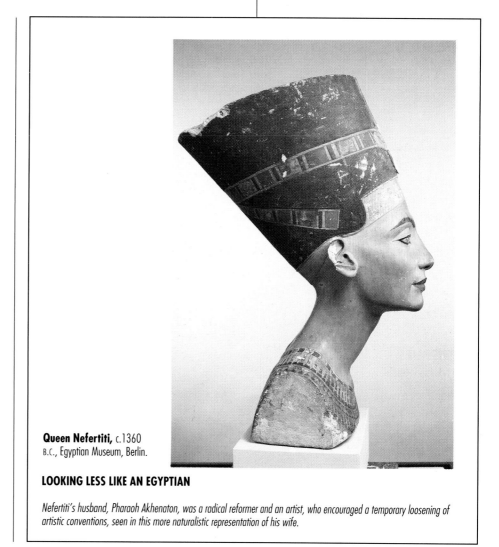

Queen Nefertiti, c.1360 B.C., Egyptian Museum, Berlin.

LOOKING LESS LIKE AN EGYPTIAN

Nefertiti's husband, Pharaoh Akhenaton, was a radical reformer and an artist, who encouraged a temporary loosening of artistic conventions, seen in this more naturalistic representation of his wife.

MUMMY ART

The Egyptians believed the ka, or life force, was immortal. To provide a durable receptacle for the deceased's spirit, they perfected the science of embalming. Preserving the body began with extracting the deceased's brains through the nostrils with a metal hook. Viscera, like the liver, lungs, stomach, and intestines, were removed and preserved in separate urns. What was left was then soaked in brine for more than a month, after which the pickled cadaver was literally hung out to dry. The shriveled body was then stuffed, women's breasts padded, the corpse swaddled in layers of bandages, and finally interred in nested coffins and a stone sarcophagus. In fact, Egypt's dry climate and absence of bacteria in sand and air probably aided preservation as much as this elaborate chemical treatment.

In 1881, 40 dead kings' bodies were discovered, including that of Ramses II, whose dried skin, teeth, and hair were still intact. The 3,000-year-old monarch, in whose court Moses grew up, was called "The Great" and with good reason; he sired more than 100 children during his opulent 67-year reign. Yet, when a customs inspector surveyed Ramses' mortal remains during the transfer of the mummy to Cairo, he labeled it "dried fish."

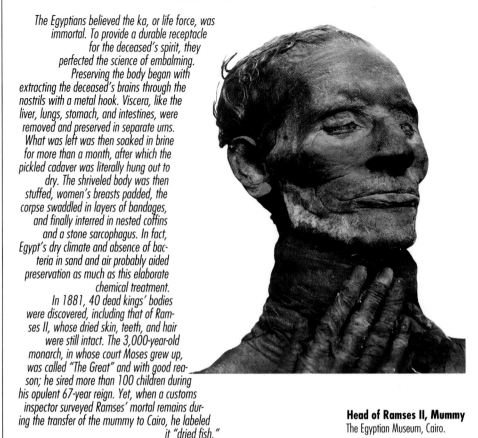

Head of Ramses II, Mummy
The Egyptian Museum, Cairo.

GENERAL CONTRACTING FOR THE GREAT PYRAMID

One of 80 remaining pyramids, the Great Pyramid of Cheops at Giza is the largest stone structure in the world. Ancient Egyptians leveled its 13-acre site — the base a perfect square — so successfully that the southeast corner is only one-half inch higher than the northwest. Since the interior is an almost solid mass of limestone slabs, great engineering skill was required to protect the small burial chambers from the massive weight of stone above. The Grand Gallery's ceiling was tiered and braced, while the king's chamber had six granite-slab roofs above separate compartments to relieve stress and displace the weight of overhead blocks. Built in 2600 B.C. to last forever, so far it has. If you were to construct the Great Pyramid, this is what you'd need:

SUPPLIES:

2,300,000 limestone blocks, each weighing an average of 2 $\frac{1}{2}$ tons

Rudimentary copper-and-stone-cutting tools

Barges to float blocks from quarry on east side of Nile to west bank

Log rollers, temporary brick ramps, wooden sledges to haul stone to construction site

Pearly white limestone facing to surface finished 480-foot-tall pyramid

LABOR:

4,000 construction workers to move blocks weighing up to 15 tons, without benefit of draft animals, the wheel, or block-and-tackle

ESTIMATED COMPLETION TIME:

23 years (average life span at the time was 35)

SCHEMATIC DESIGN OF THE PYRAMID

*The inner design of the pyramid included two burial chambers (**1** and **2**), which were left incomplete. The final chamber (**3**) was reached through the Grand Gallery (**4**) and was ventilated by two narrow air shafts (**5** and **6**). After the Ascending Corridor (**7**) was sealed from within by stone plugs, workmen in the Gallery escaped down a shaft (**8**) and up the Descending Corridor (**9**).*

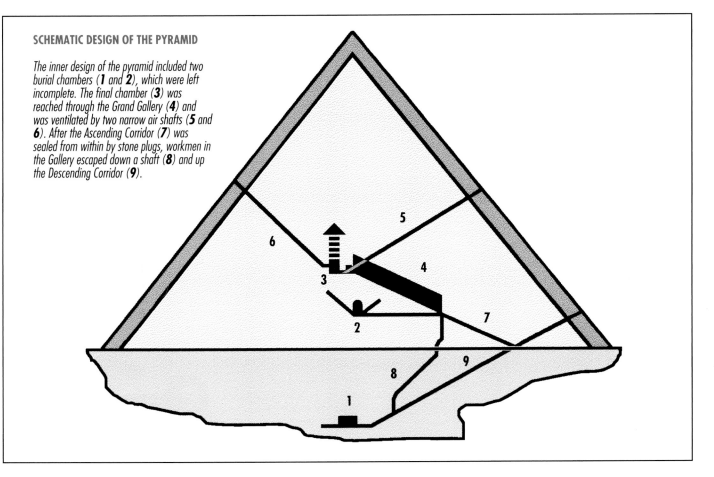

THE DISCOVERY OF KING TUT'S TOMB

In life, King Tutankhamen, who died at the age of 19, was unimportant. Yet in death and 3,000 years later, he became the most celebrated pharaoh of all. His tomb is the only one to be discovered in its near-original condition. The British archeologist Howard Carter was alone in his belief the tomb could be found. For six years he dug in the Valley of Kings, twice coming within two yards of the tomb's entrance. In 1922 he literally struck pay dirt. When he lit a match to peek into the darkness, he saw "everywhere the glint of gold."

Our knowledge of the magnificence of a pharaoh's funerary regalia comes from Tut's tomb. The contents ranged from baskets of fruit and garlands of flowers still tinged with color, a folding camp bed and a toy-box, to four chariots completely covered with gold. Indeed, gold was the prevailing decorating motif: golden couches, gilded throne, gold walls, a 6'2" coffin of solid gold, as well as the now famous solid gold death mask covering the royal mummy's face in the innermost of three nested coffins.

More than 20 people connected with unsealing the tomb died under mysterious circumstances, giving rise to lurid "curse of the pharaoh" stories. Such superstition didn't, however, prevent the King Tut tour of the world's museums from attracting more visitors than any other single art show in history.

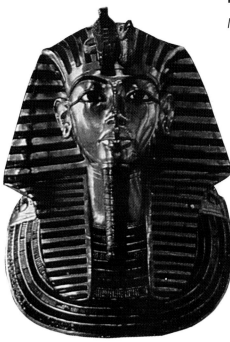

Mask of King Tutankhamen, 1352 B.C., The Egyptian Museum, Cairo. *Even within the final coffin, the face of the mummy was concealed by a beaten-gold mask.*

GREECE:
THEY INVENTED A LOT MORE THAN THE OLYMPICS

The history — some would argue the zenith — of Western civilization began in ancient Greece. For a brief Golden Age, 480–430 B.C., an explosion of creativity resulted in an unparalleled level of excellence in art, architecture, poetry, drama, philosophy, government, law, logic, history, and mathematics. This period is also called the Age of Pericles, after the Athenian leader who championed democracy and encouraged free thinking.

Greek philosophy was summed up in the words of Protagoras: "Man is the measure of all things." This, combined with other philosophers' emphasis on rational inquiry and challenging the status quo, created a society of intellectual and artistic risk-takers.

Just as man's dignity and worth were central Greek concepts, the human figure was the principal motif of Greek art. Where Greek philosophy stressed harmony, order, and clarity of thought, Greek art and architecture reflected a similar respect for balance.

PAINTING. The Greeks were skilled painters. According to literary sources, Greek artists achieved a breakthrough in realistic trompe l'oeil effects. Their paintings were so lifelike that birds pecked murals of painted fruit. Unfortunately, none of these works survive, but we can judge the realistic detail of Greek painting by the figures that adorn their everyday pottery.

VASE PAINTING. Vase painting told stories about gods and heroes of Greek myths as well as such contemporary subjects as warfare and drinking parties. The earliest (c. 800 B.C.) vase design was called the Geometric Style, because the figures and ornaments were primarily geometric shapes. The later Archaic Period was the great age of vase painting. In the black-figured style at the outset of this period, black forms stood out against a reddish clay background. The artist scratched in details with a needle, to expose the red beneath. The red-figured style, starting around 530 B.C., reversed this color scheme. The figures, on a black background, were composed of natural red clay with details painted in black.

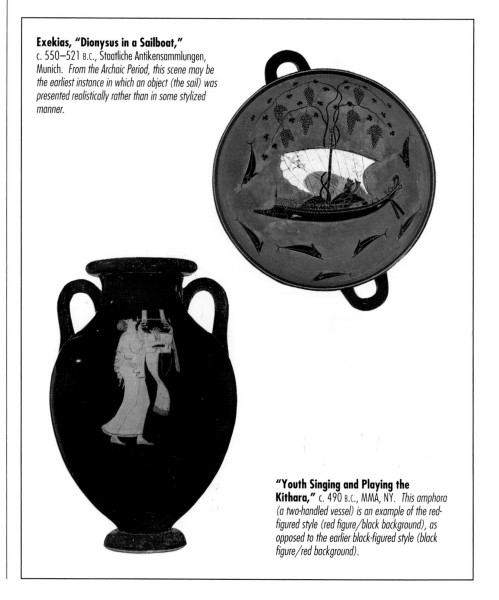

Exekias, "Dionysus in a Sailboat," c. 550–521 B.C., Staatliche Antikensammlungen, Munich. *From the Archaic Period, this scene may be the earliest instance in which an object (the sail) was presented realistically rather than in some stylized manner.*

"Youth Singing and Playing the Kithara," c. 490 B.C., MMA, NY. *This amphora (a two-handled vessel) is an example of the red-figured style (red figure/black background), as opposed to the earlier black-figured style (black figure/red background).*

SCULPTURE: THE BODY BEAUTIFUL. The Greeks invented the nude in art. The ideal proportions of their statues represented the perfection of both body (through athletic endeavor) and mind (through intellectual debate). The Greeks sought a synthesis of the two poles of human behavior — passion and reason — and, through their artistic portrayal of the human form (often in motion), they came close to achieving it.

Greek statues were not the bleached white marble we associate with Classical sculpture today. The marble was embellished with colored encaustic, a mixture of powdered pigment and hot wax applied to hair, lips, eyes, and nails of the figure. Although male nudity was always acceptable in sculpture, the representation of female images evolved from fully clothed to sensually nude. In earlier statues, clinging folds of drapery united the figure in a swirling rhythm of movement. Another innovation was the discovery of the principle of weight shift, or contrapposto, in which the weight of the body rested on one leg with the body realigned accordingly, giving the illusion of a figure in arrested motion.

ETERNAL YOUTH: INFLUENCE OF THE GREEK IDEAL

The ideal proportions of Classical statues, as well as the Greek philosophy of humanism reflected in Nike ("Winged Victory"), influenced the heroic style of Michelangelo's "David." In turn, Rodin's study of Michelangelo's Renaissance sculpture made his work less academic, inspiring "The Age of Bronze."

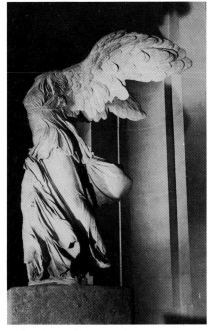

"Nike of Samothrace," c. 190 B.C., Louvre, Paris.

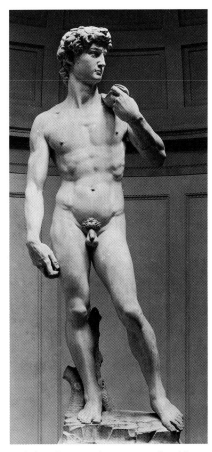

Michelangelo, "David," 1501–4, Galleria dell' Accademia, Florence.

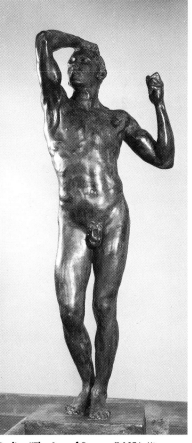

Rodin, "The Age of Bronze," 1876, Minneapolis Institute of Arts.

ARCHITECTURE FIT FOR THE GODS. Greek culture influenced the art and architecture of every subsequent period of Western civilization, but most especially the Renaissance (when many Classical works were rediscovered) and eighteenth- and nineteenth-century Greek Revival crazes. During the latter period, the vogue for Greek style was so widespread that every museum, art academy, and college proudly displayed reproductions of Greek sculpture. Public buildings, such as courthouses and banks, became pseudo-Greek temples.

Architects intended the brilliant white marble Parthenon to be the ultimate expression of Athens' grandeur. Even in ruins, it crowns the Acropolis. The Parthenon's perfection was due to barely perceptible departures from straight lines. Columns curve slightly inward and the entablature and stepped platform are barely arched. These "refinements," as they were called, bent straight lines to give the illusion of upward thrust and solid support for the central mass. Built without mortar, the Parthenon remained relatively intact until 1687, when a direct rocket hit destroyed its core.

In 1801 Lord Elgin carted off much of the sculpture to the British Museum, where the poet John Keats gazed at the marbles for hours, "like a sick eagle looking at the sky."

WHO WAS WHO IN ANCIENT GREECE

Ancient Greece is best known for its philosophers (Socrates, Plato, Aristotle), playwrights (Aeschylus, Aristophanes, Euripides, Sophocles), and mathematicians (Euclid, Pythagoras). Some of the leading artists were:

PHIDIAS (500–432 B.C.), most famous Athenian sculptor, overseer of Parthenon statuary, first used drapery to reveal body

POLYKLEITOS (active 450–420 B.C.), rival of Phidias, wrote book on proportion; most celebrated work colossal gold and ivory statue of Hera at Argos

PRAXITELES (active mid-4th century B.C.), Athenian sculptor famous for first entirely nude Aphrodite statue; introduced more sensual, natural concept of physical beauty

ARCHITECTURE FOR THE AGES

Considered one of the most beautiful and influential buildings of all time, the Parthenon indirectly inspired the temple format of Thomas Jefferson's Virginia Capital and Michael Graves's Post-Modern revival of Classical elements like columns and arcades.

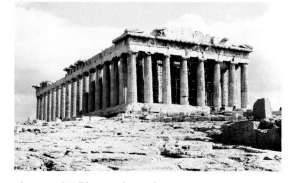

Iktinos and Kallikrates, the Parthenon, 448–432 B.C., Acropolis, Athens.

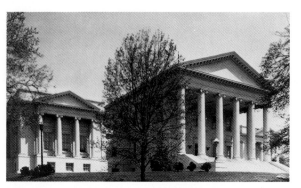

Jefferson, Capitol of Virginia, 1785–92, Richmond, VA.

Graves, Clos Pegase Winery, 1987, Napa Valley, CA.

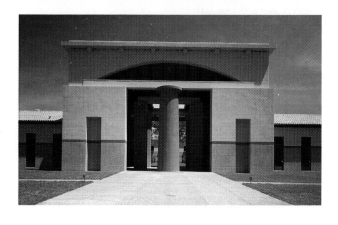

GREEK ARCHITECTURE: A PRIMER

Monuments were treated by the Greeks as large sculpture and were built with the same rules of symmetry and ideal proportions. Public rites took place in front of the temple, where elaborate sculpture told the story of the temple's deity. The most common locations for sculpture were the triangular pediments and horizontal frieze. During the Classic period, features on faces were impassive, giving rise to the term Severe Style. Regardless of the violent events depicted, faces showed little expression as in the Temple of Zeus at Olympia, where a woman seemed lost in thought as she, almost incidentally, removed a drunken centaur's hand from her breast.

Sculpted figures on a building's pediment often protruded sharply from their background stone, which was painted red or blue. Even though the backs of figures could not be seen, because of the Greek obsession with completeness and harmony they were nearly finished.

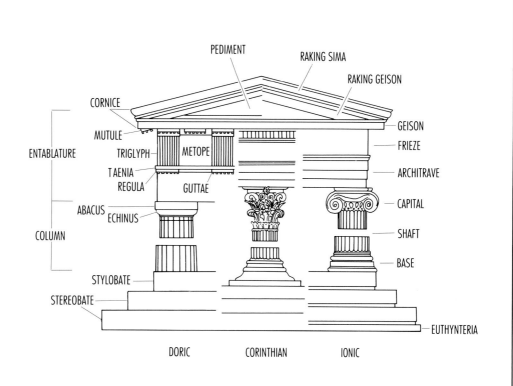

The phrase "Doric order" referred to all the standard components of a Doric temple, typically found on mainland Greece. The "Ionic order" was more widespread in the Greek settlements of Asia Minor and the Aegean. The "Corinthian order," its columns topped by stylized leaves of the acanthus plant, developed much later. It was not widely used on exteriors until Roman times. The curve along the tapering lines of a column was called entasis. In keeping with the Greeks' fixation on harmony, this slight curve conveyed a fluid, rather than rigid, effect. Occasionally, female figures called caryatids replaced fluted columns.

GREEK ART

GOLDEN AGE: 480–430 B.C.

PHILOSOPHY: Moderation in all

MOST FAMOUS WORK: "Winged Victory"

MOST FAMOUS BUILDING: Parthenon

CHARACTERISTIC FORM: Male nude

SIGNATURE CITY: Athens

MAJOR CONTRIBUTIONS: Democracy, individualism, reason

GREEK ART STYLES

GEOMETRIC ART (9th–8th century B.C.), pottery ornamented with geometric banding and friezes of simplified animals, humans

ARCHAIC ART (600–480 B.C.), period includes kouros stone figures and vase painting

KOUROS (nude male youth)/KORE (clothed maiden), earliest (625–480 B.C.) free-standing statues of human figures; frontal stance, left foot forward, clenched fists, and grimace known as "Archaic smile"

SEVERE STYLE, early phase of Classical sculpture characterized by reserved, remote expressions

CLASSICAL ART (480–323 B.C.), peak of Greek art and architecture, idealized figures exemplify order and harmony

HELLENISTIC ART (323–31 B.C.), Greek-derived style, found in Asia Minor, Mesopotamia, Egypt; more melodramatic (as in "Laocoön," 50 B.C.) than Classical style

ROME: THE ORGANIZERS

At its height, the Roman Empire stretched from England to Egypt and from Spain to southern Russia. Because of their exposure to foreign lands, the Romans absorbed elements from older cultures — notably Greece — and then transmitted this cultural mix (Greco-Roman) to all of Western Europe and Northern Africa. Roman art became the building block for the art of all succeeding periods.

At first, awestruck Romans were overwhelmed by the Greek influence. This appetite was so intense that Greek marbles and bronzes arrived by the galleonful to ornament Roman forums. Nero imported 500 bronzes from Delphi alone, and when there were no more originals, Roman artisans made copies. The poet Horace noted the irony: "Conquered Greece," he wrote, "took her rude captor captive."

Later, however, Romans put their own spin on Greek art and philosophy. Having founded the greatest empire the world had ever known, they added managerial talents: organization and efficiency. Roman art is less idealized and intellectual than Classical Greek, more secular and functional. And, where the Greeks shined at innovation, the Romans' forte was administration. Wherever their generals marched, they brought the civilizing influence of law and the practical benefits of roads, bridges, sewers, and aqueducts.

ROMAN ART

PHILOSOPHY: Efficiency, organization, practicality

ART FORMS: Mosaics, realistic wall paintings, idealized civic sculpture

MOST FAMOUS BUILDING: Pantheon

SIGNATURE CITY: Rome

ROLE MODEL: Greece

MAJOR CONTRIBUTIONS: Law, engineering, cement

IS IT GREEK OR IS IT ROMAN?

Greek and Roman art and architecture are often confused. Here's a chart of the major differences.

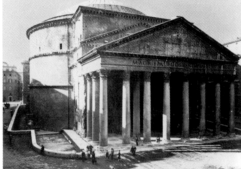

The Pantheon, A.D. 118–125, Rome. *The domed rotunda of the Pantheon illustrates the Roman architects' ability to enclose space.*

Parthenon, 448–432 B.C., Athens. *The Parthenon's triangular pediment and columned portico show classic Greek temple format.*

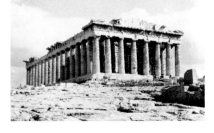

	GREEK	ROMAN
PREFERRED STRUCTURE:	Temples to glorify gods	Civic buildings (baths, forum) to honor Empire
WALLS:	Made of cut stone blocks	Concrete with ornamental facing
TRADEMARK FORMS:	Rectangles, straight lines	Circles, curved lines
SUPPORT SYSTEM:	Post and lintel	Rounded arch, vaults
COLUMN STYLE:	Doric, Ionic	Corinthian
SCULPTURE:	Idealized gods and goddesses	Realistic human beings, idealized officials
PAINTING:	Stylized figures floating in space	Realistic images with perspective
SUBJECT OF ART:	Mythology	Civic leaders, military triumphs

THE LEGACY OF ROME

Roman architects used Greek forms but developed new construction techniques like the arch to span greater distances than the Greek post and lintel system (two vertical posts with a horizontal beam). Concrete allowed more flexible designs, as in the barrel-vaulted roof, and the dome-covered, huge circular areas. Here are some Roman contributions to architecture:

BASILICA, an oblong building with semicircular apses on either end and high clerestory windows, used as meeting place in Roman times and widely imitated in medieval Christian churches.

BARREL VAULT, deep arch forming a half-cylindrical roof

GROIN VAULT, two intersecting barrel vaults at the same height that form a right angle

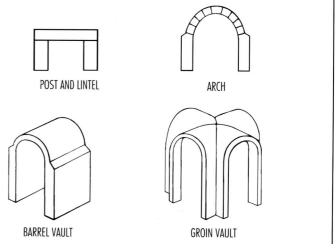

POST AND LINTEL ARCH

BARREL VAULT GROIN VAULT

ROMAN ARCHITECTURE: VAULTING AMBITION.

Besides Roman law, perhaps Rome's most valuable contributions were in the areas of architecture and engineering. Roman builders not only developed the arch, vault, and dome but pioneered the creative use of concrete. These innovations proved revolutionary, allowing Romans for the first time to cover immense interior spaces without inner supports.

Rome became incredibly rich from conquered booty. Nero's palace, the Golden House, with its mile-long portico, was the most opulent residence in antiquity. In the banquet room, perfume sprinkled down on guests from the ceiling. Inside, a domed roof revolved so that visitors could follow the constellations through its central opening.

The Romans loved baths, and the more extravagant, the better. At the enormous Baths of Caracalla (A.D. 215), a capacity crowd of 1,600 bathed in pools of varying water temperatures. An elaborate pipe system stoked by slaves heated steam baths and exercise rooms as well. "We have become so luxurious," observed the writer Seneca, "that we will have nothing but precious stones to walk upon."

ROMAN SCULPTURE: POLITICS AS USUAL.

Although the Romans copied Greek statues wholesale to satisfy the fad for Hellenic art, they gradually developed their own distinctive style. In general, Roman sculpture was more literal. The Romans had always kept wax death masks of ancestors in their homes. These realistic images were completely factual molds of the deceased's features, and this tradition influenced Roman sculptors.

An exception to this tradition was the assembly-line, godlike busts of emperors, politicians, and military leaders in civic buildings throughout Europe, establishing a political presence thousands of miles from Rome. Interestingly, during Rome's decline, when assassination became the preferred means for transfer of power, portrait busts reverted to brutal honesty. An unflattering statue of Caracalla reveals a cruel dictator, and Philip the Arab's portrait shows a suspicious tyrant.

The other principal form of Roman sculpture was narrative relief. Panels of sculpted figures depicting military exploits decorated triumphal arches, under which victorious armies paraded, leading long lines of chained prisoners. The Column of Trajan (A.D. 106–113) was the most ambitious of these efforts. A 650-foot-long relief wound around the column in an unbroken spiral, commemorating mass slaughter in more than 150 scenes.

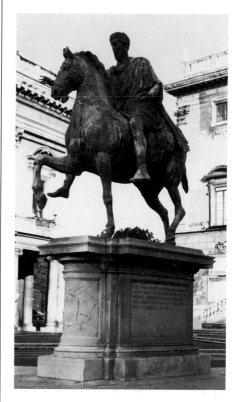

Marcus Aurelius, A.D. 165, Capitoline Hill, Rome. *The Emperor Marcus Aurelius was a Stoic philosopher who detested war. The sculptor represented this gentle, reflective ruler as a superhuman ideal.*

THE COLOSSEUM

With a million people in Rome, many of them poor, emperors distracted the masses from their grievances with large-scale public entertainment. At the Colosseum, which seated 50,000 spectators, for the opening act in A.D. 80, the entire arena was flooded to stage a naval battle reenacted by a cast of 3,000.

Combat between gladiators was popular. Some were armed with shield, sword, and helmet, while others carried only net and trident. Boxers wore leather gloves, their fists clenched around lumps of iron. To guarantee an energetic performance, the combat was to the death. Slaves carrying whips with lead weights on the lashes drove fleeing men or beasts back into the fray. Up to forty gladiators (if the crowd was in a thumbs-down mood) died per day. In the course of a single day's events, thousands of corpses were dragged off with a metal hook.

Half-time shows featured the execution of criminals, followed by man–wild beast contests. Early "elevators" raised hundreds of starving lions from underground cages to attack unarmed Christians or slaves. Man-versus-bear struggles were also much admired, as were animal hunts starring elephants or rhinoceroses. To celebrate one victory, the Emperor Trajan sacrificed 11,000 lions, leopards, ostriches, and antelopes. To disguise the odor of stables, slaves sprayed clouds of perfume at distinguished spectators and sprinkled red powder on the arena's sand floor to make bloodstains less conspicuous.

Still one of the world's largest buildings in terms of sheer mass, the Colosseum was so efficiently laid out that it inspired present-day stadium design. Each spectator had a seat number corresponding to a certain gate, which allowed smooth crowd flow via miles of corridors and ramps. Three types of columns framed the 161-foot-high structure, using the Doric order at the base, Ionic in the middle, and Corinthian above — the typical design sequence for a multistoried Roman building. The balance of vertical columns and horizontal bands of arches unified the exterior, relating the enormous façade to a more human scale. Sadly, Rome's rich Barberini family later stripped off the stadium's marble facing for their building projects.

Colosseum, A.D. 70–82, Rome.

Pont du Gard, Nîmes, 1st century B.C., France. *Beginning in the 4th century B.C., Romans constructed huge aqueducts to carry water for distances up to 50 miles. These structures were built on continuous gradual declines to transport water by force of gravity. On the Pont du Gard aqueduct, which carried 100 gallons of water a day for each inhabitant of the city, each large arch spanned 82 feet.*

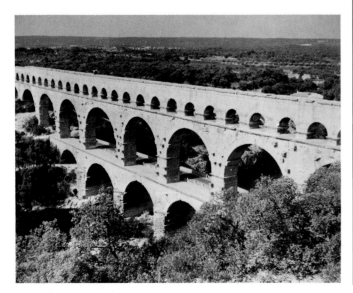

POMPEII: A CITY TURNED TO CARBON

It was 1 P.M. on a summer day when, according to eyewitness Pliny the Younger, Mt. Vesuvius erupted, spewing molten lava and raining ash on the nearby towns of Pompeii and Herculaneum. A black mushroom cloud rose 12 miles over the peak until, by the end of the next day, the villages were covered with 18 feet of ash and pumice. They remained covered — forgotten — for 1,700 years, preserving an incredible hoard of nearly intact artifacts, mosaics, and wall paintings.

Pompeii was a luxurious resort community with a population of 25,000. The scientific excavation that began in the mid-1800s disclosed not only ordinary objects like carbonized loaves of bread, fish, eggs, and nuts (a priest's abandoned lunch) but whole villas in which every wall was painted with realistic still lifes and landscapes. Since the interiors of villas had no windows, only a central atrium opening, ancient Romans painted make-believe windows with elaborate views of fantasy vistas. This style of wall painting ranged from simple imitations of colored marble to trompe l'oeil scenes of complex cityscapes as seen through imaginary windows framed by imaginary painted columns. Artists mastered tricks of perspective and effects of light and shadow that were unknown in world art. Walls glowed with vivid red, tan, and green panels.

Mosaics made of bits of colored stone, glass, or shell (called tesserae) covered floors, walls, and ceilings. Many were as intricate as paintings. In one, fifty tiny cubes composed a one-and-a-half-inch eye. Entrances often included a mosaic of a dog with the words "Cave Canem" (Beware of the Dog).

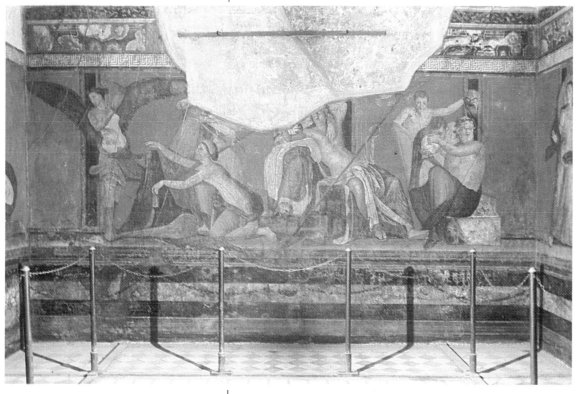

Frieze, Villa of the Mysteries, c. 50 B.C., Pompeii. *A frieze of nearly life-size figures presumably depicted secret Dionysian rites, such as drinking blood of sacrificed beasts.*

PRE-COLUMBIAN ART OF THE AMERICAS: NEW WORLD ART WHEN IT WAS STILL AN OLD WORLD

"Pre-Columbian" refers to the period before Columbus landed in the New World, or before European customs began to influence Native American artisans of North, Central, and South America. Arrowheads from 10,000 B.C. and pottery from 2000 B.C. have been found, evidence of how ancient New World culture actually was. Art was vitally important to tribal society. Objects used in religious rituals, such as carved masks and pipebowls, were thought to be charged with magic. In a life of uncertainty, craftsmen hoped these objects would appease nature and help the tribe survive.

NATIVE AMERICAN ART: A SAMPLING

Pre-Columbian art ranges from the mountains of Peru to the plains of the Midwest to the coast of Alaska. The following were some of the best-known tribal artisans:

NAVAHO: Southwest tribe known for geometric-design rugs colored with herbal and mineral dyes, especially carmine red. Shamans created sand paintings to heal disease, promote fertility, or assure a successful hunt. Still practicing today, Navaho sand painters use natural pigments, like powdered rock in various colors, corn pollen, and charcoal, to produce temporary works on a flat bed of sand.

HOPI: Carved and painted kachina dolls out of cottonwood roots to represent gods and teach religion. Also decorated ceremonial underground kivas in Arizona with elaborate mural paintings of agriculture deities.

KWAKIUTL: Northwest coast tribe that produced totem poles, masks, and decorated houses and canoes. Facial features of masks exaggerated in forceful wood carvings. Mortuary poles and totem poles indicated social status.

ESKIMO: Alaskan tribe that carved masks with moving parts used by shamans; often combined odd materials in surprising ways.

MAYAN: In Guatemala and Mexico, Mayans created enormous temples in stepped-pyramid form. Huge limestone temples were richly carved with relief sculpture and hieroglyphics. Tikal (population 70,000) was largest Mayan site, with highest pyramid reaching 230 feet. Although the Mayans had sophisticated calendar and knowledge of astronomy, civilization withered about A.D. 900.

AZTEC: Capital was Mexico City, the urban center of this large empire. Produced massive statues of gods who demanded regular human sacrifices. Skilled in gold work.

INCAN: Peruvian tribe known for precisely constructed masonry temples and metallurgy; civilization at height when Spaniards arrived.

Ceremonial sand painting, 1968, Navaho, National Museum of the American Indian, NY.

Hopi kachina doll, 1972, National Museum of the American Indian, NY.

Eskimo shaman mask, before 1900, National Museum of the American Indian, NY.

Totem pole, Nootka, 1928 , Smithsonian Institution, Washington, D.C.

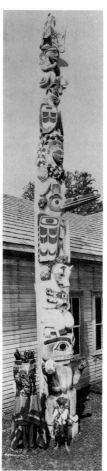

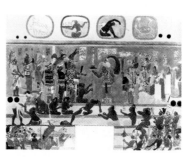

Temple mural, Mayan, A.D. 790–800, Peabody Museum, Harvard.

Gold Figurine of King Tizoc, Aztec, c. 1481–86, Mexican, National Museum of the American Indian, NY.

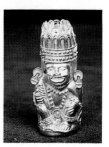

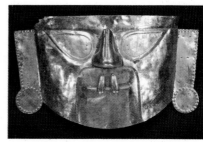

Gold funerary mask, Incan, 12th–14th century, MMA, NY.

MOUND-BUILDERS

Native Americans have always been environmentalists. Their philosophy was based on unity between nature — a maternal force to be loved and respected — and humanity. In the Great Serpent Mound of Ohio, Native Americans constructed an elaborate natural shrine as a setting for their religion. About a quarter-mile long, the burial mound was in the shape of a snake holding an egg in its jaws.

From 2000 B.C., tribes constructed these mounds, each some 100 feet high, from Florida to Wisconsin. More than 10,000 existed in the Ohio Valley alone. Some imitated the shape of a tribe's totem animal, such as an enormous bird with spreading wings. Others were simply shaped like domes, but in each case, the builders hauled millions of tons of earth by hand in baskets, then tamped it down. The volume of the largest mound, near St. Louis, was greater than that of the Great Pyramid. In some cases, inner burial chambers contained archeological treasures, like the body of an aristocrat clothed entirely in pearls.

Mound-builders partly inspired Earthworks, a movement that emerged in the late 1960s to make the land itself a work of art. Robert Smithson's "Spiral Jetty" (in Great Salt Lake, Utah) is one of the better-known examples of this movement.

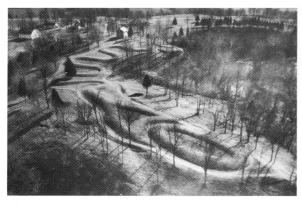

"The Great Serpent Mound," 1000 B.C.–A.D. 400, length 1,400', Adams County, Ohio.

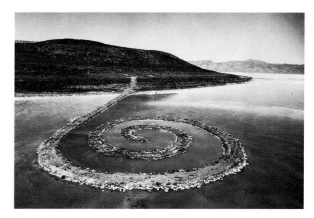

Smithson, "Spiral Jetty," 1970, rock, salt crystals, and earth, coil length 1500', Great Salt Lake, Utah.

Besides their role in important events like initiations, funerals, and festivals, beautiful objects were also prized because Native Americans valued gift-giving. High-quality gifts bestowed prestige on the giver, and artisans excelled in silverwork, basketry, ceramics, weaving, and beadwork. Native Americans were also skilled at wall painting. Their work tended toward the abstract, with stylized pictographs floating almost randomly, as in cave paintings, without foreground or background.

Much Native American art was inspired by visions. The shaman (priest-healer) would reproduce objects the gods communicated to him during a trance. Among the results of drawing on such subconscious impulses were extremely distorted Eskimo masks, among the most original art ever seen.

20TH-CENTURY "TRIBAL" ART

Among the many modern painters influenced by Native American art were Diego Rivera and Jackson Pollock, whose 20th-century works grew out of centuries-old practices.

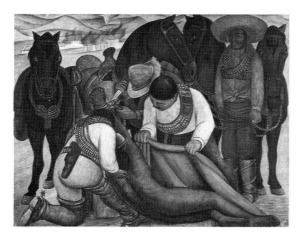

Rivera, "The Liberation of the Peon," 1931, Philadelphia Museum of Art. The part-Spanish, part-Indian Mexican painter Diego Rivera based his style on Mayan murals, even experimenting with cactus juice as a medium.

Pollock, "Bird," 1941, MoMA, NY. After seeing Navaho shamans making sand paintings, Pollock began to use tinted sand and to paint with his canvas on the floor, saying, "On the floor I . . . feel nearer, more a part of the painting, since this way I can walk around it, work from the four sides, and literally be in the painting [like] the Indian sand painters of the West."

AFRICAN ART: THE FIRST CUBISTS

The main artistic products of tropical Africa were wood carvings, both masks and sculpture in-the-round. In form these objects were angular, off-balance, and distorted. For members of African society, they were sacred objects harboring the life force of an ancestor or nature spirit and had power to cure illnesses or harm enemies. On special occasions the figures and masks were removed from their shrines, washed, anointed with palm oil, and decorated with beads and cloth. In between rituals, the figures were considered so infused with supernatural power they were hidden, and women and children were forbidden to look at them. Although the moist jungle climate rotted many of these wooden objects, those that remain express the emotional intensity their society invested in them.

MASKS. Wooden masks were used in ritual performances with complex musical rhythms, dances, and costumes. For their full impact, they should be thought of in motion, surrounded by colorful garments and the rapid swaying and rustling of raffia skirts and arm fringes.

Masks were intentionally unrealistic: when confronting a supernatural power, the idea was for the performer to conceal his true identity behind this artificial face. For dramatic effect, carvers simplified human features in a series of sharply cut advancing and receding planes.

This freedom from European tradition is what appealed to Pablo Picasso — who became aware of African art around 1905 — and inspired the Cubist movement. Picasso described his reaction to African fetish masks this way: "It came to me that this was very important. . . . These masks were not just pieces of sculpture like the rest. . . .They were magic."

Their influence is evident in Picasso's landmark painting, "Les Demoiselles d'Avignon." (Avignon was the name of a street in Barcelona's red-light district, and the women were intended to depict prostitutes.) The painting was a transition point between Picasso's African-influenced period and pure Cubism. Inspired by the distortions of African carving and in order to show multiple aspects of an object at the same time, Picasso painted the figures in jagged planes.

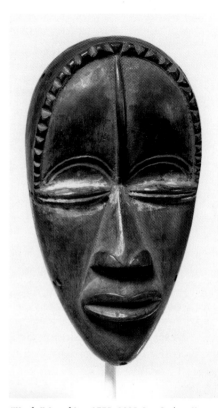

"Kagle" (mask), c. 1775–1825, Dan, Rietberg Museum, Zürich. *African masks were typically lozenge-shaped, with wedge noses and almondlike eyes.*

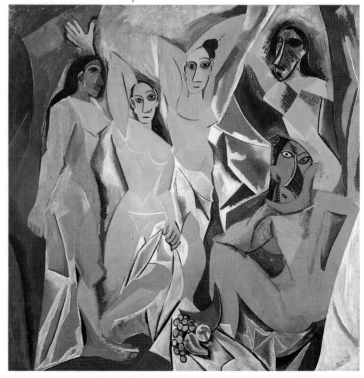

Picasso, "Les Demoiselles d'Avignon," 1907, MoMA, NY. *After seeing African masks, Picasso raced back to his studio to repaint the faces in this picture.*

AFRICAN SCULPTURE. African carvers consistently rejected real-life appearance in favor of vertical forms, tubular shapes, and stretched-out body parts derived from the cylindrical form of trees. Since sculptures were believed to house powerful spirits, these wooden figures could wreak havoc or bestow blessings among the living.

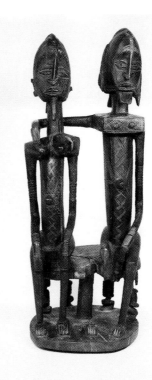

"**Couple,**" n.d., wood, Dogon, Mali, The Barnes Foundation, PA.

THE FAR-FLUNG INFLUENCE OF TRIBAL ART

Beginning with Gauguin's pace-setting appreciation of South Sea islanders, primitive art influenced professional Western artists from the late nineteenth century through the present. The following artists and movements were the most affected by the art of pre-industrial societies:

GAUGUIN: Gauguin went to Tahiti in 1891, seeking an exotic culture unspoiled by civilization. The brilliant colors and simplified anatomy of his island paintings reflect decorative Oceanic art.

FAUVES: Around 1904-8, the Fauves discovered African and South Pacific sculpture. Matisse, Derain, and Vlaminck were key painters who enthusiastically collected African masks.

CUBISTS: Picasso and Braque pioneered this movement based on African tribal sculpture and masks, which fractured reality into overlapping planes. Cubism stimulated developments throughout Europe, leading to the abstraction of Malevich and Mondrian.

SURREALISTS: In the 1920s, antirational artists like Ernst, Miró, Magritte, Giacometti, and Dalí collected Pacific carvings, African masks, and fanciful Eskimo masks.

MEXICAN MURALISTS: José Clemente Orozco, David Siqueiros, and Diego Rivera dominated Mexican art in the 1930s by paying homage to the Mayan and Aztec empires.

MODERNISTS: Sophisticated artists like Modigliani found a freshness and vitality in tribal art missing in conventional art. His paintings of long-necked women resemble African carved figures.

ABSTRACT EXPRESSIONISTS: The impermanence of Navaho sand paintings, destroyed at the end of a rite, influenced Abstract Expressionists to focus on the process of artistic creation rather than the end product.

CONTEMPORARY: Artists as diverse as Jasper Johns, Roy Lichtenstein, Keith Haring, and David Salle have incorporated images of African masks into their work.

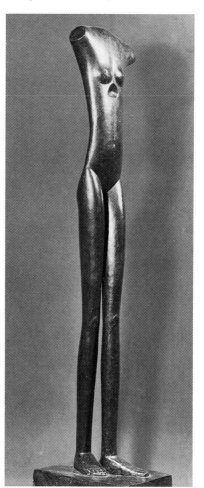

Giacometti, "Walking Woman," 1932–33, collection of Rhode-St.-Genése. *Another Modernist whose work resembles tribal African art is Giacometti, known for his elongated sculptures.*

THE MIDDLE AGES:
THE REIGN OF RELIGION

The Middle Ages included the millennium from the fifth to the fifteenth century, roughly from the fall of Rome until the Renaissance. During its initial period, called the Dark Ages, after the death of the Byzantine Emperor Justinian in 565 until the reign of Charlemagne in 800, barbarians destroyed what had taken 3,000 years to build. Yet the Dark Ages were only part of the Middle Ages story. There were many bright spots in art and architecture, from the splendor of the Byzantine court in Constantinople to the majesty of Gothic cathedrals.

Three major shifts occurred that had far-reaching effects on Western civilization:

1. Cultural leadership moved north from the Mediterranean to France, Germany, and the British Isles.
2. Christianity triumphed over paganism and barbarism.
3. Emphasis shifted from the here-and-now to the hereafter, and with it from the body as beautiful to the body as corrupt.

Since the Christian focus was on salvation for a glorious afterlife, interest in realistically representing objects of the world disappeared. Nudes were forbidden, and even images of clothed bodies showed ignorance of anatomy. The Greco-Roman ideals of harmonious proportions and balance between the body and mind ceased to exist. Instead, medieval artisans were interested exclusively in the soul, especially in instructing new believers in church dogma. Art became the servant of the church. Theologians believed church members would come to appreciate divine beauty through material beauty, and lavish mosaics, paintings, and sculpture were the result.

In architecture, this orientation toward the spiritual took the form of lighter, more airy buildings. The mass and bulk of Roman architecture gave way to buildings reflecting the ideal Christian: plain on the outside but glowing with spiritually symbolic mosaics, frescoes, or stained glass inside.

Medieval art was composed of three different styles: Byzantine, Romanesque, and Gothic.

GOLDEN AGE OF BYZANTINE ART

Byzantine refers to eastern Mediterranean art from A.D. 330, when Constantine transferred the seat of the Roman Empire to Byzantium (later called Constantinople) until the city's fall to the Turks in 1453. In the interim, while Rome was overrun by barbarians and declining to a heap of rubble, Byzantium became the center of a brilliant civilization combining early Christian art with the Greek Oriental taste for rich decoration and color. In fact, the complex formality of Byzantine art and architecture doubtless shaped the modern sense of the word "Byzantine."

ART OF THE MIDDLE AGES

Throughout the Middle Ages, in a succession of three styles, art was concerned with religion. The main forms of art and architecture associated with each style were:

	BYZANTINE	ROMANESQUE	GOTHIC
ART	Mosaics, icons	Frescoes, stylized sculpture	Stained glass, more natural sculpture
ARCHITECTURE	Central-dome church	Barrel-vaulted church	Pointed-arch cathedral
EXAMPLE	Hagia Sophia	St. Sernin	Chartres
DATE	532–37	Begun 1080	1194–1260
PLACE	Constantinople, Turkey	Toulouse, France	Chartres, France

ICONS

As gloomy as these images of tortured martyrs were, no discussion of Byzantine art is complete without a look at icons. Icons were small wood-panel paintings, believed to possess supernatural powers. The images of saints or holy persons were typically rigid, frontal poses, often with halos and staring, wide eyes. Icons supposedly had magical properties. According to legend, one wept, another emitted the odor of incense. Ardent believers carried them into battle or wore away their faces by kissing them. So powerful did the cult of icons become that they were banned from 726–843 as a violation of the commandment against idolatry.

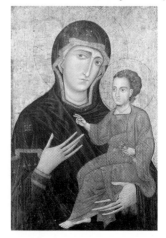

Berlinghiero, "Madonna and Child," early 12th century, MMA, NY.

MOSAICS. Some of the world's greatest art, in the form of mosaics, was created during the fifth and sixth centuries in Turkish Byzantium and its Italian capital, Ravenna. Mosaics were intended to publicize the now-official Christian creed, so their subject was generally religion with Christ shown as teacher and all-powerful ruler. Sumptuous grandeur, with halos spotlighting sacred figures and shimmering gold backgrounds, characterized these works.

Human figures were flat, stiff, and symmetrically placed, seeming to float as if hung from pegs. Artisans had no interest in suggesting perspective or volume. Tall, slim human figures with almond-shaped faces, huge eyes, and solemn expressions gazed straight ahead, without the least hint of movement.

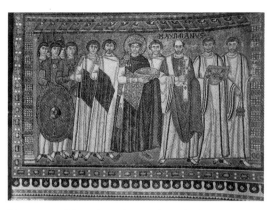

"Justinian and Attendants," c. 547, San Vitale, Ravenna.

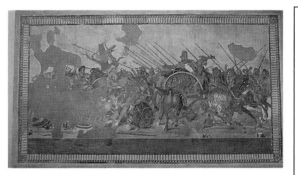

"The Battle of Issus," Pompeii, c. 80 B.C., Museo Nazionale, Naples.

Although drawing on the Roman tradition of setting colored cubes, or tesserae, in plaster to form a picture, Byzantine mosaics (above, right) were distinct from Roman (left). Here are the principal variations:

ROMAN MOSAICS	VS.	BYZANTINE MOSAICS
Used opaque marble cubes		Used reflective glass cubes
Pieces had smooth, flat finish		Surfaces left uneven so work sparkled
Colors limited due to use of natural stones		Glowing glass in wide range of colors
Typically found on floor of private homes		Found on walls and ceilings — especially church dome and apse
Subjects were secular, like battles, games		Subjects were religious, like Christ as shepherd
Used minute pieces for realistic detail		Large cubes in stylized designs
Background represented landscape		Background was abstract: sky-blue, then gold

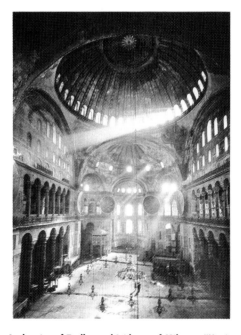

Anthemius of Tralles and Isidorus of Miletus, "Hagia Sophia," Constantinople (Istanbul, Turkey), 532–37. *Cathedrals from Venice to Russia were based on this domed structure, a masterpiece of Byzantine architecture.*

HAGIA SOPHIA. When Emperor Justinian decided to build a church in Constantinople, the greatest city in the world for 400 years, he wanted to make it as grand as his empire. He assigned the task to two mathematicians, Anthemius of Tralles and Isidorus of Miletus. They obliged his ambition with a completely innovative structure, recognized as a climax in Byzantine architectural style.

The Hagia Sophia (pronounced AYE yah soh FEE ah; the name means "holy wisdom") merged the vast scale of Roman buildings like the Baths of Caracalla with an Eastern mystical atmosphere. Nearly three football fields long, it combined the Roman rectangular basilica layout with a huge central dome. Architects achieved this breakthrough thanks to the Byzantine contribution to engineering — pendentives. For the first time, four arches forming a square (as opposed to round weight-bearing walls, as in the Pantheon) supported a dome. This structural revolution accounted for the lofty, unobstructed interior with its soaring dome.

Forty arched windows encircle the base of the dome, creating the illusion that it rests on a halo of light. This overhead radiance seems to dissolve the walls in divine light, transforming the material into an otherworldly vision. So successful was his creation, that Justinian boasted, "Solomon, I have vanquished thee!"

ROMANESQUE ART: STORIES IN STONE

With the Roman Catholic faith firmly established, a wave of church construction throughout feudal Europe occurred from 1050 to 1200. Builders borrowed elements from Roman architecture, such as rounded arches and columns, giving rise to the term Romanesque for the art and architecture of the period. Yet because Roman buildings were timber-roofed and prone to fires, medieval artisans began to roof churches with stone vaulting. In this system, barrel or groin vaults resting on piers could span large openings with few internal supports or obstructions.

Pilgrimages were in vogue at the time, and church architecture took into account the hordes of tourists visiting shrines of sacred bones, garments, or splinters from the True Cross brought back by the Crusaders. The layout was cruciform, symbolizing the body of Christ on the cross with a long nave transversed by a shorter transept.

Arcades allowed pilgrims to walk around peripheral aisles without disrupting ceremonies for local worshipers in the central nave. At the *chevet* ("pillow" in French), called such because it was conceived as the resting place for Christ's head as he hung on the cross, behind the altar, were semicircular chapels with saints' relics.

The exterior of Romanesque churches was rather plain except for sculptural relief around the main portal. Since most church-goers were illiterate, sculpture taught religious doctrine by telling stories in stone. Sculpture was concentrated in the tympanum, the semicircular space beneath the arch and above the lintel of the central door. Scenes of Christ's ascension to the heavenly throne were popular, as well as grisly Last Judgment dioramas, where demons gobbled hapless souls, while devils strangled or spitted naked bodies of the damned.

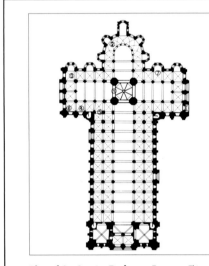

Plan of St. Sernin, Toulouse, France. *This typical segmented, Romanesque structure includes multiple semicircular chapels and vaulted square bays.*

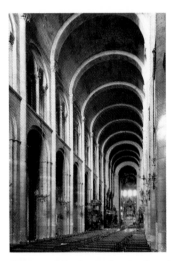

The nave of St. Sernin showing barrel vaults, c. 1080–1120.

Last Judgment from west tympanum, Autun Cathedral, c.1130–35. *In Romanesque sculpture, realism yielded to moralism. Bodies, distorted to fit the masonry niche, were elongated with expressions of intense emotion.*

GIOTTO: PIONEER PAINTER

Because Italy maintained contact with Byzantine civilization, the art of painting was never abandoned. But at the end of the 13th century, a flowering of technically skilled painting occurred, with masters like Duccio and Simone Martini of Siena and Cimabue and Giotto of Florence breaking with the frozen Byzantine style for softer, more lifelike forms. The frescoes (paintings on damp plaster walls) of Giotto di Bondone (pronounced JOT toe; c.1266–1337) were the first since the Roman period to render human forms suggesting weight and roundness. They marked the advent of what would afterward become painting's central role in Western art.

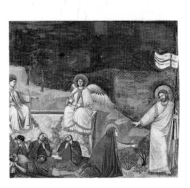

Giotto, "Noli me tangere," 1305, fresco, Arena Chapel, Padua. *Giotto painted human figures with a sense of anatomical structure beneath the drapery.*

HOW TO TELL THEM APART

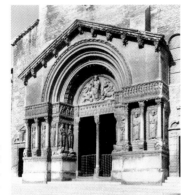

St. Trophime,
late 12th
century, Arles,
France.

Romanesque churches had round arches and stylized sculpture. Gothic cathedrals had pointed arches and more natural sculpture. Keeping Romanesque and Gothic straight means recognizing the distinctive features of each, like the following:

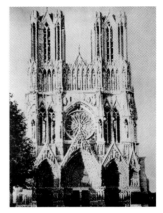

**Reims Cathedral,
west façade,**
c.1220–36, France.

	ROMANESQUE	VS.	GOTHIC
EMPHASIS	horizontal		vertical
ELEVATION	modest height		soaring
LAYOUT	multiple units		unified, unbroken space
MAIN TRAIT	rounded arch		pointed arch
SUPPORT SYSTEM	piers, walls		exterior buttresses
ENGINEERING	barrel & groin vaults		ribbed groin vaults
AMBIANCE	dark, solemn		airy, bright
EXTERIOR	simple, severe		richly decorated with sculpture

ILLUMINATED MANUSCRIPTS. With hordes of pillagers looting and razing cities of the former Roman Empire, monasteries were all that stood between Western Europe and total chaos. Here monks and nuns copied manuscripts, keeping alive both the art of illustration in particular and Western civilization in general.

By this time, the papyrus scroll used from Egypt to Rome was replaced by the vellum (calfskin) or parchment (lambskin) codex, made of separate pages bound at one side. Manuscripts were considered sacred objects containing the word of God. They were decorated lavishly, so their outward beauty would reflect their sublime contents. Covers were made of gold studded with precious and semiprecious gems. Until printing was developed in the fifteenth century, these manuscripts were the only form of books in existence, preserving not only religious teachings but also Classical literature.

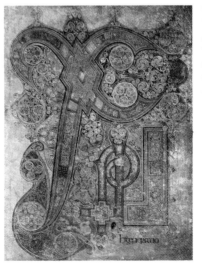

Some of the richest, purely ornamental drawings ever produced are contained in the illuminated gospel called the **Book of Kells** (760–820), collection of Trinity College, Dublin, produced by Irish monks. The text was highly embellished with colorful abstract patterns. Enormous letters, sometimes composed of interlacing whorls and fantastic animal imagery, cover entire pages.

GOTHIC ART: HEIGHT AND LIGHT

The pinnacle of Middle Ages artistic achievement, rivaling the wonders of ancient Greece and Rome, was the Gothic cathedral. In fact, these "stone Bibles" even surpassed Classical architecture in terms of technological daring. From 1200 to 1500, medieval builders erected these intricate structures, with soaring interiors unprecedented in world architecture.

What made the Gothic cathedral possible were two engineering breakthroughs: ribbed vaulting and external supports called flying buttresses. Applying such point supports where necessary allowed builders to forgo solid walls pierced by narrow windows for skeletal walls with huge stained glass windows flooding the interior with light. Gothic cathedrals acknowledged no Dark Ages. Their evolution was a continuous expansion of light, until finally walls were so perforated as to be almost mullions framing immense fields of colored, story-telling glass.

In addition to the latticelike quality of Gothic cathedral walls (with an effect like "petrified lace," as the writer William Faulkner said), verticality characterized Gothic architecture. Builders used the pointed arch, which increased both the reality and illusion of greater height. Architects vied for the highest naves (at Amiens, the nave reached an extreme height of 144 feet). When, as often happened, ambition outstripped technical skill and the naves collapsed, church members tirelessly rebuilt them.

Gothic cathedrals were such a symbol of civic pride that an invader's worst insult was to pull down the tower of a conquered town's cathedral. Communal devotion to the buildings was so intense that all segments of the population participated in construction. Lords and ladies, in worshipful silence, worked alongside butchers and masons, dragging carts loaded with stone from quarries. Buildings were so elaborate that construction literally took ages — six centuries for Cologne Cathedral — which explains why some seem a hodge-podge of successive styles.

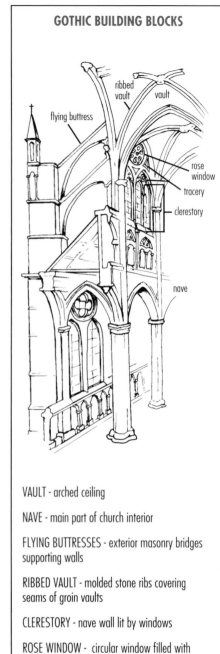

GOTHIC BUILDING BLOCKS

VAULT - arched ceiling

NAVE - main part of church interior

FLYING BUTTRESSES - exterior masonry bridges supporting walls

RIBBED VAULT - molded stone ribs covering seams of groin vaults

CLERESTORY - nave wall lit by windows

ROSE WINDOW - circular window filled with stained glass

TRACERY - stone armature decorating windows

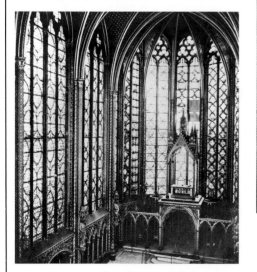

Sainte-Chapelle, 13th century, Paris. *More than three-fourths of the exterior structure is composed of stained glass, filling the interior with rose-violet light.*

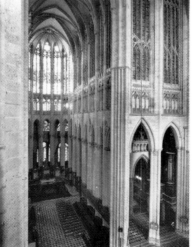

Choir of Beauvais Cathedral, begun 1272. *Beauvais Cathedral's linear design and pointed arches are characteristic of Gothic architecture.*

THE ART OF ARCHITECTURE. Medieval theologians believed a church's beauty would inspire parishioners to meditation and belief. As a result, churches were much more than just assembly halls. They were texts, with volumes of ornaments preaching the path to salvation. The chief forms of inspirational decoration in Gothic cathedrals were sculpture, stained glass, and tapestries.

Jamb statues, Royal Portals, Chartres Cathedral, 1145–70.

SCULPTURE: LONG AND LEAN. Cathedral exteriors displayed carved Biblical tales. The Early Gothic sculptures of Chartres (pronounced shartr) and the High Gothic stone figures of Reims (pronounced ranz) Cathedral show the evolution of medieval art.

The Chartres figures of Old Testament kings and queens (1140–50) are pillar people, elongated to fit the narrow columns that house them. Drapery lines are as thin and straight as the bodies, with few traces of naturalism. By the time the jamb figures of Reims were carved, around 1225–90, sculptors for the first time since antiquity approached sculpture in-the-round. These figures are almost detached from their architectural background, standing out from the column on pedestals. After the writings of Aristotle were discovered, the body was no longer despised but viewed as the envelope of the soul, so artists once again depicted flesh naturally.

In "The Visitation," both the Virgin Mary and her kinswoman, Elizabeth, lean primarily on one leg, their upper bodies turned toward each other. The older Elizabeth has a wrinkled face, full of character, and drapery is handled with more imagination than before.

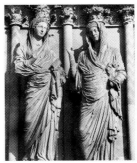

"The Visitation," jamb statues of west façade, Reims Cathedral, c. 1225–90, France. *Sculpture developed from stiff, disproportionately long figures (above) to a more rounded, natural style.*

Rose window, Chartres Cathedral,
13th century. *Thousands of pieces of glass, tinted with chemicals like cobalt and manganese, were bound together with strips of lead, which also outlined component figures.*

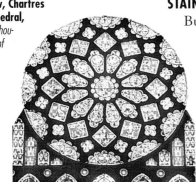

STAINED GLASS. Chartres Cathedral was the visible soul of the Middle Ages. Built to house the veil of the Virgin given to the city by Charlemagne's grandson, Charles the Bald, in 876, it is a multi-media masterpiece. Its stained glass windows, the most intact collection of medieval glass in the world, measure 26,900 feet in total area. Illustrating the Bible, the lives of saints, even traditional crafts of France, the windows are like a gigantic, glowing, illuminated manuscript.

TAPESTRY. Weavers in the Middle Ages created highly refined tapestries, minutely detailed with scenes of contemporary life. Large wool-and-silk hangings, used to cut drafts, decorated stone walls in chateaus and churches. Huge-scale paintings were placed behind the warp (or lengthwise threads) of a loom in order to imitate the design in cloth.

A series of seven tapestries represents the unicorn legend. According to popular belief, the only way to catch this mythical beast was to use a virgin sitting in the forest as bait. The trusting unicorn would go to sleep with his head in her lap and awaken caged. The captured unicorn is chained to a pomegranate tree, a symbol of both fertility and, because it contained many seeds within one fruit, the church. During the Renaissance, the unicorn was linked with courtly love, but in the tapestry's ambiguous depiction both lying down and rearing up, he symbolizes the resurrected Christ.

"The Unicorn in Captivity," c. 1500, The Cloisters, MMA, NY.

The Rebirth of Art: Renaissance and Baroque

ALL ROADS LEAD FROM FLORENCE

The Renaissance from the Early Renaissance in Florence and
High Renaissance in Rome and Venice to points North, East, and West

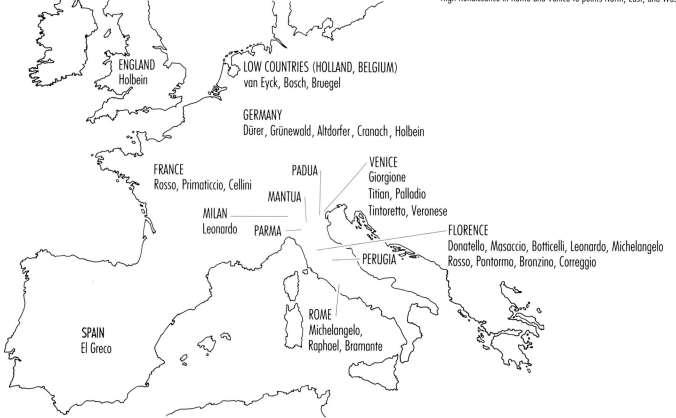

ENGLAND
Holbein

LOW COUNTRIES (HOLLAND, BELGIUM)
van Eyck, Bosch, Bruegel

GERMANY
Dürer, Grünewald, Altdorfer, Cranach, Holbein

FRANCE
Rosso, Primaticcio, Cellini

PADUA

VENICE
Giorgione
Titian, Palladio
Tintoretto, Veronese

MANTUA

MILAN
Leonardo

PARMA

FLORENCE
Donatello, Masaccio, Botticelli, Leonardo, Michelangelo
Rosso, Pontormo, Bronzino, Correggio

PERUGIA

ROME
Michelangelo,
Raphael, Bramante

SPAIN
El Greco

The Middle Ages are so called because they fall between twin peaks of artistic glory: the Classical period and the Renaissance. While art hardly died in the Middle Ages, what was reborn in the Renaissance — and extended in the Baroque period — was lifelike art. A shift in interest from the supernatural to the natural caused this change. The rediscovery of the Greco-Roman tradition helped artists reproduce visual images accurately. Aided by the expansion of scientific knowledge, such as an understanding of anatomy and perspective, painters of the fifteenth through sixteenth centuries went beyond Greece and Rome in technical proficiency.

In the Baroque period of the seventeenth and eighteenth centuries, reverence for Classicism persisted, but everything revved up into overdrive. Ruled by absolute monarchs, the newly centralized states produced theatrical art and architecture of unprecedented grandeur, designed to overwhelm the senses and emotions.

WORLD HISTORY		ART HISTORY
	1400–1500	Early Renaissance
	1420s	Perspective discovered
Gutenberg invents printing with movable type	1446–50	
Medicis deposed in Florence, art center shifts to Rome	1492	
	1500–20	High Renaissance
Renaissance spreads to Northern Europe	1500–1600	
	1503–6	Leonardo paints "Mona Lisa"
	1508–12	Michelangelo frescoes Sistine Chapel ceiling
	1509–11	Raphael creates Vatican frescoes
	1510	Giorgione paints first reclining nude
Balboa sights Pacific Ocean	1513	Titian active in Venice
Luther posts 95 Theses, Reformation begins	1517	
Magellan circumnavigates globe	1520	Dürer excels at printmaking
	1520–1600	Mannerism
Rome sacked by Germans and Spanish	1527	
	1530s	Holbein paints British royalty
Henry VIII of England founds Anglican Church	1534	
	1534–41	Michelangelo works on "Last Judgment"
Copernicus announces planets revolve around sun	1543	Cellini creates gold salt-cellar
Elizabeth I reigns in England	1558–1603	
	1577	El Greco goes to Spain
England defeats Spanish Armada	1588	Tintoretto paints dramatic scenes from life of Christ
Edict of Nantes establishes religious tolerance	1598	
	1601	Caravaggio paints "Conversion of St. Paul," Baroque begins
Galileo invents telescope	1609	Rubens paints royal and mythological figures
King James Bible published	1611	
Harvey discovers circulation of blood	1619	Hals produces smiling portraits
Pilgrims land at Plymouth	1620	
	1630s	Van Dyck paints aristocracy
	1642	Rembrandt creates "Nightwatch"
	1645	Bernini designs Cornaro Chapel
	1648	Poussin establishes Classical taste, Royal French Academy of Painting and Sculpture founded
Charles I of England beheaded	1649	
	1656	Velázquez paints "Las Meninas"
	1668	Louis XIV orders Versailles enlarged
	1675	Wren designs St. Paul's Cathedral
Newton devises theory of gravity	1687	
Fahrenheit invents mercury thermometer	1714	
	1715	Louis XIV dies, French Rococo begins
Bach completes first Brandenburg Concerto	1720	
	1738	Pompeii and Herculaneum discovered
Catherine the Great rules Russia	1762	
James Watt invents steam engine	1765	
	1768	Reynolds heads Royal Academy
Priestley discovers oxygen	1774	
American colonies declare independence	1776	
	1784–85	David launches Neoclassicism
Mozart becomes court musician to Emperor Joseph II	1787	
French Revolution breaks out	1789	

THE RENAISSANCE: THE BEGINNING OF MODERN PAINTING

In the early 1400s, the world woke up. From its beginnings in Florence, Italy, this renaissance, or rebirth, of culture spread to Rome and Venice, then, in 1500, to the rest of Europe (known as the Northern Renaissance): the Netherlands, Germany, France, Spain, and England.

Common elements were the rediscovery of the art and literature of Greece and Rome, the scientific study of the body and the natural world, and the intent to reproduce the forms of nature realistically.

Aided by new technical knowledge like the study of anatomy, artists achieved new heights in portraiture, landscape, and mythological and religious paintings. As skills increased, the prestige of the artist soared, reaching its peak during the High Renaissance (1500–1520) with megastars like Leonardo, Michelangelo, and Raphael.

During the Renaissance, such things as the exploration of new continents and scientific research boosted man's belief in himself, while, at the same time, the Protestant Reformation decreased the sway of the church. As a result, the study of God the Supreme Being was replaced by the study of the human being. From the minutely detailed, realistic portraits of Jan van Eyck, to the emotional intensity of Dürer's woodcuts and engravings, to the contorted bodies and surreal lighting of El Greco, art was the means to explore all facets of life on earth.

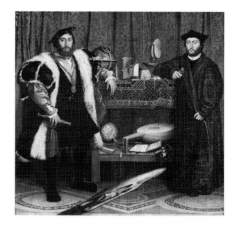

Hans Holbein the Younger, "The French Ambassadors," 1533, NG, London. *This portrait of two "universal men" expressed the versatility of the age. Objects like globes, compasses, sundials, lute, and hymnbook show wide-ranging interests from mathematics to music. Holbein fully exploited all the technical discoveries of the Renaissance: the lessons of composition, anatomy, realistic depiction of the human form through light and dark, lustrous color, and flawless perspective.*

Masaccio, "The Tribute Money," c. 1427, Santa Maria del Carmine, Florence. *Masaccio revolutionized painting through his use of perspective, a consistent source of light, and three-dimensional portrayal of the human figure.*

THE TOP FOUR BREAKTHROUGHS

During the Renaissance, technical innovations and creative discoveries made possible new styles of representing reality. The major breakthroughs were the change from tempera paint on wood panels and fresco on plaster walls to oil on stretched canvas and the use of perspective, giving weight and depth to form; the use of light and shadow, as opposed to simply drawing lines; and pyramidal composition in paintings.

1. OIL ON STRETCHED CANVAS. Oil on canvas became the medium of choice during the Renaissance. With this method, a mineral like lapis lazuli was ground fine, then mixed with turpentine and oil to be applied as oil paint. A greater range

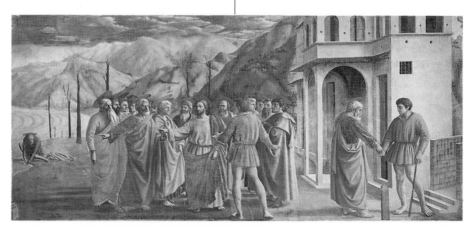

of rich colors with smooth gradations of tone permitted painters to represent textures and simulate three-dimensional form.

2. PERSPECTIVE. One of the most significant discoveries in the history of art was the method for creating the illusion of depth on a flat surface called "perspective," which became a foundation of European painting for the next 500 years. Linear perspective created the optical effect of objects receding in the distance through lines that appear to converge at a single point in the picture known as the vanishing point. (In Masaccio's "The Tribute Money," lines converge behind the head of Christ.) Painters also reduced the size of objects and muted colors or blurred detail as objects got farther away.

3. THE USE OF LIGHT AND SHADOW. Chiaroscuro (pronounced key arrow SKEWR o), which means "light/dark" in Italian, referred to the new technique for modeling forms in painting by which lighter parts seemed to emerge from darker areas, producing the illusion of rounded, sculptural relief on a flat surface.

4. PYRAMID CONFIGURATION. Rigid profile portraits and grouping of figures on a horizontal grid in the picture's foreground gave way to a more three-dimensional "pyramid configuration." This symmetrical composition builds to a climax at the center, as in Leonardo's "Mona Lisa," where the focal point is the figure's head.

THE EARLY RENAISSANCE: THE FIRST THREE HALL-OF-FAMERS
The Renaissance was born in Florence. The triumvirate of quattrocento (15th-century) geniuses who invented this new style included the painter Masaccio and sculptor Donatello, who reintroduced naturalism to art, and the painter Botticelli, whose elegant linear figures reached a height of refinement.

MASACCIO. The founder of Early Renaissance painting, which became the cornerstone of European painting for more than six centuries, was Masaccio (pronounced ma SAHT chee oh; 1401–28). Nicknamed "Sloppy Tom" because he neglected his appearance in his pursuit of art, Masaccio was the first since Giotto to paint the human figure not as a linear column, in the Gothic style, but as a real human being. As a Renaissance painter, Vasari said, "Masaccio made his figures stand upon their feet." Other Masaccio innovations were a mastery of perspective and his use of a single, constant source of light casting accurate shadows.

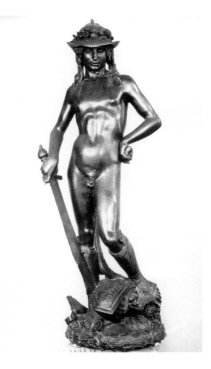

Donatello, "David," c. 1430–32, Museo Nazionale, Florence. *Donatello pioneered the Renaissance style of sculpture with rounded body masses.*

DONATELLO. What Masaccio did for painting, Donatello (1386–1466) did for sculpture. His work recaptured the central discovery of Classical sculpture: contrapposto, or weight concentrated on one leg with the rest of the body relaxed, often turned. Donatello carved figures and draped them realistically with a sense of their underlying skeletal structure.

His "David" was the first life-size, freestanding nude sculpture since the Classical period. The brutal naturalism of "Mary Magdalen" was even more probing, harshly accurate, and "real" than ancient Roman portraits. He carved the aged Magdalen as a gaunt, shriveled hag, with stringy hair and hollowed eyes. Donatello's sculpture was so lifelike, the artist was said to have shouted at it, "Speak, speak, or the plague take you!"

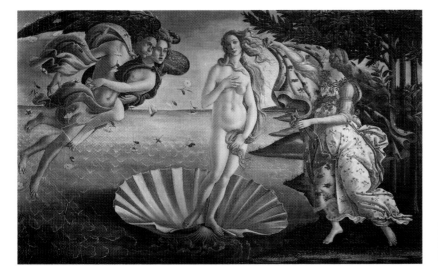

Botticelli, "Birth of Venus," 1482 , Uffizi, Florence. *Botticelli drew undulating lines and figures with long necks, sloping shoulders, and pale, soft bodies.*

BOTTICELLI. While Donatello and Masaccio laid the groundwork for three-dimensional realism, Botticelli (pronounced bought tee CHEL lee; 1444–1510) was moving in the opposite direction. His decorative linear style and tiptoeing, golden-haired maidens were more a throwback to Byzantine art. Yet his nudes epitomized the Renaissance. "Birth of Venus" marks the rebirth of Classical mythology.

THE ITALIAN RENAISSANCE

HEROES OF THE HIGH RENAISSANCE. In the sixteenth century, artistic leadership spread from Florence to Rome and Venice, where giants like Leonardo, Michelangelo, and Raphael created sculpture and paintings with total technical mastery. Their work fused Renaissance discoveries like composition, ideal proportions, and perspective — a culmination referred to as the High Renaissance (1500–1520).

LEONARDO DA VINCI. The term "Renaissance man" has come to mean an omnitalented individual who radiates wisdom. Its prototype was Leonardo (1452–1519), who came nearer to achieving this ideal than anyone before or since.

Leonardo was universally admired for his handsome appearance, intellect, and charm. His "personal beauty could not be exaggerated," a contemporary said of this tall man with long blond hair, "whose every movement was grace itself, and whose abilities were so extraordinary that he could readily solve every difficulty." As if this were not enough, Leonardo could sing "divinely" and "his charming conversation won all hearts."

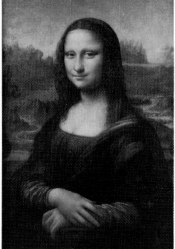

**Leonardo, "Mona Lisa," or
"La Gioconda,"** 1503–6, Louvre, Paris. *The world's most famous portrait embodied all the Renaissance discoveries of perspective, anatomy, and composition.*

An avid mountain climber who delighted in scaling great heights, Leonardo was also fascinated with flight. Whenever he saw caged birds, he paid the owner to set them free. He frequently sketched fluttering wings in his notebooks, where he constantly designed flying contraptions that he eventually built and strapped on himself in hopes of soaring. He once wrote, "I wish to work miracles," an ambition evident in his inventions: a machine to move mountains, a parachute, a helicopter, an armored tank, and a diving bell.

Leonardo did more to create the concept of the artist-genius than anyone else. When he began his campaign, the artist was considered a menial craftsman. By constantly stressing the intellectual aspects of art and creativity, Leonardo transformed the artist's public status into, as he put it, a "Lord and God."

His brilliance had one flaw. The contemporary painter Vasari called Leonardo "capricious and fickle." His curiosity was so omnivorous that distractions constantly lured him from one incomplete project to another. When commissioned to paint an altarpiece, he first had to study tidal movements in the Adriatic, then invent systems to prevent landslides. A priest said Leonardo was so obsessed with his mathematical experiments "that he cannot stand his brushes."

Less than 20 completed works by Leonardo survive. He died at age 67 in France, where he had been summoned by Francis I for the sole duty of conversing with the king. On his deathbed, said Vasari, Leonardo admitted "he had offended God and mankind by not working at his art as he should have."

MONA LISA

It hung in Napoleon's bedroom until moving to the Louvre in 1804. It caused traffic jams in New York when 1.6 million people jostled to see it in seven weeks. In Tokyo viewers were allowed ten seconds. The object of all this attention was the world's most famous portrait, "Mona Lisa."

Historically, she was nobody special, probably the young wife of a Florentine merchant named Giocondo (the prefix "Mona" was an abbreviation of Madonna, or Mrs.). The portrait set the standard for High Renaissance paintings in many important ways. The use of perspective, with all lines converging on a single vanishing point behind Mona Lisa's head, and triangular composition established the importance of geometry in painting. It diverged from the stiff, profile portraits that had been the norm by displaying the subject in a relaxed, natural, three-quarter pose. For his exact knowledge of anatomy so evident in the Mona Lisa's hands, Leonardo had lived in a hospital, studying skeletons and dissecting more than thirty cadavers.

One of the first easel paintings intended to be framed and hung on a wall, the "Mona Lisa" fully realized the potential of the new oil medium. Instead of proceeding from outlined figures, as painters did before, Leonardo used chiaroscuro to model features through light and shadow. Starting with dark undertones, he built the illusion of three-dimensional features through layers and layers of thin, semi-transparent glazes (Even the Mona Lisa's pupils were composed of successive gauzy washes of pigment). This "sfumato" technique rendered the whole, as Leonardo said, "without lines or borders, in the manner of smoke." His colors ranged from light to dark in a continuous gradation of subtle tones, without crisp separating edges. The forms seemed to emerge from, and melt into, shadows.

And then there's that famous smile. To avoid the solemnity of most formal portraits, Leonardo engaged musicians and jesters to amuse his subject. Although he frequently left his works incomplete because of frustration when his hand could not match his imagination, this work was instantly hailed as a masterpiece, influencing generations of artists. In 1911 an Italian worker, outraged that the supreme achievement of Italian art resided in France, stole the painting from the Louvre to return it to its native soil. "Mona Lisa" was recovered from the patriotic thief's dingy room two years later in Florence.

By 1952 more than 61 versions of the Mona Lisa had been created. From Marcel Duchamp's goateed portrait in 1919 to Andy Warhol's silkscreen series and Jasper Johns's image in 1983, the Mona Lisa is not only the most admired, but also the most reproduced, image in all art.

THE LAST SUPPER

If "Mona Lisa" is Leonardo's most famous portrait, his fresco painting, "The Last Supper," has for five centuries been the world's most revered religious painting. Leonardo declared the artist has two aims: to paint the "man and the intention of his soul." Here he revolutionized art by capturing both, particularly what was going through each figure's mind.

Leonardo immortalized the dramatic moment after Christ announced one of his disciples would betray him, with each reacting emotionally and asking, "Lord, is it I?" Through a range of gesture and expression, Leonardo revealed for the first time in art the fundamental character and psychological state of each apostle. His use of perspective, with all diagonal lines converging on Christ's head, fixed Christ as the apex of the pyramidal composition.

Unfortunately, Leonardo was not temperamentally suited to the demands of traditional fresco painting, which required quick, unerring brushwork instead of accumulated blurred shadings. In "The Last Supper," he experimented with an oil/tempera emulsion of his own invention that failed to bond to the plaster. Even during his lifetime, the mural began to disintegrate. It didn't help that the building was used as a stable and then partly destroyed in World War II. Behind a barricade of sandbags, mildew reduced the fresco to a sad ruin. After 20 years, an inch-by-inch restoration was completed in 1999.

Leonardo, "The Last Supper," c. 1495, Santa Maria delle Grazie, Milan.
Leonardo revealed the disciples' character through facial expressions and gestures.

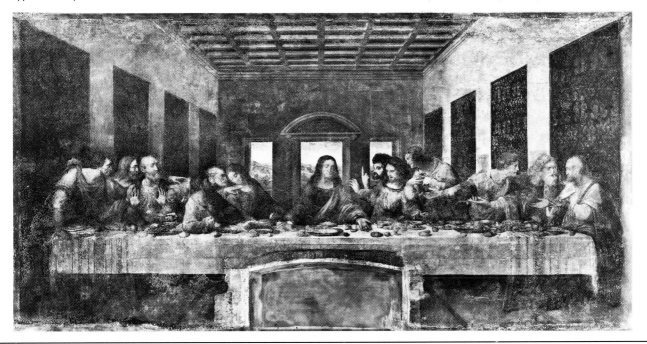

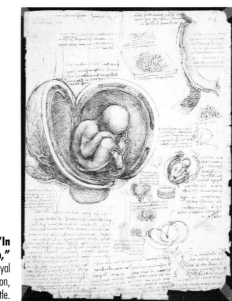

Leonardo, "In the Womb," c. 1510, Royal Collection, Windsor Castle.

The Notebooks

Evidence of Leonardo's fertile imagination lies in the thousands of pages of sketches and ideas in his notebooks. His interests and expertise encompassed anatomy, engineering, astronomy, mathematics, natural history, music, sculpture, architecture, and painting, making him one of the most versatile geniuses ever. Although the notes were unknown to later scientists, Leonardo anticipated many of the major discoveries and inventions of succeeding centuries. He built canals, installed central heating, drained marshes, studied air currents, and invented a printing press, telescope, and portable bombs. From his study of blood vessels, he developed the theory of circulation 100 years before Harvey. He was the first to design a flying machine and first to illustrate the interior workings of the human body. His sketches of the growth of the fetus in the womb were so accurate they could teach embryology to medical students today.

MICHELANGELO: THE DIVINE M. As an infant, Michelangelo (1475–1564) was cared for by a wet nurse whose husband was a stonecutter. The boy grew up absorbed with carving, drawing, and art, even though his family beat him severely to force him into a "respectable" profession. But the Medici prince Lorenzo the Magnificent recognized the boy's talent and, at the age of 15, took Michelangelo to his Florentine court, where the budding artist lived like a son.

Michelangelo did more than anyone to elevate the status of the artist. Believing that creativity was divinely inspired, he broke all rules. Admirers addressed him as the "divine Michelangelo," but the price for his gift was solitude. Michelangelo once asked his rival, the gregarious Raphael, who was always surrounded by courtiers, "Where are you going in such company, as happy as a Monsignor?" Raphael shot back, "Where are you going, all alone like a hangman?"

Michelangelo refused to train apprentices or allow anyone to watch him work. When someone said it was too bad he never married and had heirs, Michelangelo responded, "I've always had only too harassing a wife in this demanding art of mine, and the works I leave behind will be my sons." He was emotional, rough and uncouth, happy only when working or hewing rock at the marble quarry. His wit could be cruel, as when he was asked why the ox in another artist's painting was so much more convincing than other elements. "Every painter," Michelangelo said, "does a good self-portrait."

An architect, sculptor, painter, poet, and engineer, Michelangelo acknowledged no limitations. He once wanted to carve an entire mountain into a colossus. Michelangelo lived until nearly 90, carving until he died. His deathbed words: "I regret that I am dying just as I am beginning to learn the alphabet of my profession."

WHO PAID THE BILLS?

Before there were art galleries and museums, artists depended on the patronage system not only to support themselves but to provide expensive materials for their work. Under the inspired taste of Lorenzo the Magnificent, this resulted in an entire city — Florence — becoming a work of art, as wealthy rulers commissioned lavish buildings and art. Yet, significantly, the word for "patron" is the same in both French and Italian as the word for "boss." With irascible artists like Michelangelo, the tension between being a creator and being told what to create erupted in ugliness. The best example of the strengths and weaknesses of the system was Michelangelo's testy relation to his Medici patrons.

Michelangelo owed his training to Lorenzo de'Medici, but Lorenzo's insensitive son ordered the maestro to sculpt a statue out of snow in the palazzo courtyard. Years later, Medici popes Leo X and Clement VII (the sculptor worked for seven of the thirteen popes who reigned during his lifetime) hired Michelangelo to drop other work and sculpt tomb statues for their relatives. When the stone faces of the deceased bore no resemblance to actual appearance, Michelangelo would brook no interference with his ideal concept, saying that, in 100 years, no one would care what his actual subjects looked like. Unfortunately, the works remain unfinished, for his fickle patrons constantly changed their minds, abruptly cancelling, without explanation and often without pay, projects Michelangelo worked on for years.

Michelangelo's worst taskmaster was Pope Julius II, the "warrior-pope" who was bent on restoring the temporal power of the papacy. Julius had grandiose designs for his own tomb, which he envisioned as the centerpiece of a rebuilt St. Peter's Cathedral. He first commissioned Michelangelo to create forty life-size marble statues to decorate a mammoth two-story structure. The project tormented Michelangelo for forty years as Julius and his relatives gradually whittled down the design and interrupted his progress with distracting assignments. When referring to the commission, Michelangelo darkly called it the "Tragedy of the Tomb."

Michelangelo, "Pietà,"
1498/99–1500, St. Peter's, Rome.
Michelangelo's first masterpiece groups Christ and the Virgin in a pyramidal composition.

THE SCULPTOR. Of all artists, Michelangelo felt the sculptor was most godlike. God created life from clay, and the sculptor unlocked beauty from stone. He described his technique as "liberating the figure from the marble that imprisons it." While other sculptors added pieces of marble to disguise their mistakes, Michelangelo always carved his sculptures from one block. "You could roll them down a mountain and no piece would come off," said a fellow sculptor.

The first work to earn him renown, carved when Michelangelo was 23, was the "Pietà," which means "pity." The pyramidal arrangement derived from Leonardo, with the classic composure of the Virgin's face reflecting the calm, idealized expressions of Greek sculpture. The accurate anatomy of Christ's body is due to Michelangelo's dissection of corpses. When first unveiled, a viewer attributed the work to a more experienced sculptor, unable to believe a young unknown could accomplish such a triumph. When Michelangelo heard, he carved his name on a ribbon across the Virgin's breast, the only work he ever signed.

THE PAINTER: THE SISTINE CHAPEL. A few vines on a blue background — that's all Pope Julius II asked for, to spruce up the barnlike ceiling of the Sistine Chapel. What the artist gave him was more than 340 human figures (10' to 18' tall) representing the origin and fall of man — the most ambitious artistic undertaking of the whole Renaissance. The fact that Michelangelo accomplished such a feat in less than four years, virtually without assistance, was a testimonial to his single-mindedness.

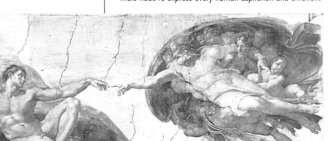

Michelangelo, "The Creation of Adam," detail, 1508–12, Sistine Chapel, Vatican, Rome. *A Zeus-like God transmits the spark of life to Adam. Michelangelo used the male nude to express every human aspiration and emotion.*

Physical conditions alone presented a formidable challenge. Nearly one-half the length of a football field, the ceiling presented 10,000 square feet to be designed, sketched, plastered, and painted. The roof leaked, which made the plaster too damp. The curved shape of the barrel vault divided by cross vaults made Michelangelo's job doubly hard. In addition, he had to work on a seven-story-high scaffold in a cramped and uncomfortable position.

Despite his disdain for painting, which he considered an inferior art, Michelangelo's fresco was a culmination of figure painting, with the figures drawn not from the real world but from a world of his own creation. The nudes, which had never been painted on such a colossal scale, are simply presented, without background or ornament. As in his sculpture, the torsos are more expressive than the faces. His twisted nude forms have a relieflike quality, as if they were carved in colored stone.

Michelangelo, "The Last Judgment," detail, 1541, Sistine Chapel, Rome. *St. Bartholomew, a martyr who was flayed alive, holds up his skin with a grotesque self-portrait of Michelangelo.*

Encompassing an entire wall of the Sistine Chapel is the "Last Judgment" fresco Michelangelo finished twenty-nine years after the ceiling. Its mood is strikingly gloomy. Michelangelo depicted Christ not as a merciful Redeemer but as an avenging Judge with such terrifying effect that Pope Paul III fell to his knees when he saw the fresco. "Lord, hold not my sins against me!" the pope cried. Here, too, Michelangelo showed his supreme ability to present human forms in motion, as nearly 400 contorted figures struggled, fought, and tumbled into hell.

Michelangelo, Campidoglio, 1538–64, Rome. *Michelangelo broke Renaissance rules by designing this piazza with interlocking ovals and variations from right angles.*

THE ARCHITECT. In his later years, Michelangelo devoted himself to architecture, supervising the reconstruction of Rome's St. Peter's Cathedral. Given his life-long infatuation with the body, it's no wonder Michelangelo believed "the limbs of architecture are derived from the limbs of man." Just as arms and legs flank the trunk of the human form, architectural units, he believed, should be symmetrical, surrounding a central, vertical axis.

The best example of his innovative style was the Capitoline Hill in Rome, the first great Renaissance civic center. The hill had been the symbolic heart of ancient Rome, and the pope wanted to restore it to its ancient grandeur. Two existing buildings already abutted each other at an awkward 80° angle. Michelangelo made an asset of this liability by adding another building at the same angle to flank the central Palace of Senators. He then redesigned the facade of the lateral buildings so they would be identical and left the fourth side open, with a panoramic view toward the Vatican.

Unifying the whole was a statue of Emperor Marcus Aurelius (see p. 17) on a patterned oval pavement. Renaissance architects considered the oval "unstable" and avoided it, but for Michelangelo, measure and proportion were not determined by mathematical formulae but "kept in the eyes."

RAPHAEL. Of the three major figures of the High Renaissance school (Leonardo, Michelangelo, and Raphael), Raphael (pronounced rah fa yell; 1483–1520) would be voted Most Popular. While the other two were revered and their work admired, Raphael was adored. A contemporary of the three men, Vasari, who wrote the first art history, said Raphael was "so gentle and so charitable that even animals loved him."

Raphael's father, a mediocre painter, taught his precocious son the rudiments of painting. By the age of 17, Raphael was rated an independent master. Called to Rome by the pope at age 26 to decorate the Vatican rooms, Raphael completed the frescoes, aided by an army of fifty students, the same year Michelangelo finished the Sistine ceiling. "All he knows," said Michelangelo, "he learned from me."

The rich, handsome, wildly successful Raphael went from triumph to triumph, a star of the brilliant papal court. He was a devoted lady's man, "very amorous," said Vasari, with "secret pleasures beyond all measure." When he caught a fever after a midnight assignation and died on his thirty-seventh birthday, the entire court "plunged into grief."

Raphael's art most completely expressed all the qualities of the High Renaissance. From Leonardo he borrowed pyramidal composition and learned to model faces with light and shadow (chiaroscuro). From Michelangelo, Raphael adapted full-bodied, dynamic figures and the contrapposto pose.

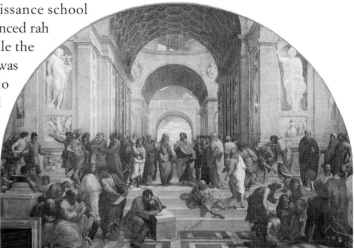

Raphael, "School of Athens," 1510–11, Vatican, Rome. *Raphael's masterpiece embodies the High Renaissance in its balance, sculptural quality, architectural perspective, and fusion of pagan and Christian elements.*

Titian, "Bacchanal of the Adrians," 1518, Prado, Madrid. *This pagan wine party contains the major ingredients of Titian's early style: dazzling contrasting colors, ample female forms, and asymmetric compositions.*

TITIAN: THE FATHER OF MODERN PAINTING. Like his fellow Venetian painters, Titian (pronounced TISH un; 1490?–1576), who dominated the art world in the city for sixty years, used strong colors as his main expressive device. First he covered the surface of the canvas with red for warmth, then he painted both background and figures in vivid hues and toned them down with thirty or forty layers of glazes. Through this painstaking method, he was able to portray any texture completely convincingly, whether polished metal, shiny silk, red-gold hair, or warm flesh. One of the first to abandon wood panels, Titian established oil on canvas as the typical medium.

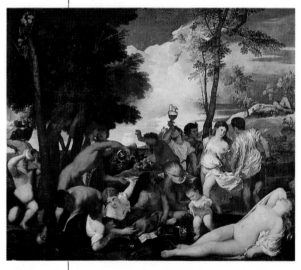

After his wife died in 1530, Titian's paintings became more muted, almost monochromatic. Extremely prolific until his late 80s, as his sight failed Titian loosened his brushstrokes. At the end they were broad, thickly loaded with paint, and slashing. A pupil reported that Titian "painted more with his fingers than with his brushes."

THE VENETIAN SCHOOL

While artists working in Florence and Rome concentrated on sculptural forms and epic themes, Venetian painters were fascinated with color, texture, and mood. Giovanni Bellini (1430–1516) was the first Italian master of the new oil painting technique. Titian's mentor, Bellini was also the first to integrate figure and landscape. Giorgione (1476–1510) aroused emotion through light and color. In his "Tempest," a menacing storm cloud created a sense of gloom and mystery. After Titian — the most famous of Venetian artists — Tintoretto and Veronese continued the large-scale, majestic style of deep coloring and theatricality. In the eighteenth century, the Rococo painter Tiepolo carried on the Venetian tradition, as did Guardi and Canaletto in their atmospheric cityscapes.

ARCHITECTURE IN THE ITALIAN RENAISSANCE. Informed by the same principles of harmonious geometry that underlay painting and sculpture, architecture recovered the magnificence of ancient Rome. The most noted Renaissance architects were Alberti, Brunelleschi, Bramante, and Palladio.

A writer, painter, sculptor, and architect, Alberti (pronounced al BEAR tee; 1404–72) was the Renaissance's major theorist who wrote treatises on painting, sculpture, and architecture. He downplayed art's religious purpose and urged artists to study "sciences" like history, poetry, and mathematics as building blocks. Alberti wrote the first systematic guide to perspective and provided sculptors with rules for ideal human proportions.

Another multifaceted Renaissance man, Brunelleschi (pronounced brew nell LESS kee; 1377–1446) was skilled as a goldsmith, sculptor, mathematician, clock builder, and architect. But he is best known as the father of modern engineering. Not only did he discover mathematical perspective, he also championed the central-plan church design that replaced the medieval basilica. He alone was capable of constructing a dome for the Florence Cathedral, called the Eighth Wonder of the World. His inspiration was to build two shells, each supporting the other, crowned by a lantern stabilizing the whole. In designing the Pazzi Chapel, Brunelleschi used Classical motifs as surface decoration. His design illustrates the revival of Roman forms and Renaissance emphasis on symmetry and regularity.

In 1502, Bramante (pronounced brah MAHN tee; 1444–1514) built the Tempietto ("Little Temple") in Rome on the site where St. Peter was crucified. Although tiny, it was the perfect prototype of the domed central plan church. It expressed the Renaissance ideals of order, simplicity, and harmonious proportions.

Known for his villas and palaces, Palladio (pronounced pah LAH dee oh; 1508–90) was enormously influential in later centuries through his treatise, *Four Books on Architecture*. Neoclassical revivalists like Thomas Jefferson and Christopher Wren, architect of St. Paul's in London, used Palladio's rule book as a guide. The Villa Rotonda incorporated Greek and Roman details like porticos with Ionic columns, a flattened dome like the Pantheon, and rooms arranged symmetrically around a central rotunda.

THE FOUR R'S OF RENAISSANCE ARCHITECTURE

The four R's of Renaissance architecture are Rome, Rules, Reason, and 'Rithmetic.

ROME In keeping with their passion for the classics, Renaissance architects systematically measured Roman ruins to copy their style and proportion. They revived elements like the rounded arch, concrete construction, domed rotunda, portico, barrel vault, and column.

RULES Since architects considered themselves scholars rather than mere builders, they based their work on theories, as expressed in various treatises. Alberti formulated aesthetic rules that were widely followed.

REASON Theories emphasized architecture's rational basis, grounded in science, math, and engineering. Cool reason replaced the mystical approach of the Middle Ages.

'RITHMETIC Architects depended on arithmetic to produce beauty and harmony. A system of ideal proportions related parts of a building to each other in numerical ratios, such as the 2:1 ratio of a nave twice as high as the width of a church. Layouts relied on geometric shapes, especially the circle and square.

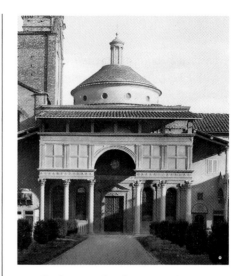

Brunelleschi, Pazzi Chapel, 1440–61, Florence.

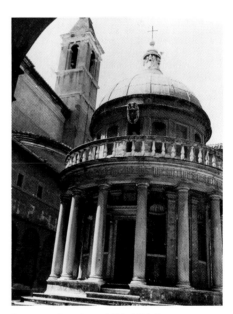

Bramante, Tempietto, 1444–1514, Rome.

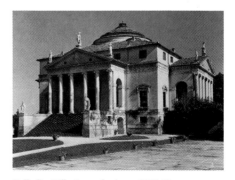

Palladio, Villa Rotonda, begun 1550, Vicenza.

THE NORTHERN RENAISSANCE

In the Netherlands as well as in Florence, new developments in art began about 1420. But what was called the Northern Renaissance was not a rebirth in the Italian sense. Artists in the Netherlands — modern Belgium (then called Flanders) and Holland — lacked Roman ruins to rediscover. Still, their break with the Gothic style produced a brilliant flowering of the arts.

While the Italians looked to Classical antiquity for inspiration, northern Europeans looked to nature. Without Classical sculpture to teach them ideal proportions, they painted reality exactly as it appeared, in a detailed, realistic style. Portraits were such faithful likenesses that Charles VI of France sent a painter to three different royal courts to paint prospective brides, basing his decision solely on the portraits.

This precision was made possible by the new oil medium, which Northern Renaissance painters first perfected. Since oil took longer to dry than tempera, they could blend colors. Subtle variations in light and shade heightened the illusion of three-dimensional form. They also used "atmospheric perspective" — the increasingly hazy appearance of objects farthest from the viewer — to suggest depth.

As the Renaissance spread north from Italy, it took different forms.		
ITALIAN RENAISSANCE ART	**VS.**	**NORTHERN RENAISSANCE ART**
SPECIALTY: Ideal beauty		Intense realism
STYLE: Simplified forms, measured proportions		Lifelike features, unflattering honesty
SUBJECTS: Religious and mythological scenes		Religious and domestic scenes
FIGURES: Heroic male nudes		Prosperous citizens, peasants
PORTRAITS: Formal, reserved		Reveal individual personality
TECHNIQUE: Fresco, tempera, and oil paintings		Oil paintings on wood panels
EMPHASIS: Underlying anatomical structure		Visible appearance
BASIS OF ART: Theory		Observation
COMPOSITION: Static, balanced		Complex, irregular

THE RENAISSANCE IN THE LOW COUNTRIES

In Holland and Flanders, cities like Bruges, Brussels, Ghent, Louvain, and Haarlem rivaled Florence, Rome, and Venice as centers of artistic excellence. The trademark of these northern European artists was their incredible ability to portray nature realistically, down to the most minute detail.

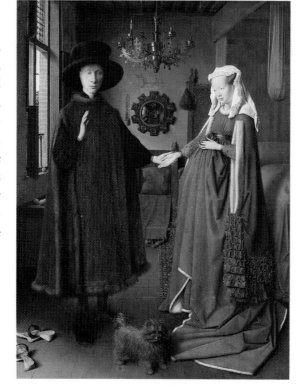

Van Eyck, "Arnolfini Wedding," *1434, NG, London. A master of realism, van Eyck recreated the marriage scene, in miniature in the mirror. Virtually every object symbolizes the painting's theme — the sanctity of marriage — with the dog representing fidelity and the cast-off shoes holy ground.*

JAN VAN EYCK. Credited with inventing oil painting, the Flemish artist Hubert van Eyck was so idolized for his discovery that his right arm was preserved as a holy relic. His brother, Jan van Eyck (c.1390–1441), about whom more is known, used the new medium to achieve a peak of realism.

Trained as a miniaturist and illuminator of manuscripts, Jan van Eyck painted convincingly the most microscopic details in brilliant, glowing color. One of the first masters of the new art of portrait painting, van Eyck included extreme details like the beginning of stubble on his subject's chin. His "Man in a Red Turban," which may be a self-portrait (1433), was the earliest known painting in which the sitter looked at the spectator. In one of the most celebrated paintings of the Northern Renaissance, "The Arnolfini Wedding," van Eyck captures surface appearance and textures precisely and renders effects of both direct and diffused light.

BOSCH: GARDEN OF THE GROTESQUE. It's not hard to understand why twentieth-century Surrealists claimed Dutch painter Hieronymous Bosch (c. 1450–1516) as their patron saint. The modern artists exploited irrational dream imagery but hardly matched Bosch's bizarre imagination.

Bosch's moralistic paintings suggested inventive torments meted out as punishment for sinners. Grotesque fantasy images — such as hybrid monsters, half-human, half-animal — inhabited his weird, unsettling landscapes. Although modern critics have been unable to decipher his underlying meanings, it seems clear Bosch believed that corrupt mankind, seduced by evil, should suffer calamitous consequences.

Bosch, detail, "The Garden of Earthly Delights," c. 1500, Prado, Madrid. *Bosch probably intended this as an allegory, warning against the dangers of eroticism. Such disturbing imagery made Bosch a forerunner of Surrealism.*

Bruegel, "Hunters in the Snow," 1565, Kunsthistorisches Museum, Vienna. *Bruegel portrayed peasants both honestly and satirically.*

BRUEGEL: PAINTER OF PEASANTS. Flemish painter Pieter Bruegel the Elder (pronounced BROY gull; c.1525–69) was influenced by Bosch's pessimism and satiric approach. Bruegel took peasant life as his subject. In his scenes of humble folk working, feasting, or dancing, the satiric edge always appeared. "The Peasant Wedding," for example, features guests eating and drinking with gluttonous absorption. Besides elevating genre painting (scenes of everyday life) to the stature of high art, Bruegel also illustrated proverbs, such as "The Blind Leading the Blind," with horrific, bestial facial expressions typical of Bosch's Biblical scenes.

Bruegel's most famous painting, "Hunters in the Snow," came from a series depicting man's activities during the months of the year. His preoccupation with peasant life is shown in the exhausted hunters plodding homeward, silhouetted against the snow. Bruegel used atmospheric perspective — from sharp foreground to hazy background — to give the painting depth.

THE GERMAN RENAISSANCE

After lagging behind the innovative Netherlanders, German artists began to lead the Northern School. In the first quarter of the sixteenth century, Germans suddenly assimilated the pictorial advances of their Southern peers Leonardo, Michelangelo, and Raphael. Simultaneous with Italy's peak of artistic creativity was Germany's own High Renaissance, marked by Grünewald's searing religious paintings, Dürer's technically perfect prints, and Holbein's unsurpassed portraits.

HOLBEIN: PRINCELY PORTRAITS. Hans Holbein the Younger (1497–1543), is known as one of the greatest portraitists ever. Like Dürer, he blended the strengths of North and South, linking the German skill with lines and precise realism to the balanced composition, chiaroscuro, sculptural form, and perspective of Italy.

Although born in Germany, Holbein first worked in Basel. When the Reformation decreed church decoration to be "popery" and his commissions disappeared, Holbein sought his fortune in England. His patron, the humanist scholar Erasmus, recommended him to the English cleric Sir Thomas More with the words, "Here [in Switzerland] the arts are out in the cold." Holbein's striking talent won him the position of court painter to Henry VIII, for whom he did portraits of the king and four of his wives.

"The French Ambassadors" (see p. 32) illustrates Holbein's virtuoso technique, with its linear patterning in the Oriental rug and damask curtain, accurate textures of fur and drapery, faultless perspective of the marble floor, sumptuous enameled color, and minute surface realism. The object in the foreground (a distorted skull) and numerous scholarly implements show the Northern penchant for symbolic knickknacks. Holbein depicted faces with the same accuracy as Dürer but with a neutral expression characteristic of Italy rather than the intensity of Dürer's portraits. Holbein's exquisite draftsmanship set the standard for portraits, the most important form of painting in England for the next three centuries.

Dürer, "Four Horsemen of the Apocalypse," c. 1497–98, woodcut, MMA, NY. *Dürer used fine, engravinglike lines for shading. In this doomsday vision, the final Four Horsemen — war, pestilence, famine, and death — trample humanity.*

DÜRER: GRAPHIC ART. The first Northern artist to be also a Renaissance man, Albrecht Dürer (pronounced DEWR er; 1471–1528) combined the Northern gift for realism with the breakthroughs of the Italian Renaissance. Called the "Leonardo of the North" for the diversity of his interests, Dürer was fascinated with nature and did accurate botanical studies of plants. Believing art should be based on careful scientific observation, he wrote, "Art stands firmly fixed in nature, and he who can find it there, he has it." This curiosity led, unfortunately, to his demise, as he insisted on tramping through a swamp to see the body of a whale and caught a fatal fever.

Dürer took as his mission the enlightenment of his Northern colleagues about the discoveries of the South. He published treatises on perspective and ideal proportion. He also assumed the mantle of the artist as cultivated gentleman-scholar, raising the artist's stature from mere craftsman to near prince. He was the first to be fascinated with his own image, leaving a series of self-portraits (the earliest done when he was 13). In his "Self-Portrait" of 1500, he painted himself in a Christ-like pose, indicating the exalted status of the artist, not to mention his high opinion of himself.

What assured Dürer's reputation as the greatest artist of the Northern Renaissance was his graphic work. Before Dürer, woodcuts were primitive studies of black and white contrasts. He adapted the form-creating hatching of engraving to the woodcut, achieving a sliding scale of light and shade. Like an engraver, he used dense lines to render differences in texture and tone as subtle as any oil painting. Dürer was the first to use printmaking as a major medium for art.

MAKING PRINTS: THE INVENTION OF GRAPHIC ARTS

One of the most popular (and still affordable) forms of art collecting in recent years has been limited-edition prints, each signed by the artist who oversees the reproduction process. The art of printmaking first flowered during the Northern Renaissance.

WOODCUT

The oldest technique for making prints (long known in China) was the woodcut, which originated in Germany about 1400. In this method, a design was drawn on a smooth block of wood, then the parts to remain white (called "negative space") were cut away, leaving the design standing up in relief. This was then inked and pressed against paper to produce thousands of copies sold for a few pennies each. For the first time, art was accessible to the masses and artists could learn from reproductions of each others' work. Once printing with movable type was developed around the mid-fifteenth century, books illustrated with woodcuts became popular.

Woodcuts reached a peak with Dürer but were gradually replaced by the more flexible and refined method of engraving. In Japan, the colored woodcut was always very popular. In the late nineteenth and early twentieth centuries in Europe, the woodcut enjoyed a revival, with Munch, Gauguin, and the German Expressionists adopting the medium for its jagged intensity.

ENGRAVING

Begun about 1430, engraving was a technique opposite to the woodcut's raised relief. The method was one of several in printmaking known as intaglio (ink transferred from below the surface), where prints are made from lines or crevices in a plate. In engraving, grooves were cut into a metal (usually copper) plate with a steel tool called a burin. Ink was rubbed into the grooves, the surface of the plate wiped clean, and the plate put through a press to transfer the incised design to paper. Forms could be modeled with fine-hatched lines to suggest shading. This technique flowered in the early sixteenth century with Dürer, whose use of the burin was so sophisticated, he could approximate on a copper plate the effects of light and mass achieved by the Dutch in oil and Italians in fresco.

Graphic arts techniques that became popular in later centuries include DRYPOINT, ETCHING, LITHOGRAPHY, and SILKSCREENING (see p. 109).

Dürer, "Saint Jerome," 1514, engraving, MMA, NY. *Through straight and curved hatching and crosshatching, Dürer depicted light streaming through bottle-glass windows, casting accurate shadows.*

MANNERISM AND THE LATE RENAISSANCE

Between the High Renaissance and the Baroque, from the death of Raphael in 1520 until 1600, art was at an impasse. Michelangelo and Raphael had been called "divino." Kings begged them for the slightest sketch. All problems of representing reality had been solved and art had reached a peak of perfection and harmony. So what now?

The answer: replace harmony with dissonance, reason with emotion, and reality with imagination. In an effort to be original, Late Renaissance, or Mannerist, artists abandoned realism based on observation of nature. Straining after novelty, they exaggerated the ideal beauty represented by Michelangelo and Raphael, seeking instability instead of equilibrium.

The times favored such disorder. Rome had been sacked by the Germans and Spaniards and the church had lost its authority during the Reformation. In the High Renaissance, when times were more stable, picture compositions were symmetrical and weighted toward the center. In the Late Renaissance, compositions were oblique, with a void in the center and figures crowded around — often cut off by — the edge of the frame. It was as if world chaos and loss of a unifying faith ("The center cannot hold," as W. B. Yeats later said) made paintings off-balance and diffuse.

The name "Mannerism" came from the Italian term "di maniera," meaning a work of art done according to an acquired style rather than depicting nature. Mannerist paintings are readily identifiable because their style is so predictable. Figures writhe and twist in unnecessary contrapposto. Bodies are distorted — generally elongated but sometimes grossly muscular. Colors are lurid, heightening the impression of tension, movement, and unreal lighting.

Notable Mannerists were Pontormo and Rosso (see sidebar); Bronzino, whose precious, elegant portraits featured long necks and sloping shoulders; Parmigianino, whose "Madonna with the Long Neck" displayed similar physical distortions; and Benvenuto Cellini, a sculptor and goldsmith known for his arrogant autobiography.

LIFE ON THE EDGE

Mannerists deliberately cultivated eccentricity in their work. Some were equally odd in their private lives. Rosso, who lived with a baboon, was said to have dug up corpses, fascinated with the process of decomposition. His canvases often had a sinister quality, as when he painted St. Anne like a haggard witch. On seeing one of his macabre works, a priest ran from the room shrieking the painter was possessed by the devil.

Pontormo was certifiably mad. A hypochondriac obsessed by fear of death, he lived alone in an especially tall house he had built to isolate himself. His garret room was accessible only by a ladder that he pulled up after himself. His paintings showed this bizarre sensibility. The perspective was irrational and his colors — lavender, coral, puce, poisonous green — unsettling. His figures often looked about wildly, as if sharing their creator's paranoid anxiety.

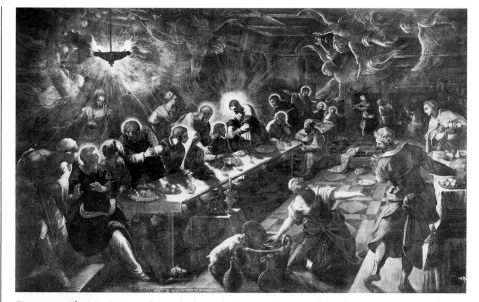

Tintoretto, "The Last Supper," 1594, San Giorgio Maggiore, Venice. *Tintoretto's (1518–94) crowded, dramatic canvases displayed obvious Mannerist traits like a plunging diagonal perspective, making the picture seem off-balance. He used light for emotional effect, from the darkest black to the incandescent light emanating from Christ's head and sketchy, chalk-white angels.*

THE SPANISH RENAISSANCE

The most remarkable figure of the Renaissance working in Spain was the painter El Greco (1541–1614). Born in Crete (then a possession of Venice), he received his first training in the flat, highly patterned Byzantine style. After coming to Venice, he appropriated Titian's vivid color and Tintoretto's dramatic lighting and was also influenced by Michelangelo, Raphael, and the Mannerists in Rome. His real name was Domenikos Theotocopoulos, but he was nicknamed "The Greek" and went to Toledo to work when about age 35.

At the time, Spain was in the grip of a religious frenzy, with the Counter Reformation and Inquisition holding sway. Many of El Greco's surreal, emotionally intense paintings reflected this climate of extreme zealotry.

A supremely self-confident artist, El Greco once said Michelangelo couldn't paint and offered to revamp "The Last Judgment." He also said he detested walking in sunlight because "the daylight blinds the light within." The most striking characteristic of his paintings comes from this inner light. An eerie, unearthly illumination flickers over the canvases, making his style the most original of the Renaissance.

Critics have disputed whether El Greco should be considered a Mannerist; some claim he was too idiosyncratic to be classified. His art manifested certain undeniable Mannerist attributes, such as an unnatural light of uncertain origin and harsh colors like strong pink, acid green, and brilliant yellow and blue. His figures were distorted and elongated — their scale variable — and the compositions full of swirling movement. Like the Mannerists, El Greco — in his religious

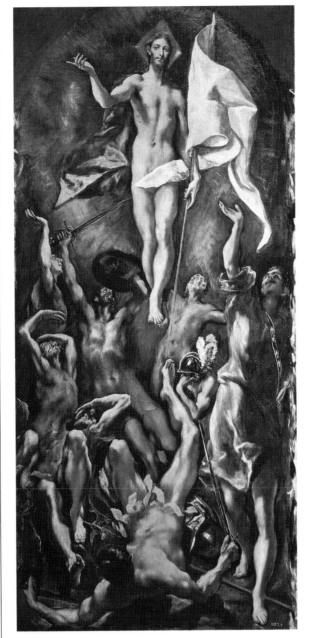

El Greco, "Resurrection," c. 1597–1604, Prado, Madrid. *Many characteristics of El Greco's late, mystical style are evident here: immensely long bodies, harsh light as if from a threatening storm, strong colors, twisted figures, sense of movement, and intense emotionalism.*

paintings although not his portraits — cared little for accurately representing the visual world. He preferred to create an emotion-laden vision of celestial ecstasy.

BEAUTY SECRETS OF THE SPANISH LADIES

Ridiculously elongated hands and slender figures were a hallmark of Mannerism. The fingers in an El Greco painting are characteristically long, thin, and expressive. Spanish ladies of the time so admired refined hands that they tied their hands to the top of the bedstead at night to make them pale and bloodless.

BAROQUE: THE ORNATE AGE

Baroque art (1600–1750) succeeded in marrying the advanced techniques and grand scale of the Renaissance to the emotion, intensity, and drama of Mannerism, thus making the Baroque era the most sumptuous and ornate in the history of art. While the term "baroque" is often used negatively to mean overwrought and ostentatious, the seventeenth century not only produced such exceptional artistic geniuses as Rembrandt and Velázquez but expanded the role of art into everyday life.

Artists now termed as Baroque came to Rome from all of Europe to study the masterpieces of Classical antiquity and the High Renaissance then returned to their homes to give what they learned their own particular cultural spin. Just as seventeenth-century colonists followed the sixteenth-century explorers, so too did these artists build upon past discoveries. While styles ranged from Italian realism to French flamboyance, the most common element throughout was a sensitivity to and absolute mastery of light to achieve maximum emotional impact.

The Baroque era began in Rome around 1600 with Catholic popes financing magnificent cathedrals and grand works to display their faith's triumph after the Counter Reformation and to attract new worshipers by overwhelming them with theatrical, "must-see" architecture. It spread from there to France, where absolute monarchs ruled by divine right and spent sums comparable to the pharaohs to glorify themselves. Palaces became enchanted environments designed to impress visitors with the power and grandeur of the king. Wealth flowing in from the colonies funded the elaborate furnishings, gardens, and art of showplaces like Louis XIV's Versailles. Though just as opulent as religious art, French paintings had nonreligious themes derived from Greek and Roman models, such as Poussin's calm landscapes populated by pagan deities.

In Catholic countries like Flanders, religious art flourished, while in the Protestant lands of northern Europe, such as England and Holland, religious imagery was forbidden. As a result, paintings tended to be still lifes, portraits, landscapes, and scenes from daily life. Patrons of art were not only prosperous merchants eager to show off their affluence but middle-class burghers buying pictures for their homes as well. From Rembrandt's "Nightwatch," characteristic of Northern Baroque art to Rubens's sensuous, highly colored panoramas typical of Catholic Baroque, art of the period had a theatrical, stage-lit exuberance and drama.

Caravaggio, "The Conversion of St. Paul," c. 1601, Santa Maria del Popolo, Rome. *Although criticized for portraying holy figures as common people, Caravaggio's radical style of sharp light and dark contrasts changed European art.*

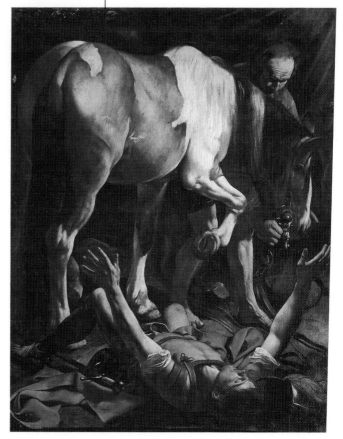

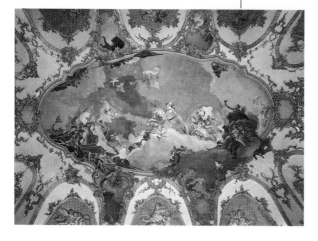

Tiepolo, "Apollo Conducts the Bride, Beatrice, to Babarossa of Burgundy," 1751–52 , Residenz Palace, Würzburg, Germany. *Tiepolo's ceiling fresco of gods and heroes floating heavenward showed the vigorous movement and vivid colors of Baroque art.*

ITALIAN BAROQUE

Artists in Rome pioneered the Baroque style before it spread to the rest of Europe. By this time, art academies had been established to train artists in the techniques developed during the Renaissance. Artists could expertly represent the human body from any angle, portray the most complex perspective, and realistically reproduce almost any appearance. Where Baroque diverged from Renaissance was the emphasis on emotion rather than rationality, dynamism rather than stasis. It was as if Baroque artists took Renaissance figures and set them spinning like tops. Three artists in different media best represent the pinnacle of Italian Baroque: the painter Caravaggio, the sculptor Bernini, and the architect Borromini.

CARAVAGGIO: **THE SUPERNATURAL MADE REAL.** The most original painter of the seventeenth century, Caravaggio (1571–1610) injected new life into Italian painting after the sterile artificiality of Mannerism. He took realism to new lengths, painting bodies in a thoroughly "down and dirty" style, as opposed to pale, Mannerist phantoms. In so doing, Caravaggio secularized religious art, making saints and miracles seem like ordinary people and everyday events.

Although specializing in large religious works, Caravaggio advocated "direct painting" from nature — often, it seemed, directly from the seamy slums. In "The Calling of St. Matthew," for example, the apostle-to-be sits in a dark pub, surrounded by dandies counting money, when Christ orders him, "Follow Me." A strong diagonal beam of light illuminates the thunderstruck tax-collector's expression and gesture of astonishment.

In "Supper at Emmaus," Caravaggio showed the moment the apostles realized their table companion was the resurrected Christ as an encounter in a wineshop. The disciples, pushing back chairs and throwing open their arms and a bowl of wormy fruit about to topple off the table make the action leap out of the picture frame, enveloping the viewer in the drama. "The Conversion of St. Paul" demonstrates Caravaggio's ability to see afresh a traditional subject. Other painters depicted the Pharisee Saul converted by a voice from heaven with Christ on the heavenly throne surrounded by throngs of angels. Caravaggio showed St. Paul flat on his back, fallen from his horse, which is portrayed in an explicit rear-end view. The hard focus and blinding spotlight

THE FIRST FEMINIST PAINTER

Caravaggio had many followers, called "i tenebrosi" or "the Caravaggisti," who copied his dark tonality and dramatic lighting in "night pictures." One of the most successful was the Italian Artemisia Gentileschi (1593–1653), the first woman painter to be widely known and appreciated. A precociously gifted artist who traveled widely and lived an eventful, independent life rare for a woman in that time, Gentileschi depicted feminist subjects in Caravaggio's style of brilliantly lighted main players against a plain, dark background.

As a 19-year-old art student, Gentileschi was raped by her tutor and then subjected to a painful and humiliating trial in which she was tortured with thumbscrews to get her to recant. After her attacker was acquitted, Gentileschi devoted herself to painting women who wreak violence against men who have wronged them. In "Judith and Maidservant with the Head of Holofernes," Gentileschi painted the Hebrew heroine (in five different pictures) as an explicit self-portrait. Lit by a candle as the single source of light, the painting reeked with menace and terror, as Judith beheaded the lustful Babylonian general to save Israel.

THE FIRST BOHEMIAN ARTIST

If Caravaggio, as has been said, was the first artist intentionally seeking to shock and offend, he certainly succeeded. His contemporaries called him an "evil genius" and the "anti-Christ of painting," while the Victorian writer John Ruskin accused him of "perpetual … feeding upon horror and ugliness and filthiness of sin."

Caravaggio's life was as unorthodox as his art. A bohemian and rebel, Caravaggio consorted with the dregs of society. As we know from his lengthy police record, the surly artist was constantly brawling in taverns and streets. After stabbing a man in the groin over a tennis wager, he fled Rome to escape prosecution for murder. In chronic trouble with the law, Caravaggio wandered from city to city and from one lurid scandal to another.

Caravaggio was also disdainful of artistic convention and a very vocal opponent of tradition. When advised to study Classical models and adhere to Renaissance ideals of beauty, he instead hailed a gypsy off the street, preferring to paint this outcast rather than an idealized Greek goddess. Many thought he went too far when, in "Death of the Virgin," he used a drowned corpse as model for the Virgin, irreverently representing the Madonna with bare feet and swollen body, surrounded by grieving commoners. Although the painting was refused by the parish that commissioned it, the Duke of Mantua purchased it on the advice of his court painter, Rubens.

Caravaggio always insisted that back alleys, mean streets, and the unsavory folk he found there were the one true source of art, not rules decreed by others. After a stormy life, this radical talent died at the age of 37.

reveal details like veins on the attendant's legs and rivets on Saul's armor, while inessential elements disappear in the dark background.

Caravaggio's use of perspective brings the viewer into the action, and chiaroscuro engages the emotions while intensifying the scene's impact through dramatic light and dark contrasts. This untraditional, theatrical staging focuses a harsh light from a single source on the subject in the foreground to concentrate the viewer's attention on the power of the event and the subject's response. Because of the shadowy background Caravaggio favored, his style was called "il tenebroso" (in a "dark manner").

Many of Caravaggio's patrons who commissioned altarpieces refused to accept his renditions, considering them vulgar or profane. However, Caravaggio's choice of disreputable, lower-class folk as suitable subjects for religious art expressed the Counter Reformation belief that faith was open to all.

To the contemporary French painter Poussin, known for his peaceful scenes, Caravaggio was a subversive betrayer of the art of painting. To the police, he was a fugitive wanted for murder (see sidebar, p. 47). But to major artists like Rubens, Velázquez, and Rembrandt, he was a daring innovator who taught them how to make religious paintings seem both hyperreal and overwhelmingly immediate.

BERNINI: SCULPTURE IN MOTION.

Gianlorenzo Bernini (1598–1680) was more than the greatest sculptor of the Baroque period. He was also an architect, painter, playwright, composer, and theater designer. A brilliant wit and caricaturist, he wrote comedies and operas when not carving marble as easily as clay. More than any other artist, with his public fountains, religious art, and designs for St. Peter's, he left his mark on the face of Rome.

The son of a sculptor, Bernini carved his remarkable marble "David" when age 25. Unlike Michelangelo's "David" (see p. 13) where the force was pent-up, Bernini's captured the moment of maximum torque, as he wound up to hurl the stone. Biting his lips from strain, Bernini's David conveyed power about to be unleashed, causing any observer standing in front of the statue to almost want to duck. This dynamic, explosive energy epitomized Baroque art and involved the viewer in its motion and emotion by threatening to burst its physical confines.

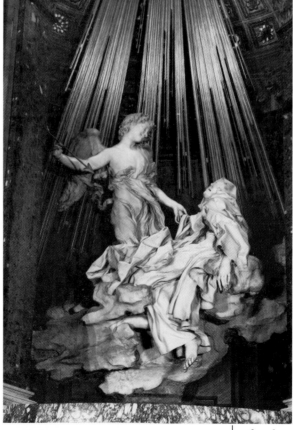

Bernini, "The Ecstasy of St. Theresa," 1645–52, Cornaro Chapel, Santa Maria della Vittoria, Rome. *Bernini fused sculpture, painting, and architecture in a total environment designed to overwhelm the emotions.*

"THE ECSTASY OF ST. THERESA."

Bernini's masterpiece — and the culmination of Baroque style — was "The Ecstasy of St. Theresa." He even designed a whole chapel as a stage set to show it off, including painted balconies on the walls filled with "spectators" sculpted in relief.

St. Theresa reportedly saw visions and heard voices, believing herself to have been pierced by an angel's dart infusing her with divine love. She described the mystical experience in near-erotic terms: "The pain was so great that I screamed aloud; but at the same time I felt such infinite sweetness that I wished the pain to last forever."

Bernini's marble sculpture represented the saint swooning on a cloud, an expression of mingled ecstasy and exhaustion on her face. Since the Counter Reformation Church stressed the value of its members reliving Christ's passion, Bernini tried to induce an intense religious experience in worshipers. He used all the resources of operatic stagecraft, creating a total artistic environment in the chapel. The saint and angel appear to be floating on swirling clouds, while golden rays of light pour down from a vault of heaven painted on the ceiling. The sculptor's virtuosity with textures made the white marble "flesh" seem to quiver with life, while the feathery wings and frothy clouds are equally convincing. The whole altarpiece throbs with emotion, drama, and passion.

ST. PETER'S CATHEDRAL

For most of his life, Bernini worked on commissions for Rome's St. Peter's Cathedral. The focal point of the church's interior was Bernini's bronze canopy-altar (known as a "baldachin") beneath the central dome marking the burial site of St. Peter. Taller than a ten-story building, this extravagant monument features four gigantic, grooved, spiral columns (covered with carved vines, leaves, and bees) that seem to writhe upward like corkscrews. The ensemble, including four colossal bronze angels at the corners of the canopy, is the essence of Baroque style. Its mixture of dazzling colors, forms, and materials produces an overwhelming and theatrical effect of imaginative splendor.

 For a climactic spot at the end of the church, Bernini designed the Cathedra Petri, another mixed-media extravaganza to enshrine the modest wooden stool of St. Peter. The sumptuous composition includes four huge bronze figures supporting — almost without touching it — the throne, which is enveloped by flights of angels and billowing clouds. Everything appears to move, bathed in rays of golden light from a stained glass window overhead.

 Outside the cathedral, Bernini designed the vast piazza and surrounded it with two curving, covered colonnades supported by rows of four columns abreast. Bernini planned arcades flanking the huge oval space to be like the Church's maternal, embracing arms, welcoming pilgrims to St. Peter's.

Aerial view of the piazza, St. Peter's Cathedral, Rome.

BORROMINI: DYNAMIC ARCHITECTURE. What Caravaggio did for painting, Francesco Borromini (1599–1667) did for architecture. Just as the painter's spotlighted subjects seem to leap out at the viewer, Borromini's undulating walls create a sense of being strobe-lit. The highly original work of both artists revolutionized their respective fields.

Borromini was a rebellious, emotionally disturbed genius who died by suicide. The son of a mason, he worked first as a stonecutter under Bernini, who later became his arch-rival. But, while Bernini employed up to thirty-nine assistants to execute his hastily sketched designs, the brooding, withdrawn Borromini worked obsessively on the most minute decorative details. He rejected countlesss ideas before saying "questo!" (this one) when he finally settled on a choice.

Even in buildings of modest dimensions, Borromini combined never-before-linked shapes in a startling fashion. The odd juxtaposition of concave and convex surfaces made his walls seem to ripple. Indeed, this quality and his complex floor plans have been compared to the multiple voices of a Bach organ fugue, both designed to produce a mood of exaltation.

Despite the bold elasticity of Borromini's buildings, the structures were unified and cohesive. The scalloped walls of St. Ivo's Church in Rome continuously taper to the top of a fantastic six-lobed dome, with the dome's frame being identical to the shape of the walls below — an organic part of a whole, as opposed to a separate Renaissance dome set upon a supporting block. The variety of curves and counter-curves typical of Borromini's work can be seen in San Carlo alle Quattro Fontane, where the serpentine walls seem in motion.

Borromini, facade, San Carlo alle Quattro Fontane, 1665–67, Rome. *Borromini's trademark was alternating convex and concave surfaces to create the illusion of movement.*

FLEMISH BAROQUE

The southern Netherlands, called Flanders and later Belgium, remained Catholic after the Reformation, which gave artists ample incentive to produce religious paintings. The story of Flemish Baroque painting is really the story of one man, Sir Peter Paul Rubens (1577–1640).

"A prince of painters and a painter of princes," an English ambassador said of Rubens. He led a charmed life, which took him to all the courts of Europe as both painter and diplomat. He was truly a European rather than regional painter, working for rulers of Italy, France, Spain, and England as well as Flanders. As a result, his work perfectly synthesized the styles and concepts of the South and North.

A rare creative genius who had it all, both worldly success and personal happiness, Rubens was outgoing, classically educated, handsome, vigorous, and well traveled. He spoke six languages fluently and had inexhaustible stamina. A visitor to Rubens's studio recalled the maestro painting a picture while listening to Ovid in the original Latin, carrying on a learned conversation, and dictating a letter — all at the same time. As one patron said, "Rubens had so many talents that his knowledge of painting should be considered the least of them."

Energy was the secret of Rubens's life and art. His output of more than 2,000 paintings was comparable only to Picasso's. He was swamped by commissions, which made him both wealthy and renowned. He rose each morning at 4 A.M., and worked nonstop until evening. Still, he needed an army of assistants to keep up with the demand for his work. His studio has been compared to a factory, where Rubens did small color sketches in oil of his conception or outlined a work full-size, to be painted by assistants (which is how van Dyck got his start), then finished by the master himself.

His studio in Antwerp (open to visitors today) still retains the balcony Rubens designed overlooking his work area, where customers could watch him paint huge pictures. One recalled how Rubens stared at a blank panel with arms crossed, then exploded in a flurry of quick brushstrokes covering the entire picture.

RELIGIOUS PAINTING. One painting that created a sensation, establishing Rubens's reputation as Europe's foremost religious painter, was "The Descent from the Cross." It has all the traits of mature Baroque style: theatrical lighting with an ominously dark sky and glaringly spot-lit Christ, curvilinear rhythms leading the eye to the central figure of Christ, and tragic theme eliciting a powerful emotional response. The English painter Sir Joshua Reynolds called the magnificent body of Christ "one of

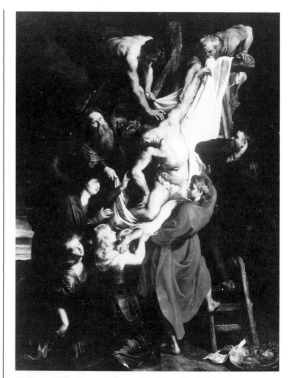

Rubens, "The Descent from the Cross," c. 1612, Antwerp Cathedral. *This painting, full of Baroque curves and dramatic lighting, established Rubens's reputation.*

the finest figures that ever was invented." His drooping head and body falling to the side conveyed the heaviness of death with intense, you-are-there accuracy.

FAT IS BEAUTIFUL. Rubens was probably best known for his full-bodied, sensual nudes. He was happily married to two women (when his first wife died, he married a 16-year-old). Both were his ideal of feminine beauty that he painted again and again: buxom, plump, and smiling with golden hair and luminous skin.

As the art historian Sir Kenneth Clark wrote in *The Nude*, skin represents the most difficult problem for a painter. Rubens's mastery was such, he promised patrons "many beautiful nudes" as a selling point. Whatever the subject, his compositions were always based on massive, rounded human figures, usually in motion. While most painters, because they revered the Classical style, worked from plaster casts or antique sculptures, Rubens preferred to sketch from living models.

HUNTING PICTURES. One characteristic Rubens shared with Hals and Velázquez was that his method of applying paint was in itself expressive. Rubens's surging brushstrokes made his vibrant colors come alive. Nowhere was this more evident than in his hunting pictures, a genre he invented.

MARIE DE'MEDICI SERIES

Rubens's most ambitious project was a sequence of paintings celebrating the life of the queen of France, Marie de'Medici, a silly, willful monarch chiefly remembered for squandering huge sums of money and quarreling incessantly with her spouse (she ruled temporarily after he was assassinated), and for commissioning Rubens to decorate two galleries with pictures immortalizing her "heroic" exploits.

"My talent is such," Rubens wrote, "that no undertaking, however vast in size . . . has ever surpassed my courage." True to his boast, he finished Marie's twenty-one large-scale oils in just three years, virtually without assistance. Even more difficult, however, must have been creating glorious epics out of such inglorious raw material. Here, too, the tactful Rubens was up to the task. He portrayed Marie giving birth to her son (the royal heir before she had him banished) as a solemn nativity scene. His panel on Marie's education featured divinities like Minerva and Apollo tutoring her in music and eloquence.

In "Marie Arrives at Marseilles," the goddess of Fame heralds the queen's landing in France with golden trumpets. Rubens diplomatically omitted Marie's double chin (though in later scenes he did portray her queen-size corpulence) and concentrated instead on three voluptuous assistants to Neptune in the foreground, even lovingly adding beadlike drops of water on their ample buttocks.

Rubens shared the Baroque era's love of pomp, indicated by the painting's exuberant colors, rich costumes, and golden barge. He approached his life and work with vigor. No matter what the subject, he gave his paintings an air of triumph. As Rubens said, "It is not important to live long, but to live well!"

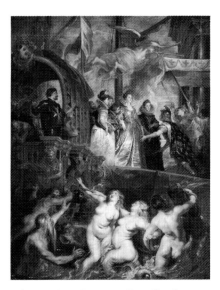

Rubens, "Marie Arrives at Marseilles," 1622–25, Louvre, Paris. *Rubens painted the arrival of the French queen as a sensory extravaganza spilling over with color and opulence.*

Van Dyck, "Charles I at the Hunt," 1635, Louvre, Paris. *Van Dyck specialized in flattering portraits of elegant aristocrats, posed informally to give the official portrait new liveliness.*

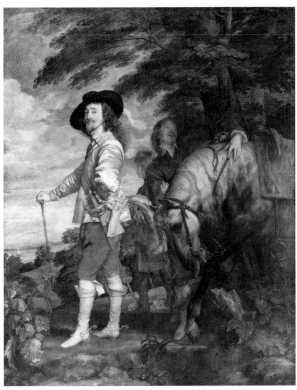

VAN DYCK: THE INFORMAL, FORMAL PORTRAIT. A true child prodigy, Sir Anthony van Dyck (1599–1641) was an accomplished painter when only 16. For a few years he worked with Rubens in Antwerp but, not content to play second fiddle, he struck out on his own, first to Italy and later to England to become court painter to Charles I.

The handsome, vain, fabulously gifted painter was dubbed "il pittore cavalleresco" (painter who gives himself fancy airs) for his snobbish dandyism. He was addicted to high society and dressed ostentatiously, strutting about with a sword and adopting the sunflower as his personal symbol. Van Dyck was a supreme portraitist, establishing a style, noble yet intimate and psychologically penetrating, that influenced three generations of portrait painters.

Van Dyck transformed the frosty, official images of royalty into real human beings. In this new kind of portrait, he posed aristocrats and royals in settings of Classical columns and shimmering curtains to convey their refinement and status. Yet van Dyck's ease of composition and sense of arrested movement, as though the subjects were pausing rather than posing, lent humanity to an otherwise stilted scene.

Another reason for van Dyck's popularity was his ability to flatter his subjects in paint, all becoming slim paragons of perfection, despite eyewitness accounts to the contrary. Charles I was stubby and plain, but in van Dyck's hands, he became a dashing cavalier king, standing on a knoll like a warrior surveying the battlefield beneath the canopy of a tree. One trick van Dyck used to great effect was to paint the ratio of head to body as one to seven, as opposed to the average of one to six. This served to elongate and slenderize his subject's figure.

DUTCH BAROQUE

Though Holland shared its southern border with Flanders, culturally and politically the two countries could not have been more different. While Flanders was dominated by the monarchy and the Catholic Church, Holland, or The Netherlands, was an independent, democratic, Protestant country. Religious art was forbidden in the severe, whitewashed churches and the usual sources of patronage — the church, royal court, and nobility — were gone. The result was a democratizing of art in both subject matter and ownership.

Artists, for the first time, were left to the mercy of the marketplace. Fortunately, the prosperous middle class had a mania for art collecting. One visitor to Amsterdam in 1640 noted, "As For the art off Painting and the affection off the people to Pictures, I think none other goe beeyond them, . . . All in generalle striving to adorne their houses with costly pieces." Demand for paintings was constant. Even butchers, bakers, and blacksmiths bought paintings to decorate their shops.

Such enthusiasm produced a bounty of high-quality art and huge numbers of artists that specialized in specific subjects such as still lifes, seascapes, interiors, or animals. In the seventeenth century, there were more than 500 painters in Holland working in still life alone.

Dutch art flourished from 1610 to 1670. Its style was realistic, its subject matter commonplace. But what made its creators more than just skilled technicians was their ability to capture the play of light on different surfaces and to suggest texture — from matte to luminous — by the way light was absorbed or reflected. Most of these Dutch painters, a fairly conservative crew, are referred to as the Little Dutchmen, to distinguish them from the three great masters, Hals, Rembrandt, and Vermeer, who went beyond technical excellence to true originality.

STILL LIFE. As a genre of painting, the still life began in the post-Reformation Netherlands. Although the form was considered inferior elsewhere, the seventeenth century was the peak period of Dutch still life painting, with artists achieving extraordinary realism in portraying domestic objects. Often still lifes were emblematic, as in

THE STILL LIFE

Dutch still life masters who pioneered the form as a separate genre were interested in how light reflected off different surfaces. Heda's "Still Life" counterpoints the dull gleam of pewter against the sheen of silver or crystal.

In the eighteenth century, the French painter Chardin spread the still life art form to the south by concentrating on humble objects. Nineteenth-century painters like Corot, Courbet, and Manet used still life to examine objects' aesthetic qualities. Cézanne, the Cubists, and the Fauves employed the still life to experiment with structure and color, while Italian painter Morandi concentrated almost exclusively on still lifes. A photo-realist style of trompe l'oeil painting arose in the United States beginning with the Peale brothers' still lifes, followed by the lifelike "deceptions" of Harnett and Peto, up to contemporary painters like Audrey Flack.

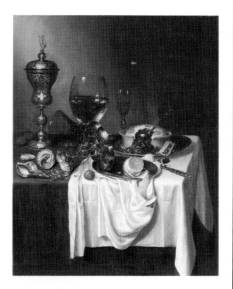

Heda, "Still Life," c.1636, Fine Arts Museums of San Francisco.

"vanitas" paintings, with symbols like a skull or smoking candle representing the transience of all life.

LANDSCAPE. Before the Baroque era, landscape views were little more than background for whatever was going on in the front of the picture. The Dutch established landscape as deserving of its own artistic treatment. In contrast to France, where Poussin and Claude focused on an idealized nature, the great Dutch landscape artists, such as Aelbert Cuyp, Jacob van Ruisdael, and Meindert Hobbema, treated nature realistically, often set against towering clouds in a great sky.

RUISDAEL: "BIG SKY" PAINTINGS. The most versatile landscape artist was Ruisdael (1629–82). Although he painted sharply defined details, he emphasized great open stretches of sky, water, and fields and used dramatic contrasts of light and shadow and threatening clouds to infuse his work with melancholy. This expansiveness and somber mood distinguished him from hundreds of other landscape artists working at the time.

HALS: MASTER OF THE MOMENT.

Frans Hals's (1580–1666) contribution to art was his ability to capture a fleeting expression. Whether his portraits depicted musicians, gypsies, or solid citizens, he brought them to life, often laughing and hoisting a tankard. His trademark was portraits of men and women caught in a moment of rollicking high spirits.

Hals's most famous painting, "The Laughing Cavalier," portrays a sly figure with a smile on his lips, a twinkle in his eyes, and a mustache rakishly upturned. Hals achieved this swashbuckling effect chiefly through his brushstrokes. Before Hals, Dutch realists prided themselves on masking their strokes to disguise the process of painting, thereby heightening a painting's realism. Hals put his own "signature" on his images through slashing, sketchlike brushstrokes.

In this "alla prima," technique, which means "at first" in Italian, the artist applies paint directly to the canvas without an undercoat. The painting is completed with a single application of brushstrokes. Although Hals's strokes were clearly visible at close range, like Rubens's and Velázquez's, they formed coherent images from a distance and perfectly captured the immediacy of the moment. Hals caught his "Jolly Toper" in a freeze-frame of life, with lips parted as if about to speak and hand in mid-gesture.

Hals transformed the stiff convention of group portraiture. In his "Banquet of the Officers of the Saint George Guard Company," he portrayed militiamen not as fighters but feasters at an uproarious banquet. Before Hals, artists traditionally painted group members as in a class picture, lined up like effigies in neat rows. Hals seated them around a table in relaxed poses, interacting naturally, with each facial expression individualized. Although the scene seems impromptu, the composition was a balance of poses and gestures with red-white-and-black linkages. The Baroque diagonals of flags, sashes, and ruffs reinforced the swaggering, boys-night-out feeling.

Hals's outgoing, merry portraits of the 1620s and '30s reveal his gift for enlivening, rather than embalming, a subject. Sadly, at the end of his life, Hals fell from favor. Although he had been a successful portraitist, the love of wine and beer his paintings celebrated spilled over into his personal life. With ten children and a brawling second wife who was often in trouble with the law, Hals, "filled to the gills every evening," as a contemporary wrote, died destitute.

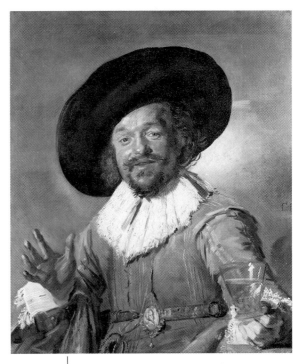

Hals, "The Jolly Toper," 1627, Rijksmuseum, Amsterdam. *Hals used sweeping, fluid brushstrokes to freeze the passing moment in candid portraits of merry tipplers.*

Ruisdael, "Windmill at Wijk-bij-Duurstede," c. 1665, Rijksmuseum, Amsterdam. *Ruisdael's landscapes convey a dramatic mood through the wind-raked sky, mobile clouds, and alternating sun and shadow streaking the low horizon.*

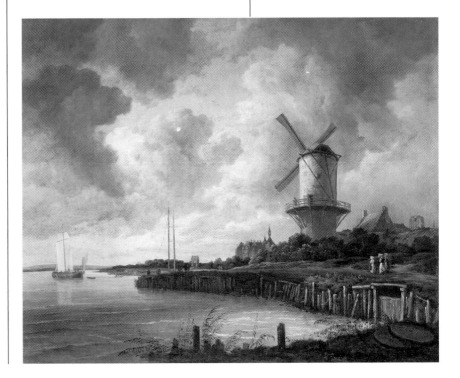

REMBRANDT: THE WORLD FAMOUS. Probably the best-known painter in the Western world is Rembrandt van Rijn (1606–69). During his lifetime, Rembrandt was a wildly successful portrait painter. Today his reputation rests principally on the probing, introspective paintings of his late years, their subtle shadings implying extraordinary emotional depth.

EARLY STYLE. For the first twenty years of his career, Rembrandt's portraits were the height of fashion, and he was deluged with commissions. Although his output was prolific, he was difficult to deal with. "A painting is finished," he said, "when the master feels it is finished." Customers often resorted to bribery to receive their portraits on time. During this prosperous period, Rembrandt also painted Biblical and historical scenes in a Baroque style. These intricately detailed works were lit dramatically, with the figures reacting melodramatically.

LATE STYLE. The year of "The Nightwatch," 1642, marked a turning point in Rembrandt's career. His dearly loved wife died prematurely (they had already lost three children in infancy) and he increasingly abandoned facile portraits with Baroque flourishes for a quieter, deeper style. In his mature phase, Rembrandt's art became less physical, more psychological. He turned to Biblical subjects but treated them with more restraint. A palette of reds and browns came to dominate his paintings, as did solitary figures and a pervasive theme of loneliness. He pushed out the limits of chiaroscuro, using gradations of light and dark to convey mood, character, and emotion.

ETCHING. Rembrandt is considered the most accomplished etcher ever. He handled the needle with such skill and speed, his etchings convey the spontaneity of a sketch. One of his best-known etchings, "Six's Bridge," a landscape, was said to have been done between courses during dinner when a servant dashed to a nearby village to fetch mustard.

Nightwatch. *"The Nightwatch," an example of his early style, shows Rembrandt's technical skill with lighting, composition, and color that earned it the reputation as one of the world's greatest masterpieces.*

The painting was erroneously believed to be a night scene because of the darkened varnish that coated it. After cleaning, it was evident the scene took place in the day, at the dramatic moment the larger-than-life captain at center gives his militia company its marching orders.

Like Hals, Rembrandt revolutionized the clichéd group portrait from stiff, orderly rows to a lively moment of communal action, giving a sense of hectic activity through Baroque devices of light, movement, and pose. The captain and lieutenant seem on the verge of stepping into the viewer's space, while contrasting light flashes and dark background keep the eye zig-zagging around the picture. The crisscrossing diagonals of pikes, lances, rifles, flag, drum, and staff make the scene appear chaotic, but — since they converge at right angles — they are part of a hidden geometric pattern holding everything together. Color harmonies of yellow in the lieutenant's uniform and girl's dress and red sash and musketeer's uniform also unify the design.

According to a now-disproved legend, since each member of the company had paid equally to have his portrait immortalized, Rembrandt's obscuring some faces marked the beginning of his decline from favor. A student of the painter wrote that Rembrandt paid "greater heed to the sweep of his imagination than to the individual portraits he was required to do," yet added that the painting was "so dashing in movement and so powerful" that other paintings beside it seemed "like playing cards."

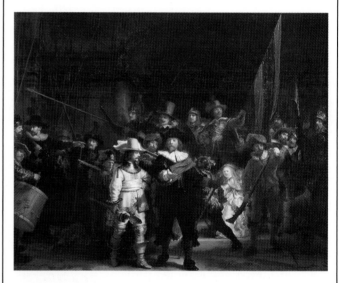

Rembrandt, "The Nightwatch," 1642, Rijksmuseum, Amsterdam.

EARLY STYLE, c. 1622–42	**LATE STYLE, c. 1643–69**
Used dramatic light/dark contrasts	Used golden-brown tones, subtle shading
Design seemed to burst frame	Static, brooding atmosphere
Scenes featured groups of figures	Scenes simplified with single subject
Based on physical action	Implied psychological reaction
Vigorous, melodramatic tone	Quiet, solemn mood
Highly finished, detailed technique	Painted with broad, thick strokes

PAINTINGS. Rembrandt's technique evolved from attention to minute detail to large-scale subjects given form through broad, thick smudges of paint. His first biographer wrote, "In the last years of his life, he worked so fast that his pictures, when examined from close by, looked as if they had been daubed with a bricklayer's trowel." He almost carved with pigment, laying on heavy impasto "half a finger" thick with a palette knife for light areas and scratching the thick, wet paint with the handle of the brush. This created an uneven surface that reflected and scattered the light, making it sparkle, while the dark areas were thinly glazed to enhance the absorption of light.

Rembrandt's only known comment on art was in a letter, where he wrote that he painted "with the greatest and most deep-seated emotion." The rest of his remarkable contribution to art he left on the canvas.

SELF-PORTRAITS

Rembrandt's nearly 100 self-portraits over the course of forty years were an artistic exploration of his own image that remained unique until van Gogh. The self-portraits ranged from a dewy-eyed youth to an old man stoically facing his own physical decay. In between were brightly lit portraits of the affluent, successful entrepreneur, dressed in furs and gold. Later, the distinctions between light and shadow became less pronounced as he used chiaroscuro to find his inner being.

Comparing an early and late self-portrait shows the change from fine detail to bolder strokes. In the first, done when Rembrandt was about 23, he used Caravaggesque lighting, with one side of the face in deep shadow. He paid as much attention to superficial costume detail (see the rivets on his iron collar) as to character traits. In the later self-portrait, when Rembrandt was 54, the inner man was the focus, conveyed through freer application of paint.

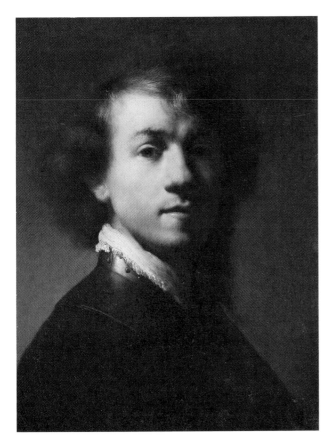

Rembrandt, "Self-Portrait," c.1629–30, Mauritshuis, The Hague.

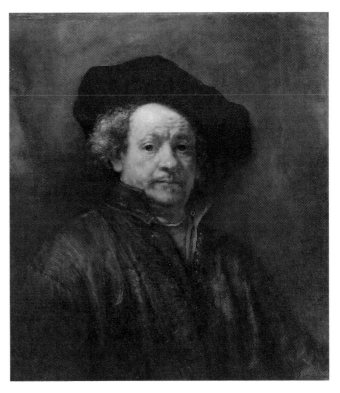

Rembrandt, "Self-Portrait," 1660, MMA, NY.

VERMEER: MASTER OF LIGHT. Called the "Sphinx of Delft" because of the mystery about his life, the painter Johannes Vermeer (1632–75) is now considered second only to Rembrandt among Dutch artists. He remained in his native city of Delft until he died bankrupt at the age of 43, leaving a widow and eleven children. His surviving paintings are few, only thirty-five to forty. Perhaps he never painted more, for no painter until Ingres worked so deliberately.

And no painter except perhaps van Eyck was as skillful as Vermeer in his masterful use of light. While other artists used a gray/green/brown palette, Vermeer's colors were brighter, purer, and glowed with an intensity unknown before.

Besides his handling of color and light, Vermeer's perfectly balanced compositions of rectangular shapes lend serenity and stability to his paintings. A typical canvas portrays a neat, spare room lit from a window on the left and a figure engrossed in a simple domestic task. But what elevates his subjects above the banal is his keen representation of visual reality, colors perfectly true to the eye, and the soft light that fills the room with radiance. His pictures contain no central anecdote, passion, or event. The soft, buttery — almost palpable — light roaming over various surfaces is his true subject.

Vermeer used a "camera obscura" to aid his accuracy in drawing. This was a dark box with a pinhole opening that could project an image of an object or scene to be traced on a sheet of paper. Yet Vermeer did not merely copy the outlines of a projected scene. His handling of paint was also revolutionary. Although in reproduction the brushstrokes appear smooth and detailed, Vermeer often applied paint in dabs and pricks so that the raised surface of a point of paint reflected more light, giving vibrancy and a sense of rough, three-dimensional texture. His technique was close to the pointillism of the Impressionists. One critic described his paint surface as "crushed pearls melted together."

In "The Kitchenmaid," his method of defining forms not by lines but by beads of light was evident, especially around the rim of the milk pitcher, a mosaic of paint daubs. Vermeer was also a master of varying the intensity of color in relation to an object's distance from the light source. The crusty bread picks up the strongest light and reflects it, through precise touches of impasto (or thickly applied paint). Almost too attentive to detail, Vermeer, to avoid monotony on the whitewashed wall, even adds stains, holes, and a nail. The composition is so balanced and cohesive that removing just one of the elements would threaten its sta-

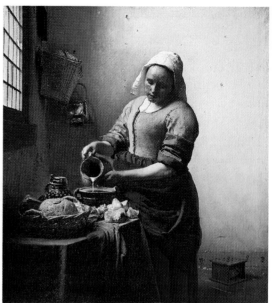

Vermeer, "The Kitchenmaid," c. 1658, Rijksmuseum, Amsterdam. *Vermeer's true subject was light and its effect on color and form.*

bility. Although the painting is devoid of dramatic incident, the maid's utter absorption in her task gives her work an air of majesty. As one critic said of Vermeer, "No Dutch painter ever honored woman as he did."

WHO WERE THE OLD MASTERS?

Besides the group portrait on the Dutch Masters cigar box, is there any agreement on which painters comprise the auction category "Old Masters"? It's actually a flexible concept — rather than an explicit listing — of notable painters from the Renaissance and Baroque periods. The following are some of the main artists sure to top anyone's list of Old Masters.

Bellini	Correggio	Masaccio	Tintoretto
Bosch	Dürer	Michelangelo	Titian
Botticelli	El Greco	Poussin	Van Dyck
Bruegel	Giorgione	Raphael	Van Eyck
Canaletto	Hals	Rembrandt	Velázquez
Caravaggio	Holbein	Reni	Vermeer
Carracci	La Tour	Rubens	Veronese
Claude	Leonardo	Tiepolo	Zurbarán

ENGLISH BAROQUE

The seventeenth century was a period of upheaval in England, with Charles I losing his head, Cromwell destroying church art, and Parliament seizing power. While in literature the 1600s was an era of extraordinary creativity (Shakespeare, Donne, Milton), the visual arts in England lagged far behind. Since religious art was forbidden in Puritan churches and the taste for mythological subjects never caught on, English art was limited almost exclusively to portraits. In the past, England had imported its painters (Holbein and van Dyck). Now, for the first time, it produced three important native artists: Hogarth, Gainsborough, and Reynolds.

HOGARTH: THE ARTIST AS SOCIAL CRITIC. "I have endeavored to treat my subjects as a dramatic writer; my picture is my stage," wrote the painter/engraver William Hogarth (1697–1764). Influenced by contemporary satirists like Fielding and Swift, Hogarth invented a new genre — the comic strip — or a sequence of anecdotal pictures that poked fun at the foibles of the day. The masses bought engravings based on these paintings by the thousands as Hogarth became the first British artist to be widely admired abroad.

Hogarth's lifelong crusade was to overcome England's inferiority complex and worship of continental artists. He criticized the Old Masters as having been "smoked into worth" by time, and thereby rendered nearly indecipherable; he denounced fashionable portrait painters as "face painters." In his portraits, he refused to prettify the subject, believing that irregularities revealed character. Commissions, as a result, were few, which led him to

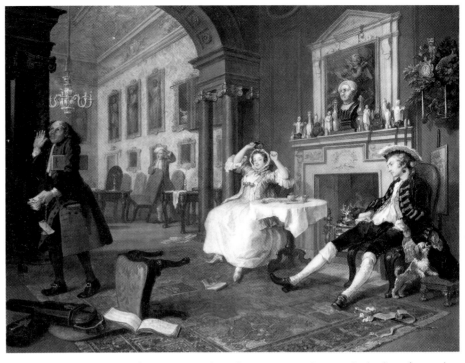

Hogarth, "Breakfast Scene," from Marriage à la Mode, c. 1745, NG, London. *Hogarth is best known for satirical pictures poking fun at English society.*

discover his true calling — satirical prints.

When Hogarth was still a boy, his schoolmaster father had been imprisoned for debt, an experience that permanently marked the painter. In his series The Rake's Progress, Hogarth candidly shows the seamy side of life, exposing the deplorable conditions of debtors' prison and Bedlam hospital for the insane. Hogarth could also be considered the first political cartoonist. He drew his targets from the whole range of society, satirizing with equal aplomb the idle aristocracy, drunken urban working class (a first in visual art), and corrupt politicians.

Hogarth's series Marriage à la Mode ridiculed a nouveau riche bride wed to a dissolute viscount in a marriage arranged to improve the social standing of the former and bank account of the latter. As Hogarth's friend, Henry Fielding, wrote in the comic novel *Tom Jones*, "His

designs were strictly honorable, as the phrase is; that is, to rob a lady of her fortune by way of marriage."

Hogarth used many small touches to suggest the storyline of his paintings. In "Breakfast Scene," a bride coyly admires the groom her father's dowry has purchased, while the disheveled noble looks gloomy, hung over, or both. The clock, with its hands past noon, suggests a sleepless night of debauchery, further indicated by the cards on the floor, overturned chair, and broken sword. The lace cap in the aristocrat's pocket hints at adultery.

Uncompromising honesty tinged with humor were the hallmarks of Hogarth's art. He once said he would rather have "checked the progress of cruelty than been the author of Raphael's [paintings]."

HOW TO TELL THEM APART

GAINSBOROUGH AND REYNOLDS: PORTRAITS OF THE UPPER CRUST.

Two contemporaneous portrait painters of the era were Thomas Gainsborough (1727–88) and Sir Joshua Reynolds (1723–92). Both were highly successful, painting thousands of elegant, full-length portraits of the British aristocracy. Their works often hang side by side in art galleries, easily confused because of their common subject matter. In many ways, however, they defined the distinction between informal and formal.

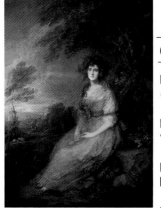

Gainsborough, "Mrs. Richard Brinsley Sheridan," c.1785, NG, Washington. *In Gainsborough's fashionable portraits, the sitter posed informally with a landscape background.*

GAINSBOROUGH	REYNOLDS
Easy-going, often overdue with commissions (wrote "painting and punctuality mix like oil and vinegar")	Hard-working, careful businessman, complete professional
Naive, spontaneous, exclaimed to sitter: "Madame, is there no end to your nose?"	Consummate gentleman/scholar, at home in most genteel social circles
No intellectual pretensions or ambitions, loved nature, music	Well educated in classics, England's first art theorist
Solo act — didn't use assistants	Employed assistants and drapery painters
Casual poses without posturing	Aimed at "senatorial dignity" in portraits
Natural setting, landscape background	Antique props: urns, pedestals, columns
Sitters in contemporary dress	Sitters in character as goddesses, saints

Reynolds, "Jane, Countess of Harrington," 1777, Henry E. Huntington Library and Art Gallery, San Marino, CA. *Reynolds idealized his subjects, converting them to Classical deities.*

GAINSBOROUGH: BACK TO NATURE.

Gainsborough worshiped van Dyck. He learned from the master how to elongate figures to make them seem regal and set them in charmingly negligent poses to make them seem alive. Gainsborough refreshed British art with his loving portrayal of landscape backgrounds. He painted landscapes for his own pleasure, constructing miniature scenes in his studio of broccoli, sponges, and moss to simulate unspoiled nature. These did not sell, so Gainsborough had to content himself with inserting landscape backgrounds in his portraits.

In "Mrs. Richard Brinsley Sheridan," his subject was dressed informally, seated on a rock in a rustic setting (the painter wished to add sheep for a more "pastoral" air). The natural beauty of both the landscape and subject harmonize perfectly. The framing tree at right arcs into the painting to lead the eye back, while the curves of clouds and mid-ground tree, shrubs, hills, and skirt bring the focus back to the sitter's face. This Baroque swirl of encircling eye movement repeats the oval of her face.

The leafy look of Gainsborough's paintings helped establish the concept, taken up in earnest by nineteenth-century painters like Constable, that nature was a worthwhile subject for art.

REYNOLDS: HOMAGE TO ROME.

Testimony of Reynolds' devotion to the Grand Tradition is that he went deaf from spending too much time in the frosty rooms of the Vatican while sketching the Raphaels that hung there. While on the continent, he also caught a lifelong dose of "forum fever," thereafter littering his portraits with Roman relics and noble poses. His dilemma was that, although he could get rich at "face painting," only history painters were considered poets among artists. Reynolds tried to combine the two genres, finding fault with Gainsborough for painting "with the eye of the painter, not the poet."

Reynolds was a champion of idealizing reality. In separate portraits both he and Gainsborough did of the actress Mrs. Siddons, Gainsborough showed her as a fashionable lady, while Reynolds portrayed her as a Tragic Muse enthroned between symbols of Pity and Terror. He so idolized such masters as Raphael, Michelangelo, Rubens, and Rembrandt he even painted his self-portrait costumed as the latter.

His portraits succeeded in spite of his pedantic self. "Damn him! How various he is!" Gainsborough exclaimed of this artist who could paint imposing military heroes, genteel ladies, and playful children with equal skill. Ironically, in his best portraits Reynolds ignored his own rules. Instead of idealizing what he termed "deficiencies and deformities," he relied on an intimate, direct style to capture the sitter's personality.

BAROQUE ARCHITECTURE: ST. PAUL'S CATHEDRAL. England's main contribution to Baroque architecture was St. Paul's Cathedral, designed by Sir Christopher Wren (1632–1723). In fact, Wren designed more than fifty stone churches in London, a feat necessitated by the Great Fire of London in 1666 that destroyed more than 13,000 houses and eighty-seven churches.

St. Paul's was Wren's masterpiece (indeed, his remains are entombed there), intended to rival Rome's St. Peter's. The project began inauspiciously, since workers were unable to demolish the sturdy pillars of the burned church. When blasting away with gunpowder didn't work, they resorted to a medieval battering ram. After a day of "relentless battering," the last remnants of the old church fell and the new church began to rise — a forty-year undertaking.

Wren was an intellectual prodigy — a mathematician and astronomer praised by Sir Isaac Newton. He used his engineering skills to design the church's dome, second in size only to St. Peter's. Its diameter was 112 feet, and at a height of 365 feet, it was higher than a football field. The lantern and cross atop the dome alone weighed 64,000 tons. How to support such a tremendous load? Wren's pioneering solution was to contruct the dome as a wooden shell covered in thin lead. He could then create a beautiful silhouette on the outside and a high ceiling in the interior with a fraction of the weight. St. Paul's is one of the major churches of the world. As Wren's inscription on his tomb in the great cathedral says, "If you seek a monument, look around you."

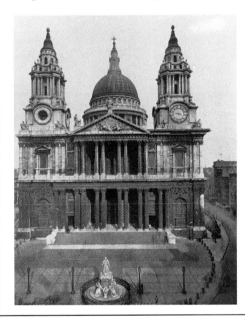

Wren, St. Paul's Cathedral, West facade, 1675–1712, London.

BAROQUE

Baroque art throughout Europe tended to be larger than life — full of motion and emotion — like the grandiose religious works produced in Rome. Yet, rather than merely imitating Italian masterpieces, each country developed its own distinctive style and emphasis.

	ITALIAN	FLEMISH	DUTCH	SPANISH	ENGLISH	FRENCH
HEYDAY	1590–1680	1600–40	1630–70	1625–60	1720–90	1670–1715
EMPHASIS	Religious works	Altarpieces	Portraits, Still Lifes, Landscapes	Court Portraits	Portraits of Aristocracy	Classical Landscapes and Decorative Architecture
PATRON	Church	Church, Monarch	People	Monarch	Upper Class	Monarch
STYLE	Dynamic	Florid	Virtuoso	Realistic	Restrained	Pretentious
QUALITIES	Drama, Intensity, Movement	Sensuality	Visual Accuracy, Studies of Light	Dignity	Elegance	Order and Ornament

SPANISH BAROQUE

Spain's major gift to world art was Diego Velázquez (1599–1660). Extraordinarily precocious, while still in his teens he painted pictures demonstrating total technical mastery. At the age of 18, he qualified as a master painter. On a visit to Madrid, Velázquez did a portrait so perfect in execution it attracted the king's attention. His first painting of Philip IV pleased the monarch so much he declared from then on only Velázquez would do his portrait. At the age of 24, Velázquez became the country's most esteemed painter and would spend more than thirty years portraying the royal court.

Like Holbein's, Velázquez's royal portraits were masterpieces of visual realism, but the Spaniard's methods were the opposite of Holbein's linear precision. No outlines are visible in his portraits; he created forms with fluid brushstrokes and by applying spots of light and color, a precursor of Impressionism.

Velázquez differed from most Baroque artists in the simplicity and earthiness of his work. He never forgot his teacher's advice: "Go to nature for everything." As a result, he never succumbed to the pompous style of strewing allegorical symbols and Classical bric-a-brac about his paintings. Instead, he depicted the world as it appeared to his eyes. Velázquez's early paintings portrayed even holy or mythological figures as real people, drawn against a neutral background.

Whether portraying the king or a court dwarf, Velázquez presented his subjects with dignity and, in all cases, factuality. His approach humanized the stiff, formal court portrait tradition by setting models in more natural poses without fussy accessories. Although a virtuoso in technique, Velázquez preferred understatement to ostentation and

WORLD'S GREATEST PAINTING

In a 1985 poll of artists and critics, Velázquez's "Las Meninas" ("The Maids of Honor") was voted, by a considerable margin, "the world's greatest painting." Picasso paid it homage by doing a series of forty-four variations on the work. Velázquez took seriously Leonardo's dictate, "the mirror is our master," and tried to approximate what he saw as closely as possible, often working years on a canvas.

The painting was ostensibly a royal portrait of the five-year-old princess Margarita, attended by her ladies in waiting and two dwarfs. With the diverse additional portraits, it is also like a group painting of the subject: "Visitors to the Artist's Studio." In the middle ground is a mirrored reflection of the king and queen, in the background a full-length portrait of a court official on the steps.

Critics have speculated Velázquez was playing with the idea of the ambiguity of images, including many versions of portraiture, even on the left a self-portrait of himself in the act of reproducing this very scene from a mirror. His skill was such that all the images seem equally convincing, whether indirect (mirrored reflections and paintings of paintings) or "direct" portraits.

"Las Meninas" shows Velázquez's constant concern with design and composition. Although the figures seem informally grouped, the composition actually consists of a carefully balanced series of overlapping triangles. He used only the lower half of the canvas for portraits and filled the space above with a range of light and shadow to produce the illusion of space. Firm verticals and horizontals keep the viewer's eye from getting lost in the room. In 1650, a connoisseur of art said of Velázquez's work that, while all the rest was art, this alone was truth.

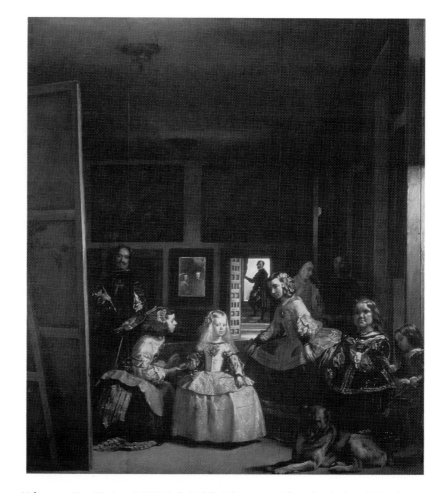

Velázquez, "Las Meninas," 1656, Prado, Madrid. *Velázquez created forms through color and light rather than through lines, achieving startlingly real images of the human figure.*

realism to idealism.

On his friend Rubens's advice Velázquez visited Rome to study Renaissance and Classic masters in the Vatican collection. While there, he painted perhaps his finest portrait, "Pope Innocent X." The sitter's sharp glance was so lifelike — almost predatory—the pope declared it "troppo vero" (too truthful).

Although Velázquez is considered a master of realism, he achieved his effects with loose brushstrokes that, when scrutinized at close range, seem to melt into blurred daubs of paint. As the contemporary Spanish writer on art Antonio Palomino said, "One cannot understand it if standing too close, but from a distance, it is a miracle!"

To accomplish this "miracle," Velázquez dabbed quick touches of paint with which to suggest reflected light. An Italian painter exclaimed of his work, "It is made of nothing, but there it is!"

THE TOP 10

In 1985, a panel of art experts for the *Illustrated London News* judged "Las Meninas" as "by far the greatest work of art by a human being." The following is a list of the winners and how they placed:

1. Velázquez "Las Meninas"
2. Vermeer "View of Delft"
3. Giorgione "The Tempest"
4. Botticelli "La Primavera"
5. Francesca "The Resurrection"
6. El Greco "The Burial of the Count Orgaz"
7. Giotto "The Lamentation"
8. Grünewald "The Isenheim Altarpiece"
9. Picasso "Guernica"
10. Rembrandt "The Return of the Prodigal Son"

THE VELAZQUEZ ARTISTIC TREE

Because Spain was artistically isolated, Velázquez's work was not widely known until the nineteenth century. Then, his brilliant brushwork, which captured the visual world with an almost hyperrealism, inspired painters seeking to break free of the academic straitjacket. The tree shows some prominent artists directly influenced by Velázquez.

BACON — hallucinatory "Head Surrounded by Sides of Beef" showed his obsession with Velázquez's "Pope Innocent X."

WHISTLER — used dark, full-length figures on neutral ground, reduced content to essential expressive forms.

SARGENT — influenced by technique, color, casual arrangement of multigroup figures.

MANET — considered Velázquez's method totally new, said "I have found in him . . . my ideal of painting."

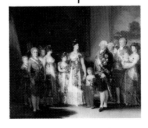

GOYA — learned subtle gradations of color, glowing highlights.

VELÁZQUEZ

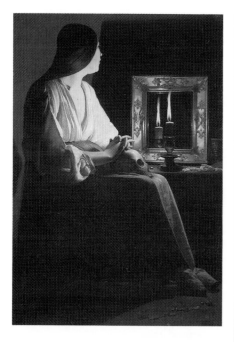

La Tour, "The Penitent Magdalen," c.1638–43, MMA, NY. *The first important French painter of the seventeenth century was Georges de La Tour, who specialized in candlelit night scenes derived from Caravaggio. Here he pictured Mary Magdalen at the moment of her conversion, her face illuminated by a bright flame amid almost total darkness. La Tour simplified all forms to near-geometric abstraction so the light appeared to fall smoothly without refraction. This drew the observer into the circle of light to share the mood of inner stillness and intimacy. As one critic said of La Tour, "A candle has conquered the enormous night."*

FRENCH BAROQUE

In the seventeenth century, France was the most powerful country in Europe, and Louis XIV tapped the finest talents to glorify his monarchy with a palace of unparalleled splendor. With the coming of Versailles, France replaced Rome as the center of European art (a distinction it retained until World War II), even as it modeled its art on Roman relics.

POUSSIN: MASTER OF COMPOSITION. The most famous French painter of the seventeenth century, Nicolas Poussin (pronounced poo SAHN; 1594–1665), worked not in France but in Rome. Passionately interested in antiquity, he based his paintings on ancient Roman myths, history, and Greek sculpture. The widespread influence of Poussin's work revived this ancient style, which became the dominant artistic influence for the next 200 years.

Poussin took Classical rationalism so seriously that, when Louis XIII summoned him to Paris to paint a Louvre ceiling fresco, he refused to conform to the prevailing code of soaring saints. People don't fly through the air, he insisted with faultless logic, thus losing the commission and returning to his beloved Roman ruins.

Left to his own devices, Poussin chose to paint in what he called "la maniera magnifica" (the grand manner). Or, as he put it, "The first requirement, fundamental to all others, is that the subject and the narrative be grandiose, such as battles, heroic actions, and religious themes." The artist must shun "low" subjects. Those who didn't avoid everyday life (like Caravaggio, whom he detested) "find refuge in [base subjects], because of the feebleness of their talents."

Poussin's work exerted enormous influence on the course of French (and, therefore, world) art for the next two centuries because all artists were trained in "Poussinism," an institutionalized Classicism.

CLAUDE: NATURE AS IDEAL. After Poussin, the best known French Baroque painter was Claude Lorrain (1600–82), known simply as Claude. Like Poussin, Claude was drawn to Italy, where he painted idyllic scenes of the Italian countryside. Where the two differed was in their inspiration, for Claude was inspired less by Classical forms than by nature itself and the serene light of dawn and dusk that unified his canvases.

Claude lived for extended periods among shepherds, sketching trees, hills, and romantic ruins of the Italian *campagna* in the early morning or late afternoon. His paintings were typically arranged with dark, majestic trees forming a partial arch that framed a radiant countryside view and intensified the central light. Claude had no interest in the tiny human figures that inhabited his countrysides; their only purpose was to establish scale for the natural elements. Indeed, he paid other artists to paint them for him.

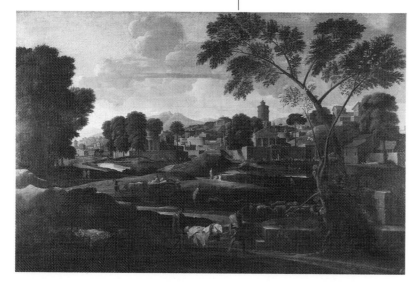

Poussin, "Burial of Phocion," 1648, Louvre, Paris. *Poussin's balanced, orderly scenes shaped Western art for 200 years.*

VERSAILLES: PALACE OF POMP. The pinnacle of Baroque opulence was the magnificent château of Versailles, transformed from a modest hunting lodge to the largest palace in the world. It was a tribute to the ambition of one man, King Louis XIV (1638–1715), who aspired, it was said, "beyond the sumptuous to the stupendous." "L'état c'est moi" (I am the state), said the absolute monarch known as the "Sun King." Surrounded by an entourage of 2,000 nobles and 18,000 soldiers and servants, Louis created a total environment of ostentatious luxury, designed to impress visitors with the splendor of both France and his royal self.

Versailles' hundreds of rooms were adorned with crystal chandeliers, multicolored marble, solid-silver furniture, and crimson velvet hangings embroidered in gold. The king himself, covered in gold, diamonds, and feathers, received important guests seated on a nine-foot, canopied silver throne. His royal rising (*lever*) and retiring (*coucher*) were attended by flocks of courtiers in formal rituals as important to the court as the rising and setting of the sun. Four hundred ninety-eight people were required merely to present the king with a meal. "We are not like private people," said the king. "We belong entirely to the public."

Visual impact took precedence over creature comforts in the palace. The vast marble floors made the interior so frigid, water froze in basins, while the thousands of candles illuminating soirées made summer events stiflingly hot. Despite such drawbacks, Louis XIV hosted fêtes like jousting tournaments, banquets, and Molière comedies. The ballroom was garlanded with flowers. Outdoor trees were illuminated with thousands of pots of candles and hung with oranges from Portugal or currants from Holland. As La Fontaine said, "Palaces turned into gardens and gardens into palaces."

The grounds contained a private zoo with elephants, flamingos, and ostriches, a Chinese carousel turned by servants pumping away underground, and gondolas on the mile-long Grand Canal. The Versailles court lived in unmatched luxury amid opulent furnishings and artworks, most of which qualify as decorative rather than fine art.

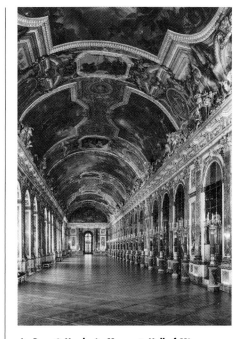

Le Brun & Hardouin-Mansart, Hall of Mirrors, Versailles, c. 1680. *This 240-foot-long gallery was lined with massive silver furniture (later melted down to finance a war). With seventeen floor-to-ceiling windows and mirrors reflecting the sun, this gallery impressed one visitor as "an avenue of light."*

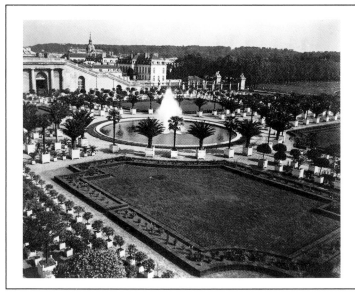

Le Nôtre, Parterre du Midi, 1669–85, Versailles. *The symmetrical patterns of Versailles' park and gardens restructured nature on a vast scale.*

GARDENING ON A GRAND SCALE

The vastness of Versailles' interior was dwarfed by extensive gardens designed by André Le Nôtre. In place of marshes and forests, he imposed a mathematically exact scheme of gardens, lawns, and groves of trees. "The symmetry, always the symmetry," Louis XIV's mistress Madame de Maintenon complained. To avoid the monotony of geometric patterns, Le Nôtre emphasized water — both in motion, as in the gold-covered Fountain of Apollo, and in large reflecting pools. His scheme required so much water that Louis XIV assigned 30,000 troops in a failed attempt to divert the River Eure from 40 miles away.

ROCOCO

Rococo was born in Paris, where it coincided with the reign of Louis XV (1723–74). By 1760, it was considered outmoded in France but was in vogue until the end of the century for luxurious castles and churches throughout Germany, Austria, and Central Europe. Rococo was primarily a form of interior decoration, the name deriving from the "rocaille" motif of shellwork and pebbles ornamenting grottoes and fountains.

In some ways, the Rococo style looks like the word itself. The decorative arts were the special display ground for its curvilinear, delicate ornamentation. Floors were inlaid in complicated patterns of wood veneer, furniture was richly carved and decorated with Gobelin upholstery and inlays of ivory and tortoiseshell. Clothing, silverwork, and china were also overwrought with curlicues as well as flowers, shells, and leaves. Even carriage designers avoided straight lines for carved swirls and scrolls, and horses wore immense plumes and bejeweled harnesses. Rococo art was as decorative and nonfunctional as the effete aristocracy that embraced it.

PAINTING PICNICS IN THE PARK. After Louis XIV died in 1715, the aristocracy abandoned Versailles for Paris, where the salons of their ornate townhouses epitomized the new Rococo style. The nobility lived a frivolous existence devoted to pleasure, reflected in a characteristic painting, the "fête galante," an outdoor romp peopled by elegantly attired young lovers. The paintings of Antoine Watteau (1684–1721), François Boucher (1703–70), and Jean–Honoré Fragonard (1732–1806) signaled this shift in French art and society from the serious and grandiose to the frothy and superficial.

In Watteau's "Pilgrimage to Cythera," romantic couples frolic on an enchanted isle of eternal youth and love. Boucher also painted gorgeously dressed shepherds and shepherdesses amid feathery trees, fleecy clouds, and docile lambs. Boucher's style was artificial in the extreme; he refused to paint from life, saying nature was "too green and badly lit." His pretty pink nudes in seductive poses earned him great success among the decadent aristocracy. Fragonard's party paintings were also frilly and light-hearted. In his best known, "The Swing," a young girl on a swing flirtatiously kicks off a satin slipper, while an admirer below peeks up her lacy petticoats.

WOMAN'S DAY

The pre-French-Revolution eighteenth century was a period when women dominated European courts. Madame de Pompadour was virtual ruler of France, Maria Theresa reigned in Austria, and Elizabeth and Catherine were monarchs of Russia. Female artists, too, made their mark, the most notable being two portrait painters to Queen Marie-Antoinette, ELISABETH VIGÉE-LEBRUN (1755–1842) and ADÉLAIDE LABILLE-GUIARD (1749–1803). The Venetian painter ROSALBA CARRIERA's (1675–1757) fashionable portraits pioneered the use of pastels (chalklike crayons later used by the Impressionists).

Watteau, "Pilgrimage to Cythera," 1717, Louvre, Paris. *Watteau idealized his delicate fantasy landscapes, inhabited by graceful aristocrats engaged in amorous flirtation, with fuzzy color and hazy atmosphere.*

ROCOCO ART

MOOD:
Playful, superficial, alive with energy

INTERIOR DÉCOR:
Gilded woodwork, painted panels,
enormous wall mirrors

SHAPES:
Sinuous S- and C-curves, arabesques,
ribbonlike scrolls

STYLE:
Light, graceful, delicate

COLORS:
White, silver, gold, light pinks, blues, greens

FRENCH BUZZWORDS:
la grâce (elegance), *le goût* (refined taste)

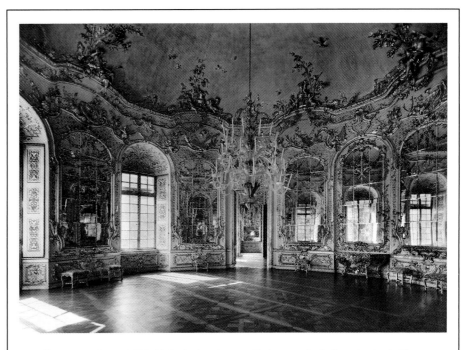

Cuvilliés, Mirror Room, 1734–39, Amalienburg, Germany. *The best example of a Rococo interior, the Mirror Room was designed by François de Cuvilliés (1698–1768), who was originally hired as a court dwarf. This "maison de plaisance," or pleasure house, is profusely but delicately decorated. A series of arched mirrors, doors, and windows is surrounded by carved plants, cornucopias, animals, and musical instruments — all silver-gilt on a cool-blue background. The rising and sinking curves of the ornamentation make this a tour de force of Rococo style.*

Gaudí, Casa Milà, 1907, Barcelona. *Although Rococo love of artifice was alien to the Spanish architect Antonio Gaudí (1852–1926), his work incorporated sinuous, Rococo curves. Gaudí's work grew out of Art Nouveau and was based on his desire to jettison tradition and assume the random forms of nature. In its avoidance of straight lines and rippling effect — with windows shaped like lily pads — this apartment house is heir to the Rococo.*

ROCOCO ARCHITECTURE: INTERIOR DECORATING. In eighteenth-century France, the exteriors of buildings continued to be Baroque, gradually giving way to Neoclassical. But inside private townhouses of Paris and the churches and palaces of Germany, Austria, Prague, and Warsaw, fanciful Rococo ornamentation ran wild.

The Nineteenth Century: Birth of the "Isms"

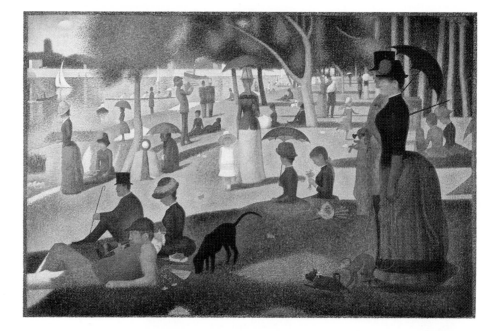

For Western civilization the nineteenth century was an age of upheaval. The church lost its grip, monarchies toppled, and new democracies suffered growing pains. In short, tradition lost its luster and the future was up for grabs. Unfamiliar forces like industrialization and urbanization made cities bulge with masses of dissatisfied poor. The fast pace of scientific progress and the ills of unrestrained capitalism caused more confusion.

The art world of the 1800s seethed with factions, each overreacting to the other. Instead of one style dominating for centuries, as in the Renaissance and Baroque eras, movements and countermovements sprang up like crocuses in spring. What had been eras became "isms," each representing a trend in art. For most of the century, three major styles competed with one another: Neoclassicism, Romanticism, and Realism. Toward the end of the century, a blur of schools — Impressionism, Post-Impressionism, Art Nouveau, and Symbolism — came and went in quick succession.

WORLD HISTORY		ART HISTORY
Washington, D.C., becomes U.S. capitol	1800	
Louisiana Purchase	1803	Blake illustrates poems with his own prints
Napoleon Bonaparte crowned French emperor	1804	David paints splendor of Napoleon's court
Fulton invents steamboat	1807	
Bolívar leads South American revolution	1811	
Napoleon defeated at Waterloo	1815	Goya creates "Disasters of War" prints
	1818–19	Géricault's "The Raft of the Medusa"
Mexico gains independence from Spain	1822	
Beethoven completes 9th Symphony	1823	Constable paints rural landscapes
Erie Canal opens; first railroad built in England	1825	Delacroix active
Queen Victoria crowned	1837	
	1839	Daguerre exhibits daguerreotype, early photograph
	1841	Collapsible tin tubes patented for oil paint
Marx and Engels issue *Communist Manifesto;* Gold discovered in California	1848	Pre-Raphaelite Brotherhood formed
	1855	Courbet's Pavilion of Realism
Flaubert writes *Madame Bovary*	1856–57	
Mendel begins genetic experiments	1857	
First oil well drilled; Darwin publishes *Origin of Species*	1859	
Steel developed	1860	Snapshot photography developed
Italy unifies; U.S. Civil War breaks out	1861	Daumier produces satirical drawings
Lincoln abolishes slavery	1863	Salon des Refusés launches modern art
Suez Canal built	1869	
Prussians besiege Paris	1871	Whistler eliminates details for color harmonies
First national park, Yellowstone, established in U.S.	1872	
	1873	First color photos appear
	1874	Impressionists hold first group show
Custer defeated at Little Big Horn; Bell patents telephone	1876	Morris designs textiles; Eakins's "Gross Clinic" incites controversy
Edison invents electric light	1879	
	1880	Van Gogh begins painting career
Population of Paris hits 2,200,000	1881	Picasso born
	1883	Sargent paints "Madame X"; Gaudí begins la Sagrada Familia
First motorcar built	1885	First Chicago skyscraper built
	1886	Impressionists hold last group show
	1888	Portable Kodak camera perfected
Hitler born	1889	Eiffel Tower built
	1890	Monet's first haystacks series
	1891	Gauguin goes to Tahiti
	1892	Rodin sculpts Balzac
Chicago World's Fair	1893	Art Nouveau spreads
Dreyfus trial begins	1894	Monet finishes Rouen Cathedral series
Freud develops psychoanalysis	1895	Vollard shows Cézanne paintings; Lumière Brothers introduce movies
U.S. Supreme Court approves "separate but equal" segregation	1896	
Curies discover radium	1898	Vienna Secession artists exhibit modernist designs

NEOCLASSICISM: ROMAN FEVER

From about 1780 to 1820, Neoclassic art reflected, in the words of Edgar Allan Poe, "the glory that was Greece, /And the grandeur that was Rome." This revival of austere Classicism in painting, sculpture, architecture, and furniture was a clear reaction against the ornate Rococo style. The eighteenth century had been the Age of Enlightenment, when philosophers preached the gospel of reason and logic. This faith in logic led to the orderliness and "ennobling" virtues of Neoclassical art.

The trendsetter was Jacques-Louis David (pronounced Dah VEED; 1748–1825), a French painter and democrat who imitated Greek and Roman art to inspire the new French republic. As the German writer Goethe put it, "the demand now is for heroism and civic virtues." "Politically correct" art was serious, illustrating tales from ancient history or mythology rather than frivolous Rococo party scenes. As if society had overdosed on sweets, principle replaced pleasure and paintings underscored the moral message of patriotism.

NEOCLASSICISM

VALUES:
Order, solemnity

TONE:
Calm, rational

SUBJECTS:
Greek and Roman history, mythology

TECHNIQUE:
Stressed drawing with lines, not color; no trace of brushstrokes

ROLE OF ART:
Morally uplifting, inspirational

FOUNDER:
David

In 1738, archeology-mania swept Europe, as excavations at Pompeii and Herculaneum offered the first glimpse of well-preserved ancient art. The faddish insistence on Greek and Roman role models sometimes became ridiculous, as when David's followers, the "primitifs," took the idea of living the Greek Way literally. They not only strolled about in short tunics, they also bathed nude in the Seine, fancying themselves to be Greek athletes. When novelist Stendhal viewed the nude "Roman" warriors in David's painting "Intervention of the Sabine Women," he was skeptical. "The most ordinary common sense," he wrote, "tells us that the legs of those soldiers would soon be covered in blood and that it was absurd to go naked into battle at any time in history."

The marble frieze statuary brought from Athens' Parthenon to London by Lord Elgin further whetted the public appetite for the ancient world. "Glories of the brain" and "Grecian grandeur" is how the poet John Keats described the marbles. Leaders of art schools and of the French and British Royal Academies were solidly behind the Neoclassic movement and preached that reason, not emotion, should dictate art. They emphasized drawing and line, which appealed to the intellect, rather than color, which excited the senses.

The hallmark of the Neoclassical style was severe, precisely drawn figures, which appeared in the foreground without the illusion of depth, as in Roman relief sculpture. Brushwork was smooth, so the surface of the painting seemed polished, and compositions were simple to avoid Rococo melodrama. Backgrounds generally included Roman touches like arches or columns, and symmetry and straight lines replaced irregular curves. This movement differed from Poussin's Classicism of a century earlier in that Neoclassical figures were less waxen and ballet-like, more naturalistic and solid.

Ancient ruins also inspired architecture. Clones of Greek and Roman temples multiplied from Russia to America. The portico of Paris's Pantheon, with Corinthian columns and dome, copied the Roman style exactly. In Berlin, the Brandenburg gate was a replica of the entrance to Athens' Acropolis, topped by a Roman chariot. And Thomas Jefferson, while serving as ambassador to France, admired the Roman temple Maison Carrée in Nîmes, "as a lover gazes at his mistress." He renovated his home, Monticello, in the Neoclassical style.

FRENCH NEOCLASSICISM

***DAVID:* PAINTING THE PAST.** It was on a trip to Rome, when he first saw Classical art, that David had his breakthrough vision. He said he felt as if he "had been operated on for cataract." He avidly drew hands, eyes, ears, and feet from every antique sculpture he encountered, saying, "I want to work in a pure Greek style." Before long, David's disciples were throwing bread pellets at Watteau's "Pilgrimage to Cythera," to show their contempt for what they felt was "artificial" art.

In "Oath of the Horatii," three brothers swear to defeat their enemies or die for Rome, illustrating the new mood of self-sacrifice instead of self-indulgence. Just as the French Revolution overthrew the decadent royals, this painting marked a new age of stoicism. David demonstrated the difference between old and new through contrasting the men's straight, rigid contours with the curved, soft shapes of the women. Even the painting's composition underscored its firm resolve. David arranged each figure like a statue, spot-lit against a plain background of Roman arches. To assure historical accuracy, he dressed dummies in Roman costumes and made Roman helmets that he could then copy.

David, a friend of the radical Robespierre, was an ardent supporter of the Revolution and voted to guillotine King Louis XVI. His art was propaganda for the republic, intended to "electrify," he said, and "plant the seeds of glory and devotion to the fatherland." His portrait of a slain leader, "Death of Marat," is his masterpiece. Marat, a close friend of David, was a radical revolutionary stabbed to death by a counterrevolutionary in his bath. (Before the Revolution, while hiding from the police in the Paris sewers, Marat had contracted psoriasis and had to work in a medicated bath, using a packing box for a desk.) Right after the murder, David

David, "Oath of the Horatii," 1784, Louvre, Paris. *David's "Oath of the Horatii" marked the death of Rococo and birth of Neoclassical art, which should, David said, "contribute forcefully to the education of the public."*

rushed to the scene to record it. Although the background is coldly blank, David's painting emphasized the box, bloodstained towel, and knife, which, as actual objects, were worshiped by the public as holy relics. David portrays Marat like a saint in a pose similar to Christ's in Michelangelo's "Pietà."

When Robespierre was guillotined, David went to jail. But instead of losing his head, the adaptable painter became head of Napoleon's art program. From the taut compositions of his revolutionary period, he turned to pomp and pageantry in his paintings of the little emperor's exploits, such as "Coronation of Napoleon and Josephine." Although his colors became brighter, David stuck to the advice he gave his pupils, "Never let your brushstrokes show." His paintings have a tight, glossy finish, smooth as enamel. For three decades, David's art was the official model for what French art, and by extension, European art, was supposed to be.

David, "Death of Marat," 1793, Musées Royaux des Beaux-Arts de Belgique, Brussels. *David painted the slain revolutionary hero like a modern-day Christ.*

INGRES: ART'S FINEST DRAFTSMAN.

Following David, the first half of nineteenth-century art was a contest between two French painters: Jean Auguste Dominique Ingres (pronounced ANN gruh; 1780–1867), champion of Neoclassicism, and Eugène Delacroix (pronounced duh la KRWAH; 1798–1863), ardent defender of Romanticism. Ingres came naturally to Neoclassicism, for he was the star pupil of David.

An infant prodigy, at the age of 11 Ingres attended art school and

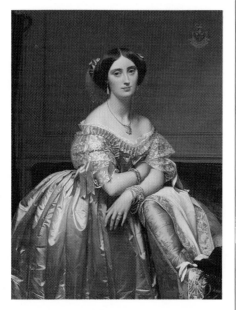

Ingres, "Portrait of the Princesse de Broglie," *1853, MMA, NY. Ingres's clear, precise forms, idealized beauty, and balanced composition sum up the Neoclassical style.*

at 17 was a member of David's studio. The young disciple never let his brushstrokes show, saying paint should be as smooth "as the skin of an onion." Ingres, however, went even further than his master in devotion to the ancients. In his early work, he took Greek vase paintings as his model and drew flat, linear figures that critics condemned as "primitive" and "Gothic."

Then Delacroix and Géricault burst on the scene, championing emotion and color rather than intellect and draftsmanship as the basis of art. Against the "barbarism" of these "destroyers" of art, Ingres became the spokesman of the conservative wing, advocating the old-time virtue of technical skill. "Drawing is the probity of art," was his manifesto. He cautioned against using strong, warm colors for visual impact, saying they were "antihistorical."

The battle sank into name calling, with Ingres labeling Rubens, the hero of the Romantics, "that Flemish meat merchant." He considered Delacroix the "devil incarnate." When Delacroix left the Salon after hanging a painting, Ingres remarked, "Open the windows. I smell sulfur." In turn, the Romantics called the paintings of

Ingres and his school "tinted drawings."

Ironically, this arch-defender of the Neoclassic faith sometimes strayed from his devout principles. True, Ingres was an impeccable draftsman whose intricate line influenced Picasso, Matisse, and Degas (who remembered Ingres's advice to "draw many lines"). But Ingres's female nudes were far from the Greek or Renaissance ideal. The languid pose of his "Grande Odalisque" was more Mannerist than Renaissance. Although identified with controlled, academic art, Ingres was attracted to exotic, erotic subjects like the harem girl in "Odalisque." Critics attacked the painting for its small head and abnormally long back. "She has three vertebrae too many," said one. "No bone, no muscle, no life," said another. Ingres undoubtedly elongated the limbs to increase her sensual elegance.

Ingres preached logic, yet the romantic poet Baudelaire noted that Ingres's finest works were "the product of a deeply sensuous nature." Indeed, Ingres was a master of female nudes. Throughout his career, he painted bathers, rendering the porcelain beauty of their flesh in a softer style than David's.

In "Portrait of the Princesse de Broglie," Ingres paid his usual fastidious attention to crisp drapery, soft ribbons, fine hair, and delicate flesh, without a trace of brushwork. The color has an enamellike polish and the folds of the costume fall in precise, linear rhythm. Ingres is chiefly remembered as one of the supreme portraitists of all time, able to capture physical appearance with photographic accuracy.

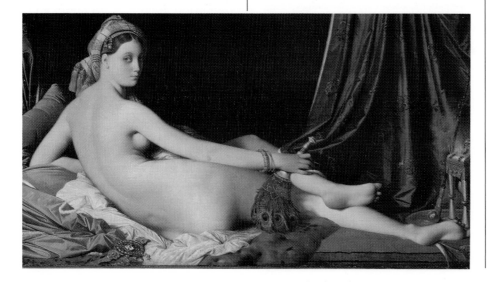

Ingres, "La Grande Odalisque," *1814, Louvre, Paris. This portrait shows Ingres's trademarks of polished skin surface and simple forms contoured by lines, in contrast to the irregular drapery.*

ODALISQUE

The reclining, or recumbent, female nude, often called Odalisque after the Turkish word for a harem girl, is a recurrent figure throughout Western art. Here is how some artists have given their individual twist to a traditional subject.

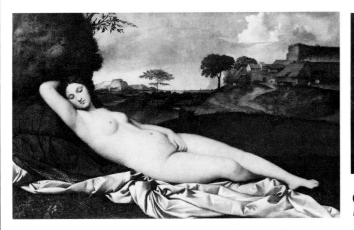

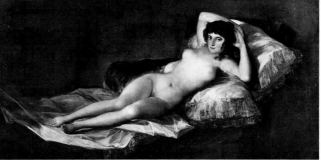

Giorgione, "Sleeping Venus" (the Dresden Venus), c. 1510, Staatliche Kunstsammlungen, Dresden. *The first known recumbent female nude as an art subject was by the Venetian Giorgione, a Renaissance painter about whom little is known. He probably painted "Sleeping Venus" in 1510, the year of his early death from the plague. Titian was said to have finished the work, adding the Arcadian landscape and drapery. Traits associated with this popular genre of painting are a simple setting, relaxed pose propped on pillows, and the absence of a story. Giorgione was handsome and amorous, a keen lover of female beauty, yet he portrays his Venus as a figure of innocence, unaware of being observed.*

Goya, "The Nude Maja," 1796–98, Prado, Madrid. *Goya was denounced during the Inquisition for this "obscene," updated version featuring full frontal nudity. The title means "nude coquette," and Goya's blatantly erotic image caused a furor in prudish Spanish society. His friend and patron, the aristocratic but very unconventional Countess of Alba, is believed to be the model. A clothed replica of the figure, in an identical pose but very hastily sketched, also exists. It is said that Goya painted it when the Count was on his way home, to justify all the time the painter had spent in the Countess' company. Goya was probably inspired by Velázquez's "Rokeby Venus," a recumbent nude seen from the back. Although an outraged suffragette slashed Velázquez's "Venus," Goya's nude is much more seductive, with her soft, smooth flesh contrasted to the crisp brushwork of satin sheet and lace ruffles.*

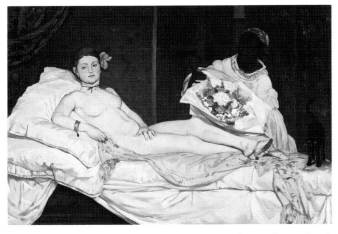

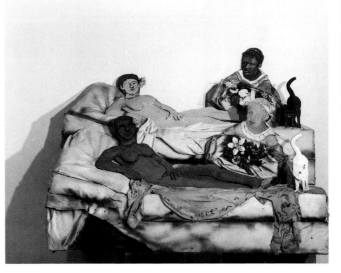

Manet, "Olympia," 1863, Musée d'Orsay, Paris. *Manet's "Olympia" also caused a public outcry. With her bold, appraising stare and individualized features, this was obviously no idealized goddess but a real person. One critic called her a "female gorilla." Others attacked Manet's nonacademic technique: "The least beautiful woman has bones, muscles, skin, and some form of color. Here there is nothing." "The shadows are indicated," another wrote, "by large smears of blacking." Most considered the painting's sexuality immoral: "Art sunk so low does not even deserve reproach."*

Huge crowds flocked to the Salon to see what the fuss was about. After the canvas was physically attacked, it was hung out of reach, high above a doorway. One viewer complained, "You scarcely knew what you were looking at — a parcel of nude flesh or a bundle of laundry." Manet became the acknowledged leader of the avant-garde because of "Olympia's" succès de scandale.

Rivers, "I Like Olympia in Blackface," 1970, Centre Pompidou, Paris. *New York painter Larry Rivers (1923–2002) was a member of the generation following Abstract Expressionism that challenged abstract art's dismissal of realism and developed Pop art. Rivers combined the free, vigorous brushstrokes of Abstract Expressionism with subject matter from diverse sources ranging from advertising to fine art. Color, not subject matter, according to Rivers, "is what has meaning." His version of Manet's "Odalisque" gives a fresh face to a centuries-old concept.*

AMERICAN NEOCLASSICISM

The founding of the American republic coincided with the popularity of Neoclassicism. Since the ancient Roman republic seemed an apt model, the new country clothed itself in the garb of the old. It adopted Roman symbols and terms like "Senate" and "Capitol" (originally a hill in ancient Rome). For a century, official buildings in Washington were Neoclassic knock-offs.

The fact that Neoclassic became *the* style was mostly due to Thomas Jefferson, an amateur architect. He built the University of Virginia as a learning lab of Classicism. The ensemble included a Pantheon-like Rotunda and pavilions in Roman temple forms. Jefferson used Doric, Ionic, and Corinthian orders to demonstrate the various styles of architecture to students.

In sculpture, antique figures in an idealized, Classical style were also the rage. One of the most acclaimed works of the nineteenth century was Hiram Powers's "Greek Slave" (1843), a marble statue of a naked girl in chains that won international fame. Horatio Greenough applied Neoclassical doctrines less successfully. The practical American public laughed at his statue of a bewigged George Washington with a nude torso and Roman sandals.

The first American-born painter to win international acclaim was Benjamin West (1738–1820), whose work summed up the Neoclassic style. He was so famous for battle scenes that he became president of the British Royal Academy and was buried in St. Paul's Cathedral. West spent his entire career in England, and his London studio was a mandatory stop for visiting American painters.

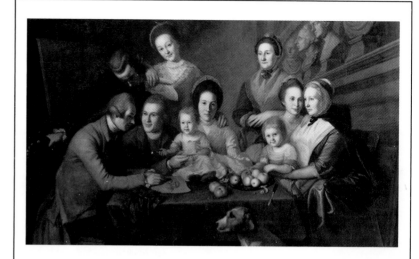

"The Peale Family," 1770–1773, New-York Historical Society.

Peale: The Leonardo of the New World. *Charles Willson Peale (1741–1827) was a model Enlightenment man. A scientist as well as artist who was unfailingly curious and energetic, his list of skills and interests rivaled Leonardo's. He came to painting through craftsmanship and was a saddler, watchmaker, silversmith, and upholsterer before becoming the most fashionable portraitist in the colonies. Peale was also a Revolutionary war soldier, politician, and ingenious inventor. He conceived a new type of spectacles, porcelain false teeth, a steam bath, and a stove that consumed its own smoke. He was also first to excavate a mastodon skeleton, which he exhibited in the natural history museum he founded in Philadelphia with more than 100,000 objects. His list of firsts included the first art gallery in the colonies and the first art school.*

Peale was the father of seventeen children. He named them after painters and they obliged him by becoming artists, like the portraitist Rembrandt, still-life painter Raphaelle, and artist/naturalist Titian. "The Peale Family" includes nine family members and their faithful nurse (standing with hands folded). Peale himself stoops at left holding his palette. He titled the painting on the easel "Concordia Animae" (Harmony of Souls), indicating the painting's theme.

The composition emphasizes the essential unity of the group. Although they are divided into two camps, all are linked by contact of hand or shoulder except the nurse. The figures slightly overlap, with the scattered fruit also binding the two halves. Peale suggests a visual tie by the painter's brother seated at left sketching his mother and her grandchild at right. This type of picture, or "conversation piece," was popular in eighteenth- and early-nineteenth-century painting. It represents perfectly the ideal of e pluribus unum.

Peale's most famous work is "The Staircase Group," a life-size trompe l'oeil portrait of his two sons climbing stairs with a real step at the bottom and door jamb as a frame. Peale painted the scene so convincingly that George Washington reportedly tipped his hat to the boys.

At the age of 86, the inexhaustible Peale was known to whoop down hills riding one of the first bicycles. He finally succumbed to overexertion while searching for a fourth wife.

BEGINNINGS OF AMERICAN ART. The fact that a talented American had to pursue his craft in England was due to the backward state of the arts. Most colonists were farmers, preoccupied with survival and more interested in utility than beauty. They were from working-class stock, hardly the type to commission works of art. The influence of Puritanism with its prejudice against "graven images" meant that the church would not be a patron. There were no large buildings to adorn or great wealth to buy luxury items. Silver and furnishings showed fine craftsmanship and Federal architecture was handsome. But sculpture was practically unknown except for graveyard statuary.

The first American painters were generally self-taught portrait or sign painters. Their work was flat, sharply outlined, and lacking in focal point. Portraiture was, not surprisingly, the most sought-after art form, since politics stressed respect for the individual. Itinerant limners, as early painters were called, painted faceless single or group portraits in the winter and, in spring, sought customers and filled in the blanks.

COPLEY: THE FIRST GREAT AMERICAN PAINTER. Painting in America was considered a "useful trade like that of a Carpenter or shoe maker, not as one of the most noble Arts in the world," complained America's first painter of note, John Singleton Copley (pronounced COPP lee; 1738–1815). Despite this disrespect, the Bostonian taught himself the profession by studying anatomy books and reproductions of paintings. In his teens, he set up as a portrait painter and, by the age of 20, completely outstripped any native artist. He was the first colonial to have a work exhibited abroad. With Copley, art in America grew up.

Copley had an astonishing ability to record reality accurately. His subjects had real bulk, and he brilliantly simulated reflected light on various textures. Copley also portrayed his sitter's personality with penetrating observation. Eliminating the columns and red curtains used to dress up portraits, he concentrated on the fleeting expressions and gestures that reveal character. Although he painted his well-to-do clients' costumes in detail, he focused on the individuality of their faces, where each wrinkle suggested character.

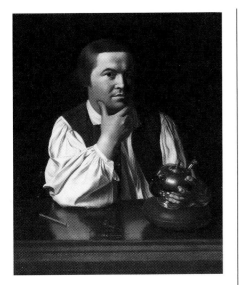

Copley, "Portrait of Paul Revere," c. 1768–70, Museum of Fine Arts, Boston. *Copley's portraits of Boston society offered sharp glimpses into his subjects' personalities.*

PAINTING THE CHARACTER OF THE COLONIES. Copley's portrayal of his friend, a shirt-sleeved Paul Revere, was an innovation for its time, when a portrait never pictured manual labor. Yet Copley posed the silversmith holding a teapot he had made, his tools in clear sight. Revere had not yet taken the midnight ride that Longfellow set to verse but was already a leading opponent of British rule. His shrewd, uncompromising gaze and the informal setting without courtly trappings summed up the Revolution's call for independence.

STUART: THE FIRST DISTINCTIVE AMERICAN STYLE. Gilbert Stuart (1755–1828) was America's other great painter of the Neoclassic period. Stuart refused to follow established recipes for painting flesh, saying he would not bow to any master, but "find out what nature is for myself, and see her with my own eyes." He used all the colors to approximate flesh but without blending, which he believed made skin look muddy, like saddle leather. Something of a pre-Impressionist, Stuart made skin seem luminous, almost transparent, through quick brushstrokes rather than layered glazes. Each stroke shone through the others like blood through skin, giving a pearly brilliance to his faces. Flesh, Stuart said, is "like no other substance under heaven. It has all the gaiety of a silk mercer's shop without its gaudiness and gloss, and all the soberness of old mahogany without its sadness."

Stuart was the equivalent of court painter for the new republic. His contribution was in simplifying portraiture, discarding togas and passing gestures to emphasize timeless aspects. Stuart painted faces with such accuracy that Benjamin West said Stuart "nails the face to the canvas."

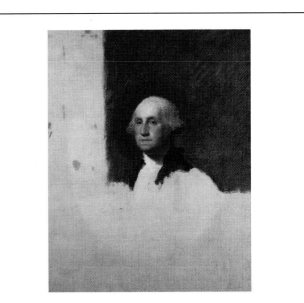

Stuart, "George Washington," (The Athenaeum Portrait), 1796, Museum of Fine Arts, Boston. *Stuart's portraits of George Washington demonstrate how the painter went beyond the European tradition. By stripping away all nonessentials (the background was never completed), Stuart implies that greatness springs only from individual character. The portrait omits Washington's smallpox scars but hints at his endurance in the firm line of his mouth. Some have questioned whether the tightly clamped lips indicated not the fortitude to survive Valley Forge but the general's uncomfortable wooden teeth.*

In any event, this image has become the most famous American portrait of all time. A victim of his own success, Stuart came to hate the job of duplicating the likeness, which he called his "hundred dollar bills." Now this national icon stares from its niche on the one-dollar bill.

GOYA: MAN WITHOUT AN "ISM"

The paintings of the Spanish artist Francisco de Goya (1746–1828) fit no category. His work was indebted only to the realism of Velázquez, the insight of Rembrandt, and, as he said, to "nature." Goya was a lifelong rebel. A libertarian fiercely opposed to tyranny of all sorts, the Spanish artist began as a semi-Rococo designer of amusing scenes for tapestries. Then he became painter to Charles IV of Spain, whose court was notorious for corruption and repression. Goya's observation of royal viciousness and the church's fanaticism turned him into a bitter satirist and misanthrope.

His work was subjective like the nineteenth-century Romantics', yet Goya is hailed as the first modern painter. His nightmarish visions exposing the evil of human nature and his original technique of slashing brushstrokes made him a forerunner of anguished twentieth-century art.

Goya's "Family of Charles IV" is a court painting like no other. The stout, red-faced king, loaded with medals, appears piggish; the sharp-eyed trio at left (including an old lady with a birthmark) seems downright predatory; and the queen insipidly vacant. Critics have marveled at the stupidity of the thirteen family members of three generations for not having realized how blatantly Goya exposed their pomposity. One critic termed the group a "grocer and his family who have just won the big lottery prize." The painting was the artist's homage to Velázquez's "Las Meninas" (see p. 60). Goya — like his predecessor — placed himself at left behind a canvas, recording impassively the parade of royal arrogance.

ART OF SOCIAL PROTEST. Goya was equally blunt in revealing the vices of church and state. His disgust with humanity followed a near-fatal illness in 1792 that left him totally deaf. During his recovery, isolated from society, he began to paint demons of his inner fantasy world, the start of a preoccupation with bizarre, grotesque creatures in his mature work.

A master graphic artist, Goya's sixty-five etchings, "The Disasters of War" from 1810–14, are frank exposés of atrocities committed by both the French and Spanish armies during the invasion of Spain. With gory precision, he reduced scenes of barbarous torture to their horrifying basics. His gaze at human cruelty was unflinching: castrations, dismemberments, beheaded civilians impaled on bare trees, dehumanized soldiers staring indifferently at lynched corpses.

"The Third of May, 1808" is Goya's response to the slaughter of 5,000 Spanish civilians. The executions were reprisal for a revolt against the French army in which the Spaniards were condemned without regard to guilt or innocence. Those possessing a penknife or scissors ("bearing arms") were marched before the firing squad in group lots.

The painting has the immediacy of photojournalism. Goya visited the scene and made sketches, and yet his departures from realism give it additional

Goya, "Family of Charles IV," 1800, Prado, Madrid. *The Spanish monarchy was so vain and imbecilic they failed to notice that Goya portrayed them in all their ostentation.*

Goya, "The Third of May, 1808," 1814–15, Prado, Madrid. *Goya protested the brutality of war by individualizing the faces of the victims of the faceless firing squad. The poet Baudelaire praised Goya for "giving monstrosity the ring of truth."*

power. He lit the nocturnal scene with a lamp on the ground, casting a garish light. In the rear, the church is dark, as if the light of all humanity had been extinguished. Bloody carcasses project toward the viewer, with a line of victims stretching off in the distance. The immediate victims are the center of interest, with a white-shirted man throwing wide his arms in a defiant but helpless gesture recalling the crucified Christ. The acid shades and absence of color harmony underscore the event's violence.

In other paintings of that time, warfare was always presented as a glorious pageant and soldiers as heroes. Goya contrasted the victims' faces and despairing gestures with the faceless, automatonlike figures of the firing squad. Although deafness cut Goya off from humanity, he passionately communicates his strong feelings about the brutality and dehumanization of war.

LATE STYLE: BLACK PAINTINGS. Goya became obsessed with depicting the suffering caused by the political intrigue and decadence of the Spanish court and church. He disguised his repulsion with satire, however, such as in the disturbing "black paintings" he did on the walls of his villa, Quinta del Sordo (house of the deaf). The fourteen large murals in black, brown, and gray of 1820–22 present appalling monsters engaged in sinister acts. "Saturn Devouring His Children" portrays a voracious giant with glaring, lunatic eyes stuffing his son's torn, headless body into his maw. Goya's technique was as radical as his vision. At one point he executed frescoes with sponges, but his satiric paintings were done with broad, ferocious brushstrokes as blazing as the events portrayed.

Goya died in France, in self-imposed exile. He was the father of 20 children but left no followers. His genius was too unique and his sympathies too intense to duplicate.

ROMANTICISM:
THE POWER OF PASSION

"Feeling is all!" the German writer Goethe proclaimed, a credo that sums up Romantic art. Rebelling against the Neoclassic period's Age of Reason, the Romantic era of 1800–50 was the Age of Sensibility. Both writers and artists chose emotion and intuition over rational objectivity. As the German Romantic landscape painter Caspar David Friedrich wrote, "The artist should paint not only what he sees before him, but also what he sees in him." Romantics pursued their passions full-throttle. Living intensely rather than wisely had its price. Romantic poets and composers like Byron, Keats, Shelley, Chopin, and Schubert all died young.

Romanticism got its name from a revived interest in medieval tales called romances. "Gothic" horror stories combining elements of the macabre and occult were in vogue (it was during this period that Mary Shelley wrote *Frankenstein*), as was Gothic Revival architecture, seen in the towers and turrets of London's Houses of Parliament. The "in" decorating look was arms and armor. Sir Walter Scott built a pseudo-Gothic castle, as did the novelist Horace Walpole, where he could, he said, "gaze on Gothic toys through Gothic glass."

Another mark of Romanticism was its cult of nature worship. Painters like Turner and Constable lifted the status of landscape painting by giving natural scenes heroic overtones. Both man and nature were seen as touched by the supernatural, and one could tap this inner divinity, so the Romantic gospel went, by relying on instinct.

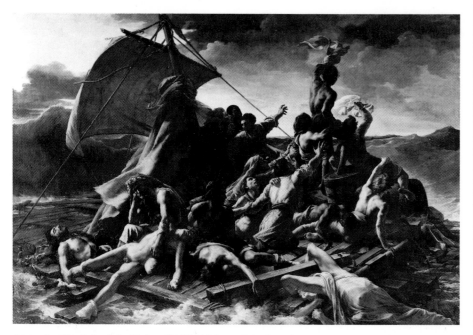

Géricault, "The Raft of the Medusa," 1818–19, Louvre, Paris. *Géricault inaugurated Romanticism with this canvas contrasting images of extreme hope and despair.*

ROMANTICISM

VALUES:
Intuition, Emotion, Imagination

INSPIRATION: Medieval and Baroque eras, Middle and Far East

TONE: Subjective, spontaneous, nonconformist

COLOR: Unrestrained; deep, rich shades

SUBJECTS: Legends, exotica, nature, violence

GENRES: Narratives of heroic struggle, landscapes, wild animals

TECHNIQUE: Quick brushstrokes, strong light-and-shade contrasts

COMPOSITION: Use of diagonal

FRENCH ROMANTICISM

GÉRICAULT. Théodore Géricault (pronounced JHAY ree coe; 1791–1824) launched Romanticism with one painting, "The Raft of the Medusa." He based the huge (16' x 23$\frac{1}{2}$') canvas on a contemporary event, a shipwreck that caused a political scandal. A government ship, the *Medusa*, carrying French colonists to Senegal sank off the west coast of Africa due to the incompetence of the captain, a political appointee. The captain and crew were first to evacuate and took over the lifeboats, towing a makeshift raft piled with 149 passengers. Eventually they cut the towrope, leaving the immigrants to drift under the equatorial sun for twelve days without food or water, suffering unspeakable torments. Only fifteen lived.

Géricault investigated the story like a reporter, interviewing survivors to hear their grisly tales of starvation, madness, and cannibalism. He did his utmost to be authentic, studying putrid bodies in the

morgue and sketching decapitated heads of guillotine victims and faces of lunatics in an asylum. He built a model raft in his studio and, like an actor immersing himself in a role, even lashed himself to the mast of a small boat in a storm.

This extraordinary preparation accounts for the painting's grim detail. But Géricault's romantic spirit is at the root of its epic drama. The straining, contorted body language of the nude passengers says everything about the struggle for survival, a theme that obsessed the artist.

Because of the graphic treatment of a macabre subject and the political implications of the government's incompetence, the painting created a huge sensation. Romantic passion was, for the first time, visible in extremis, capturing not some idealized form from the past but contemporary reality. The painting's fame broke the stranglehold of the Classical Academy. From this time, French art was to stress emotion rather than intellect.

In his private life, Géricault was also an archetypal Romantic. Like the fiery poet Lord Byron who died the same year, "safety last" could have been his motto. He had no concern for his own well-being and dedicated himself to a life of passion and defending the downtrodden. His teacher called Géricault a madman, and the Louvre banned him for brawling in the Grande Galerie. Fascinated with horses, Géricault died at the age of 32 after a series of riding accidents.

Although he exhibited only three paintings publicly in his decade-long, meteoric career, Géricault left an indelible mark. His energetic handling of paint and rousing scenes of titanic struggle kicked off the Romantic era in French art.

DELACROIX: PAINTER OF PASSION.

Eugène Delacroix became leader of the Romantic movement after Géricault's death. A moody, solitary man, he always ran a slight fever. Delacroix believed the artist should feel the agony of creation and, like his friend the composer Frederic Chopin, he was consumed by the flame of genius. "The real man is the savage," he confided to his journal. As the Romantic poet Baudelaire put it, Delacroix was "passionately in love with passion."

Delacroix chose his subjects from literature or from stirring topical events. Instead of the Neoclassic style of antique calm, violence charged his exotic images. Delacroix painted an early work, "Massacre at Chios," as soon as he heard the news of Turks slaughtering Christians on the island of Chios. Although purists called it a "massacre of painting," spectators wept when they saw the pitiful babe clutching its dead mother's breast.

OUT OF AFRICA.

In 1832, a visit to Morocco changed Delacroix's life. He infiltrated a harem and made hundreds of sketches. Delacroix was fascinated by the colorful costumes and characters, like throwbacks to a flamboyant past. "The Greeks and Romans are here," he wrote, "within my reach." For the next thirty years, he stuck to lush colors, swirling curves, and animals like lions, tigers, and horses knotted in combat.

"The Death of Sardanapalus" shows Delacroix's attraction to violence. Delacroix based the painting on Byron's verses of the Assyrian emperor Sardanapalus, who, faced with military defeat, ordered his possessions destroyed before immolating himself on a funeral pyre. Delacroix portrays the shocking instant when servants execute the king's harem girls and horses. It is an extravaganza of writhing bodies against a flaming red background. The intense hues, vivid light/dark contrasts, and turbulent forms in broad brushstrokes are a virtual manifesto of Romanticism.

Delacroix, "Death of Sardanapalus," 1827, Louvre, Paris. *Fascinated by physical and emotional excess, Delacroix portrays a wild, writhing scene as an emperor's concubines are murdered.*

NEOCLASSICISM VS. ROMANTICISM

Ingres, "Paganini," 1819, Louvre, Paris.

For twenty-five years Delacroix and Ingres led rival schools whose squabbling dominated the Paris art scene. Their two paintings of the virtuoso violinist Paganini demonstrate the different outlooks and techniques of the Neoclassic and Romantic movements.

Ingres was a talented violinist himself and knew Paganini personally, yet his version of the maestro is an objective, formal portrait of the public man. With photographic accuracy, his crisp, precise lines duplicate exactly Paganini's physical appearance. This is a rational man, totally in control.

Delacroix defines the musician's form through color and energetic, fluid brushwork, as opposed to lines. Unlike Ingres's ramrod-straight figure, Delacroix's Paganini is curved like a violin, carried away by the ecstasy of performance. Eyes closed, foot almost tapping, Delacroix's painting is a figure of passionate abandon. This is the inner man in the throes of emotion.

Delacroix, "Paganini," c. 1832, Phillips Collection, Washington, DC.

CONTRIBUTIONS. Delacroix liberated painting from the Classical concept of color as a tint applied over forms defined by line drawing. Under his hand, color — especially vibrating adjacent tones — became the indispensable means to model forms, a discovery extended by van Gogh, Renoir, Degas, Seurat, and Cézanne. The admiring van Gogh remarked, in fact, that "only Rembrandt and Delacroix could paint the face of Christ."

Delacroix did not attempt to reproduce reality precisely but aimed at capturing its essence. He established the right of a painter to defy tradition and paint as he liked. Goya, who had been similarly idiosyncratic, saw Delacroix's work when the Spaniard was an old man and heartily approved.

Delacroix, whose output was enormous, claimed he had enough compositions for two lifetimes and projects to last 400 years. He painted at a fever-pitch, furiously attacking the whole canvas at once, saying that, "If you are not skillful enough to sketch a man falling out of a window during the time it takes him to get from the fifth story to the ground, then you will never be able to produce monumental work." A friend eulogized Delacroix as a painter "who had a sun in his head and storms in his heart; who for 40 years played upon the keyboard of human passions."

THE ARTIST'S PALETTE

The Machine Age — in full swing by the nineteenth century — brought improved materials that affected the way artists painted. For one thing, a wider range of colors was available. Before, artists used earth colors because most pigments came from minerals in the earth. Now chemical pigments were invented that could approximate a greater variety of the colors in nature. Emerald green, cobalt blue, and artificial ultramarine were a few of the pigments discovered.

The burden of laboriously preparing colors shifted from the artist to professional tradesmen. Part of every artist's training had been how to grind paint by hand and mix it with linseed oil to create oil paint. Now machines ground pigments that were mixed with poppy oil as a binder and sold to artists in jars. With the poppy oil, the paint retained the mark of the brush more, for a textured effect as in van Gogh's paintings. For the Impressionist generation, in fact, the visible sign of brushwork represented an artist's individual signature.

With these innovations, chiaroscuro, or the multilayered, subtle gradations of color to suggest three-dimensional volume, gradually became obsolete. No longer did artists — as they had since Leonardo's time — indicate shadows by thin, transparent washes of dark color and highlights by thick, opaque clots of light pigment. Painters represented both light and shade in opaque colors applied with a loaded brush. Instead of successive layers of paint, each applied after the preceding one had dried, the rapid, sketchlike alla prima style took over by 1850, allowing artists to produce an entire work at a single sitting.

The biggest change resulted from the invention of the collapsible tin tube for paint in 1840, which made the artist's studio portable. By the 1880s, the Impressionists chose to paint outdoors using the new bright colors, so they could heed Corot's maxim, "Never lose the first impression which has moved you."

ENGLISH ROMANTICISM

Two English painters, born only a year apart, did more than anyone to establish landscape painting as a major genre. Yet stylistically J.M.W. Turner and John Constable could not have been further apart. Constable made nature his subject, while for Turner the subject was color. Constable painted placid scenes of the actual countryside, while Turner's turbulent storms existed mainly in his imagination.

CONSTABLE: FIELD AND STREAM. What William Wordsworth's poems did for England's Lake District, John Constable's (1776–1837) landscapes did for East Anglia, now known as Constable country, on the east coast of England. Both romanticized boyhood rambles through moors and meadows as the subject for poetry and art.

Constable's work was not well received during his lifetime. His father, a prosperous miller, bitterly opposed Constable being a "lowly" painter, and Constable did not sell a painting until he was 39. Members of the Academy called his work, now considered bold and innovative, "coarse" and "rough."

In turn, Constable looked down on conventional landscape painters who based their work on tradition rather than what they actually saw. He said others were always "running after pictures and seeking the truth at second hand." Constable, in contrast, never went abroad and learned only from close observation of nature in his native Suffolk. His views of the English countryside are serene, untroubled, and gentle: "the sound of water escaping from mill-dams," he wrote, "willows, old rotten planks, slimy posts, and brickwork — I love such things. These scenes made me a painter."

As a boy, Constable had learned to "read" the sky while setting the sails on his father's windmills, and as a man he applied this interest in meteorology to his painting. He often went "skying" — sketching cloud formations as source material for paintings. The sky, he believed, was "the key note, . . . and the chief organ of sentiment" in a painting. This love of clouds and sun and shadow led him to make the first oil sketches ever painted outdoors, starting in 1802, thus anticipating the Impressionists' open-air methods (though Constable executed the final finished paintings — "six-footers," he called them — in his studio).

Constable believed landscapes should be based on observation. His rural scenes reflect an intense love of nature, but he insisted they were not idealized: "imagination never did, and never can, produce works that are to stand by comparison with realities," he wrote.

Because of his devotion to actual appearances, Constable rebelled against the coffee-colored tones then in vogue for landscapes, correctly insisting they were actually the result of darkened varnish on Old Master paintings. When a friend claimed Poussin's original tints were the brownish color of a violin, Constable responded by putting a violin on the grass to demonstrate the difference.

Constable simulated the shimmer of light on surfaces by tiny dabs of color stippled with white. (Many found these white highlights incomprehensible, calling them "Constable's snow.") He put tiny red dots on leaves to energize the green, hoping the vibrations between complementary hues would convey an impression of movement like the flux of nature.

Constable, "The Hay Wain," 1821, NG, London. *Constable portrays the farmer with his hay wagon (or "wain") as an integral part of the landscape, emphasizing Constable's mystical feeling of man being at one with nature. Critics found this landscape so lifelike one exclaimed, "The very dew is on the ground!"*

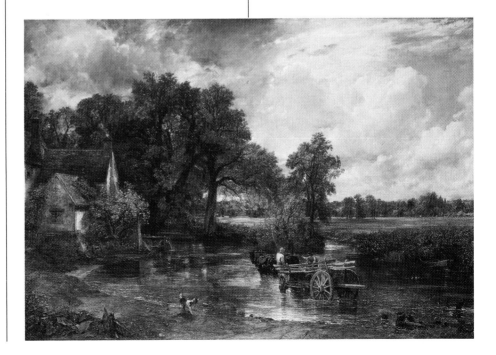

TURNER: A TURN TOWARDS ABSTRACTION. Like Constable, J.M.W. Turner (1775–1851) began painting bucolic landscapes with a smooth, detailed technique. Also like Constable, he later experimented with more radical techniques and evolved a highly original style that influenced later generations of artists. The two painters differed, however, in Turner's love of the dramatic, of subjects like fires and storms. Turner painted nature in the raw.

The child of a poor London barber, Turner skipped school to sketch his father's customers. By the age of 12 he was selling his watercolors and at 15 had exhibited at the Royal Academy. His calm, familiar, rural scenes were an immediate hit with the public and made him a financial success. Once Turner began to travel to the continent, he became fascinated by the wilder aspects of nature and evolved his distinct style. He aimed to evoke awe in his viewers and shifted his subject from calm countrysides to Alpine peaks, flaming sunsets, and the theme of man's struggle against the elements.

Turner's style gradually became more abstract as he attempted to make color alone inspire feeling. The foremost colorist of his day, Turner was the first to abandon brown or buff priming for a white undercoat, which made the final painting more brilliant. He neutralized deep tones by adding white and left light tones like yellow undiluted for greater luminosity. People said he put the sun itself into his paintings.

"Rain, Steam, and Speed — The Great Western Railway" is a typical late painting in which Turner eliminated detail to concentrate on the essential form of a locomotive speeding over a bridge toward the viewer. This was one of the first paintings of a steam train, which had been invented only twenty years before. In it Turner tried to express the idea of speed, air, and mist through veils of blue and gold pigment. Turner supposedly researched the painting by sticking his head out of a train window for ten minutes during a storm. Critics jeered at the work when it appeared for its lack of realism. Constable meant to criticize Turner's mature work when he called it "golden visions" and said, "He seems to paint with tinted steam, so evanescent and airy."

At the end of his life, just before exhibiting his nearly abstract paintings, Turner painted in people and added titles to make them more comprehensible to the public. Violently attacked, these canvases were considered unfinished and indistinguishable from each other. One critic accused Turner of thinking "that in order to be poetical it is necessary to be almost unintelligible." Although Turner never considered himself an abstract painter, paintings discovered after his death contain no recognizable subject whatsoever, just swirling masses of radiant color. His discovery of the power of pigment had an enormous influence on the course of modern art. Turner pushed the medium of paint to its expressive limit. His last works anticipate modern art in which paint itself is the only subject.

Turner became increasingly reclusive in his later years, hiding from acquaintances and living under an assumed name. He turned down handsome prices and hoarded his best paintings, selling only those he considered second-rate. On his deathbed, the story goes, Turner asked to be taken to the window so he could die gazing at the sunset.

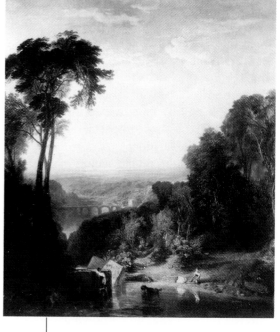

Turner, "Crossing the Brook," 1815, Tate Gallery, London. *Although Turner became the most original landscape artist, his early work was a tame imitation of traditional techniques and content.*

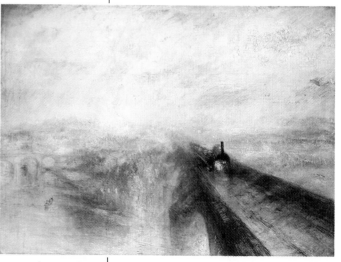

Turner, "Rain, Steam, and Speed — The Great Western Railway," 1844, NG, London. *This painting of a steam locomotive demonstrates the shimmering light and pearly atmospheric glow of Turner's near-abstract, late work, in which he implies rather than depicts a subject.*

AMERICAN ROMANTICISM

Romantic painting in America encompassed two subjects: nature and the natural man. The former included landscapes and the latter were genre paintings of common people in ordinary activities. In both, the subjects were seen through rose-colored glasses, like the seven dwarfs' "hi-ho, hi-ho" version of working in a mine. Forests were always picture-postcard perfect, and happy settlers without exception were cheerful at work or play.

THE AMERICAN LANDSCAPE: AH, WILDERNESS. Before 1825, Americans considered nature menacing. The first thing colonial settlers did was burn or hack down vast tracts of virgin woods to make clearings for fields and villages. They admired nature only when it was tamed in plantations and gardens. After 1830 a shift occurred. America's natural wonders became a bragging point equal to Chartres or the Colosseum. As tides of settlers poured westward, pushing back frontiers, the wilderness became a symbol of America's unspoiled national character.

This shift in sentiment affected art. American writers like Emerson and Thoreau preached that God inhabited nature, which dignified landscapes as a portrait of the face of God. Suddenly the clichéd formula art of London, Paris, and Rome, which had before guided American painting, was obsolete. The grandeur of the American continent became the artist's inspiration.

The Hudson River School was America's first native school of painting. Its members, Thomas Cole, Asher B. Durand, John F. Kensett, and Thomas Doughty, delivered visual sermons on the glories of nature. They were the first to concentrate exclusively on landscapes, which replaced portraits as the focus of American art. Their patriotic scenes of the Hudson River area conveyed a mood of worshipful wonder. They combined realistic detail with idealized composition in a new form of romantic realism. Typically, the scenes were on a large scale with sweeping panoramic horizons that seemed to radiate beyond the painting's borders, suggesting America's unlimited future.

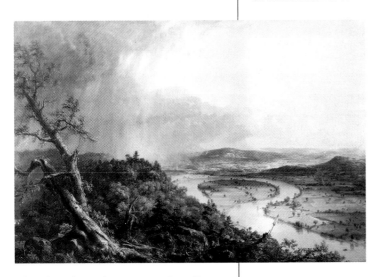

Cole, "The Oxbow (The Connecticut River Near Northampton)," 1836, MMA, NY. *Leader of the Hudson River School, Cole emphasized the grandeur and immensity of America's landscape.*

COLE: **HUDSON RIVER SCHOOL LEADER.** Thomas Cole (1801–48) was the founder of the Hudson River School of Romantic landscapes. Cole, a self-taught artist, lived on a bluff overlooking the Hudson River. An outdoor enthusiast, he rambled on foot throughout the area in the spring, summer, and fall, scaling peaks to make pencil sketches of untouched natural scenes. During the winter, after his memory of particular locales had faded to a fuzzy afterglow, he portrayed the essential mood of a place in oil paintings. Cole's finished work — a combination of real and ideal— reflects this working method. He presents foreground in minute detail and blurs distant vistas to suggest the infinite American landscape.

In "The Oxbow," Cole faithfully reproduced rocks, juicy vegetation, a gnarled tree, and his folding chair and umbrella. The blond panorama of the Connecticut River Valley and receding hills seems to stretch forever. The painting depicts the moment just after a thunderstorm, when the foliage, freshened by a cloudburst, glistens in a theatrical light.

Cole's work expressed the proud belief that America was a primeval paradise, a fresh start for humanity. For the optimistic Hudson River School, communion with nature was a religious experience that cleansed the soul as surely as rainfall renewed the landscape. As Cole wrote in his diary before painting this picture, "I would not live where tempests never come, for they bring beauty in their train." America may have lacked picturesque ancient ruins, but its lush river valleys and awesome chasms and cascades were subject enough for the Hudson River School.

ARTIST-EXPLORERS: BIERSTADT AND CHURCH. The generation of painters after the Hudson River School tackled more far-flung landscapes. Frederic Edwin Church (1826–1900) and Albert Bierstadt (1830–1902) were the Lewis and Clark of painting — "intrepid limners" they were called — as they sketched the savage beauty of nature from the lush vegetation of the tropics to the icebergs of the Arctic.

Bierstadt specialized in sweeping views of thrilling natural wonders. His career coincided with the westward movement begun by the forty-niners and their wagon trains. At the age of 29, Bierstadt joined a survey team mapping a westward route. Face to face with the Rocky Mountains, he found his personal mother lode: sketching the overwhelming vistas of the mountains. When he returned to his New York studio, he surrounded himself with photographs, sketches, Indian artifacts, and animal trophies and began to paint the views of the American West that made him world famous.

"The Rocky Mountains" is one of Bierstadt's typical images of the West as a Garden of Eden. He employed his usual compositional devices of a highly detailed foreground (the peaceful encampment of Shoshone Indians) and distant soaring mountains pierced by a shaft of sunlight. His paintings were like a commercial for westward expansion, as if that were America's Manifest Destiny.

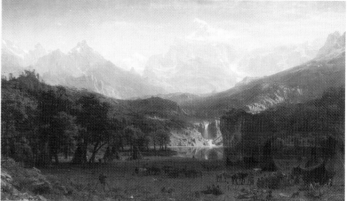

Bierstadt, "The Rocky Mountains," 1863, MMA, NY. *Bierdstadt captured the adventurous frontier spirit as well as the concept of the noble savage in harmony with nature.*

THE P. T. BARNUM OF AMERICAN ART

Bierstadt's paintings were as vast in scale as the scenes he depicted — wall-sized canvases as big as a 9'x12' rug. A running joke was that his next subject would be "all outdoors" and that he had built a château near the widest part of the Hudson River so he would have room to turn his canvases. Bierstadt had a flair for showmanship. He not only sold paintings for $25,000 each (an enormous sum then), he charged 25 cents admission when he exhibited a work. Crowds lined up for the theatrical display of his paintings, which were flanked by potted plants and velvet draperies. The artist thoughtfully supplied magnifying glasses to scrutinize details of the polished scene, and although an entire painting might have a Paul Bunyan–like scale, on close inspection, one could see minute petals of individual wildflowers.

GENRE PAINTING: THE AMERICAN DREAM IN ACTION

Genre painting also gained respect in the first half of the nineteenth century. No longer placed on painting's lowest rung, these scenes of the common people engaged in everyday activity were enormously popular.

BINGHAM: SON OF THE PIONEERS. The first important painter of the West was George Caleb Bingham (1811–79), known for his scenes of frontier life. Criticized in the East for uncouth subjects like riverboatmen playing cards, fishing, and chewing tobacco, he saw himself as a social historian immortalizing pioneer life.

Unlike many other artists who took the wilderness as a subject, Bingham was part of the life he portrayed. He spent his childhood on a hard-scrabble farm in Missouri and was apprenticed to a cabinetmaker before trying his hand at sign painting. He taught himself to paint with a how-to manual and homemade pigments, then took off down the Missouri and Mississippi rivers painting portraits. Bingham was soon acclaimed for celebrating the march west and the activities of the frontier. To Bingham, the commonplace was grand and bargemen at a hoedown were just as noble as ancient heroes in battle.

Bingham, "Fur Traders Descending the Missouri," 1845, MMA, NY. *In this classic "genre" painting, Bingham romanticizes the settling of the Wild West.*

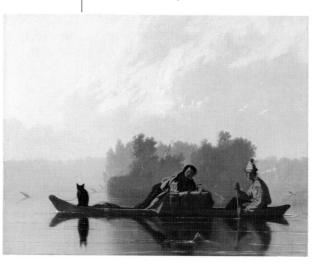

REALISM

During the first half of the nineteenth century, as artistic wars between Neoclassicism and Romanticism raged, Realism, a force that would dominate art for the second half of the century, slowly began to emerge. With the first grindings of the Machine Age, Neoclassicism's anachronisms and Romanticism's escapism would prove to be no match for Realism's hard edge.

In a sense, Realism had always been a part of Western art. During the Renaissance, artists overcame all technical limitations and represented nature with photographic accuracy. From van Eyck to Vermeer to Velázquez, artists approximated visual reality with consummate skill. But before Realism, artists in the nineteenth century modified their subjects by idealizing or sensationalizing them. The "new" Realism insisted on precise imitation of visual perceptions without alteration. Realism's subject matter was also totally different. Artists limited themselves to facts of the modern world as they personally experienced them; only what they could see or touch was considered real. Gods, goddesses, and heroes of antiquity were out. Peasants and the urban working class were in. In everything from color to subject matter, Realism brought a sense of muted sobriety to art.

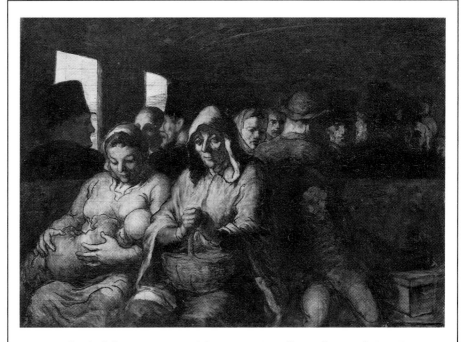

Daumier, "The Third-Class Carriage," c. 1862, MMA, NY. *A spiritual heir to William Hogarth, Honoré Daumier (1808–79) drew savagely satirical caricatures that punctured the pomposity of Royalists, Bonapartists, and politicians. King Louis Philippe jailed Daumier for his cartoon of the king swallowing "bags of gold extorted from the people." Still Daumier continued his attacks. "The Third-Class Carriage" portrayed working-class passengers as dignified, despite being crammed together like lemmings. This was the earliest pictorial representation of the dehumanizing effect of modern transportation.*

ROSA BONHEUR *(1822–99) was the nineteenth century's leading painter of animals. Her pictures of sheep, cows, tigers, and wolves reflected her passion for the animal kingdom. When someone reproached her saying, "You are not fond of society," the French artist replied, "That depends on what you mean by society. I am never tired of my brute friends." Her home in Paris was a menagerie of goats, peacocks, chickens, even a steer, wandering in and out of the studio. When she painted outdoors, dogs lay about her in a circle.*

Bonheur's lifelike images reflected her thorough research. For "The Horse Fair," Bonheur sketched at the Paris horse market for a year and a half, disguised as a man in order to be inconspicuous. To gain an accurate knowledge of anatomy, she worked in a slaughterhouse, "wading," as she said, "in pools of blood." Bonheur was as fiercely independent as the lions she painted. She lived with a female friend, cut her hair short like a man's, smoked cigarettes even though doing so was scandalous, and obtained a police permit to wear trousers. A courageous and colorful character, she was one of the first advocates of women's rights.

Bonheur, "The Horse Fair," 1853–55, MMA, NY.

FRENCH REALISM

COURBET. The father of the Realist movement was Gustave Courbet (pronounced Koor BAY; 1819–77). A man of great pragmatism, he defied the conventional taste for history paintings and poetic subjects, insisting that "painting is essentially a concrete art and must be applied to real and existing things." When asked to paint angels, he replied, "I have never seen angels. Show me an angel and I will paint one."

His credo was "everything that does not appear on the retina is outside the domain of painting." As a result, Courbet limited himself to subjects close to home, like "Burial at Ornans," a 22-foot-long canvas portraying a provincial funeral in bleak earth tones. Never before had a scene of plain folk been painted in the epic size reserved for grandiose history paintings. Critics howled that it was hopelessly vulgar.

When an art jury refused to exhibit what Courbet considered his most important work, "Interior of My Studio," the painter built his own exhibition hall (actually a shed) called the "Pavilion of Realism" — the first one-man show ever. There was nothing restrained about Courbet. He loudly defended the working class and was jailed for six months for tearing down a Napoleonic monument. He detested the theatricality of Academic art; his drab figures at everyday tasks expressed what Baudelaire termed the "heroism of modern life."

Courbet, "Interior of My Studio, a Real Allegory Summing Up Seven Years of My Life as an Artist," 1854–55, Musée d'Orsay, Paris. *Courbet portrays the two spheres of influence that affected his art. At left are the ordinary people that are his subjects, and at right, representatives of the Paris art world. The focal point is a self-portrait of the artist. His pivotal position between the two worlds implied that the artist was something of a go-between, linking the real world to the art world.*

THE BARBIZON SCHOOL: REALISTIC FRENCH COUNTRYSIDES.

Influenced by Constable, who painted actual scenes rather than imagined ones, a group of landscape painters known as the Barbizon School brought the same freshness to French art. Beginning in the 1830s, they painted outdoors near the town of Barbizon. The most famous names associated with this school were Millet and Corot.

COROT: MISTY TREES. Jean-Baptiste-Camille Corot (pronounced Kore ROH; 1796–1875) was taught "to reproduce as scrupulously as possible what I saw in front of me." He brought a natural, objective style to landscape painting, capturing the quality of a particular place at a particular moment. Corot used a limited palette of pearly, silvery tones with olive green, and soft, wispy strokes. The nearly monochromatic landscapes of his later years were so popular they have become some of the most widely forged paintings in the world, giving rise to the comment, "Corot painted 3,000 paintings, of which 6,000 are in America."

Peasant Portraits. *Jean-François Millet (pronounced Mee LAY; 1814–75) is forever linked to portrayals of rural laborers plowing, sowing seed, and harvesting. Born to a peasant family, he once said he desired "to make the trivial serve to express the sublime." Before, peasants were invariably portrayed as doltish. Millet gave them a sturdy dignity.*

Millet, "The Sower," c. 1850, Museum of Fine Arts, Boston.

Corot, "Ville d'Avray," 1870, MMA, NY. *Barbizon painters like Corot painted directly from nature.*

AMERICAN REALISM

HOMER. "He is a genuine painter," novelist Henry James said of Winslow Homer (1836–1910). "To see, and to reproduce what he sees, is his only care." A self-taught artist, Homer steered clear of outside influence and theory, basing his work on direct observation of nature. "When I have selected the thing carefully," he said of his method, "I paint it exactly as it appears." His skill made him the major American marine painter and watercolorist of all time.

First apprenticed to a lithographer, Homer became a successful illustrator for popular magazines. His drawings of idyllic farm scenes and girls playing croquet kept him steadily employed. As a Civil War artist, he produced illustrations of camp life. At the age of 27, he began — without instruction — to paint in oils. Homer's friends thought his total indifference to European art was "almost ludicrous," but Homer insisted on inventing himself. "If a man wants to be an artist," he said, "he should never look at paintings."

CRASHING WAVES AND STORMY SEAS. In the 1880s Homer retreated to Maine where he began to paint the raging sea. In shipwreck paintings like "The Gulf Stream" and "The Life Line," man-against-the-elements became a recurrent theme. Later Homer dropped human figures from his sea paintings altogether and simply portrayed high winds driving blue-green waves against boulders under gray skies. He sometimes waited days for just the right light, dashing out at midnight to paint moonlight on the waves. His ability to portray harsh, stormy weather, to the point where you can almost feel the icy spray, remains unmatched.

At the age of 38 Homer struck out in a new direction. Watercolors had long been used by artists in preparatory studies, but Homer was the first to display his watercolors as finished works and thereby installed the form as a major medium. His marine watercolors are luminous and brightly colored, with patches of white paper left radiant like the glaring tropical sun. In the hands of other painters, watercolors often looked anemic, but in Homer's bold style, they had the authority of oils.

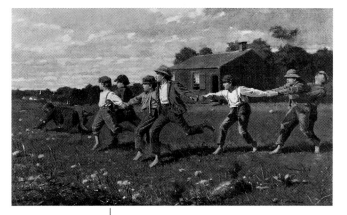

Homer, "Snap the Whip," 1872, MMA, NY. *Homer brought a new realism to genre painting, presenting exuberant images of rural America.*

WATERCOLOR

Invented by ancient Egyptians and used by Renaissance artist Dürer to tint ink drawings, the watercolor came into its own in the mid-nineteenth century as a vehicle for painting English landscapes. Used before primarily for sketches, the watercolor was finally recognized as a technique with its own potential.

Although most beginning artists start with watercolor because the clean-up and materials (brush, paint box, paper, and water) are simple, it is actually a very demanding medium. Its significant characteristics are the fluidity and transparency of the paint, which allows the white background to show through. Artists who have used watercolor with special skill are Cézanne, Sargent, Dufy, Grosz, Klee, and especially Winslow Homer and John Marin.

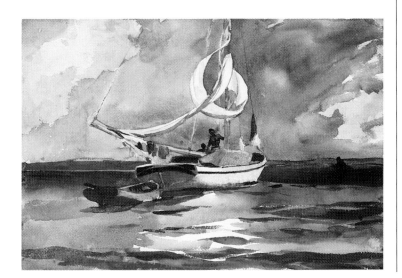

Homer, "Sloop, Nassau," 1899, MMA, NY. *Homer was America's premier marine painter and watercolorist, fascinated by the power and energy of the sea.*

EAKINS: **THE ANATOMIST.** Thomas Eakins (pronounced AY kins; 1844–1916) was such an uncompromising realist that when he decided to paint a crucifixion, he strapped his model to a cross. His first concern, he maintained, whether painting a religious picture or, more commonly, portraits and Philadelphia scenes, was to get the anatomy right.

Eakins approached his profession logically and systematically, mastering the necessary technical skills in progressive stages. To learn anatomy, he dissected cadavers and became so knowledgeable on the subject he lectured to medical students. He plotted out the perspective of his paintings with mathematical precision, laying out the structure in grids by mechanical drawing. He was as straightforward as artists came. "I hate affectation," he wrote. "I am learning to make solid, heavy work."

RADICAL TEACHING METHOD. As director of the Pennsylvania Academy, Eakins revolutionized art instruction. The accepted practice was to draw from plaster casts of ancient sculpture. Eakins detested such second-hand learning: "The Greeks did not study the antique," he said. "Nature is just as varied and just as beautiful in our day as she was in the time of Phidias." He required students to draw the nude from life, studying its motion and anatomy. The idea was ahead of its time: when he insisted on a class of both men and women drawing from what a newspaper called "the absolute nude," Eakins was fired in disgrace. Indeed, many of Eakins' attitudes were ahead of their time. When professional careers were closed to women and blacks, he encouraged them to study art. One of his pupils, Henry O. Tanner (1859–1937), became the first important black painter and the most successful black American artist before Romare Bearden and Jacob Lawrence.

PORTRAITS. From the late 1870s on, Eakins painted mostly portraits. Each captured the essence of the individual, yet because he never flattered a sitter, many customers refused the commissioned works. "The negative response was often brutally discourteous and disagreeable," wrote his biographer. Of those accepted, an inordinate number — probably 10 percent — were destroyed. Today Eakins is considered America's finest nineteenth-century painter and, in the opinion of many, the greatest painter America has produced.

STARK REALISM. *Eakins depicts an actual breast-cancer operation by the surgeon Dr. Agnew, who lectures to medical students. Critics considered Eakins's "anatomy lessons" a "degradation of art" and denounced him as a "butcher" for his graphic portrayals. The Pennsylvania Academy refused to display the painting at its exhibition, but for Eakins, clinical fact made the painting all the more truthful.*

Eakins, **"The Agnew Clinic,"** 1889, University of Pennsylvania, Philadelphia.

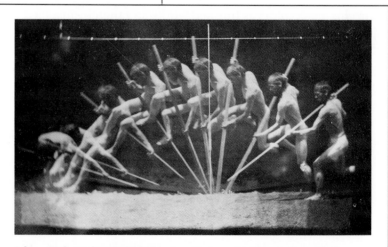

Eakins, **"Pole-Vaulter: Multiple Exposure Photograph of George Reynolds,"** 1884–85, MMA, NY. *Eakins was a pioneer in the new technique of photography. Anticipating the invention of the movie camera, he, with Eadweard Muybridge, was first to take rapid, multiple exposures. Eakins used photo sequences of a man running or hurling a javelin to analyze the anatomy of movement.*

WHISTLER: ART FOR ART'S SAKE. James Abbott McNeill Whistler (1834–1903) was one of the most controversial artists of the nineteenth century and a leading theoretician of the Art for Art's Sake doctrine. Before a painting is anything else, Whistler maintained, it is, first and foremost, a blank surface covered with colors in varying patterns. His portraits, landscapes, and night pictures were less representations of a subject than experiments in decorative design. He intended no moral uplift in his paintings, saying, "Art should be independent of all claptrap." This radical notion that a design exists in and of itself, not to describe a subject or tell a story, would later change the course of Western art, just as his paintings were precursors of modern abstraction.

Whistler's life was as unconventional as his art. Born in Lowell, Massachusetts, he spent much of his childhood in St. Petersburg, Russia, which he claimed as his birthplace. "I shall be born when and where I want, and I do not choose to be born in Lowell," he said. After flunking out of West Point for a "deficiency in chemistry," Whistler bounced around without a profession until reading in *La Vie de bohème* of the wild life of Parisian art students. At the age of 21 he sailed for Europe, never to return to America.

Whistler played the bohemian to the hilt, flaunting his relationship with his red-haired model/mistress and parading conspicuously about London in foppish dress. With his lavish life-style, he was frequently in debt. He pawned his jacket for an iced tea on a hot day, and once, after a meal, announced, "I have just eaten my washstand." Given to public tantrums, Whistler upbraided the

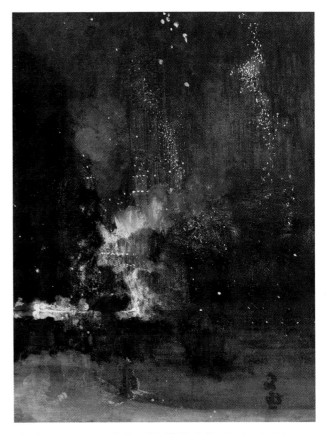

Whistler, "Nocturne in Black and Gold: The Falling Rocket," 1875, Detroit Institute of Arts. *This painting of fireworks in the night sky foreshadowed abstraction.*

"Philistines" who failed to appreciate his work. His insulting diatribes to the press prompted Degas's warning, "My friend, you behave as if you had no talent."

One notorious dispute shocked all of London. When Whistler exhibited "Nocturne in Black and Gold: The Falling Rocket," the influential critic John Ruskin denounced it as an affront to art and likened it to "flinging a pot of paint in the public's face." Outraged, Whistler sued for libel. In the widely publicized trial, he testified with caustic wit. When asked to justify a fee of 200 guineas for what Ruskin maintained was a "slovenly" painting executed in a maximum of two days, Whistler said its price was based on "the knowledge of a lifetime." He explained the painting's lack of identifiable objects: "I have meant to divest the picture from any outside anecdotal sort of interest. . . . It is an arrangement of line, form, and color first."

Whistler's most famous work, "Arrangement in Gray and Black No.1," is universally and incorrectly known as "Whistler's Mother." The artist believed the identity of the sitter was irrelevant to the painting, calling it an "arrangement" of forms. Whistler seemed to be heeding the advice of his friend, French poet Mallarmé, to "paint not the thing, but the effect that it produces."

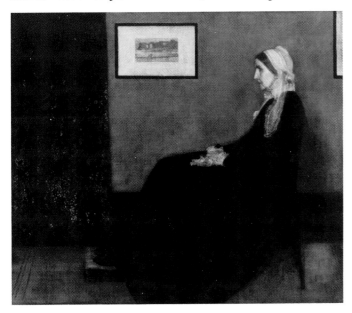

Whistler, "Arrangement in Gray and Black No. 1," 1872, Musée d'Orsay, Paris. *Whistler's strong sense of pattern and design made him insist that this painting was about shapes and colors, not his mother.*

SARGENT: PORTRAITS OF HIGH SOCIETY.

The last great literal portrait painter (before the camera made such art less in demand) was John Singer Sargent (1856–1925). Truly an international artist, he was described as "an American born in Italy, educated in France, who looks like a German, speaks like an Englishman, and paints like a Spaniard." Although he painted with Monet at Giverny, Sargent modeled himself after the Spanish painter Velázquez, the acknowledged master of visual realism.

Sargent's childhood was rootless, as his American parents flitted from one hotel to another all over the Continent. By 19 Sargent had begun formal art training in Paris and by the age of 25 he was already a sensation — though not the kind he had hoped for. The work which was to have cemented his reputation created a scandal instead. Sargent painted a bold, full-length portrait of a famous Parisian beauty, posed in a deeply cut gown, her strap dangling immodestly off her shoulder

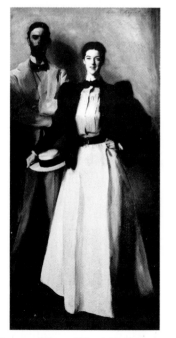

Sargent, "Mr. and Mrs. I. N. Phelps Stokes," 1897, MMA, NY. *Sargent painted portraits of high society in an elegant, elongated style.*

EARLY PHOTO-REALISM

Harnett, "Still Life – Violin and Music," 1888, MMA, NY.

William Michael Harnett (1848–92) was the most emulated American still life painter of his generation. His microscopically accurate paintings of ordinary objects (called "deceptions") were so convincing, they literally "fooled the eye" (the meaning of the term "trompe l'oeil"). Spectators had to be fenced off to keep them from wearing away the paint by touching. While academic painters exhibited their prettified nudes in the Paris Salon, Harnett's work hung in saloons. In fact, a Harnett trompe l'oeil made one pub so famous, people lined up to gape at the painting. Regulars routinely won bets with customers who insisted the painted objects were real. Harnett was nearly arrested by Treasury agents who considered his pictures of currency to be counterfeiting.

"Still Life—Violin and Music," is a tour de force of realism. Through the use of shadows (the sheet music and calling card are shown with edges bent, the door stands ajar), Harnett simulates a wide range of depth. The objects are arranged with geometrical precision. Vertical axes (the bow, wood slats, and metal latch) intersect horizontal lines defined by hinges and wood frame. The slightest rearranging of any object would upset the composition's careful balance.

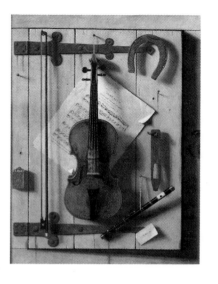

(he later painted over the strap, restoring it to propriety). Although he called the painting "Madame X," everyone recognized the subject, and, with her shocking lavender makeup, she became the laughing stock of Paris. Her mother demanded that he withdraw the work from view. Shocked by the response, Sargent left Paris for London, where he vowed to abandon frankness for flattery in all future portraits.

Sargent had a gift for posing his prosperous subjects naturally to bring them to life. When asked if he sought to represent the inner person behind the veil, Sargent replied, "If there was a veil, I should paint the veil. I can only paint what I see."

THE SOCIAL REGISTER. Witty, urbane, and perfectly at ease among the upper crust, Sargent could pick his subjects and name his price. He excelled at the "portrait d'apparat," or portrait of a person — usually rich and powerful — in his or her home setting. Although he concentrated on the full-length figure, his portraits included opulent accessories like Ming vases, yards of satin, red velvet draperies, and gleaming gold.

In "Mr. and Mrs. I. N. Phelps Stokes," Sargent intended to portray only Mrs. Stokes in a van Dyck pose with a huge dog at her side. Unfortunately, no Doberman was available, so he sketchily substituted her husband, whose vague, shadowy face indicates he was clearly an afterthought. Sargent lavished more care on the crisply drawn female figure, her face radiant with intelligence and charm. The sharp folds of her starched skirt serve to elongate her height and exaggerate her slenderness in Sargent's clean, linear design. Such elegant paintings in the tradition of Gainsborough and Reynolds made Sargent a huge success on both sides of the Atlantic.

ARCHITECTURE FOR THE INDUSTRIAL AGE

For much of the nineteenth century, revival styles like pseudo-Greek or Roman temples and updated Gothic castles dominated architecture. When the Industrial Revolution made new materials like cast-iron supports available, architects at first disguised them in Neoclassical Corinthian columns. Only in purely utilitarian structures like suspension bridges, railroad sheds, and factories was cast iron used without ornament. Gradually, however, an awareness grew that new materials and engineering methods demanded a new style as practical as the Age of Realism itself.

The Crystal Palace (1850–51), housing the first World's Fair in London, demonstrated the aesthetic possibilities of a cast-iron framework. Joseph Paxton (1801–65), an engineer who specialized in greenhouses, designed the iron-and-glass structure as a huge conservatory covering 21 acres and enclosing mature trees already on the site. Because machines stamped out cast-iron elements in prefabricated shapes, construction was a snap. In an astonishing six months, workers put the building together like a giant erector set. A barrel-vaulted transept of multiple panes of glass in an iron skeleton ran the length of the building. Interior space, flooded with light, seemed infinite, the structure itself almost weightless.

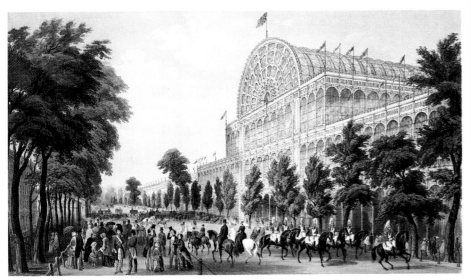

Paxton, The Crystal Palace, 1850–51, (destroyed by fire, 1935), Guildhall Library, London. *The Crystal Palace was the first iron-and-glass structure built on such a huge scale that showed industrial materials were both functional and beautiful.*

ARTSPEAK

"Realism" is one of the few terms used in art criticism where the style and the actual meaning of the word are one and the same. Many other art terms, however, have specialized meanings that can confuse the beginner. The following is a list of frequently used art terms that can seem like doublespeak.

RELIEF — a projecting design carved or modeled on a flat background.

PERSPECTIVE — a technique for representing space and three-dimensional objects on a flat surface.

FIGURATIVE — style that accurately represents figures, animals, or other recognizable objects (also called representational; its opposite is abstract or nonobjective).

GRAPHIC — art on a flat surface based on drawing and use of line (as opposed to color or relief); especially applied to printmaking.

PLANE — a flat, two-dimensional surface with a defined boundary.

STATIC — arrangement of shapes, lines, colors that reduces visual movement when looking at a picture (opposite of dynamic).

FLAT — without illusion of volume or depth; also pure color lacking gradations of tone.

COMPLEMENTARY — opposite colors on the color wheel (green/red, orange/blue).

VALUES — degree of light or dark in a color.

MONUMENTAL — pertaining to monuments; heroic scale.

Use of cast iron spread after mid-century, permitting buildings to be bigger, more economical, and fire-resistant. Many buildings with cast iron facades still stand in New York's SoHo district, and the United States Capitol dome was constructed of cast-iron in 1850–65. After 1860, when steel was available, vast spaces could be enclosed speedily. The invention of the elevator allowed buildings to grow vertically as well as horizontally, preparing for the advent of the skyscraper.

The greatest marvel of engineering and construction of the age was the Eiffel Tower. Built as the central feature of the 1889 Paris Exhibition, at 984 feet it was the world's tallest structure. The Tower consisted of 7,300 tons of iron and steel connected by 2.5 million rivets. It became a daring symbol of the modern industrial era.

ARTS AND CRAFTS. *Countering the growing prestige of Industrialism was the Arts and Crafts Movement led by British author and designer William Morris (1834–96). Throughout Europe and America, the Arts and Crafts Movement of the late nineteenth century influenced decorative arts from wallpaper and textiles to book design. The group advocated a return to the handicraft tradition of art "made by the people, and for the people, as a happiness to the maker and the user." Morris succeeded temporarily in reviving quality in design and craftsmanship, which was threatened with extinction by mass production. He did not, however, achieve his goal of art for the masses. Handmade objects were simply too expensive.*

The Arts and Crafts Movement was influenced by the Pre-Raphaelite Brotherhood, an earlier English art group formed in 1848 to restore art to the "purity" of Italian art before Raphael. It included the painters W. H. Hunt, J. E. Millais, and D. G. Rossetti.

Morris, "Cray" chintz, 1884, Victoria & Albert Museum, London.

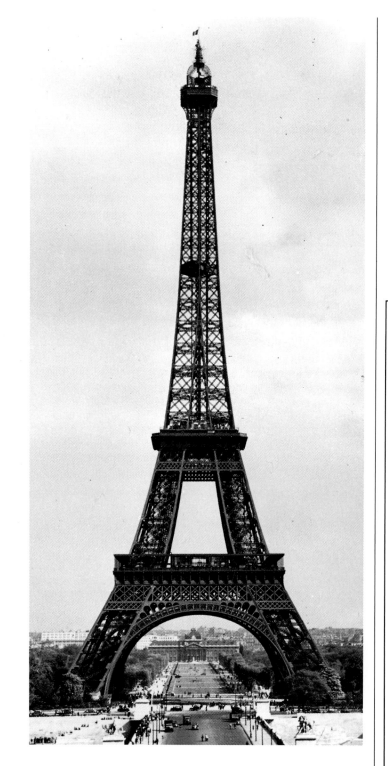

Eiffel, Eiffel Tower, 1889, Paris. *A triumph of modern engineering, the Eiffel Tower flaunted its iron-and-steel skeleton, devoid of allusions to past architectural styles.*

ART NOUVEAU

Art Nouveau, which flourished between 1890 and World War I, was an international ornamental style opposed to the sterility of the Industrial Age. Art Nouveau relied upon twining, flowering forms to counter the unaesthetic look of machine-made products. Whether called Jugendstil (Youth Style) in Germany, Modernista in Spain, Sezessionstil in Austria, Stile Liberty in Italy, or Style Moderne in France, Art Nouveau was easily recognizable by its sinuous lines and tendrillike curves. It was used to maximum effectiveness in the architecture of Antonio Gaudí (see p. 65) and the Belgian Victor Horta, and in interior design of the period in general. Art Nouveau's trademark water lily shape exerted a pervasive influence on the applied arts such as wrought-iron work, jewelry, glass, and typography.

BEARDSLEY: **AESTHETIC DECADENCE.** Aubrey Beardsley (1872–98) was an illustrator whose curvilinear drawings ideally reflect Art Nouveau design. Beardsley's black-and-white illustrations for his friend Oscar Wilde's *Salome* caused a sensation when the book was published. In one illustration, Salome kisses the severed head of John the Baptist, whose dripping blood forms a stem. The drawing's perverse eroticism typified fin-de-siècle decadence. Beardsley eliminated shading in his graphic art, contrasting black and white patterns in flowing, organic motifs.

Beardsley, "Salome," 1892, Princeton University Library. *Beardsley used Art Nouveau's sinuous, curving lines based on plant forms.*

Tiffany studios, "Grape Vine," 1905, MMA, NY. *Tiffany's Art Nouveau works in stained glass reflected his two passions: nature and color.*

TIFFANY: GLASS MENAGERIE. The epitome of Art Nouveau's creeping-vine motif was the glasswork of American Louis Comfort Tiffany (1848–1933). Tiffany's lamps cascaded with stained-glass wisteria, his vases blossomed into lotuses, and his stained-glass windows dripped clusters of grapes. Whatever the object, all Tiffany designs were bowers of willowy leaves and petals in gleaming colors.

Son of the founder of New York's Tiffany's jewelers, Tiffany studied painting, then designed stained-glass windows for churches. When he replaced martyrs and saints with poppies and peacocks, his work became immensely popular. In the floral, landscaped windows celebrating nature's profusion, Tiffany created some of the most innovative glasswork ever.

BIRTH OF PHOTOGRAPHY

In the early nineteenth century scientific discoveries in optics and chemistry converged to produce a new art form: photography. In 1826 French chemist Nicéphore Niépce (1765–1833) made the first surviving photographic image, a view of the courtyard outside his home. To obtain the hazy image, Niépce exposed a polished pewter plate for eight hours.

His collaborator, Louis-J.-M. Daguerre (1789–1851), invented a more practical process of photography in 1839. His first picture, "Still Life," was a brilliantly detailed view of a corner of his studio, exposed for 10 to 15 minutes. In 1839 Daguerre inadvertently took the earliest known photograph of a human being. His picture of a Parisian boulevard known to have been crowded with rushing pedestrians is eerily empty of life, except for a man having his shoes shined — the only human being who stood still long enough for his image to register during the long exposure.

An Englishman, William Henry Fox Talbot (1800–77), further improved the process of photography with his invention of calotypes, or the photo negative, announced in 1839. He had begun experimenting by pressing leaves, feathers, and pieces of lace against prepared paper that was exposed to sunlight. His later prints of projected images were blurred compared to the sharp daguerreotypes, but were achieved with paper negatives and paper prints.

Other advances soon followed. In 1851 a process called wet-plate reduced exposure time to seconds and produced prints almost as precise as Daguerre's. Then the tintype was invented, with an image on a thin metal plate instead of delicate glass. Next the dry-plate liberated the photographer from dashing into the darkroom immediately. Not only would the image keep longer before developing, the speed of exposure was so fast the photographer no longer needed a tripod. By 1858, instant photography replaced the daguerreotype. In the 1880s, portable hand-held cameras and roll film took over.

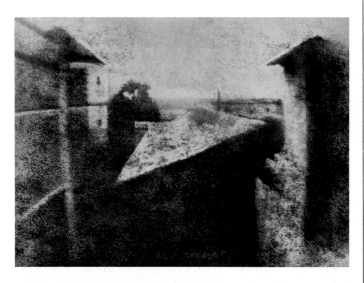

Niépce, "View from His Window at Gras," 1826, Gernsheim Collection, University of Texas at Austin. *This is the first surviving photograph, exposed for eight hours.*

Daguerre, "A Portrait of Charles L. Smith," 1843, International Museum of Photography at George Eastman House, Rochester, NY. *Daguerre invented a practical method of photography.*

Fox Talbot, "Sailing Craft," c. 1844, Science Museum, London. *Fox Talbot developed paper negatives and prints.*

TYPES OF POPULAR PHOTOGRAPHY

TRAVEL PHOTOGRAPHY. Professional photographers swarmed to wayward locales to document far-off wonders and feed the public's appetite for the exotic. Suddenly the pyramids and sphinxes of Egypt, Old Faithful erupting, Niagara Falls, and the Grand Canyon were accessible to armchair travelers. These first mobile shutterbugs surmounted formidable difficulties, lugging heavy equipment and fragile plates up Alpine peaks, working under broiling sun, and then in the stifling gloom of portable darkrooms. Blackened fingers, clothes corroded by silver nitrate, and often great physical danger could not daunt the early pioneers of photography.

WAR PHOTOGRAPHY AND MATTHEW BRADY. In more than 7,000 negatives, Matthew Brady (1823–96) brought home the horrors of the Civil War. "A spirit in my feet said go, and I went," he explained. In addition to his spirit, he had to take along a wagonload of equipment. Troops called his darkroom on wheels the "Whatsit" wagon. It often became the target of enemy fire as Brady crouched inside processing glass plates while battles raged around him. Since it took three minutes to make an impression on a plate, Brady was confined to pictures of soldiers posing in camp, battlefields, and corpses in trenches. His photos of skeletons with canteens still slung around them recorded the grim reality of war with a heretofore-unknown authenticity and inspired Lincoln's Gettysburg Address.

At Bull Run, Brady was almost killed and was lost for three days. Still wearing his long linen duster, straw hat, and a borrowed sword, a gaunt and hungry Brady straggled into Washington. After loading up on new supplies, he rushed back to the front.

O'Sullivan, "Canyon de Chelly, Arizona," 1867, International Museum of Photography at George Eastman House, Rochester NY. *Travel photographs of the American West convinced Eastern legislators to establish the first national parks.*

Brady, "Ambulance Wagons and Drivers at Harewood Hospital," 1863, Library of Congress, Washington, DC. *Civil War photographer Brady's authentic pictures demonstrated the new medium's claim to be a "mirror with a memory."*

DOCUMENTARY PHOTOGRAPHY. Jacob Riis (1849–1914) was a New York police reporter who had direct experience with the violence of sordid city slums. After flash gunpowder (the equivalent of a modern flashbulb) was invented, he had the element of surprise on his side and invaded robbers' hangouts, sweatshops, and squalid tenements to document appalling conditions on Manhattan's Lower East Side. Riis published the shocking details in newspaper exposés and a book, *How the Other Half Lives* (1890). His graphic images led to the first legislation to reform housing codes and labor laws.

Riis, "Street Arabs in the Area of Mulberry Street," c. 1889, Jacob A. Riis Collection, Museum of the City of New York. *Muckraking photojournalist Riis documented unsavory living and working conditions among the urban poor, as in this shot of homeless children.*

PORTRAIT PHOTOGRAPHY. Nadar (1820–1910), a French caricaturist, began to photograph the leading artistic figures of Paris in 1853. His portraits of luminaries like George Sand, Corot, Daumier, and Sarah Bernhardt were more than just stiff documentary portraits. He conceived, posed, and lighted the figures to highlight their character traits. For instance, in his photograph of Bernhardt, the archetypal tragic actress, he posed her swathed in a dramatic sweep of drapery. Nadar was among the first to use electric light for photographs and invented aerial photography, hovering above Paris in a hot air balloon. He built one of the largest balloons in the world, Le Géant ("the giant"), and was once swept away to Germany and dragged 25 miles over rough terrain before he could halt the runaway craft.

Nadar, "Sarah Bernhardt," 1859, International Museum of Photography at George Eastman House, Rochester, NY. *Nadar photographed Paris's leading lights like the famed actress.*

Cameron, "Call, I follow; I follow; let me die," c. 1867, Royal Photographic Society, Bath. *Cameron was the first to shoot pictures out of focus in order to convey atmosphere.*

ART PHOTOGRAPHY. Julia Margaret Cameron (1815–79) wanted to capture nothing less than ideal beauty. When given a camera at the age of 48, she began making portraits of famous Victorians who also happened to be her friends: Tennyson, Carlyle, Browning, Darwin, and Longfellow. Cameron excelled at defining personality in intense portraits and said, "When I have had such men before my camera my whole soul has endeavored to do its duty towards them in recording faithfully the greatness of the inner as well as the features of the outer man. The photograph thus taken has been almost the embodiment of a prayer." She was first to have lenses specially built for a soft-focus effect in her allegorical and often overly sentimental genre pictures.

EARLY PORTRAIT PHOTOGRAPHY

It's no wonder our ancestors look stiff and grim in early daguerreotypes, given the pain involved in capturing an image. To take the first photo portraits, Samuel F. B. Morse made his wife and daughter sit dead still for twenty minutes on the roof of a building in glaring light with their eyes closed (he later painted in the eyes). Most photographers had special chairs called "immobilizers," which clamped the sitters' heads in a vise hidden from the camera's sight, to make sure their subjects held still. One victim described the ordeal, recalling that he sat "for eight minutes, with the strong sunlight shining on his face and tears trickling down his cheeks while . . . the operator promenaded the room with watch in hand, calling out the time every five seconds." Despite the discomfort, daguerreotypes were wildly popular. Emperor Napoleon III even halted his march to war in front of a studio to have his portrait taken.

PHOTOGRAPHY'S IMPACT ON PAINTING

When the French romantic painter Delaroche, known for his painstakingly detailed scenes, heard of the first photograph, he proclaimed, "From this day, painting is dead!" The art of painting miniature portraits was immediately doomed, replaced by the ubiquitous daguerreotypes which could be ready in fifteen minutes for 12½ cents. The Fauve painter Vlaminck spoke for fearful painters when he said, "We hate everything that has to do with the photograph."

Other artists viewed photographs as helpful adjuncts. Delacroix used them as studies for hard-to-hold poses, saying, "Let a man of genius make use of the Daguerreotype as it should be used, and he will raise himself to a height that we do not know." His bitter rival, Ingres, denied that photographs could ever be fine art but also used them as portrait studies, admiring "their exactitude that I would like to achieve." His portraits have a silvery style similar to daguerreotypes.

Soon many painters saw the advantage of using photographs for portraits instead of interminable sittings. After artists had reproduced the camera likeness, the subject had only to sit for final color touch-ups. Bierstadt found photos useful models for his panoramic landscapes, while Courbet and Manet also used them. Degas's frozen-action shots helped him devise unusual poses and unconventional compositions. Within three generations after the invention of photography, painters abandoned the image for abstraction.

Gradually photographers began to insist their craft was more than a trade of snapping portraits or groundwork for painting but a fine art in itself. As the writer Lamartine put it, photography was "more than an art, it is a solar phenomenon, where the artist collaborates with the sun." The camera excelled at reproducing images realistically, but photographers aspired to imitate painting. To compete with the artist's imagination, "art photographers" began to shoot images slightly out of focus, retouch negatives, add paint to prints, superimpose negatives, and otherwise manipulate the mechanically produced images. A new art form for the post-Industrial-Revolution world was born.

IMPRESSIONISM:
LET THERE BE COLOR AND LIGHT

The movement known as Impressionism marked the first total artistic revolution since the Renaissance. Born in France in the early 1860s, in its purest form it lasted only until 1886, but it nevertheless determined the course of most art that followed. Impressionism radically departed from tradition by rejecting Renaissance perspective, balanced composition, idealized figures, and chiaroscuro. Instead, the Impressionists represented immediate visual sensations through color and light.

Their main goal was to present an "impression," or the initial sensory perceptions recorded by an artist in a brief glimpse. They built on Leonardo's observation that a person's face and clothes appear green when walking through a sunlit field. Color, they discovered, is not an intrinsic, permanent characteristic of an object but changes constantly according to the effects of light, reflection, or weather on the object's surface.

To meet the challenge of portraying such fleeting qualities of light, they created a distinctive short, choppy brushstroke. These brightly colored spots formed a mosaic of irregular daubs throbbing with energy like the pulsebeat of life or the shimmer of light on water. At close range, the Impressionists' daubs of pure color side by side looked unintelligible, causing critics to charge they "fired paint at the canvas with a pistol." At a distance, however, the eye fused separate streaks of blue and yellow, for instance, into green, making each hue seem more intense than if mixed on a palette. Even their painted shadows were not gray or black (the absence of color which they abhorred) but composed of many colors.

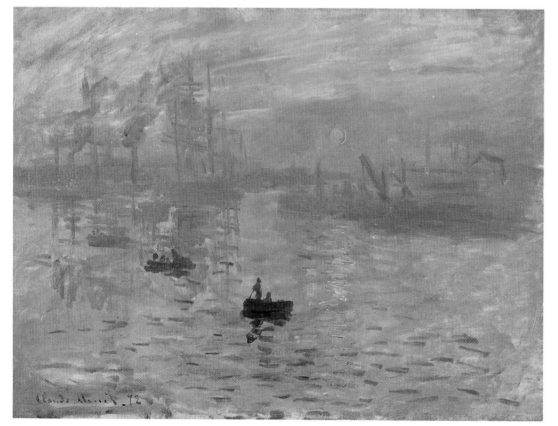

Monet, "Impression: Sunrise," 1872, Musée Marmottan, Paris. *In 1874 Degas, Sisley, Pissarro, Morisot, Renoir, and Monet, among others, mounted their first group exhibition, which included "Impression: Sunrise." This painting earned the group the name "Impressionists," coined by a critic as a derogatory slur on the "unfinished" nature of the work. (The term "impression" had before been used to denote a rapid, sketchlike treatment or first intuitive response to a subject.) Here Monet's blobs and streaks of color indicating ripples and boats at dawn were the finished painting. The name stuck.*

HOW TO TELL THEM APART

It doesn't help that Manet's and Monet's names are almost identical or that the whole group often painted the same scenes in virtually indistinguishable canvases. First impressions can be deceiving, however. Basic differences are just as striking as the similarities.

Monet, "Rouen Cathedral," 1892–94, Museum of Fine Arts, Boston.

Renoir, "Le Moulin de la Galette," 1876, Musée d'Orsay, Paris.

Manet, "Bar at the Folies-Bergère," 1882, Courtauld Institute, London.

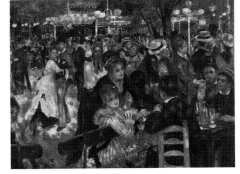

Degas, "Prima Ballerina," c. 1876, Musée d'Orsay, Paris.

ARTIST	MANET	MONET	RENOIR	DEGAS
SUBJECTS	Updated Old Masters themes, painted contemporary scenes with hard edge	Landscapes, waterfront scenes, series on field of poppies, cliffs, haystacks, poplars, Rouen Cathedral; late work: near-abstract water lilies	Voluptuous, peach-skinned female nudes, café society, children, flowers	Pastel portraits of human figure in stop-action pose; ballerinas, horse races, café society, laundresses, circus; late work: nudes bathing
COLORS	Dark patches against light, used black as accent; early: somber; late: colorful	Sunny hues, pure primary colors dabbed side by side (shadows were complementary colors dabbed side by side)	Rich reds, primary colors, detested black — used blue instead	Gaudy hues side by side for vibrancy; early: soft pastel; late: broad smears of acid-colored pastels
STYLE	Simplified forms with minimal modeling, flat color patches outlined in black	Dissolved form of subject into light and atmosphere, soft edges, classic Impressionist look	Early: quick brushstrokes, blurred figures blended into hazy background; late: more Classical style, solidly formed nudes	Offbeat angles with figures cropped at edge of canvas, asymmetrical composition with void at center
ADVICE	Not much of a theorist but did say artist "simply seeks to be himself and no one else"	"Try to forget what objects you have before you, a tree, a house, a field or whatever. Merely think, here is a little square of blue, here an oblong of pink, here a streak of yellow, and paint it just as it looks to you."	"Paint with joy, with the same joy that you would make love to a woman."	"Even when working from nature, one has to compose."

LANDMARK PAINTINGS IN ART HISTORY

Certain paintings altered the course of Western art, signaling a profound shift from one style to the next. These seminal works not only kicked off a revolution in how painters saw art, they changed the way people thought about the world.

Each of these groundbreaking paintings seemed radical in its day. Most provoked howls of outrage from conservatives. Now, however, they've become part of yesterday's tradition that new artists defy in even more controversial gestures of independence. "All profoundly original art, " said critic Clement Greenberg, "looks ugly at first."

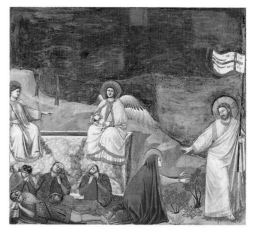

Giotto, "Noli me tangere," 1305–6, Arena Chapel, Padua. *Giotto founded the Western tradition in painting when he broke away from stylized, Byzantine figures for a more three-dimensional style and convincing sense of space. Giotto's natural style, coupled with the Renaissance mastery of anatomy and perspective, was the cornerstone of Western art until the twentieth century.*

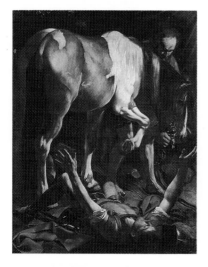

Caravaggio, "Conversion of St. Paul," c. 1601, Santa Maria del Popolo, Rome. *In his strongly lit, realistically painted figures, Caravaggio rejected Renaissance-idealized beauty and Mannerist artificiality. He introduced everyday reality into art, engaging the viewer's emotions through thrusting compositions and dramatic shadows. Although Caravaggio worked only twelve years, he revolutionized Western painting, portraying old subjects in completely new ways and ushering in the theatrical Baroque Age.*

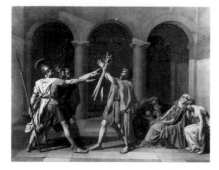

David, "Oath of the Horatii," 1784, Louvre, Paris. *David's austere, taut composition marked the end of fluffy, frivolous Rococo art. Henceforth, Neoclassical art, with its revival of interest in antiquity and morality and its rational sense of order, dominated.*

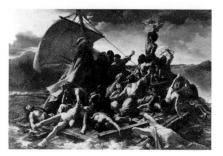

Géricault, "The Raft of the Medusa," 1818–19, Louvre, Paris. *Géricault rejected stiff, intellectualized art for passionate, subjective topics and technique. By treating a contemporary event (a shipwreck) with epic grandeur, he ushered in a new concept of what constitutes art. Instead of academic history painting, Romantic art could portray individual emotional concerns.*

Manet, "Le Déjeuner sur l'herbe," 1863, Musée d'Orsay, Paris. *Manet shattered tradition by painting female nudes as contemporary human beings, not idealized goddesses, and by abandoning academic chiaroscuro for bold light-dark contrasts. By repudiating the allegorical Salon style, he brought painting into the modern world of real life.*

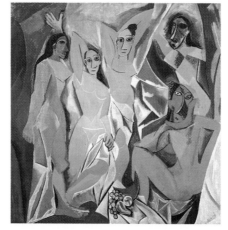

Picasso, "Les Demoiselles d'Avignon," 1907, MoMA, NY. *In this transitional painting on the brink of Cubism, Picasso exploded traditional ideas of beauty, perspective, anatomy, and color. He replaced the appearance-based style that had reigned since the Renaissance with an intellectual structure that existed only in his mind — the most important turning point in the development of no-holds-barred Contemporary art.*

Pollock, "Number 1, 1950 (Lavender Mist)," 1950, NG, Washington, DC. *Around 1947 Pollock abandoned paint brushes and easel painting, putting his canvas on the floor and pouring paint without premeditation. This process, prompted by the subconscious and incorporating chance effects, created an all-over pattern of lines and drips that eliminated accepted ideas of composition like focal point, background, and foreground. Pollock's breakthrough gave unprecedented freedom to artists and moved the avant-garde capital from Paris to New York.*

THE MOVEMENT.

Impressionism arose around 1862 when Renoir, Monet, Bazille, and Sisley were students in the same Parisian studio. Exceptionally close-knit because of their common interest in painting nature out-of-doors, they took excursions together to paint with the Barbizon artists. When urged by a teacher to draw from antique casts, the young rebels dropped formal course work. "Let's get out of here," Monet said. "The place is unhealthy." They claimed Manet as their hero, not for his style but for his independence. Rejected by the gatekeepers of officialdom, in 1874 the Impressionists decided to show their work as a group — the first of eight cooperative shows.

Their work differed drastically from the norm both in approach and technique. Painting from start to finish in the open air was their modus operandi; the usual method of sketching outside, then carefully finishing a work in the studio was, for them, a heresy. Their use of light and color rather than meticulously drawn form as guiding principles was also considered shocking. This new work had no discernible narrative content; it didn't rehash history but portrayed instead a slice of contemporary life or a flash snapshot of

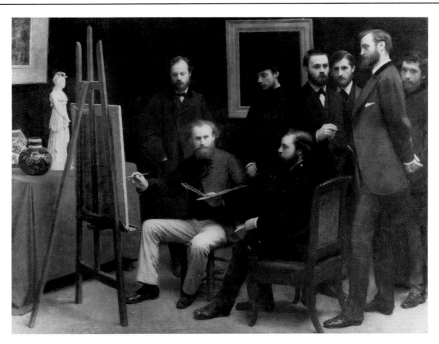

Fantin-Latour, "L'Atelier des Batignolles," 1870, Musée d'Orsay, Paris.

Manet's Gang. The still life painter Fantin-Latour celebrated Manet's role as leader of French avant-garde artists with this group portrait at Manet's studio, or "atelier." Manet is at the easel with the German painter Scholderer standing behind and writer Astruc seated for his portrait. On the right (from left) are Renoir, Zola, Edmond Maitre, Bazille, and Monet. The word "Batignolles" in the title refers to a section of Montmartre in Paris where the Impressionist painters gathered to debate art. Since they painted only during daylight hours, in the evenings they met at the Café Guerbois. Manet presided over this group of renegade painters: Degas, Cézanne, Sisley, Renoir, Fantin-Latour, Bazille, Pissarro, and Monet, known as "Manet's gang." Monet recalled, "From [these evenings] we emerged with a firmer will, with our thoughts clearer and more distinct." 1869 was the turning point. Renoir and Monet then worked side by side outdoors with their portable easels and traveling paint boxes. They established the new technique while capturing the fleeting effects of sunlight on the waters of the Seine.

nature. And how unkempt the Impressionist version of nature appeared! Landscapes were supposed to be artificially arranged à la Claude with harmoniously balanced hills and lakes. Composition for the Impressionists seemed nonexistent, so overloaded was one side of the canvas, with figures chopped off by the picture frame.

The work was considered so seditious that a cartoon showed a pregnant woman barred from entering the Impressionist exhibit, lest her exposure to such "filth" injure her unborn child. A newspaper solemnly recounted how a man, driven insane by the paintings, rushed out to bite innocent bystanders. The art critics were even

crueler. One claimed Renoir's "Nude in the Sun" made the model's flesh look putrid. They called Monet's dark daubs "tongue lickings" and pronounced his technique "slapdash." Not until the 1880s were Impressionist painters accepted and acclaimed.

CONTRIBUTIONS.

After Impressionism, painting would never again be the same. Twentieth-century painters either extended their practice or reacted against it. By defying convention, these rebels established the artist's right to experiment with personal style. Most of all, they let the light of nature and modern life blaze through the shadowy traditions of centuries.

FIRST IMPRESSIONISM

PERIOD: 1862–86

ORIGINAL CAST: Manet, Monet, Renoir, Degas, Pissarro, Sisley, Morisot, Cassatt

SUBJECTS: Outdoors, seaside, Parisian streets and cafés

PURPOSE: To portray immediate visual sensations of a scene

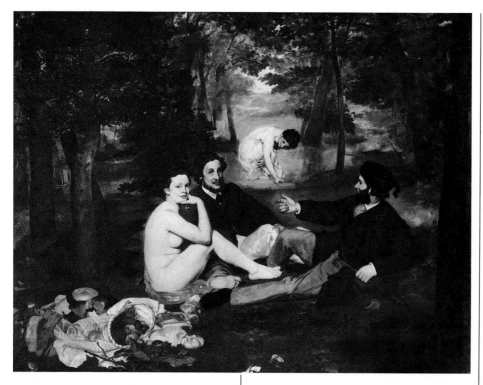

Manet, "Le Déjeuner sur l'herbe," 1863, Musée d'Orsay, Paris. *Manet painted flat areas of color — a radical break with traditional chiaroscuro.*

MANET: **PIONEER OF THE MODERN.**
Edouard Manet (1832–83) is often called the Father of Modern Art. A reluctant martyr to the avant-garde who wanted nothing more than the official recognition he was denied, Manet is difficult to classify.

Although he painted alongside Renoir and Monet, who hailed him as their leader, he never exhibited with the Impressionists. Classically trained, he saw himself in the tradition of the great masters whose motifs he often borrowed. Yet critics vilified his work, labeling it a "practical joke . . . a shameful, open sore."

What outraged the public and made Manet a hero to young rebels was his translating the Great Tradition into modern terms. Manet stripped away idealizing mythology to portray modern life candidly. He also eliminated the subtle glazing and detailed polish of academic technique. His sketchy brushwork gave his pictures an unfinished look, making his images appear flat and hard.

Art history credits Manet with launching "the revolution of the color patch." With this new technique, Manet suggested form through broad, flat areas (or patches) of color. Almost as if consciously declining to compete with the camera's realism, he refused to simulate three-dimensionality through modeling forms with lines or gradations of color. His stencillike images were purposely shallow and simplified. In place of halftones to suggest volume, he used starkly contrasting light tones against dark.

This radical shift in technique forced people to look anew at the picture surface. Ever since the Renaissance, artists regarded the framed painting as a window to look *through*, in order to see a painted scene "receding" in the distance. With Manet's minimized modeling and perspective, he insisted his viewers look *at* the picture surface itself — a flat plane covered with painted shapes.

"Déjeuner sur l'herbe," or "Luncheon on the Grass," is the painting that stigmatized Manet as "a danger" to public morality. Shown at the Salon des Refusés in 1863 (an exhibition composed of canvases rejected by the official Salon), "Déjeuner" offended on both moral and aesthetic grounds. Portraying a naked woman and two clothed men picnicking was considered indecent because Manet failed to idealize the nude. Her contemporary look, direct gaze, and the fact that she resembled no pagan deity scandalized viewers, for whom nudity was acceptable only if disguised in Classical trappings.

Actually, Manet firmly grounded the work in the Renaissance tradition, basing the painting on both Giorgione's "Concert Champêtre" and an engraving after a Raphael design. The painting was also an

updating of the traditional "fête galante" painting where decorative aristocrats lolled in misty parks. In addition, Manet used traditional elements like the triangular grouping of figures, the still life arrangement in the left foreground, the goddesslike figure bathing at rear, and receding perspective for the illusion of depth.

He tried to make the public see what Baudelaire called the "epic" side of "actual life," or "how grand we are in our neckties and varnished boots!" Yet because Manet recast these conventions in realistic modern dress, the work aroused an unprecedented firestorm of hostility.

Two years later, in 1865, Manet's "Olympia" (see p. 71) caused an even greater stir. Crowds lined up 20 feet deep — held at bay by hefty guards — to gawk at what has been called "the first modern nude," a courtesan frankly confronting the spectator. Again Manet drew on precedent, using Titian's "Venus of Urbino" as model, but this time he substituted a prostitute for a goddess. The novelist Zola praised Manet for his modernity, calling Manet "a child of the century." To the conservative majority, however, Manet's matter-of-fact presentation of a real, unclothed human being was merely vulgar.

Academic artists who exhibited to great acclaim in the annual Salon often portrayed nudes, but only as Classical deities. Their technique also differed from Manet's sketchy style. At the time, painters charged by the hour. The more meticulously they worked on a painting, putting in endless detail and a high degree of finish, the higher the sale price. Although Manet worked hard on his paintings, often repainting them many times until satisfied, he was scorned as crudely incompetent for his "shortcuts" in applying paint with broad strokes.

LATE STYLE. In the 1870s, Manet's brushwork became even freer and looser. As he began to accompany Monet and Renoir on painting trips along the Seine, his work became indistinguishable from Impressionism. Manet's late masterpiece, "A Bar at the Folies-Bergère," shows how completely he absorbed Impressionist principles. He expressed, as Matisse observed, "only what immediately touched his senses." Far more important than the cabaret bar or barmaid, the subject of the painting is the painter's sensory impressions rendered through color.

Manet excelled at giving vital, visual form to the boulevards and cafés of contemporary Paris. Alone among the Impressionists, he faced the political upheavals of his day. When starving masses rioted, other Impressionists fled to the countryside to paint flowers, but Manet rushed to the scene to record the drama of class struggle. He never blinked at reality or compromised his highly original vision. By liberating his work from artistic convention, he earned Renoir's accolade: "Manet was a whole new era of painting."

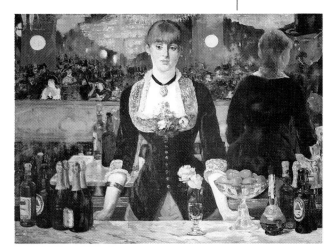

Manet, "A Bar at the Folies-Bergère," 1882, Courtauld Institute, London. *Manet used Impressionist techniques of flickering light and color.*

***MONET:* LIGHT = COLOR.** Claude Monet (1840–1926) once said he wished he had been born blind and then gained his sight so he could, without preconceptions, truly paint what he saw. As it was, revelation came at age 18 when he began to paint out-of-doors. "Suddenly a veil was torn away," he said. "My destiny as a painter opened out to me."

Monet began as a commercial artist and caricaturist but after roaming the coast of Normandy painting sunlit, water-drenched scenes, he became a leading exponent of recording nature directly to convey his immediate impression of a given moment. After studying landscapes by Constable and Turner in London, Monet contributed "Impression: Sunrise" to the first Impressionist exhibit in 1874, which summed up the new movement's theme and gave it its name forevermore. For the next half-century, while others of the original group evolved their own variations on the theme, Monet remained true to the credo that light is color.

His dedication had its price. Like Renoir, during the 1860s and '70s, Monet suffered appalling poverty, pawning his possessions for paint. In 1869 a visitor reported that Monet was desperate: "completely starved, his wings clipped." He only survived because Renoir brought him bread from his own table. In 1875 he begged his friends for financial assistance, writing Zola, "We haven't a single sou in the house, not even anything to keep the pot boiling today." Monet pleaded with collectors to take his canvases at any price and burned 200 paintings rather than let them fall into his creditors' hands. By 1886, things were different. At the Impressionists' first New York exhibit, Monet was an established success and could afford to build a special studio to house his huge canvases.

OBSESSION. Monet's unwavering devotion to Impressionist ideals entailed physical as well as economic hardship. He was so obsessed with accurately portraying fugitive conditions of light that the outdoors became his studio. Regardless of weather, he hauled thirty canvases to the field to record haystacks, replacing one canvas with the next as the light changed. In winter he planted his easel in the snow and waded through ice floes in hip boots,

CATHEDRAL SERIES

In the 1890s Monet fixed on the idea of painting the same subject under different lighting conditions at different seasons to show how color constantly changes according to the sun's position. His series of haystacks, poplars, water lilies, and the Rouen Cathedral show how light and weather conditions define both form and color. In the cathedral sequence of more than thirty canvases, the Gothic stone building, dependent on fleeting atmospheric effects recorded from dawn to twilight, virtually dissolves. At left in glaring daylight the cathedral appears bleached out. At right, the projecting stone catches the fading yellow light, with flaming orange concavities and shadows in complementary blue.

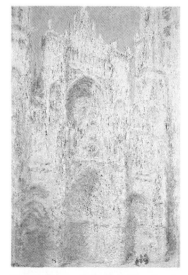

Monet, "Rouen Cathedral, West Facade, Sunlight," 1894, NG, Washington, DC.

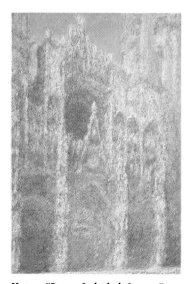

Monet, "Rouen Cathedral, Sunset," 1892–94, Museum of Fine Arts, Boston.

waiting patiently for just the right slant of light on the Seine. Once, when he painted on the beach during a storm, he was swept under by a wave.

Monet loved the water, once remarking that he wished to be buried in a buoy, and painted the sea frequently. He even converted a flat-bottomed boat, fitted out with grooves to hold his canvases, into a floating studio where he painted stacks of pictures from dawn till dusk. A visitor recalled: "In one of his Poplars the effect lasted only seven minutes, or until the sunlight left a certain leaf, when he took out the next canvas and worked on that."

Monet's lifelong fervor for open-air painting appeared as early as 1866 when he painted "Women in the Garden." Although the canvas was more than eight feet high, he was determined to paint it entirely outside and had a trench dug to hold the bottom of the canvas. He then raised and lowered the painting on pulleys as he worked on different levels. When the painter Courbet visited, he was astonished that Monet threw down his paint brush, refusing to paint even background leaves when the sun went behind a cloud.

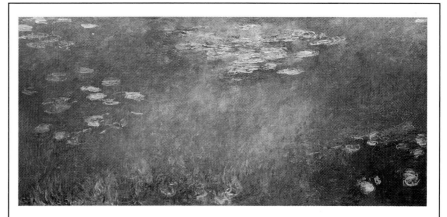

Monet, "Waterlilies," 1919–26, Cleveland Museum of Art.

GIVERNY. *When Monet went to live in Giverny, 40 miles from Paris, in 1883, it was hardly what it would become — a living canvas he called "my most beautiful masterpiece." At first he just planted a few flowers to provide still life subjects for rainy days. In 1890 Monet began to improve the garden, planting wisteria, weeping willows, and bamboo to create "a virgin forest of highly hued blossoms." Each day a gardener removed weeds and insects from the pond and clipped lily pads to keep the surface reflective. He even "bathed" the water lilies daily to increase their lustre. "Aside from painting and gardening," Monet said, "I am good for nothing."*

Each interest fed the other until, after 1911, the garden became his sole subject. Monet gradually expanded the size of the pond and the scale of his paintings, placing canvases 6 feet high and 14 feet long side by side in triptychs. When cataracts blurred his vision, Monet's painted water lilies became hazier and finally indistinguishable from the water and reflections. He had invented a new kind of painting that foreshadowed abstraction. "The essence of the motif is the mirror of water whose appearance alters at every moment, thanks to the patches of sky which are reflected in it, and which give it light and movement," he said.

Monet's compulsion to paint was so extreme he described himself as an animal endlessly turning a millstone. During his vigil at his first wife's deathbed, instead of mourning, he could not refrain from painting, recording blue, gray, and yellow streaks on her face as the pallor of death replaced the flush of life.

TECHNIQUE. Monet's style consisted of applying to the canvas small dabs of pigment corresponding to his immediate visual observations. Instead of the conventional gradations of tone, he placed vibrating spots of different colors side by side. In an effect called "optical mixing," these "broken colors" blended at a distance. To represent shadows, instead of black Monet added the complementary (or opposite) color to the hue of the object casting a shadow.

In the 1880s, Monet changed his handling of pigment. Rather than many specks of paint, he lengthened his brushstrokes into sinuous sweeps of color. In his hundreds of water lily paintings of 1900–26, Monet eliminated outlines and contours until form and line almost disappeared in interwoven brushstrokes. Vibrant colors melt into each other just as flowers blend into water and foliage. No image is the central focus, perspective ceases to exist, and reflections and reality merge in a hazy mist of swirling color. In these near-abstractions foreshadowing twentieth-century art, paint alone representing a moment of experience in light became Monet's subject.

Vision, for Monet, was supreme. He painted his colorful visions until his death at 86. "Monet is only an eye," Cézanne said. "But what an eye."

RENOIR: LOVE, LUST, AND LAUGHTER. "Renoir," a contemporary writer said, "is perhaps the only painter who never produced a sad painting." Pierre-Auguste Renoir (1841–1919) believed, "A picture must be an amiable thing, joyous and pretty — yes, pretty! There are enough troublesome things in life without inventing others."

Renoir came by the prettiness naturally, for he began by painting flowers on porcelain. Even through years of struggle when he was "so poor," as Bazille said, "that he used to pick up empty paint tubes and still squeeze something out of them," Renoir kept his cheerful optimism. This joie de vivre makes him perhaps the most beloved, and accessible, painter ever. Renoir's subjects were invariably crowd pleasers: beautiful women (often nude), flowers, pretty children, sunny outdoor scenes full of people and fun. He rooted his art in actual experience, convinced, as he said, that "Life was a perpetual holiday."

"Le Moulin de la Galette" (the name of a popular outdoor café) bursts with gaiety. Like Monet, who often painted the same subject at Renoir's side, Renoir fragmented form into glowing patches of light applied as short brush-strokes of distinct colors. The absence of outline, with form suggested by highlights, and dappled light are other Impressionist features, as was his refusal to use black. "It's not a color," he said, believing black punched a hole in the canvas. (He painted shadows and coats dark blue.) By snipping off figures at the edge of the canvas, he implied the scene expanded beyond the frame and engaged the viewer. His subjects seem unposed — momentarily caught in the flux of living.

Renoir's brother described the painter's research for the picture as far from onerous: "When he painted the Moulin de la Galette he settled down to it for six months, wedded to this whole world which so enchanted him, and for which models in poses were not good enough. Immersing himself in this whirlpool of pleasure-seeking, he captured the hectic moment with dazzling vivacity."

As his Impressionist works gained success, however, Renoir became discontent with the style, saying in 1881, "[I] had traveled as far as Impressionism could take me." He rejected the insubstantiability of the Impressionist method and looked for a more organized, structured technique. After studying Renaissance masters, Renoir turned away from contemporary scenes toward universal subjects, particularly nudes in classical poses.

NUDES. Renoir's favorite eighteenth-century artists were the painters of pretty women, Boucher and Fragonard. Where Fragonard boasted he painted with his bottom, Renoir claimed to paint with his maleness. A lusty, enthusiastic

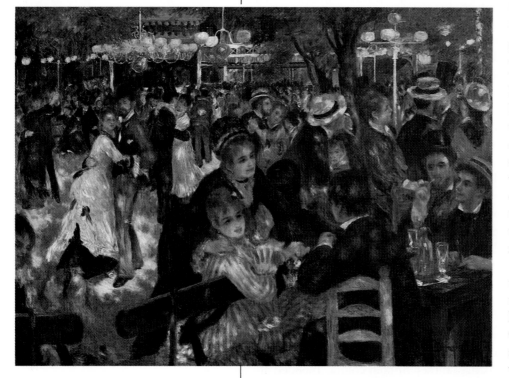

Renoir, "Le Moulin de la Galette," 1876, Musée d'Orsay, Paris. *Renoir specialized in human figures bathed in light and color, expressing the everyday joys of life. "The earth as the paradise of the gods, that is what I want to paint," he said.*

man, Renoir delighted in his portrayal of sensuous, rosy, ample nude women whom he described in amorous terms: "I consider my nude finished when I feel like smacking her bottom."

Hot red is the dominant color in his paintings of nudes, for he took great care to approximate healthy flesh tones. "I want a red to be loud, to ring like a bell; if it doesn't turn out that way, I put on more reds or other colors until I get it," he explained. "I look at a nude; there are myriads of tiny tints. I must find the ones that will make the flesh on my canvas live and quiver."

Renoir wanted to express more than just vitality and fertility, however, with his earth-mother nudes. He paid new attention to design and outlined forms distinctly in his "manière aigre" (sharp style). He posed the nudes in crisp arrangements according to Classical prototypes, as Venuses and nymphs, and eliminated background detail for a sense of timeless grandeur. "I like painting best when it looks eternal without boasting about it," he said, "an everyday eternity, revealed on the street corner: a servant-girl pausing a moment as she scours a saucepan, and becoming a Juno on Olympus."

After 1903 Renoir, afflicted with severe arthritis, lived on the Riviera. Confined to a wheelchair, his hands paralyzed, he painted with a brush strapped to his wrist. Despite what his dealer called the "torture" of this "sad state," Renoir displayed "the same good disposition and the same happiness when he [could] paint." Sadly, Renoir's diminishing artistic control is evident in his late nudes, where the buxom, ruddy-cheeked females are swollen, grossly exaggerated, and intensely colored. More important than skill for the painter, Renoir thought, was that "one should be able to see that he loves to caress his canvas."

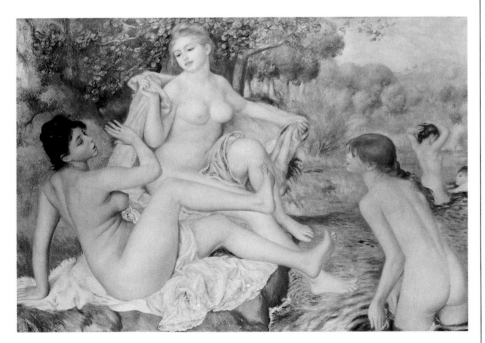

Renoir, "The Bathers," 1887, Philadelphia Museum of Art. *In Renoir's Post-Impressionist period, he painted sensuous nudes as solid, carefully defined forms.*

WHILE PARIS BURNED . . .

Ironically, while the Impressionists churned out their upbeat canvases full of light, Paris endured some of its darkest, most desperate days. In 1870–71 during the Franco-Prussian War, France suffered one humiliating defeat after another. German troops besieged Paris, devastated the city by shelling, and prevented all supplies from entering. Citizens resorted to eating rats and animals from the zoo and stripped parks of trees for fuel. Thirty-six thousand people starved to death.

Although Manet, Degas, Bazille (who died in the fighting), and Renoir served in the Army (Renoir without seeing action), Sisley, Pissarro, and Monet fled to England to escape the draft. The only blood that ever appeared in Pissarro's work was when Prussians turned his studio into a slaughterhouse, using his 1,500 painted canvases as aprons while butchering hogs.

After France's ignominious defeat, Parisian republicans set up a reform government, the Commune, brutally repressed by French troops. Civil war broke out. During this fierce resistance, 30,000 were executed. Meanwhile, the Impressionists decamped — except Manet, who produced lithographs protesting the suppression of the Commune. In rural retreats they painted dazzling landscapes, blithely oblivious to the civic upheavals they considered an unwelcome intrusion into their artistic activities.

DEGAS: THE RELUCTANT IMPRESSIONIST. "Art is not a sport," said Edgar Degas (1834–1917), explaining why he detested painting out-of-doors. Yet, despite this basic difference from the Impressionists, he was counted a charter member of the group through friendship, his commitment to contemporary subject matter, and his opposition to official academic painting.

Distinct from the others, Degas had zero interest in landscape painting and no concern for the effects of changing atmosphere and light. His subjects were limited: racetracks, circuses, opera, café scenes, women at work, nudes bathing, and — above all — ballerinas. Thoroughly trained in academic art, Degas idolized Ingres, who advised him, "Draw lines, young man, many lines, from memory or from nature; it is this way that you will become a good painter." Degas's emphasis on linear drawing and composition, as well as the three-dimensional depth and firm contours of his pictures, set him apart from the Impressionists, as did his preference for artificial light.

Degas shared with Monet, Manet, and Renoir, however, an interest in scenes that appeared unplanned and spontaneous, as if capturing a split-second glimpse of the world. For Degas, this haphazard appearance was carefully contrived. "No art was ever less spontaneous than mine," he said. "A picture is an artificial work, outside nature. It calls for as much cunning as the commission of a crime."

AT THE BARRE. Degas's specialty was the human figure in a moment of arrested motion. His hundreds of paintings, drawings, and pastels of ballerinas show his compulsion to portray casual moments of action. The unconventional poses catch the dancers off-guard while scratching, yawning, or adjusting their slippers. This "unposed," snapshot effect derived from Degas's interest in photography, which froze subjects in awkward movements.

His eccentric compositions reflect the influence of Japanese prints, which placed figures informally off-center, sometimes cropped by the edge of the frame. Degas represented dancers, onstage or at rehearsal, from oblique angles with lighting often originating below as if from footlights. He typically clusters figures to one side with large empty areas of floor space exposed. In "Prima Ballerina," (see p. 97), the stage is viewed from above, as if the spectator were in an upper box. The off-center composition and steeply tilted floor are characteristic of Degas's bold, unexpected designs.

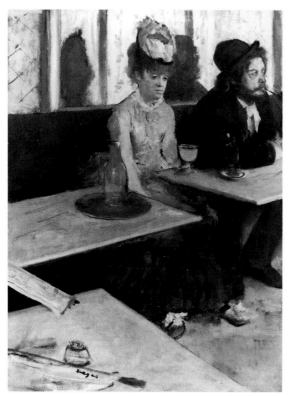

Degas, "The Glass of Absinthe," 1876, Musée d'Orsay, Paris. *Degas's "slice of life" shows the lonely downside of modern urban life.*

AT THE BAR. Degas's "Glass of Absinthe" shows a similar overloading of the figures to one side, balanced by the diagonal zigzag of empty tables drawing the reader into the picture. Although the painting has the abrupt, realistic quality of a snapshot and presents contemporary life unadorned, the effect was painstakingly contrived. Degas refused to prettify his subject, shown with brutal honesty seated before a glass of absinthe. "Art cannot be done with the intention of pleasing," he said.

NUDES. After 1886, Degas focused on pictures of women bathing, seen, he said, as if "through a keyhole," denoting the unposed quality of the works. As with dancers and subjects in the cafés, he did not idealize the figures. "I show them deprived of their airs and affectations, reduced to the level of animals cleaning themselves," he said. This innovation — to portray nudes unaware of observation, engaged in strictly utilitarian acts like toweling dry or combing their hair — gives nakedness for the first time a practical function in a picture.

To avoid stereotyped poses, Degas directed his models to move freely about the studio. He later fabricated a pose from memory, to convey a private but thoroughly natural attitude. "It is all very well to copy what you see, but it is better to draw only what you still see in your memory," he said. "Then you reproduce only what has struck you, that is to say, the essentials." Surprisingly, for one who portrayed the nude so intimately, his pictures emit no sensual warmth. When asked why his women were ugly, Degas replied, "Women in general are ugly."

PASTELS: A FIRST. As Degas's eyesight began to fail in the 1870s, he switched from oil to pastel, a powdered pigment in stick form like chalk. Pastels allowed him to draw and color at the same time, and he developed a highly original style, giving new strength to the medium. Degas was first to exhibit pastels as finished works rather than sketches and the only painter to produce a large body of major work in the medium.

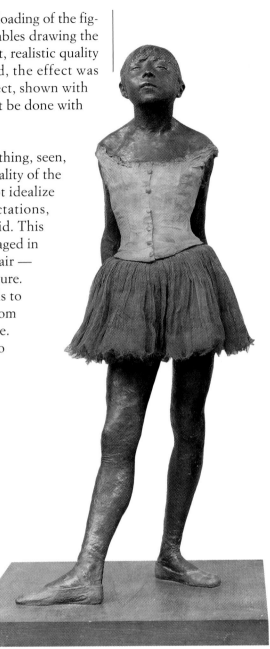

Degas, "The Little 14-Year-Old Dancer," 1879–81, cast in 1922, MMA, NY. *Degas sculpted this figure in wax when his eyesight was failing and he had to create by touch.*

As his eyes weakened, Degas's colors intensified and he simplified his compositions. In the late pastels, he loosened his handling of pigment, which exploded in free, vigorous strokes with bright colors slapped together to enhance the impact of both. He outlined forms decisively, filling them in with patches of pure color. As always, the pictures of nudes seem casually arranged, but the underlying structure was firmly composed and daring.

SCULPTURE. "A blind man's art" is what Degas called sculpture. Nearly blind, he relied on his sense of touch to model wax figurines of dancers and horses, which were cast in bronze after his death. Renoir considered them superior to Rodin's sculpture in their sense of movement — always Degas's first concern.

SUPPORTING CAST

Besides the four major Impressionist artists, other notable painters working in the style were Cassatt, Morisot, and Pissarro.

CASSATT. Although he hated to admit a woman could draw so well, when Degas first saw Mary Cassatt's (pronounced Cah SAT; 1845–1926) work, he said, "There is a person who feels as I do." Soon after they became lifelong friends, and Cassatt began to exhibit with the Impressionists. "I had already recognized who were my true masters. I admired Manet, Courbet, and Degas," she said. "I hated conventional art. I began to live."

Cassatt also hated social conventions that forbade women from pursuing a profession. Born to a wealthy Pennsylvania family, she left the United States as soon as possible to study art in Europe before settling in Paris. "How wild I am to get to work, my fingers fairly itch," she said. It wasn't so simple, however, for Victorian women. Since they were not permitted to be alone with any man except a relation, Cassatt's only male subjects were her father, brothers, and Degas (she destroyed that canvas). Her trademark images were portraits of mothers with children.

Inspired by Japanese prints, Cassatt adopted — in oil, pastels, and prints — their brightly colored, flat images and sharp designs. A gifted draftsman, like Degas she crisply and precisely outlined her figures and composed tautly calculated designs. Her figures typically dominate the picture space, crammed close to the surface, but are surrounded by expressive space, for Cassatt exploited the visual power of space between objects. She used the Impressionist palette of vivid hues, pale tints, golden light, and shadows tinged with color.

In her mother-and-child pictures (modern icons of maternity like Picasso's and Henry Moore's), the figures gesture realistically. In protective poses with faces close together, they touch, caress, and embrace.

Keenly aware of restraints imposed on all women, Cassatt became both a socialist and supporter of women's suffrage. "After all give me France," she said. "Women do not have to fight for recognition here if they do serious work." As Gauguin observed, "Mary Cassatt has charm, but she also has force."

Cassatt, "Young Mother Sewing," c. 1893, MMA, NY. *In Cassatt's trademark mother-and-child images, she adopted elements from Japanese prints like strong linear patterning and flat forms in high-keyed color.*

PRINT COLLECTING

A print is made by creating a design on a hard surface like wood, metal, or stone, which is then inked and pressed against paper to transfer the image. Relief cutting, as in Dürer's Renaissance woodcuts, was the earliest method for duplicating images. Then Rembrandt achieved subtle effects with drypoint, but until the late 1800s most artists concentrated on one-of-a-kind artworks rather than multiples.

In the 1870s what had been mainly a commercial process for duplicating pictures was revitalized by painter-engravers like Pissarro, Toulouse-Lautrec, Bonnard, and Munch. Before, artists had colored etchings (printed in ink of one color) by hand. When the Impressionists saw Japanese color woodblock prints using inks of different colors, they began applying this technique in drypoint prints (Cassatt) and color lithographs (Lautrec). Color prints became the rage in France in the 1890s, and the limited-edition color print was born. For the most part, the public did not consider prints a collectible artistic endeavor until the 1960s when galleries specializing in prints opened with works created for the medium. A boom in sales, exhibits, and connoisseurship occurred as Contemporary artists tried their hands at over-sized prints that rivaled the scale of canvases, at a fraction of the cost to collectors.

MORISOT. Berthe Morisot (1841–95), the great-granddaughter of Fragonard, was both intelligent and independent. Early on she rejected her stuffy drawing master to paint out-of-doors with Corot. While copying a Rubens in the Louvre, she met Manet, who was to become the chief influence on her work. She, in turn, persuaded him to try open-air painting and brighter colors. Since women were not allowed in life classes to

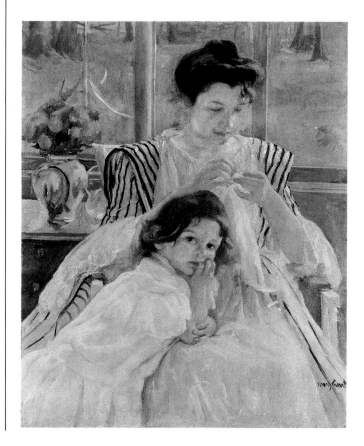

draw from the model, Morisot painted domestic scenes and women and children (her husband, Manet's younger brother, Eugène, was the only man she painted). Yet she was treated as an equal of the other Impressionists and came in for her share of condemnation at their first show. "Lunatic" critics called her, adding, "She manages to convey a certain feminine grace despite her outbursts of delirium." Morisot only laughed. In 1875, her works fetched higher prices than her male colleagues'.

Like them, Morisot used no outlines, just touches of color to indicate form and volume, but her style was even freer than the other Impressionists'. Her vigorous brushstrokes flew across the canvas in all directions. She also shared the Impressionist goal of portraying personal visual experience. Her paintings were heavily autobiographical, often dealing with her daughter, Julie. "She lived her painting," as the poet Paul Valéry said, "and painted her life."

PISSARRO. Camille Pissarro (1830–1903) was the father figure and peacemaker of the Impressionist group. A kindly anarchist, he took artists like Cézanne and Gauguin under his wing. "Do not define too closely the out-line of things," he advised. "It is the brushstrokes of the right value and color which should produce the drawing."

Pissarro excelled at reproducing an outdoor scene exactly with bright colors and patchy brushstrokes. "One must be humble in front of nature," he said. Besides rural landscapes, he is known for bustling Parisian street scenes, as if viewed from a second-story window, filled with people and carriages rendered as spots of color.

In 1890–92 Pissarro flirted briefly with the pointillism of Seurat and Signac, carefully arranging small dots of color to convey form. A patient teacher, Pissarro instructed Cézanne in how to control form through color and diagonal brushstrokes. "Humble and colossal," Cézanne called his mentor.

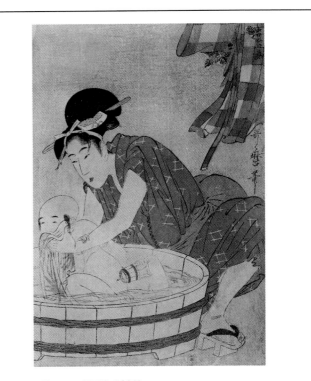

Kitagawa Utamaro (1753–1806),
"Woman Bathing Her Baby in Tub," MMA, NY.

JAPANESE WOODBLOCK PRINTS

In the 1860s Japanese color woodblock prints, known as ukiyo-e prints, were first imported into France, where they became an important influence away from the European tradition of painting. "Ukiyo," which means "floating world," referred to the red-light district of Japanese cities, where all social classes mingled in the pleasure-seeking round of theaters, restaurants, and brothels. The prints' informal glimpses of contemporary life reinforced the Impressionists' preference for modern subjects.

Artists like Degas, Manet, Cassatt, Whistler, and Gauguin also appropriated Japanese techniques, the first non-Western art to have a major impact in Europe. They imitated the flat, brightly colored, sharply outlined images and expressive, often contrasting, linear patterns. The Impressionists borrowed the prints' unusual, and often high, point of view of looking down on a scene, the lack of single-point perspective, and the off-center composition. Figures jut out of the picture frame, as if cropped haphazardly, and slanting lines lead the eye into the picture.

MORE DEVELOPMENTS IN GRAPHIC ARTS

When we left off (see p. 43), Renaissance artists were using woodcuts and engravings to produce multiple prints. Since then other techniques make possible the widespread reproduction of an artist's work.

DRYPOINT AND ETCHING. In drypoint, a design is scratched into a copperplate with a fine steel needle, which permits soft atmospheric effects. In etching, indentations on a plate are submerged in an acid bath so that only the lines appear in the print.

LITHOGRAPH. In the lithograph, the artist draws on a limestone slab with a greasy crayon. Water is applied, which adheres to the stone's nongreasy surfaces, and then greasy ink is rolled on, which sticks only where there is no water. A sheet of paper is then applied to the slab in a lithographic press to reproduce the image.

SILK SCREEN PRINTS. The newest graphic art is silk screen printing or serigraphy, developed in the United States most obviously by Andy Warhol. He attached a stencil to a screen of silk stretched on a frame, then forced ink through the stencil with a rubber squeegee. The image produced was flat and unshaded, appearing commercial and mechanical — the effect Warhol desired.

RODIN: FIRST MODERN SCULPTOR

According to the twentieth-century sculptor Brancusi, "In the nineteenth century, the situation of sculpture was desperate. Rodin arrived and transformed everything." In fact, sculpture had declined into little more than decorative public monuments. Auguste Rodin (1840–1917) singlehandedly revived sculpture as a medium worthy of an original artist.

As a young sculptor, Rodin was rejected three times by the École des Beaux-Arts. The rejection probably saved him from rigid academic formulas, as he developed his own innovative style based on the live model. A trip to Italy where Rodin studied the work of Donatello and Michelangelo marked his turning point. Michelangelo's "Bound Slave" inspired Rodin's first major, full-sized work, "The Age of Bronze." It also aroused the first major controversy in a career beset by public misunderstanding. The statue's extreme naturalism — a definitive break with the current idealizing style — so astonished critics that they accused Rodin of making it from life casts. Rodin defended the nude's realism, saying, "I obey nature in everything, and I never pretend to command her."

As compensation for maligning Rodin's reputation, he was granted the commission for a large (18'x12') sculptured portal in 1880. Based on Dante's "Inferno," the project, called the Gates of Hell, occupied Rodin until the end of his life. Although he never completed the doors, Rodin spun off many of the nearly 200 writhing figures in separate full-size sculptures, such as "The Thinker" and "The Kiss." Heavily influenced by Michelangelo's "Last Judgment," the anguished figures on the Gates tumble headlong, the intense emotion heightened by the expressive power of the human body.

To arrive at dramatic poses revealing inner feelings, Rodin refused to use professional models frozen in stock postures. "They have stuffed the antique," Rodin said of Neoclassical sculpture based on ancient Greek statuary. For Rodin, official art was too distant from real life. He hired can-can dancers to stroll about the studio assuming unusual, spontaneous poses. Compulsively modeling in clay, he followed them to capture their every movement.

The body in motion was Rodin's means of expressing emotion. "I have always endeavored," he said, "to express the inner feelings by the mobility of the muscles." Once his wife charged into the studio in a fit of anger, stomping around the room yelling. Rodin modeled her enraged face without looking at the clay. "Thank you, my dear," he said at the end of the tirade. "That was excellent."

This emphasis on personal experience as the source of art differed drastically from academic art but fit perfectly the Impressionists' focus on responding directly to the modern world. Rodin revolutionized

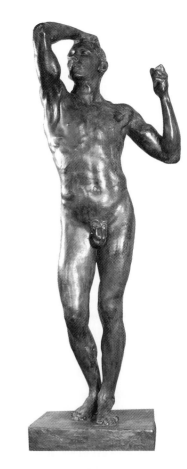

Rodin,"The Age of Bronze," 1876, Minneapolis Institute of Arts. *Rodin revitalized sculpture by abandoning the Classical tradition to present a realistic, rather than stylized, nude.*

MORE THAN RODIN'S MODEL

Stunningly beautiful and extremely talented, French sculptor Camille Claudel (1864–1943) became Rodin's model, lover, and collaborator when she was 19 and he 43. Claudel excelled at anatomy, so she contributed the hands and feet to Rodin's works. She wanted control of more than hands and feet, however. She wanted Rodin's heart. They quarreled fiercely, with frequent ruptures. Sexually insatiable, Rodin made no secret of his lust for his models. His liaisons were incessant and open. He even propositioned rich society ladies who paid him 40,000 francs each for portrait busts. After a fifteen-year stormy relationship, Claudel broke with Rodin.

Rodin acknowledged her gifts: "I have shown her where to find gold, but the gold she has found is really her own," but talent wasn't enough. As his career prospered and hers faltered, she became more bitter until her brother committed her to an asylum where she spent the last forty years of her life.

sculpture just as his Impressionist contemporaries did painting.

Rodin's greatest triumph was also his most savagely criticized work: a ten-foot-tall statue of the French writer Balzac. "I should like to do something out of the ordinary," he said with modest understatement when he began the monument. The result, unveiled in 1898 as a plaster sculpture, was so "out of the ordinary" that the public, critics, and his patrons were overwhelmingly hostile.

The statue bore little resemblance to Balzac, who, in fact, had an unprepossessing, stout build. Rodin wrapped him in a flowing robe, with most of the author's body indefinite except his grossly exaggerated mane of hair, projecting eyebrows, and recessed eyes. "I sought in 'Balzac' . . . to render in sculpture what was not photographic. My principle is to imitate not only form but also life." His radical design made no attempt to reproduce the great writer's actual features. What Rodin portrayed was the act of cre-

ativity itself, using drastic simplification and distortion to make the head seem to erupt from the massive body. It was "the face of an element," the writer Lamartine said; "the sum of my whole life," Rodin called it.

"Artistically insufficient" and "a colossal fetus," his patrons howled. Others compared "Balzac" to a penguin, a sack of coal, and a shapeless larva. "A monstrous thing, ogre, devil and deformity in one," wrote an American journalist. Rodin defended his conception as "a really heroic Balzac who . . . boils over with passion. . . . Nothing I have ever done satisfied me so much, because nothing cost me so much, nothing sums up so profoundly what I believe to be the secret law of my art."

His secret law was incompletion — or the power of suggestion — as an aesthetic principle. Rodin rescued sculpture from mechanical reproduction with his rugged, "unfinished" surfaces and suppression of detail.

CONTRIBUTIONS. By 1900 Rodin was acknowledged as the world's greatest living sculptor. Critics hailed him for the very qualities they had once denounced: portraying psychological complexity and making sculpture a vehicle for personal expression. Brancusi called Rodin's "Balzac," which brought sculpture to the brink of abstraction, "the incontestable point of departure for modern sculpture."

Rodin, "Balzac," 1897, Musée Rodin, Paris. *Rodin dispensed with literal accuracy in portraying the French writer, relying on an intuitive, summary approach that distorted anatomy to express the concept of genius.*

SHAW ON RODIN

When the English writer George Bernard Shaw decided to sit for his sculpted portrait, it was only on the condition that Rodin do it. Believing Rodin ranked with giants like Michelangelo, Shaw concluded, "any man, who, being a contemporary of Rodin, deliberately allowed his bust to be made by anybody else, must go down to posterity (if he went down at all) as a stupendous nincompoop."

The initial sitting met the satiric writer's expectations. Impressed by Shaw's forked beard, hair parted in two locks, and sneering mouth, Rodin exclaimed, "Do you know, you look like — like the devil!" Smiling with pleasure, Shaw said, "But I am the devil!"

Shaw's account of sitting for his portrait provides insight into Rodin's working methods.

"The most picturesque detail of his method was his taking a big draught of water into his mouth and spitting it onto the clay to keep it constantly pliable. Absorbed in his work, he did not always aim well and soaked my clothes."

"While he worked he achieved a number of miracles," Shaw wrote, describing how after 15 minutes Rodin produced "a bust so living that I would have taken it away with me to relieve the sculptor of any further work." The final result was "the living reproduction of the head that reposes on my shoulders."

"In sum . . . he has only two qualities that make him the most divine worker that ever was. The first is a vision more profound and truly exact than that of the others. The second is a veracity and incorruptibility. And that is all, ladies and gentlemen. And now that I have told you his secret you can all become great sculptors."

POST-IMPRESSIONISM

Post-Impressionism, like Impressionism, was a French phenomenon that included the French artists Seurat, Gauguin, Cézanne, Toulouse-Lautrec and the Dutchman van Gogh, who did his major work in France. Their careers spanned 1880–1905, after Impressionism had triumphed over academic art. The Post-Impressionists' styles derived from their forerunners' breakthroughs. Instead of the "brown gravy" of historical painting done in feebly lit studios, their canvases shone with rainbow-bright color patches. Yet the Post-Impressionists were dissatisfied with Impressionism. They wanted art to be more substantial, not dedicated wholly to capturing a passing moment, which often resulted in paintings that seemed slapdash and unplanned.

Their response to this problem split the group into two camps, much like the Neoclassical and Romantic factions earlier in the century. Seurat and Cézanne concentrated on formal, near-scientific design — Seurat with his dot theory and Cézanne with his color planes. Gauguin, van Gogh, and Lautrec, like latter-day Romantics, emphasized expressing their emotions and sensations through color and light. Twentieth-century art, with its extremes of individual styles from Cubism to Surrealism, grew out of these two trends.

Van Gogh, "The Starry Night," 1889, MoMA, NY. *Van Gogh expressed his emotional reaction to a scene through color.*

THE POST-IMPRESSIONIST ROUNDUP

To keep the major Post-Impressionists straight, here are their identifying characteristics.

ARTIST	SEURAT	TOULOUSE-LAUTREC	CEZANNE	GAUGUIN	VAN GOGH
SUBJECTS	Leisure activities in Paris	Cabaret nightlife	Still lifes with fruit, landscapes of Mont Ste-Victoire, L'Estaque	Tahiti natives, peasants in Brittany	Self-portraits, flowers, landscapes, still lifes
SIGNATURE	Bright colors in tiny dots (pointillism)	First art posters used for publicity	Proto-Cubist stress on geometric structure	Exotic primitivism	Agitated, swirling brushstrokes
MOODS	Scientific, logical	Decadent, hectic	Analytical, stable	Symbolic, mysterious	Passionate, vibrant
CONCERNS	System of optical blending in eye of beholder	Fin-de-siècle malaise	Underlying permanent order	Brilliant color to express emotion	Emotional reaction to subject through color, brushwork
HALLMARKS	Grainy surface, stylized figures in halo of light ("irradiation"); flat; precise design	Sketchy drawing, empty center, and cutoff figures at edges; eerie, indoor lighting and off-key colors, caricatures, masklike features	Balanced design; flat, squarish patches of color in graduated tones; simple geometric shapes	Simplified forms in unnatural colors, strong outlines in rhythmic patterns	Thick impasto in choppy strokes or wavy ribbons; simple forms in pure, bright colors; curling rhythms suggesting movement
BRUSH-STROKE					

***SEURAT:* POINT COUNTERPOINT.** Degas nicknamed Georges Seurat (1859–91) "the notary" because the younger painter always wore a top hat and dark suit with precisely pressed trousers. Seurat was just as meticulous in his art. "They see poetry in what I have done," Seurat once said. "No, I apply my method, and that is all there is to it."

His quasiscientific "method" is known as "pointillism." It consisted of applying confetti-sized dots of pure, unmixed color over the whole canvas. Seurat theorized that complementary (or opposite) colors, set side by side, would mix in the viewer's eye with greater luminosity than if mixed on the painter's palette. The whole was supposed to fuse together, like a mosaic, from a distance, but actually the individual specks never completely merge, giving a grainy, scintillating effect to the surface of the canvas.

Because Seurat's system was so labor-intensive, he finished only seven large paintings in his decade-long career. His most celebrated work, "A Sunday on La Grande Jatte" — so famous it inspired Stephen Sondheim's Broadway musical *Sunday in the Park with George* — took him two years and forty preliminary color studies. Seurat kept the bright, unmixed colors of the Impressionists and their holiday, open-air themes, but he added a stable design based on geometric shapes and rigorously calculated patterns.

Seurat, "A Sunday on La Grande Jatte," 1884–86, Art Institute of Chicago. *Seurat developed the pointillist technique of using small dots of pure color.*

METHOD PAINTING. After 1886, Seurat decided to systematize other elements of painting. He used color and lines like engineer's tools, assigning certain emotions to different colors and shapes to elicit predictable responses in the spectator. For Seurat, warm colors (the orange-red family) connoted action and gaiety, as did lines moving upward. Dark, cool colors (blue-green) and descending lines evoked sadness, while middle tones, or a balance of warm and cool colors, and lateral lines conveyed calm and stasis.

Seurat's last painting, "Le Cirque" (circus), conveys a mood of frenetic activity. The acid yellow and orange colors and upward-curving lines of the performers contrast jarringly with the muted spectators ranged horizontally in static rows. Seurat suppressed detail to give the scene a simplified poster style like the artificiality of the entertainment world.

Seurat died at the age of 31, three days after exhibiting the painting in an unfinished state. His mother hung "Le Cirque" over his deathbed. He was such a radical individualist that he never sought followers, saying, "The more numerous we are, the less originality we have." Yet when he died, Pissarro wrote, "You can conceive the grief of all those who followed him or were interested in his artistic researches. It is a great loss for art."

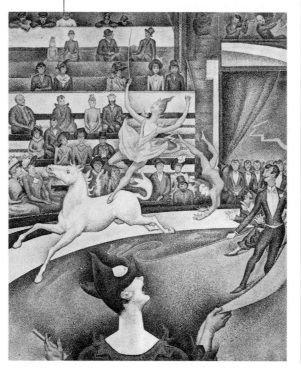

Seurat, "Le Cirque," 1891, Musée d'Orsay, Paris. *Seurat believed he could precisely stimulate emotions in his viewers by combining certain lines and colors.*

TOULOUSE-LAUTREC: POSTERS OF PARIS.

Toulouse-Lautrec's work was so similar to Degas's in style and content that he might almost be taken for a mini-Degas. Lautrec made his own sizable contributions, however, in lithography and poster art, two media he virtually invented. Although Degas, resentful of being ripped-off, was known for his sarcastic putdowns of Lautrec, he accorded him Impressionism's ultimate accolade, saying at a Lautrec exhibition, "Well, Lautrec, it's clear you're one of us."

The art of the two men was indeed similar. Henri de Toulouse-Lautrec (1864–1901) drew his subjects, like Degas, from contemporary life: Parisian theaters, dance halls, and circuses. Both artists also specialized in portraying movement and private moments through slice-of-life glimpses with abrupt, photographic cropping. The novel, asymmetric compositions of both derived from their mutual admiration of Japanese prints.

"Only the figure counts," Lautrec said. "Landscape is, and should always be, only an adjunct." Virtually all of Lautrec's paintings are of figures in interior night scenes lit somewhat arbitrarily by glaring, artificial light. His primary interests were the demimonde actors, entertainers, acrobats, and prostitutes, whom he caricatured to highlight their essential attributes.

Lautrec also caricatured his own deformed appearance in bitter self-portraits. Born to France's most blueblood family — the 1,000-year-old Counts of Toulouse — Lautrec was a self-imposed exile from high society due to a childhood tragedy. As a teenager, he broke both legs, which atrophied, giving him a five-foot stature with a child's short legs, the powerful torso of a man, and a grossly disproportionate head. As a teenage invalid, Lautrec abandoned his love of riding and shooting for his interest in art, although his teacher pronounced his early drawings "simply awful."

The adult Lautrec led a life of notorious dissipation. Alcoholic and syphilitic, he consorted with bohemians and social outcasts. For his series of paintings of bored prostitutes lounging around dreary bordellos, he lived in a brothel for a time.

Lautrec's most original contribution was in the realm of the graphic arts, for he singlehandedly made the new form of lithography and the poster respectable media for major art. Beginning about 1890, he designed posters of bold visual simplicity, which "took possession of the streets," as everyone agreed when they first appeared.

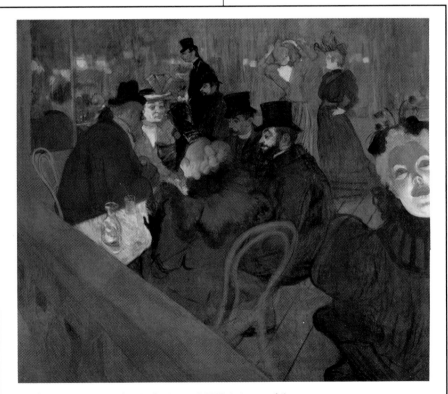

Toulouse-Lautrec, "At the Moulin Rouge," 1892, Art Institute of Chicago.

NIGHT LIFE. Lautrec's chronicle of Parisian nightlife — seen, he said, from "elbow height" — perfectly captures the malaise and decadence of the fin-de-siècle period. He uses harsh lighting and dissonant colors to convey the era's surface gaiety and underlying melancholy. Lautrec went every night to the music hall to paint and even included himself (the short bearded figure at rear), along with a host of grotesque individualized portraits.

CÉZANNE: THE PLANE TRUTH. In 1874, a critic dismissed Paul Cézanne (1839–1906) as "no more than a kind of madman, with the fit on him, painting the fantasies of delirium tremens." By 1914, "the Christopher Columbus of a new continent of form," was how another critic hailed him. In the intervening forty years, Cézanne ignored both howls and hails, painting every day, not to win "the admiration of fools," he said, but "to try to perfect what I do for the joy of reaching greater knowledge and truth."

Although he began by exhibiting with the Impressionists (after being rejected by the École des Beaux-Arts and the Salon) and was tutored in open-air painting by Pissarro, Cézanne was too much of a loner to join any group. Encouraged to come to Paris from his native Aix-en-Provence by the novelist Zola, a childhood friend, Cézanne always felt alien in the city. Even among the Impressionists he was considered beyond the pale. Manet called him a "farceur" (a joke); Degas thought he was a wild man because of his provincial accent, comical clothes, and unorthodox painting style.

The public denounced Cézanne's paintings with a vengeance: coarse, degenerate, incompetent were some of the milder opinions. At the first Impressionist exhibit in 1874, sneering crowds were loudest around Cézanne's paintings, doubling up with laughter and hooting that his canvas was "one of those weird things evolved by hashish."

Stung by ridicule, Cézanne retreated to Aix in 1886 and devoted himself tirelessly to his art. Obscure until his first one-man show in 1895, after which he was revered as a "Sage" by the younger generation of artists, Cézanne gained a reputation as an unapproachable hermit, almost an ogre. In the face of pervasive mockery and misunderstanding of his work, he continued what he called his "research" with gloomy intensity. Cézanne described his "one and only goal" as "to render, whatever our power or temperament in the presence of nature may be, the likeness of what we see, forgetting everything that has appeared before our day."

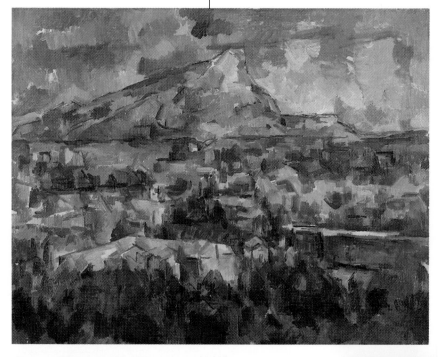

Cézanne, "Mont Sainte-Victoire," 1902–4, Philadelphia Museum of Art. *Unlike Monet's series of canvases on one subject, Cézanne's many renditions of this mountain do not vary according to season or time of day.*

Cézanne, "Still Life with Apples and Oranges," 1895–1900, Musée d'Orsay, Paris. *Cézanne wanted to express inner form, which he perceived as orderly geometric shapes, through outer form.*

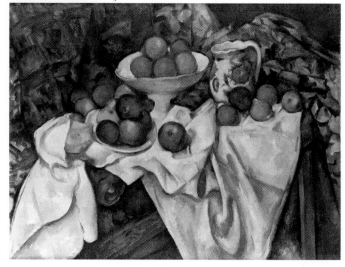

What made Cézanne's art so radical in his day and appreciated in ours was his new take on surface appearances. Instead of imitating reality as it appeared to the eye, Cézanne penetrated to its underlying geometry. "Reproduce nature in terms of the cylinder and the sphere and the cone," he advised in a famous dictum. By this he meant to simplify particular objects into near-abstract forms fundamental to all reality. "The painter possesses an eye and a brain," Cézanne said. "The two must work together."

MONT SAINTE-VICTOIRE. In "Mont Sainte-Victoire," a landscape he painted more than sixty times, Cézanne portrayed the scene like a geodesic pyramid, defining surface appearance through colored planes. To create an illusion of depth, he placed cool colors like blue, which seem to recede, at rear and warm colors like red, which seem to advance, in front.

Cézanne believed that beneath shifting appearances was an essential, unchanging armature. By making this permanent geometry visible, Cézanne hoped "to make of Impressionism," he said, "something solid and durable, like the art of the museums, to carve out the underlying structure of things." His innovative technique, applied to favorite themes of portraits, landscapes, and still lifes, was to portray visual reality refracted into a mosaic of multiple facets, as though reflected in a diamond.

STILL LIFES. Once nicknamed "Flowers and Fruit," Cézanne was as systematic in his still lifes as in landscapes. A visitor described how Cézanne set up a still life: "Cézanne arranged the fruit, contrasting the tones one against another, making complementaries vibrate, the greens

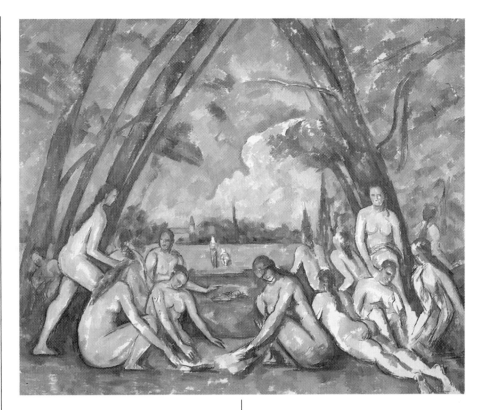

Cézanne, "Large Bathers," 1906, Philadelphia Museum of Art. *Cézanne's late nudes with their stiff, geometric forms, were a precursor to Cubism.*

against the reds, the yellows against the blues, tilting, turning, balancing the fruit as he wanted it to be. . . . One guessed that it was a feast to the eye for him." He painted and repainted so compulsively, fruit invariably rotted and had to be replaced by wax models.

NUDES. "The culmination of art is figure painting," Cézanne said, and, in his last ten years, he was obsessed with the theme of nude bathers in an outdoor setting. Because of his extreme slowness in execution, his shyness, and a fear of his prudish neighbors' suspicions, Cézanne did not work from live models. Instead he tacked up reproductions of paintings by Rubens and El Greco and drew on his own imagination rather than observation. The result — in a series of canvases — is abstracted figures as immobile as his still lifes.

Cézanne was unaffected when, in the last years of his life, recognition finally came. He continued to work just as doggedly in isolation, until the day he died. Modern artists now consider him an oracle who invented his own fusion of the real and abstract. "The greatest source of Cubism," the sculptor Jacques Lipchitz said, "was unquestionably . . . the late works of Cézanne." Like Giotto, who pioneered realistic representation, Cézanne initiated a major — though opposite — shift in art history. Cézanne liberated art from reproducing reality by reducing reality to its basic components.

GAUGUIN: "LIFE IS COLOR." "The man who came from far and who will go far" is what van Gogh called his friend Paul Gauguin (1848–1903). Both were true. Gauguin had lived in Peru as a child, spent six years before the mast as a young man sailing to exotic ports, and — before he was through — counted the South Seas islands as home.

In another sense, Gauguin had come from a vocation as far removed as the moon from the artist's life. For more than a decade, he was a prosperous Parisian stockbroker, a middle-class father of five who took up Sunday painting in 1873 and exhibited a thoroughly conventional picture in the Salon. By 1883, Gauguin had ditched his family for his new love — art — and jettisoned traditional painting for what he called "savage instinct." Not long after, the former financial wizard painted his Paris apartment chrome yellow, with the Tahitian words for "Here One Loves" over the door, and paraded the boulevards with a monkey on his shoulder and an outlandishly dressed Javanese girl on his arm.

It was obvious from the beginning Gauguin's life would be extraordinary. As an extremely gifted child always carving wood, a neighbor had predicted of him, "He'll be a great sculptor." At the age of nine Gauguin saw a picture of a hobo and ran away from home, yearning to amble down country roads with a bundle tied to a stick. "The boy is either a genius or a fool," his headmaster concluded.

When Gauguin became a full-time painter at 35, he headed for Pont-Aven in Brittany, a backward province on the French coast where, he said, "I find the primitive and the savage." He proceeded, as he said, "to restore painting to its sources," meaning to primal emotion and

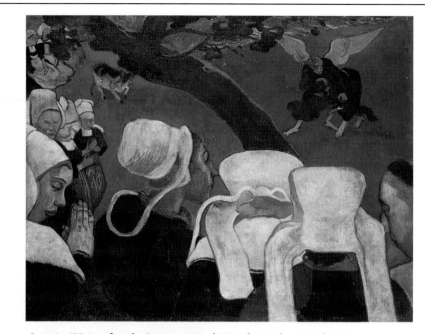

Gauguin, "Vision after the Sermon, or Jacob Wrestling with an Angel," 1888, National Gallery of Scotland, Edinburgh. *Gauguin followed his own advice, "Don't copy too much from nature. Art is an abstraction." He stylized the Breton women witnessing a supernatural vision to make them symbols of faith. He painted the ground red, separating the "real" world of the women in the foreground from the "imaginary" world of Jacob wrestling with the angel by the diagonal tree.*

imagination. In the process, Gauguin transformed art. His version of the crucifixion, "Yellow Christ," shows Christ (with Gauguin's own face) completely yellow, with the cross planted in Brittany surrounded by orange-colored trees. He used neither perspective nor chiaroscuro (which he dismissed as "hostile to color"). Young avant-garde painters (especially the group later known as the Nabis, including Vuillard and Bonnard) flocked to Pont-Aven to observe the master's startling use of color. "A meter of green is greener than a centimeter if you wish to express greenness," he told them, recommending this full approach to life as well: "Eat well, kiss well, work ditto and you'll die happy."

The public was slow to recognize his merit, and Gauguin found himself without tobacco for his pipe, sometimes going for three days without food. His painting "Breton Village in the Snow" was hung

upside down as "Niagara Falls" and sold for only seven francs. "It isn't difficult to make art," he noted ruefully. "The whole trouble is in selling it." Yet, he wrote his wife, safely ensconced with her bourgeois relatives in Denmark, "The more trouble I have the stronger I seem to grow." A visitor also noted, "He gave the strong impression of one who had sacrificed everything to art though half-knowing he would never profit from it." Often without money for materials — in Tahiti he was reduced to spreading thin paint on coarse sacking — Gauguin kept his wit. "It is true," he said, "suffering stimulates genius. It is as well not to have too much of it; otherwise it merely kills one."

What kept him going, and kept him on the move, was his "terrible longing for the unknown," as he said, "which made me commit many madnesses." This quest led him to devise a totally new method

of painting based not on his perception of reality but his conception of it. He refused to reproduce surface appearances, instead transforming colors and distorting shapes to convey his emotional response to a scene. "Life is color," Gauguin said. "A painter can do what he likes as long as it's not stupid."

"The dream caught sight of," is how he summed up what he was after in art, "something far stronger than anything material." Portraying his dreams was the essence of Gauguin's nonnaturalistic art: "A strong feeling can be translated at once," he said. "Dream over it and seek the most simple form for it." The painter Maurice Denis acknowledged Gauguin's pioneering discoveries: "Gauguin freed us from all the restraints which the idea of copying nature had placed upon us."

Seeking pure sensation untainted by "sick" civilization, Gauguin spent his last ten years in the South Seas, where he felt, as he wrote, "Free at last, without worrying about money and able to love, sing and die." He lived in a native hut with a 13-year-old Tahitian mistress, turning out vividly hued, symbolic paintings, wood sculpture, and woodcuts. Shortly before his death at age 56 in the Marquesas Islands, Gauguin remained the unrepentant individual: "It is true I know very little but I prefer the little that comes from myself," he wrote. "And who knows whether this little, taken up by others, won't become something great?"

Gauguin's contributions taken up and extended by others include flattening forms, using intensified color arbitrarily for emotional impact, and — above all — presenting his subjective response to reality. Gauguin's South Seas paintings demonstrate these tendencies. "Ia Orana Maria" (native dialect for "I hail thee, Mary") portrays the Annunciation, radically reinterpreted. Gauguin retained the angel's greeting to the Virgin and halos for Mary and Jesus. Everything else he recast in Tahitian terms, except the composition, adapted from a Javanese bas-relief. The simplified figures, the firm outlines in rhythmic patterns, the symbolism drawn from primitive and Far Eastern sources, the rich colors — especially lilac, pink and lemon —expressed the vitality that non-European culture embodied for Gauguin.

"I wanted to establish the right to dare everything," Gauguin said just before his death. "The public owes me nothing . . . but the painters who today profit from this liberty owe me something." He dared to portray an internal reality, and those who profited were Expressionists like Munch, Symbolists like Redon, Fauves like Matisse, Cubists like Picasso, and a whole slew of abstract artists. It's no wonder Gauguin is among the founders of modern art.

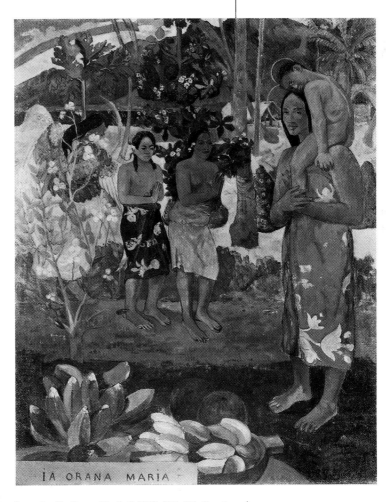

Gauguin, "Ia Orana Maria," 1892, MMA, NY. *Gauguin used flat planes, abstracted figures, and bright colors in his best-known paintings of Tahitian natives.*

VINCENT AND PAUL

Ever since they first met in Paris, van Gogh was positive he had found a kindred spirit in Gauguin. While Gauguin painted in Brittany surrounded by disciples, the Dutchman bombarded him with letters begging him to come to the South of France where they would work side by side. Van Gogh rented a small house, painted it bright yellow, and decorated a room with sunflower paintings for Gauguin. When the idolized Gauguin arrived in 1888, van Gogh was ecstatic. They painted, debated art passionately, drank, and caroused at brothels together. Gauguin brought routine to van Gogh's life, cleaning the house from top to bottom and cooking all their meals. "He seemed to catch a glimpse of all that was in him and from this sprang that whole series of sun after sun in full sunlight," Gauguin later wrote about van Gogh's masterful work during their two months together.

But bliss was not eternal. When van Gogh saw the portrait Gauguin painted of him, he said, "Yes, it's me all right, but me mad." The words proved prophetic. Later, they argued at a café and van Gogh threatened Gauguin with a straight razor. Gauguin stared him down, until van Gogh slunk away. That night, van Gogh sliced off his left ear lobe, wrapped it in a handkerchief, and presented it to a prostitute. Gauguin took the first train north. Van Gogh was thoroughly ashamed of himself. They continued to communicate by letter, and shortly before committing suicide, van Gogh referred to Gauguin as his "dear master." For his part, Gauguin later wrote, "When Gauguin says 'Vincent,' his voice is soft."

Gauguin sensed something special about their brief sojourn together. "Though the public had no idea of it," he wrote, "two men were doing a tremendous job there, useful to both. Perhaps to others too? Some things bear fruit."

VAN GOGH: PORTRAIT OF THE SUFFERING ARTIST. "Love what you love," was Dutch painter Vincent van Gogh's (1853–90) artistic credo. During a brief, ten-year career, van Gogh produced sun-scorched landscapes and brooding self-portraits.

Born in Holland, van Gogh was obsessed with religion and social service. A misfit who failed at one vocation after another, at age 27 he asked himself, "There is something inside me that could be useful, but what is it?" He determined to fulfill his "mission" to humanity through art, consoling the unfortunate through realistic portrayals of working-class life.

In 1886, when van Gogh discovered Impressionism in Paris, his work underwent a total metamorphosis. He switched from dark to bright colors and from social realist themes to light-drenched, outdoor scenes. He was still a humanitarian — at one point he proposed selling his sunflower paintings for 40¢ each to brighten the walls of workers' homes — but he changed from, as he said, trying "to express the poetry hidden in [peasants]" to portraying the healing power of nature. "These canvases will tell you what I cannot say in words," he wrote, "the health and fortifying power that I see in the country."

Even though van Gogh adopted the broken brushstroke and bright complementary colors of the Impressionists, his art was always original. He had a horror of academic technique, claiming he wanted "to paint incorrectly so that my untruth becomes more truthful than

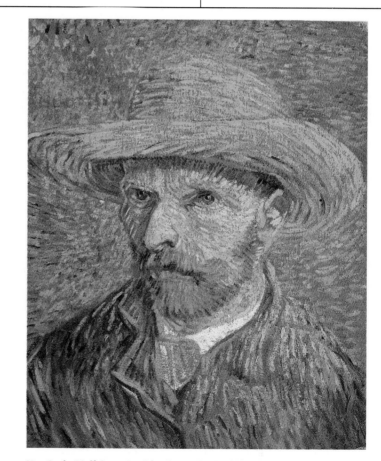

Van Gogh, "Self-Portrait with a Straw Hat," 1887, MMA, NY.

the literal truth." Van Gogh soon based his whole practice on the unorthodox use of color "to suggest any emotion of an ardent temperament." Like his hero Gauguin, van Gogh disdained realism.

Many have interpreted the distorted forms and violent, contrasting colors of van Gogh's canvases as evidence of mental imbalance. The shy, awkward painter (self-described as a "shaggy dog") was subject to overwhelming spells of loneliness, pain, and emotional collapse. Alternately depressed and hyperactive, he threw himself into painting with a therapeutic frenzy, producing 800 paintings and as many drawings in ten years. He painted all day — without stopping to eat — at white-hot speed and then continued painting into the night with candles stuck to his hat brim. He considered his work "the lightning rod for my sanity," his tenuous hold on a productive life.

Van Gogh has come to be the prototype of the suffering genius who gives himself totally to his art. "I have risked my life for my work," he said, " and my mind has half foundered." His life was bitterly unhappy. Van Gogh was thwarted in winning recognition for his work and only sold one painting during his lifetime. He was similarly unfortunate in love. Rejected by several women, when a Dutch spinster finally accepted him, her parents forbade the match and she poisoned herself.

Art became van Gogh's only refuge. In the south of France, "I let myself go," he said, "paint what I see and how I feel and hang the rules!" From 1888–90, at Arles, at the sanitorium at Saint-Rémy, and finally at Auvers under the care of Dr. Gachet, van Gogh, although deeply disturbed and prey to hallucinations, turned out one masterpiece after another, an output unmatched in the history of art. Inspired by nature, he painted cypresses, blossoming fruit trees, flowers, and wheatfields charged with his favorite color, yellow.

It was while he was a patient in the Saint-Rémy asylum that van Gogh produced "Starry Night" (see p. 112). He was painting in a "dumb fury" during this period, staying up three nights in a row to paint because, as he wrote, "The night is more alive and more richly colored than the day." Yet, though

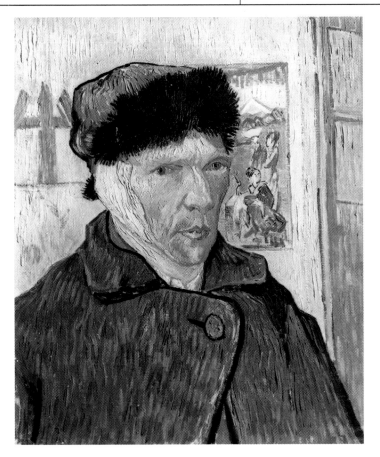

Van Gogh, "Self-Portrait with Bandaged Ear," 1889, Courtauld Institute Galleries, London.

SELF-PORTRAITS

Van Gogh did nearly forty self-portraits in oil, more than any artist except his fellow Dutchman Rembrandt. His aim in portraits was to capture the essence of human life so vividly that 100 years later, the portraits would seem like "apparitions." In his self-portraits the artist's presence seems so intense one has the impression of a tormented spirit haunting the canvas.

"Self-Portrait with a Straw Hat" reflects the Impressionist influence. Van Gogh said he wanted "to paint men and women with something of the eternal which the halo used to symbolize." The whirlpool of brushstrokes encircling his head has that effect.

The later "Self-Portrait with Bandaged Ear," done two weeks after his disastrous quarrrel with Gauguin and self-mutilation, shows van Gogh's unflinching self-revelation. Using very few colors, van Gogh concentrates all agony in the eyes. "I prefer painting people's eyes to cathedrals," he wrote, "for there is something in the eyes that is not in the cathedral."

in a fever of productivity, "I wonder when I'll get my starry night done," he wrote, " a picture that haunts me always."

The picture conveys surging movement through curving brushwork, and the stars and moon seem to explode with energy. "What I am doing is not by accident," van Gogh wrote, "but because of real intention and purpose." For all the dynamic force of "Starry Night," the composition is carefully balanced. The upward thrusting cypresses echo the vertical steeple, each cutting across curving, lateral lines of hill and sky. In both cases, the vertical forms act as brakes, counterforces to prevent the eye from traveling out of the picture. The dark cypresses also offset the bright moon in the opposite corner for a balanced effect. The forms of the objects determine the rhythmic

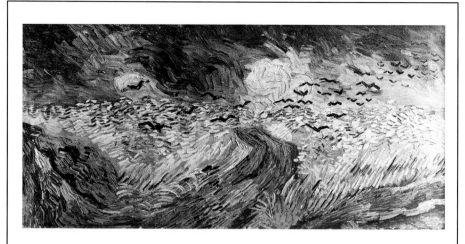

Van Gogh, "Crows over Cornfield," 1890, National Museum of Van Gogh, Amsterdam. *Shortly before he died, van Gogh painted this last picture, describing it as "vast stretches of corn under troubled skies . . . I did not need to go out of my way to express sadness and the extreme of loneliness." The dark, lowering sky and menacing crows forcefully embody his looming troubles.*

flow of brushstrokes, so that the overall effect is of expressive unity rather than chaos.

In van Gogh's last seventy days, he painted seventy canvases. Although under constant strain, he was at the peak of his powers technically, in full control of his simplified forms, zones of bright color without shadow, and expressive brushwork. "Every time I look at his pictures I find something new," his physician, Dr. Gachet, said. "He's more than a great painter, he's a philosopher."

Yet van Gogh was often despondent at his lack of prospects and dependence on his brother for financial support. "Until my pictures sell I am powerless to help," he wrote, "but the day will come when it will be seen that they are worth more than the price of the colors they are painted with, and of my life which in general is pretty barren." In 1990 van Gogh's "Portrait of Dr. Gachet" sold at auction for $82.5 million, then a record price for a work of art.

After receiving a letter from his brother complaining of financial

worries, and fearful of being a burden, van Gogh ended his last letter with the words, "What's the use?" walked into a field with a pistol, and shot himself. He died two days later. Briefly conscious before dying, he uttered his final thought, "Who would believe that life could be so sad?"

At his funeral, between sobs, Dr. Gachet eulogized van Gogh: "He was an honest man and a great artist. He had only two aims: humanity and art. It was the art that will ensure his survival." Van Gogh had said, "I would rather die of passion than boredom." He had speculated on the prospects of immortality: "A painter must paint. Perhaps there will be something else after that."

VINCENT AND THEO

Vincent and his younger brother Théo, an art dealer in Paris, had a close, though difficult, lifelong friendship. When it became obvious Vincent could never support himself in a conventional profession (he tried art gallery assistant, teacher, and missionary), Théo became his sole financial support, allowing Vincent to paint full-time. Throughout his life Vincent poured out his despair and ambitions in letters to Théo. These have become the essential source of information about the artist's life and work. When Vincent killed himself, Théo rushed to his side. Heartbroken, he wrote their mother, "He was so my own, own brother." Théo soon went mad himself and, within five months of Vincent's suicide, died.

		Record Prices for Art (in millions of dollars)
1990	$82.5	Van Gogh's "Portrait of Dr. Gachet"
2004	$104.1	Picasso's "Boy with a Pipe"
2006	$137.5	DeKooning's "Woman III"
2011	$250	Cézanne's "The Card Players"

EARLY EXPRESSIONISM

***MUNCH:* THE MIND CRACKING.** The greatest Norwegian painter and an important inspiration for the German Expressionist movement was Edvard Munch (pronounced Moonk; 1863–1944). Although he spent time in Paris where he learned from Impressionist and Post-Impressionist art, Munch's most productive period was 1892–1908 in Berlin. There he produced paintings, etchings, lithographs, and woodcuts that expressed modern anguish with unequaled power.

Munch was always an outsider, brooding and melancholy, who called his paintings his "children" ("I have nobody else," he said). His neuroses sprang from a traumatic childhood: his mother and eldest sister died of consumption when he was young, leaving him to be raised by a fanatically religious father. Even as an adult, Munch was so afraid of his father that he ordered "Puberty," his first nude painting, to be covered at an Oslo exhibit his father attended.

"Illness, madness, and death were the black angels that kept watch over my cradle," Munch wrote of his painful youth. Treated for depression at a sanatorium, Munch realized his psychological problems were a catalyst for his art. "I would not cast off my illness," he said, "for there is much in my art that I owe to it."

Munch specialized in portraying extreme emotions like jealousy, sexual desire, and loneliness. He aimed to induce a strong reaction in his viewers, saying, "I want to paint pictures that will make people take off their hats in awe, the way they do in church."

His most famous work, "The Scream," represents the intolerable fear of losing one's mind. Every line in the painting heaves with agitation, setting up turbulent rhythms with no relief for the eye. "Above the blue-black fjord," Munch wrote of "The Scream," "hung the clouds, red as blood, red as tongues of fire." Today the painting has become so famous it is practically a cliché for high anxiety, but when Munch first exhibited the painting, it caused such an uproar, the exhibit was closed.

Although Munch often went for months without painting, once he began a work, he painted in a frenzy. The easel rattled as he attacked the canvas with violent brushstrokes. After one bout of nonstop work, heavy drinking, and a disastrous love affair, Munch suffered a nervous breakdown. Afterwards determined to put aside his tormented themes, his work became more optimistic but less moving. Munch was a forerunner of Expressionism, a style that portrayed emotions through distorting form and color.

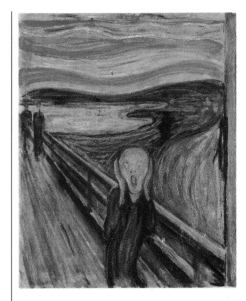

Munch, "The Scream," 1893, National Gallery, Oslo. *Munch is known for his emotionally charged images of fear, isolation, and anxiety that greatly influenced the German Expressionists.*

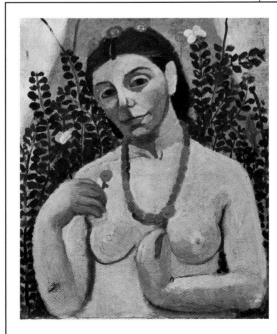

*An important precursor of Expressionism was German-born **Paula Modersohn-Becker** (1876–1907), who, working in isolation, developed a completely modern style. Searching for, as she said, "great simplicity of form," she concentrated on single figures: wide-eyed, often nude, self-portraits and portraits of peasants. In a brief career, cut short by her death from childbirth, she executed groundbreaking images of great intensity.*

Modersohn-Becker, "Self-Portrait," 1906, Öffentliche Kunstsammlung, Kunstmuseum, Basel.

SYMBOLISM

The forerunner of Surrealism, Symbolism was an artistic and literary movement that thrived in the last decade of the nineteenth century. Poets like Mallarmé and Rimbaud and painters like Odilon Redon and Gustave Moreau dis-carded the visible world of surface appearances for the inner world of fantasy. Rimbaud even advocated that the artist ought to be deranged to penetrate to the deeper truth beneath surface feelings.

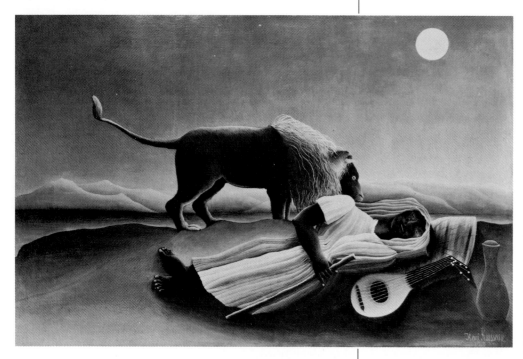

Rousseau, "The Sleeping Gypsy," 1897, MoMA, NY. *Rousseau was a self-taught painter of primitive, haunting landscapes, who was considered a forerunner of Surrealism.*

ROUSSEAU: JUNGLES OF THE IMAGINATION. When an admirer told Henri Rousseau (1844–1910) his work was as beautiful as Giotto's, he asked, "Who's Giotto?" Rousseau, also known as Le Douanier because he had been a toll collector, was as naïve as his paintings.

This French Grandma Moses was an untrained hobby painter when, confident of his ability, he quit his job at age 40 to paint full-time. "We are the two great painters of the age," he told Picasso. "You paint in the 'Egyptian' style, I in the modern." Picasso and the French avant-garde circle hailed Rousseau as "the godfather of twentieth-century painting," but one cannot be sure of Picasso's sincerity, since the professional artists who took up with Rousseau delighted in playing practical jokes on their vain, gullible colleague.

Actually, Rousseau believed his fantastic, childlike landscapes — full of strange, lurking animals and tree-sized flowers — were realistic paintings in the academic style. He studied plants and animals at the Paris zoo, but his technical limitations were clear. He minutely detailed the lush, stylized foliage and meticulously finished the painting's surface so that no brushstrokes were visible. Still, his figures were flat and the scale, proportion, and perspective were skewed. Despite — or perhaps because of — these "flaws," his stiff jungle scenes have an air of mystery and otherwordliness to them.

A simple man, Rousseau sang loudly while he worked to keep his spirits up, but sometimes frightened himself with his bizarre imaginings. Once he had to open a window and stop work until he regained his composure. A visitor saw him painting with a wreath of leaves around his thumb. When asked why, Rousseau answered, "One must study nature."

PARTY ANIMAL

Although the public derided his work, Parisian painters recognized Rousseau as a true, if somewhat dull-witted, original. Picasso hosted a banquet in his honor, decorating his studio with vines to make it look like one of Rousseau's jungles. He even set up a "throne" for Rousseau, consisting of a chair on a packing crate surrounded by flags, lanterns, and a banner proclaiming "Homage to Rousseau."

Rousseau, ensconced on the dais, stoically endured a lantern dripping wax on his head until it formed a pyramid like a dunce's cap. When the lantern caught fire, the artists easily convinced the gullible Rousseau it was a sign of divine favor. While the party swirled about him, Rousseau — who accepted the "tribute" with straight-faced gravity, even writing Picasso a thank you note — dozed off, snoring gently.

REDON: FANTASTICAL FLOWERS.

Another French painter who, like Rousseau, would later inspire the Surrealists was Odilon Redon (pronounced Ruh DON; 1840–1916). After drawing a subject accurately, "I am driven as in torment," Redon once said, "to create something imaginary." The creatures of Redon's imagination were even more bizarre than Rousseau's: macabre insects, amoeboid monsters like his noseless cyclops, plants with human heads, and a hot-air balloon that is simultaneously an eyeball.

"My originality consists in making improbable beings live," Redon said, "by putting . . . the logic of the visible at the service of the invisible." Influenced by the disturbing poetry of Poe and Baudelaire, Redon created works that evoke a hallucinatory world.

Since he was dealing with the unseen world, Redon's technique focused on suggesting rather than describing his subject. He relied on radiant color and line to inform his erotic, perverse visions.

In "Orpheus" Redon used iridescent color to evoke a magical netherworld. The painting alludes to the mythological musician — his floating, dismembered head is seen in profile beside a fragment of his lyre — who has lost his love, Eurydice. Redon's canvases sparkled with glowing color — especially the clusters of strange flowers that were his signature.

RYDER: SUBJECTIVE SEASCAPES.

The American Symbolist painter Albert Pinkham Ryder (1847–1917) was another fan of Edgar Allan Poe who, like Redon, painted pictures from his imagination and used simplified forms and yellowish light to create works of haunting intensity.

One of the most original artists of his day, Ryder was the stereotypical hermit artist, who, in his last years, refused to even go out during the day because he felt sunlight would sear his eyes. He lived alone in downtown New York amid incredible squalor. Totally indifferent to his surroundings, Ryder piled his studio waist-high with dusty papers, milk bottles, ashes, and dead mice in traps. He slept on the floor to avoid bedbugs and, when a caller knocked, it took 15 minutes to clear a path to the door. The artist "must live to paint," he said, "and not paint to live." Amid the dirt and disorder, Ryder painted a dream world that contorted reality.

Ryder looked to nature for inspiration, closely observing the sea and sky, but his paintings were intentionally short on detail to create the mystical feeling he sought. "What avails a storm cloud accurate in color," he asked, "if the storm is not within?" In "Death on a Pale Horse," his most famous painting, a menacing cobra uncoils in the foreground as a spectral figure holding a scythe gallops across a barren landscape. Although the image is drawn from Ryder's private demons, it evokes a primordial shudder.

Sadly, Ryder was as indifferent to his art materials as he was to his life-style. He worked in fits and often slapped ill-prepared paint (even candle grease) onto a wet undercoating. As a result, all 150 of his canvases are severely cracked.

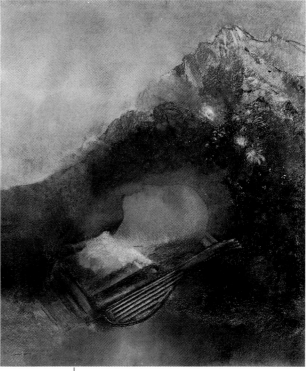

Redon, "Orpheus," 1913, Cleveland Museum of Art. *Redon is known for delicate, opalescent flowers, ghostlike profiles, and mystical apparitions.*

THE BIRTH OF MODERN ARCHITECTURE

Near the turn of the century, architecture branched out into several directions. The Neoclassical tradition continued to dominate public buildings like banks, libraries, and city halls. Architects for these civic projects studied at the École des Beaux-Arts, a prestigious but conservative art school in Paris. The "Beaux-Arts" style of domes and arches seemed out of place on the bustling streets of modern metropolises. These mock Greek or Roman buildings were like a leftover stage set from *Spartacus*.

At the same time, new materials, new technology, and new needs were drastically changing the profession of architecture, and an entirely different form of building began to emerge. Architects were called upon to design structures that had never before existed: suspension bridges, grain elevators, train sheds, factories, warehouses, and high-rise office buildings. The exorbitant cost of urban real estate made maximum use of small space imperative, and the invention of the elevator — perfected in the 1880s — made soaring skyscrapers possible. Cheap steel allowed builders to rely on a strong inner cage for support instead of the traditional masonry walls and stone columns. Architects found themselves being virtually forced by modern function to break free of ancient Greek and Roman prototypes.

Charles Garnier, Opera House, 1875, Paris. *The Beaux-Arts Opera House was the epitome of the reactionary style modern architects rejected. With its paired Corinthian columns, profusion of sculpture, and ostentatious ornament, it was the biggest and showiest theater in the world.*

Hector Guimard, Entrance to the Métro, c. 1900, Paris. *This wrought-iron entrance to the Paris Métro, or subway, shows the curling, organic, plantlike style of Art Nouveau that began to replace popular Neoclassical revival styles around the turn of the century. Twenty or so of sculptor Guimard's serpentine entrances still beautify the Métro.*

American midwestern architect Louis Sullivan's credo of "form follows function" became the rallying cry of the day. The new designs were to express a building's commercial purpose, without any overlay of historical ornament. It was somehow fitting that the first new school of architecture to emerge in centuries was born in Chicago, "Stormy, husky, brawling, /City of the Big Shoulders," as poet Carl Sandburg would later call it. Chicago was a city without a past, a city of new immigrants that seemed to be making itself up as it went along.

Chicago was also the site of the 1893 World's Fair, a huge exposition of pavilions designed to show off America's industrial might. Ironically — and sadly — the Fair's buildings, temporary plaster structures, were designed by East Coast traditionalists like Richard Morris Hunt and the firm of McKim, Mead & White in a Neo-Roman style totally out of sync with Chicago's gritty reality. Dubbed the "White City," the expo (except for Sullivan's Transportation Building) showed not the slightest trace of originality. The Fair's Neoclassicism crowned the Beaux-Arts style as king and set public architecture back for several decades. Meanwhile, the metacenter of modern design would later shift to New York where truly innovative architecture appeared in new structures like the Brooklyn Bridge, finished in 1883, and the first skyscraper, New York City's Equitable Building (1871).

***SULLIVAN*: THE FIRST MODERN ARCHITECT.** Louis Sullivan (1856–1924) virtually invented the skyscraper and, in the process, put Chicago on the cultural map. With his partner Dankmar Adler, Sullivan designed the Chicago Auditorium that opened in 1889. On opening night, dazzled by the sumptuous building, President William Henry Harrison turned to his vice-president and said, "New York surrenders, eh?"

Sullivan and Chicago were made for each other. As a boy of 12, he had wandered the streets of Boston commenting on buildings that "spoke" to him: "Some said vile things," he wrote, "some said prudent things, some said pompous things, but none said noble things." A short stint at the École des Beaux-Arts convinced him that Classicism was dead weight and a radical new approach was necessary. "It can [be done]," he wrote, "and it shall be. No one has — I will!" With this resolution, he breezed into Chicago where, despite a financial depression, "there was a stir — an energy that made [me] tingle to be in the game," he wrote.

Sullivan saw immediately that the new vertical towers demanded a wholly new aesthetic. The tall office building "must be every inch a proud and soaring thing," he said, "rising in sheer exultation that from bottom to top it is a unit without a single dissenting line." One of the earliest to use the steel frame, Sullivan insisted that this inner grid be "given authentic recognition and expression." The exterior of his designs always echoed, not only the building's function, but its interior skeleton.

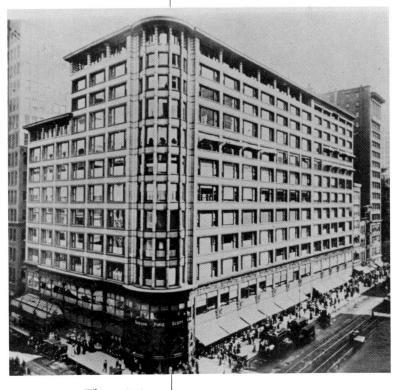

Sullivan, Carson-Pirie-Scott Department Store, 1899-1904, Library of Congress. *Louis Sullivan is considered the father of modern American architecture.*

Chicago's Carson-Pirie-Scott department store was Sullivan's revolutionary metropolitan image. Its gridlike appearance reflects its rectangular steel framework, and the sweeping horizontal bands of windows parallel the street. The stark geometric simplicity of this twelve-story building heralded the beginning of modern architecture in America.

Just because Sullivan rejected antique styles did not mean he avoided decorative elements. "Ornament, when creative, spontaneous," he wrote, "is a perfume." But just as he called for new architecture to match new technology, he wished surface decoration to be fresh and inventive. Although the top ten stories of Carson-Pirie-Scott are sleek, with bare terra-cotta sheathing, the bottom two floors, at eye level, are richly decorated with coiling cast-iron ribbons in an Art Nouveau pattern. The twisting tendrils, designed by Sullivan, interlace around the building to provide visual interest and relief from the building's unadorned bulk.

Like most visionaries, Sullivan was not appreciated as much in his day as in ours. His graceful commercial structures were considered inferior to opulent Beaux-Arts knock-'em-dead buildings like the Paris Opera House. It took Sullivan's prize pupil, Frank Lloyd Wright, to bring many of the master's ideas to fruition.

The Twentieth Century: Modern Art

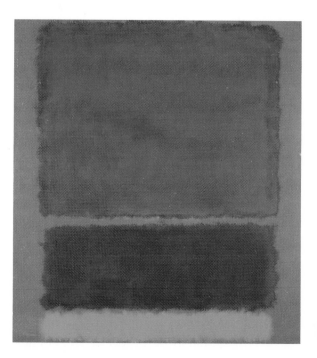

"Beauty must be convulsive or cease to be," said Surrealist spokesman André Breton. In the twentieth century, art was aggressively convulsive, with styles replacing each other as fast as hemlines changed in the fashion world. Throughout this dizzying parade, one theme was constant: art concerned itself less with exterior visual reality and more with interior vision. As Picasso put it, the artist paints "not what you see, but what you know is there."

Twentieth-century art provided the sharpest break with the past in the whole evolution of Western art. It took to an extreme what Courbet and Manet began in the nineteenth century — portraying contemporary life rather than historical events. Twentieth-century art not only declared all subjects fair game, it also liberated form (as in Cubism) from traditional rules and freed color (in Fauvism) from accurately representing an object. Modern artists defied convention with a vengeance, heeding Gauguin's demand for "a breaking of all the old windows, even if we cut our fingers on the glass."

At the core of this philosophy of rejecting the past, called Modernism, was a relentless quest for radical freedom of expression. Released from the need to please a patron, the artist stressed private concerns, experiences, and imagination as the sole source of art. Art gradually moved away from any pretense of rendering nature toward pure abstraction, where form, line, and color dominate.

During the first half of the century, the School of Paris reigned supreme. Whether or not artists of a particular trend lived in Paris, most movements emanated from France. Until World War II the City of Light shined as the brightest beacon of modern art. Fauvism, Cubism, and Surrealism originated there. In the 1950s the New York School of Abstract Expressionism dethroned the School of Paris. The forefront of innovation shifted for the first time to the United States, where Action Painter Jackson Pollock, as his colleague Willem de Kooning said, "busted our idea of a picture all to hell."

WORLD HISTORY		ART HISTORY
	1900	Guimard designs Art Nouveau ironwork
	1902	Stieglitz promotes photography as fine art
1st narrative film shown; Wrights fly airplane	1903	
Einstein announces relativity theory	1905	First Fauve exhibit; Die Brücke founded; Stieglitz opens 291 Gallery
Earthquake shakes San Francisco	1906	
	1907	Brancusi carves first abstract sculpture
1st Model T Ford produced	1908	Picasso and Braque found Cubism
	1908–13	Ash Can painters introduce realism
Peary reaches North Pole	1909	Austrian Expressionists active
	1910	Kandinsky paints first abstract canvas; Futurists issue Manifesto
	1911	Der Blaue Reiter formed
Henry Ford develops assembly line	1913	Armory Show shakes up American art
World War I declared	1914	
	1916	Dada begins
Lenin leads Russian Revolution	1917	De Stijl founded
	1918	Bauhaus formed
	1920s	Mexican muralists active
U.S. women win vote	1920	Soviets suppress Constructivism
Hitler writes *Mein Kampf*	1924	Surrealists issue Manifesto
1st "talking" movie; Lindbergh flies solo across Atlantic	1927	U.S. Precisionists active
Fleming discovers penicillin	1928	
Stock market crashes	1929	Le Corbusier designs Villa Savoye
	1930s	American Scene painters popular; Social Realists paint political art
FDR becomes President	1933	International Style architecture popular
Spanish Civil War begins	1936	New Deal employs artists
Commercial television begins	1939	
U.S. enters World War II	1941	
	1942	Hopper paints "Nighthawks"
First digital computer developed	1944	
Hiroshima hit with atom bomb; U.N. charter ratified	1945	Dubuffet coins term "L'Art Brut"
Mahatma Gandhi assassinated; Israel founded	1948	Mies van der Rohe streamlines architecture
Cold War in effect; People's Republic of China founded	1949	
Oral contraceptive invented	1950	Abstract Expressionism recognized
	1952	Harold Rosenberg coins term "Action Painting"; Frankenthaler invents stain painting
DNA structure discovered; Mt. Everest scaled	1953	
Supreme Court outlaws segregation	1954	Calder makes "mobiles"
Salk invents polio vaccine	1955	Rauschenberg creates "Bed" combine
Elvis sings rock 'n' roll	1956	Wright builds Guggenheim
Soviets launch Sputnik	1957	
Alaska and Hawaii become states	1959	Bourgeois creates abstract "totem sculptures"

FAUVISM: EXPLODING COLOR

"Fauvism isn't everything," Matisse remarked, "only the beginning of everything." In duration, Fauvism was only a blip on the screen of world art, lasting from 1904 to 1908. As the first major avant-garde art movement of the twentieth century, however, it kicked off the modern era with a bang.

The 1905 Paris exhibit that introduced Fauvism was one of those crucial moments in art history that forever changed the way we look at the world. Before, the sky was blue and grass was green. But in canvases by Fauve artists like Matisse, Vlaminck, Derain, Dufy, Braque, and Rouault, the sky was mustard-yellow, trees tomato-red, and faces pea-green. It was as if gremlins seized the color knob on the tv and all the hues went berserk.

Public response was hostile. The group got its name from a critic who called them "wild beasts" (fauves). Others termed the work "raving madness," "a universe of ugliness," and "the naive and brutal efforts of a child playing with its paintbox." A visitor to the exhibit recalled how spectators reacted with "shrieks of laughter . . . lurching hysterically in and out of the galleries."

What made critics consider the Fauves "all a little mad" was their use of color without reference to actual appearance. Far from crazy, however, they were in earnest about experimenting with new ways to express their emotional response to a scene (generally landscapes or seascapes painted outdoors).

The Fauves' radical departure from tradition originated when they saw — and were deeply impressed by — retrospectives on van Gogh, Gauguin, and Cézanne from 1901 to 1906. Vlaminck told of encountering van Gogh's work: "I was so moved, I wanted to cry with joy and despair. On that day I loved van Gogh more than my own father." Matisse had already experimented with transforming traditional subjects, as in a male figure he painted pure blue. But, after meeting Vlaminck and Derain at the van Gogh show, he visited their joint studio and saw their clashing colors and bold distortions of form. "I couldn't sleep last night," Matisse wrote the next day. The movement, which never called itself a movement although its practitioners worked together and shared common goals, was born with Matisse as its spokesman.

Another influence on the Fauves' refusal to imitate nature was their discovery of non-European tribal arts, which were to play a formative role in modern art. Derain, Vlaminck, and Matisse were among the first to collect African masks. The art of the South Seas, popularized by Gauguin, and Central and South American artifacts also led them away from the Renaissance tradition and toward freer, more individual ways of communicating emotion.

FAUVISM

LOCALE: France

PERIOD: 1904–8

NOTABLES: Matisse, Derain, Vlaminck, Dufy, Rouault, Braque

HALLMARKS: Intense, bright, clashing colors
Distorted forms and perspective
Vigorous brushstrokes
Flat, linear patterns
Bare canvas as part of overall design

TRANSLATION: Wild beast

DRUNK ON COLOR. The Fauves shared an intoxication with exaggerated, vibrant color. They liberated color from its traditional role of describing an object to expressing feelings instead. After pushing sizzling color to the extreme of non-representation, the Fauves became increasingly interested in Cézanne's emphasis on underlying structure, which gave rise to the next revolution in art: Cubism.

Braque, only very temporarily a Fauve, went on to do his best work as founder, with Picasso, of Cubism. For others, like Derain, Dufy, and Vlaminck, their brief Fauve fling represented their finest work. Of the Fauves, only Matisse continued to explore the potential of pure color as he went on reducing forms to their simplest signs. Although Fauvism was short-lived, it was highly influential, especially on German Expressionism.

By 1908, the Fauves had taken the style to its blazing limit. Burnout was inevitable. Braque explained its demise, saying, "You can't remain forever in a state of paroxysm."

VLAMINCK: TO KNOW EXCESS. Maurice de Vlaminck (1876–1958) "painted," according to one critic, "as other men throw bombs." Vlaminck did everything in extreme. When he ate lamb, he ate a whole leg; when he went cycling, he rode 150 miles in one day; when he told the story of an uneventful train derailment, he embellished it with tales of bodies littering the landscape and blood on the tracks.

Physically a big man who was extremely sure of himself, Vlaminck in his life and art was the wildest beast in the Fauve jungle. He taught boxing, played the violin in seedy cafés, and wrote soft-core porno novels. A self-taught artist, he bragged that he never set foot in the Louvre. Overwhelmed by the 1901 van Gogh show, Vlaminck, with his friend Derain, started squeezing paint on the canvas straight from the tube, smearing the bold colors thickly with a palette knife. He placed daubs of clashing colors side by side to intensify their effect, making his exuberant landscapes seem to vibrate with motion. A favorite subject was the bridge at Chatou, the Paris suburb where he lived, portrayed at a sharp tilt with thick, expressive brushwork.

DERAIN: FIREWORKS. André Derain (pronounced duh REN; 1880–1954) was the quintessential Fauve. He reduced his brushstrokes to Morse code: dots and dashes of burning, primary colors exploding, he said, like "charges of dynamite."

Derain pioneered strong color as an expressive end in itself. His bold, directional brushstrokes eliminated lines and the distinction between light and shade. In his harbor and beach scenes, the differing strokes — from choppy to flowing — give a sense of movement to sky and water.

For the first two decades of the twentieth century, Derain was at the avant-garde hub, a creator of Fauvism and an early Cubist. He later turned to the Old Masters for inspiration and his work became dry and academic. The sculptor Giacometti visited Derain, who had clearly outlived his fame, on his deathbed. When asked if he wanted anything, Derain replied, "A bicycle and a piece of blue sky."

Derain, "Big Ben," 1905, Troyes, Private collection. *Derain applied bright, clashing colors with expressive brushstrokes to distort reality — the identifying marks of Fauvism.*

DUFY: FAUVE'S ANIMATOR. It's been said one can hear tinkling champagne glasses when looking at Raoul Dufy's (pronounced Doo FEE; 1877–1953) pictures. His cheerful canvases of garden parties, concerts, horse races, regattas, and beach scenes on the coast of Normandy are undeniably fashionable. Yet Dufy was more than a mere entertainer and chronicler of the rich. His drawing was so fluid, his colors so vivacious, that he never failed to animate a scene with charm.

Everything came easily to Dufy. As a student at the École des Beaux-Arts, he found drawing with his right hand too facile, so he switched to the left, which he eventually came to prefer. Passionate about music, he closed his eyes while listening to an orchestra and visualized colors like the crimson and rose that saturate his paintings.

Although Expressionism (distorting an object's actual appearance to relay an artist's emotional response) is usually associated with violent, perverse subjects, Dufy proved it could be jovial. He used intense colors that have nothing to do with an object's appearance but everything to do with his own outlook. When accused of neglecting natural appearance in his painting, he said, "Nature, my dear sir, is only a hypothesis." Dufy's pleasure-soaked paintings of the life of leisure were immensely popular and helped win acceptance for his fellow Fauves.

ROUAULT: STAINED GLASS PAINTINGS. Georges Rouault (pronounced Roo OH; 1871–1958) worked with the Fauves briefly and shared with them technical traits like expressive brushwork and glowing color. Yet, while the other Fauves painted urbane, joyous canvases, his were filled with pain and suffering.

A devout Catholic, Rouault's lifelong concern was to redeem humanity through exposing evil. In his early work, he concentrated on condemning prostitutes and corrupt judges with savage, slashing brushstrokes. Later he portrayed sad circus clowns and finally, after 1918, virtually all his work was on religious subjects, especially the tragic face of Christ. Rouault's "passion," he believed, was best "mirrored upon a human face."

As a youth, Rouault apprenticed with a stained glass maker and repaired medieval cathedral windows. The heavy, black lines compartmentalizing bodies into richly colored segments in his mature oils have the feel of stained glass. Rouault's simplified bodies have a powerful, expressive function, to communicate his religious faith.

Rouault, "The Old King," 1916–37, Carnegie Museum of Art, Pittsburgh. *This figure of an aging Biblical king shows Rouault's trademark blocks of deep color bordered by massive black lines like stained glass.*

FIRE SALE

Georges Rouault's relationship with his dealer, the famed avant-garde champion Ambroise Vollard, was not exactly tension free. Rouault had too many overly ambitious (namely, unfinished) projects in progress at once. Vollard, whom Cézanne called a "slave driver," was always nagging him for finished work to sell.

Once Rouault nearly burned alive. Dressed as Santa Claus to amuse his children, the cotton padding in his costume caught fire from candles on the Christmas tree. His hands were seriously burned, a clear setback to his work. Vollard, ever the taskmaster, was unsympathetic. "You've been through fire!" he said. "Your painting will be all the more beautiful." But after Vollard's death, to show how little he cared for money, Rouault burned several hundred unfinished canvases in a factory furnace.

TWENTIETH-CENTURY SCULPTURE: A NEW LOOK

Sculpture soon caught up with the current of antirealism that swept twentieth-century painting.

***BRANCUSI:* THE EGG AND I.** The greatest Modernist sculptor was Rumanian artist Constantin Brancusi (1876–1957), who shaved away detail almost to the vanishing point. "Since the Gothic, European sculpture had become overgrown with moss, weeds — all sorts of surface excrescences which completely concealed shape," British sculptor Henry Moore said. "It has been Brancusi's mission to get rid of this undergrowth and to make us once more shape-conscious."

Brancusi saw reality in terms of a few basic, universal shapes: the egg, the smooth pebble, and the blade of grass. Whatever the subject, from 1910 he simplified its form — in wood, marble, or metal — into these elemental shapes. "Simplicity is not an end in art," Brancusi said. "but one arrives at simplicity in spite of oneself in drawing nearer to the reality in things."

Brancusi showed his independent spirit early. He left home at age 11 to work as a shepherd and wood-carver. He then made his way from Bucharest to Paris on foot. When he arrived in France in 1904, he was offered a job as assistant to Rodin, the reigning king of sculpture. Brancusi refused, saying, "No other tree can grow in the shadow of an oak."

Brancusi was first to abandon the accepted practice of letting professional stonecutters do the actual carving of a sculpture. In 1907 he began carving stone directly, saying his hands followed where the material led. Sculptor Jacques Lipchitz, whose studio was below Brancusi's, recalled a constant tapping like a dripping faucet that kept him awake. It was Brancusi, continually chipping away until he reached an absolute bedrock image. "Create like a god, command like a king, work like a slave," Brancusi said.

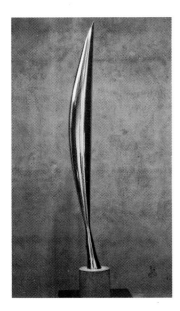

Brancusi, "Bird in Space," c. 1927, MoMA, NY. *This work represents not an actual bird but the concept of flight. "What is real is not the external form," Brancusi insisted, "but the essence of things." Although Brancusi's sculptures abandoned recognizable images entirely, he drew his themes from nature before reducing them to the most concentrated, elemental kernel.*

BRASS TAX

When "Bird in Space" was brought to the U.S. for a Brancusi show, a customs inspector refused to exempt it from duty as a sculpture. He insisted it in no way resembled a bird and was, therefore, not a work of art but a hunk of metal to be taxed as raw material. Another official had less trouble with the sculptor's work. When a Brancusi sculpture was denounced in Paris as obscene and a policeman came to haul it away, the gendarme offered this appraisal: "I see nothing indecent; this looks like a snail."

MODIGLIANI: THE PRIVILEGE OF GENIUS

Italian artist Amedeo Modigliani (1884–1920) is known primarily for paintings of reclining nudes. All the figures have long, thin necks, sloping shoulders, tilted heads with small mouths, long noses, and blank slits for eyes. In addition to his originality in painting, Modigliani was brash in both sculpture and zest for life.

Too handsome for his own good, Modi (as he was called) plunged into the bohemian life in Paris. Although poor as a pauper, he dressed to the hilt, with flying red scarf and loud corduroy suit. When the mood struck, he was wont to strip off his clothes, shouting to astounded café patrons, "Look at me! Don't I look like a god?" With his friend painter Maurice Utrillo, Modi caroused all night in bars, chanting poetry, swilling down cheap wine and absinthe, and smoking hashish. Together they made airplanes out of banknotes and sailed them over trees. He treated his mistress abominably. Once, in a violent rage, he threw her out the window. "People like us have different rights from other people because we have different needs which put us . . . above their morality," he wrote.

Modi painted portraits for a few francs to buy drink, but poverty was a real handicap when it came to sculpture. For wood to carve, he stole railway ties. Modi never cared for modeling in clay. "Too much mud," he said, so he pried up stone blocks from street beds at night. Like his neighbor, Brancusi, Modi carved simplified figures that radiate primeval power. "Your real duty is to save your dream," Modi said. After drinking all night and selling the suit he was wearing to buy more wine, he caught pneumonia in the bitter cold of dawn. Modigliani died at the age of 35.

TWIN TITANS OF THE TWENTIETH CENTURY: MATISSE AND PICASSO

If the first fifty years of twentieth-century art were reduced to two painters, they would be Picasso and Matisse, the "North and the South Pole" of art, in Picasso's words. These two prolific artists were indeed opposite points on the compass for all Modernist explorers. Each inspired a different form of revolt against realism, one of shape, the other of color. Picasso, in Cubism, broke up forms to recombine them in new ways. Matisse, not to describe form but to express feeling, launched a chromatic revolution.

MATISSE: IN LIVING COLOR. "You speak the language of color," the aging Renoir told Henri Matisse (1869–1954). From the time Matisse pioneered jellybean-bright Fauve landscapes until the brilliant cutouts of his old age, Matisse believed, "Color was not given to us in order that we should imitate Nature," he said, but "so that we can express our own emotions."

Reaction against his early experiments was so violent, Matisse would not let his wife attend his groundbreaking 1905 exhibit. When an outraged viewer insisted, "It's not a woman; it is a painting," Matisse said that was exactly his idea: "Above all, I did not create a woman, I made a picture." This was the basic premise of twentieth-century painting: art does not represent, but reconstructs, reality. Or, as the Cubist painter Braque put it, "It is a mistake to imitate what one wants to create."

ART OF OMISSION. "You were born to simplify painting," Matisse's teacher, Gustave Moreau, told his pupil. It was as if Matisse put the overblown Salon style on a diet, stripping it down to bare bones. Throughout his long career, working 12 to 14 hours a day, seven days a week, Matisse sought to eliminate nonessentials and retain only a subject's most fundamental qualities. "Condensation of sensations . . . constitutes a picture," is how Matisse explained his technique. His preliminary sketches evolved from complex to simple, from particular to general, as one after the other he pared away extraneous details. A minimalist before the term existed, Matisse perfectly evoked sensual nudes in line drawings with barely a dozen strokes.

"FEEL-GOOD PAINTINGS." Matisse lived in trying times. Countless strikes, uprisings, assassinations, and two world wars exploded around him. Yet his paintings with titles like "Joie de vivre" blithely ignored all social or political controversy. Matisse had "sun in his belly," Picasso said of his chief rival whose charming scenes shine with the radiant light of the Mediterranean coast. Matisse's typical subjects almost persuade the viewer that paradise exists on earth: tables laden with tropical fruit, flowers, and drink; views out sunny windows; and female nudes languorously reclining.

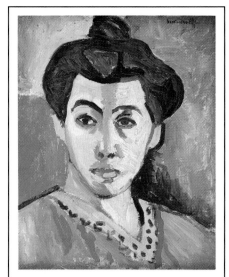

Matisse, "The Green Stripe (Madame Matisse)," 1905, Statens Museum für Kunst, Copenhagen. *Matisse used color to transform a conventional subject into a vibrating, original design. Energizing the face, the unexpected streak allows the head to compete with the assertive background. Matisse stressed surface pattern, placing equal emphasis on foreground and background, and on objects and the space around them. "No point is more important than any other," he said, abandoning shadow and perspective for a flat, ornamental, "overall" effect.*

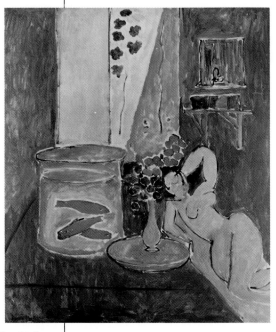

Matisse, "Goldfish and Sculpture," 1911, MoMA, NY. *One of the most influential modern painters, Matisse expressed the joy of life through powerful colors and simplified shapes.*

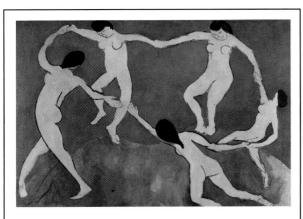

Matisse, "Dance" (first version), 1909, MoMA, NY. *Matisse used deliberately simplified forms and only three colors to portray the essence of joyful movement. The intensified colors ("The bluest of blues for the sky," he said, "the greenest of greens for the earth") were so vivacious, Matisse was startled when rays of sunlight striking the painting made it seem to quiver.*

Matisse believed painting should not only be beautiful but should bring pleasure to the viewer. He was master of the sinuously curved line called an "arabesque." "What I dream of is an art of balance, of purity and serenity devoid of troubling or depressing subject matter," he said — an art comfortable as an armchair after a hard day's work.

Matisse came late to painting, having trained to be a lawyer to please his bourgeois father. While he was recovering from an appendectomy, his mother brought him a box of paints and a how-to book, and the world lost an attorney and gained an artist. "It was as if I had been called," he remembered. "Henceforth I did not lead my life. It led me."

Matisse left for Paris to study art, with his father shouting, "You'll starve!" as the train pulled out of the station. He gained notoriety as leader of the Fauves' 1905 show. In 1917 Matisse began to spend winters on the French Riviera — first in Nice, then in Vence, where he donated a chapel of his own design that is one of the most moving religious buildings in Europe. Matisse was not a believer. His view of an afterlife was a celestial studio "where I would paint frescoes." He had, however, what he described as "a religious feeling towards life." After local nuns nursed him through a serious illness in the 1940s, the grateful Matisse devoted himself to every detail of the chapel.

THE ULTIMATE PAPER CUTOUTS. In his last years, Matisse was bedridden. Although arthritic, by fastening a charcoal stick to a bamboo fishing pole he was able to sketch huge figures on the ceiling above his bed. But his favorite activity was to cut fanciful shapes out of brightly colored paper to be glued into large-scale collages. These cutouts are the most joyous creations of any painter's old age and injected wider scope and freedom into his art.

In "Les Bêtes de la Mer" ("Beasts of the Sea"), Matisse uses symbolic shapes to imply coral, surf, and sea plants and animals. The dissonant colors produce visual excitement and energy. Indeed, his colors were so bright his doctor advised him to wear dark glasses when working on the cutouts. From floor to ceiling the vivid shapes covered his bedroom walls. "Now that I don't often get up," he said, "I've made myself a little garden to go for a walk in." The vivid collages were his most original work, the culmination of a lifetime of simplifying and intensifying art. The only difference between his earlier paintings and the cutouts, he said, was that "I have attained a form filtered to its essentials."

Matisse's constant refrain was "Exactitude is not truth." A subject's "inherent" truth — "the only truth that matters," according to Matisse — differed from outward appearance. To find this core truth meant searching for an irreducible "sign" to represent an object. The fact that the "sign" seemed childishly simple was part of Matisse's success: "I have worked for years in order that people might say, 'It seems so easy to do!'"

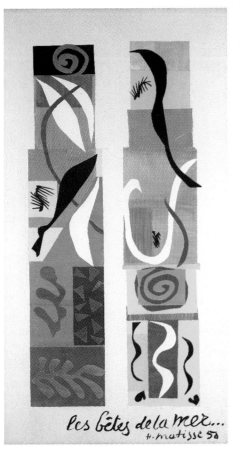

Matisse, "Les Bêtes de la Mer," 1950, NG, Washington, DC. *In Matisse's collaged paper cutouts, his characteristic elements of suggestive forms and dazzling color for emotional impact are evident.*

***PICASSO*: THE KING OF MODERN ART.** "When I was a child, my mother said to me, 'If you become a soldier, you'll be a general. If you become a monk, you'll end up as the Pope,'" Pablo Picasso (1881–1973) told his mistress Françoise Gilot. "Instead," he added, "I became a painter and wound up as Picasso."

For half a century, Picasso led the forces of artistic innovation, shocking the world by introducing a new style and then moving on as soon as his unorthodoxy became accepted. His most significant contribution — aided by Braque — was inventing Cubism, the major revolution of twentieth-century art. Until the age of 91 Picasso remained vital and versatile. Probably the most prolific Western artist ever, Picasso produced an estimated 50,000 works.

Picasso could draw before he could talk. His first words at age two were "pencil, pencil," as he beggged for a drawing tool. Born in Spain the son of a mediocre painter, by his mid-teens Picasso had mastered the art of drawing with photographic accuracy. When he visited an exhibit of children's art in 1946, he remarked at that age he could draw like Raphael, but "it took me many years to learn how to draw like these children."

Although Picasso worked in a number of distinctive styles, his art was always autobiographical. "The paintings," he said, "are the pages of my diary." Walking through the chronological sequence of work in Paris's Musée Picasso is like wandering the corridors of his love life. Women were his chief source of inspiration.

BLUE PERIOD. Picasso's first original style grew out of his down-and-out years as an impoverished artist. The Blue Period of 1901–4 is so called because of the cool indigo and cobalt blue shades Picasso used. The paintings, obsessed with scrawny blind beggars and derelicts, literally project the "blues" that seized Picasso during this period, when he had to burn his sketches for fuel. Working without recognition, he elongated the limbs of his bony figures until they looked like starved El Grecos.

ROSE PERIOD. As soon as Picasso settled full-time in Paris (he spent his working career in France) and met his first love, Fernande Olivier, his depression vanished. He began to use delicate pinks and earth colors to paint circus performers like harlequins and acrobats. The paintings of this Rose, or Circus, Period (1905–6) are sentimental and romantic.

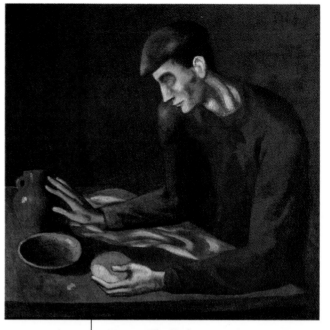

Picasso, "The Blindman's Meal," 1903, MMA, NY. *Picasso's melancholy "Blue Period" paintings portray thin, suffering beggars and tramps.*

Picasso, "Portrait of Ambroise Vollard," 1915, MMA, NY.

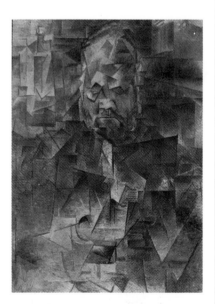

Picasso, "Portrait of Ambroise Vollard," 1910, Pushkin State Museum of Fine Arts, Moscow.

VOLLARD CUBED. *"I have no idea whether I'm a great painter," Picasso said, "but I am a great draftsman." Although he could draw likenesses as precisely as Ingres, he chose to invent new forms rather than perpetuate the old. In the Analytic Cubist portrait of Vollard, Picasso broke the subject into a crystallike structure of interlocking facets in subdued colors.*

ANATOMY OF A MASTERPIECE

During the Spanish Civil War, fascist dictator Francisco Franco hired the Nazi Lüftwaffe to destroy the small Basque town of Guernica. For three hours warplanes dropped bombs, slaughtering 2,000 civilians, wounding thousands more, and razing the undefended town. The Spaniard Picasso, filled with patriotic rage, created the 25-foot-wide by 11-foot-high mural in one month. It is considered the most powerful indictment ever of the horrors of war. "Painting is not done to decorate apartments," Picasso said. "It is an instrument of war for attack and defense against the enemy."

Picasso incorporated certain design elements to create a powerful effect of anguish. He used a black-white-gray palette to emphasize hopelessness and purposely distorted figures to evoke violence. The jagged lines and shattered planes of Cubism denote terror and confusion, while a pyramid format holds the composition together. Some of Picasso's symbols, like the slain fighter with a broken sword implying defeat, are not hard to decipher. Picasso's only explanation of his symbols was: "The bull is not fascism, but it is brutality and darkness. . . . The horse represents the people."

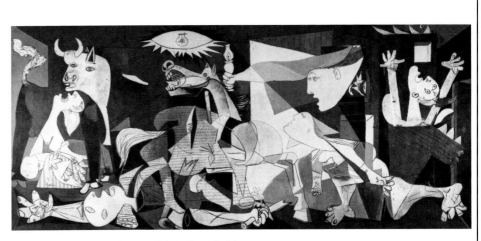

Picasso, "Guernica," 1937, Reina Sofía Art Center, Madrid.

"NEGRO" PERIOD. Picasso discovered the power of abstracted African masks around 1907, incorporating their motifs into his art. In the same year he produced the breakthrough painting "Demoiselles d'Avignon," one of the few works that singlehandedly altered the course of art.

HARBINGER OF CUBISM: "LES DEMOISELLES D'AVIGNON." Called the first truly twentieth-century painting, "Demoiselles" (see p. 22) effectively ended the nearly 500-year reign of Renaissance-ruled Western art. The most radical shift since works by Giotto and Masaccio, it shattered every precept of artistic convention. Picasso's five nudes are hazy on anatomy, with lop-sided eyes, deformed ears, and dislocated limbs. Picasso also fractured the laws of perspective, breaking up space into jagged planes without orderly recession — even presenting the eye of one figure from a frontal view and face in profile. Picasso smashed bodies to bits and reassembled them as faceted planes that one critic compared to a "field of broken glass."

The aggressive ugliness of the women repelled visitors to Picasso's studio. Matisse thought the painting a hoax and Braque, shaken, said, "It is like drinking kerosene in order to spit fire." The modern writer Gertrude Stein, Picasso's friend and patron (whose own portrait by Picasso was less than flattering, although she admitted, "For me, it is I") defended his daring: "Every masterpiece has come into the world with a dose of ugliness in it. This ugliness is a sign of the creator's struggle to say something new."

"I paint what I know," Picasso said, "not what I see." Inspired by Cézanne's geometric patterns, Picasso broke reality into shards representing multiple views of an object seen from front, rear, and back simultaneously.

SCULPTURE. Picasso shook up sculpture as thoroughly as he did painting. In 1912 his "Guitar" sheet metal assemblage completely broke with traditional methods of carving or modeling marble or clay. One of the first to use found objects, Picasso transformed the unlikeliest materials into sculpture, as in his "Head of a Bull" composed of a bicycle seat and handlebars.

DIVERSITY. After World War I, Picasso experimented with widely differing styles, drawing faithful likenesses one day and violently distorted figures the next. "To copy others is necessary," Picasso believed, "but to copy oneself is pathetic." With such miscellaneous talents and interests, there could be no smooth sequence of "early," "middle," and "late" styles.

A restless explorer constantly re-inventing the shape of art, Picasso summed up his career in the words: "I love discovering things." As his friend Gertrude Stein put it, "He alone among painters did not set himself the problem of expressing truths which all the world can see, but the truth which only he can see."

CUBISM

One of the major turning points in twentieth-century art, Cubism lasted in pure form only from 1908 to 1914. The style got its name from Matisse's dismissal of a Cubist landscape by Georges Braque as nothing but "little cubes." Although the four "true" Cubists — Picasso, Braque, Gris, and Léger — broke objects into a multitude of pieces that were not actually cubes, the name stuck. Cubism liberated art by establishing, in Cubist painter Fernand Léger's words, that "art consists of inventing and not copying."

ANALYTIC CUBISM. The first of two phases of Cubism was called "Analytic" because it analyzed the form of objects by shattering them into fragments spread out on the canvas. Picasso's "Ambroise Vollard" (see p. 136) is a quintessential work of Analytical Cubism. Picasso and Braque worked in a nearly monochrome palette, using only brown, green, and later gray in order to analyze form without the distraction of bright colors.

SYNTHETIC CUBISM. Braque and Picasso invented a new art form, called collage (from the French word "coller," to glue). From 1912 to 1914, joined by Spanish painter Juan Gris, they incorporated stenciled lettering and paper scraps into their paintings. Braque's "Mandolin" dismantles the stringed instrument only to reassemble, or "synthesize," its essential structural lines in corrugated cardboard and newsprint.

Besides Braque and Picasso, Juan Gris (pronounced Grease; 1887–1927) contributed significantly to Synthetic Cubism. From 1909, Fernand Léger (pronounced Lay ZJEH; 1881–1955) added curved

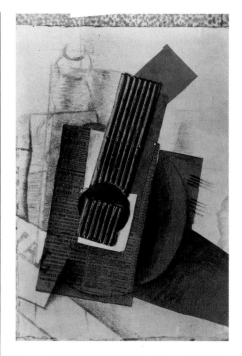

Braque, "Mandolin," 1914, Ulmer Museum, Ulm, Germany. *Coinventor of Cubism with Picasso, Braque collaborated in the development of collage during the Synthetic Cubist phase.*

forms to the angular Cubist vocabulary. Because his shapes tended to be tubular, he was inevitably dubbed a "Tubist." He is most noted for his urban, industrial landscapes full of polished, metallic shapes, robotic humanoids, and hard-edged mechanical gears.

The teasing quality of all Cubist art springs from its ambivalence between representation and abstraction. On the brink of dissolving an object into its component parts, hints of it flicker in and out of consciousness. Based on the world of appearances, Cubism delivers a multi-faceted fly's-eye view of reality. "It's not a reality you can take in your hand. It's more like a perfume," Picasso said. "The scent is everywhere but you don't quite know where it comes from."

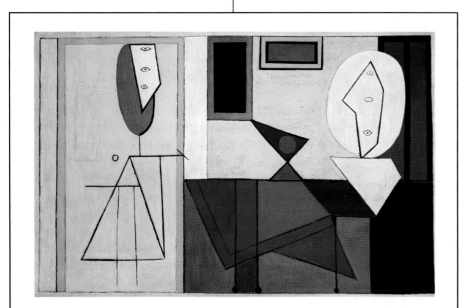

Picasso, "The Studio," 1928, MoMA, NY.

SYNTHETIC CUBISM *employs strong colors and decorative shapes. At left the painter holds a brush indicated by a small diagonal line at the end of a horizontal "arm." His oval "head" contains three vertical eyes, perhaps suggesting the painter's superior vision. A floating circle is all that remains of the artist's palette. His subject, a still life of fruit bowl and bust on a table with red tablecloth, also consists of geometric shapes. What holds the tautly constructed composition together are repeated (and precisely related) vertical, horizontal, and diagonal lines.*

MODERNISM OUTSIDE OF FRANCE

During the decade after the birth of Cubism, the world witnessed astounding changes. Technology zoomed ahead at breakneck speed, transforming the world from agrarian to industrial, from rural to urban. Against a backdrop of World War I, Europe erupted in political chaos. Finally the Russian revolution of 1917 called for the destruction of everything from the old regime. Artists searched for new forms to express this upheaval. Three movements — Futurism in Italy, Constructivism in Russia, and Precisionism in the United States — adapted the forms of Cubism to redefine the nature of art.

FUTURISM

KINETIC ART. Futurism began in 1909 as a literary movement when the Italian poet F. T. Marinetti issued its manifesto. Marinetti, a hyperactive self-promoter nicknamed "The Caffeine of Europe," challenged artists to show "courage, audacity, and revolt" and to celebrate "a new beauty, the beauty of speed."

BOCCIONI: **POETRY IN MOTION.** Marinetti found an ally in the ambitious, aggressive painter Umberto Boccioni (1882–1916), who urged painters to forsake art of the past for the "miracles of contemporary life," which he defined as railroads, ocean liners, and airplanes. The bossy Boccioni, labeled by a friend "Napoleon come back to life," refused to study academic art: "I want to paint the new, the fruit of our industrial age."

FASTER THAN A SPEEDING BULLET. The key to Futurist art, practiced by Giacomo Balla, Carlo Carrà, Luigi Russolo, and Gino Severini in addition to Boccioni, was movement. The painters combined bright Fauve colors with fractured Cubist planes to express propulsion. In his most famous painting, "The City Rises," Boccioni portrayed workers and horses bristling like porcupines with his trademark "lines of force" radiating from each figure to imply velocity. He tried to capture not just a freeze-frame "still" of one instant but a cinematic sensation of flux.

Although Futurist art was fairly well received, the members' public demonstrations caused an uproar. To provoke the passive public, Futurists climbed the bell tower of Venice's St. Mark's. As churchgoers exited, they bombarded them with outrageous slogans blasted through loudspeakers: "Burn the museums! Drain the canals of Venice! Burn the gondolas, rocking chairs for idiots! Kill the moonlight!" The rebels measured their success by the amount of abuse in the form of insults, rotten fruit, and spoiled spaghetti the crowd hurled back at them.

Boccioni's most famous work is "Unique Forms of Continuity in Space." The charging figure is an answer to Marinetti's belief that "a roaring racing car that seems to run on shrapnel is more beautiful than the Victory of Samothrace." Boccioni's Futuro-Cubist Nike (see p. 13 for original) slices through space trailing flamelike flaps. "I am obsessed these days by sculpture," Boccioni wrote. "I think I can achieve a complete revival of this mummified art." After making good on his boast, he died in a riding accident at age 34. Boccioni and Marinetti founded a movement based on speed. With the death of its leading artist, Boccioni, Futurism died fast.

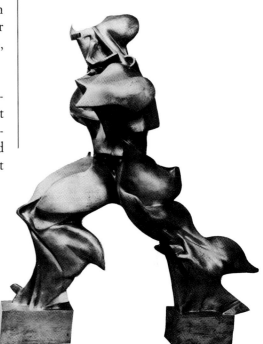

Boccioni, "Unique Forms of Continuity in Space," 1913, MoMA, NY. *Boccioni celebrated the power and dynamism of modern life in this Futurist sculpture of a striding figure.*

THE FUTURIST COOKBOOK

As part of their quest to overthrow all tradition, Futurists even advocated a new cooking style called Cucina Futuristica. Recipes used "completely new, absurd combinations" of ingredients, like a sauce made of chocolate, pistachio, red pepper, and eau de cologne. Buon appetito!

CONSTRUCTIVISM: SEEING RED.

Around 1914 the Russian avant-garde flourished with artists, called Constructivists, like Vladimir Tatlin, Liubov Popova, Kasimir Malevich, El Lissitzky, Alexander Rodchenko, Naum Gabo, and Antoine Pevsner. From Cubism the Constructivists borrowed broken shapes. From Futurism they adopted multiple overlapping images to express agitated modern life. These artists pushed art from representational to abstract.

Then the 1917 revolution converted Russian society from a feudal state to a "people's republic." Lenin tolerated the avant-garde. He thought they could teach the illiterate public his new ideology through developing novel visual styles. For a brief time, before Stalin cracked down and forbade "elitist" easel painting, Russia's most adventurous artists led a social, as well as artistic, revolution. They wanted to strip art, like the state, of petty bourgeois anachronisms. They tried to remake art, as well as society, from scratch.

THREE MODERNIST MOVEMENTS			
	FUTURISM	CONSTRUCTIVISM	PRECISIONISM
PERIOD:	1909–18	1913–32	1915–30
LOCALE:	Italy	Russia	United States
ARTISTS:	Boccioni, Balla, Severini, Carrà, Russolo	Tatlin, Malevich, Popova, Rodchenko, Lissitzky, Gabo, Pevsner	Sheeler, Demuth, O'Keeffe
FEATURES:	lines of force representing movement and modern life	geometric art reflecting modern technology	sleek urban and industrial forms

Tatlin, "Model for the Monument for the 3rd International," 1920. Recreated in 1968 for exhibition at the Moderna Museet, Stockholm. *Tatlin planned this revolving tower as a symbol of the momentum and unlimited potential of the Soviet Union.*

About 1914 Tatlin (pronounced TAT lahn; 1885–1953) originated Russian geometric art. He called this abstract art, which was intended to reflect modern technology, "Constructivism" because its aim was "to construct" art, not create it. The style prescribed using industrial materials like glass, metal, and plastic in three-dimensional works. Tatlin's most famous work was a monument to celebrate the Bolshevik revolution. Intended to be 1,300 feet tall, or 300 feet higher than the Eiffel Tower, the monument was planned for the center of Moscow. Since steel was scarce, his idea remained only a model, but it clearly would have been the most astonishing "construct" ever. Tilted like the leaning Tower of Pisa, the openwork structure of glass and iron was based on a continual spiral to denote humanity's upward progress.

Tatlin's rival, Malevich (pronounced Mah LAY uh vich; 1878–1935), also pioneered abstract geometric art. His squares floating on a white background and finally his white-on-white paintings simplified art more radically than ever before. Malevich wanted "to free art from the burden of the object." He tried to make his shapes and colors as pure as musical notes, without reference to any recognizable object. Popova (1889–1924) added glowing color to Analytic Cubism.

These artists believed they could build a technological utopia through their designs. But around 1924 the dream ended brutally. The Communist Party declared art must be functional, an art for the masses, preferably propagandistic. Stalin sent nonconforming artists to labor camps and locked away their Modernist works in cellars. The flowering of Russian invention and optimism lasted only a brief "Prague spring."

PRECISIONISM: MODERNISM IN AMERICA.

In 1907 when Picasso was effectively burying the Renaissance with "Les Demoiselles d'Avignon," American art was planted solidly in the past. Only a group of painters known as The Eight, or the Ashcan School (see p. 154) dared shake up convention by portraying real-life subjects of the Big City rather than maidens on unicorns in moonlight. Another group of American artists, the Precisionists, was concerned not just with new subject matter like the Ashcan School but with new attitudes toward form. The leading figures of this movement, which flourished in the 1920s, were the painters Charles Sheeler (1883– 1965), Charles Demuth (1883–1935), and Georgia O'Keeffe (1887–1986).

The Precisionists straddled the borderline between representation and abstraction. They simplified forms to an extreme of spare geometry, using clean-edged rectangles to indicate soaring skyscrapers and factories. Sheeler's "River Rouge Plant" praises the severe, engineered beauty of an automobile factory, while Demuth's "My Egypt" portrays grain elevators with the epic grandeur of ancient pyramids.

O'KEEFFE: AN AMERICAN ORIGINAL. One of the most free-thinking artists to bring American art out of its cultural backwater and into the Modernist mainstream was Georgia O'Keeffe. "I decided that I wasn't going to spend my life doing what had already been done," she said and proceeded to do what no one had done before. O'Keeffe is best known for her huge blowups of single flowers like irises and calla lilies. O'Keeffe told why she magnified flowers: "Nobody has seen a flower — really — it is so small — we haven't time — and to see takes time. . . . I'll paint it big and they will be surprised into taking time to look at it." O'Keeffe evoked nature without explicitly describing it and approached the brink of abstraction. "I found that I could say things with color and shapes that I couldn't say in any other way — things that I had no words for," she said in 1923.

Six years later, entranced by bare desert landscapes, O'Keeffe went to New Mexico. She painted outdoors, day and night, sleeping in a tent and wearing gloves to work on frigid days. Sometimes the wind raged so fiercely it blew the coffee out of her cup and swept away her easel. She specialized in broad, simple forms to portray red sunsets, black rocks, and rippling cliffs. In the West O'Keeffe further pared down her art, literally to the bare bones, in a series of skull and pelvic bone pictures. Her bleached-bone paintings portray austere, curvilinear forms to express, she said, "the wideness and wonder of the world."

In her nineties, despite failing eyesight, O'Keeffe tackled a new art form: pottery. At 90 she explained her success: "It takes more than talent. It takes a kind of nerve . . . a kind of nerve and a lot of hard, hard work."

STIEGLITZ AND O'KEEFFE

In 1916, Alfred Stieglitz was a famous New York photographer whose Photo-Secession Gallery (also called 291 after its Fifth Avenue address) was the hub of avant-garde activity in New York. Georgia O'Keeffe was then a 28-year-old art teacher. "Finally a woman on paper," Stieglitz supposedly declared when he saw her work. In 1917 he mounted her first public show, and they became lovers. Stieglitz documented every line of O'Keeffe's body in nearly 500 photographs. Some are so sexually graphic, they have yet to be shown. The intimate nude studies caused curiosity-seekers to flock to her shows. She was the most celebrated woman artist in America.

After their marriage the couple set a new standard for sexual liberty. Each blatantly pursued numerous extramarital affairs, Georgia O'Keeffe with both men and women. An FBI file described her as an ultraliberal security risk. In their work, O'Keeffe and Stieglitz were also risk-takers. He championed the latest trends in the arts and took landmark photographs. She was a pioneer of artistic liberty who once said, "Art is a wicked thing. It is what we are."

O'Keeffe, "City Night," 1926, Minneapolis Institute of Arts. *O'Keeffe reduces skyscrapers to polished, streamlined forms like architectural drawings.*

EXPRESSIONISM:
THE FINE ART OF FEELING

In Germany, a group known as the Expressionists insisted art should express the artist's feelings rather than images of the real world. From 1905–30 Expressionism, the use of distorted, exaggerated forms and colors for emotional impact, dominated German art.

This subjective trend, which is the foundation of much twentieth-century art, began with van Gogh, Gauguin, and Munch in the late nineteenth century and continued with Belgian painter James Ensor (1860–1949) and Austrian painters Gustav Klimt (1862–1918), Egon Schiele (1890–1918), and Oskar Kokoschka (1886–1980). But it was in Germany, with two separate groups called Die Brücke and Der Blaue Reiter, that Expressionism reached maturity.

DIE BRÜCKE: **BRIDGING THE GAP.** Founded in 1905 by Ernst Ludwig Kirchner (1880–1938), Die Brücke (pronounced dee BROOCK eh) was the earliest German group to seize the avant-garde spirit. The name means "bridge"; its members believed their work would be a bridge to the future. "To attract all revolutionary and fermenting elements," its credo claimed, "that is the purpose implied in the name 'Brücke.'" The group demanded "freedom of life and action against established and older forces." Until Die Brücke dissolved in 1913, the artists lived and worked communally, first in Dresden then in Berlin, producing intense, anguished pictures with harshly distorted forms and clashing colors. "He who renders his inner convictions as he knows he must, and does so with spontaneity and sincerity, is one of us," Kirchner proclaimed.

The major contribution of the Expressionists was a revival of the graphic arts, especially the woodcut. With dramatic black-and-white contrasts, crude forms, and jagged lines, woodcuts perfectly expressed the sickness of the soul that was a major subject of Expressionist art.

Kirchner, "Berlin Street Scene," 1913, Brücke Museum, Berlin. *Kirchner distorted figures into grotesque, jagged forms to portray their inner corruption.*

THE HORROR OF WAR

Kollwitz, "Infant Mortality," 1925, Library of Congress, Washington, DC.

Käthe Kollwitz (1867–1945) focused on pacifist subjects and the suffering of the poor. Like the later German Expressionist Max Beckmann, she was Expressionist in technique but concerned more with social protest than inner exploration. A master printmaker in etchings, lithographs, and woodcuts, Kollwitz used stark forms and harsh lines to express the tragic loss in war's aftermath. "Infant Mortality" evokes a mother's despair at her baby's death, through the woodcut's intense blackness.

KIRCHNER: LIFE IS A CABARET. Kirchner (pronounced KEAR kner) summed up the movement: "My goal was always to express emotion and experience with large and simple forms and clear colors." His series of street scenes and cabaret dancers display the brutal angularity linked with Expressionism. After World War I his style became even more frenzied and morbid until, haunted by the rise of Nazism, he committed suicide.

NOLDE: UNMASKING THE DEMON WITHIN. The painter Emil Nolde (pronounced NOHL day; 1867–1956) is an example of how Expressionists borrowed from tribal and oceanic art to revitalize decadent Western culture. Nolde saw in primitive art the vigor his age lacked. Like the Belgian painter Ensor, Nolde gave his human figures hideous, masklike faces to suggest a deformed spirit. He used garish colors, coarse forms, and ghoulish figures to communicate the evil of prewar Germany. Nolde was so intent on forcefully expressing the ugliness around him that he threw away his brushes and wiped thick blotches of pigment on the canvas with rags. His paintings were so shocking, mothers threatened unruly children, "If you don't behave, Nolde will come and get you, and smear you all over his canvas."

DER BLAUE REITER: COLOR ALONE. The second, more loosely organized vanguard group of the German Expressionists was called the Blue Rider (pronounced dehr BLAH way RIGHT er in German), after a painting by its leader Wassily Kandinsky (1866–1944). Founded in Munich around 1911, this group's most oustanding artists were Kandinsky and Swiss painter Paul Klee (1879–1940). Although the movement disintegrated with the outbreak of World War I in 1914, it had a lasting effect because of Kandinsky's breakthrough to pure abstraction.

KANDINSKY: INVENTOR OF ABSTRACT ART. The Russian painter Kandinsky was first to abandon any reference to recognizable reality in his work. He came to this revolutionary discovery by accident. Around 1910, when he returned at twilight to his studio, he recalled, "I was suddenly confronted by a picture of indescribable and incandescent loveliness. Bewildered I stopped; staring at it. The painting lacked all subject, depicted no identifiable object and was entirely composed of bright color-patches. Finally I approached closer and, only then, recognized it for what it was — my own painting, standing on its side on the easel."

This insight — that color could convey emotion irrespective of content — spurred Kandinsky to take the bold step of discarding realism altogether. He experimented with two types of paintings: "Compositions," in which he consciously arranged geometric shapes, and "Improvisations," where he exerted no conscious control over the paint he applied spontaneously. With rainbow-bright colors and loose brushwork, Kandinsky created completely nonobjective paintings with titles like "Composition No. 2," as abstract as his canvases.

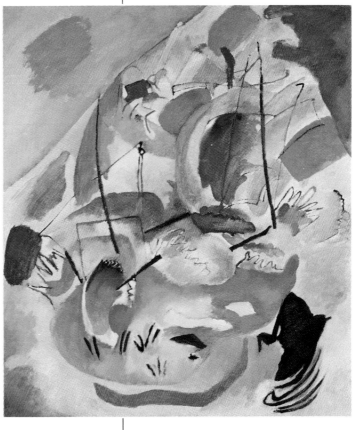

Kandinsky, "Improvisation 31 (Sea Battle)," 1913, NG, Washington, DC. *Kandinsky painted the first abstract canvases in which shape and color, not subject, are the expressive factors.*

KLEE: CHILD'S PLAY. "Color has got me," Klee (pronounced clay) exclaimed on a trip to North Africa when he was 35, "I and color are one." Throughout his career, color and line were the elements by which Klee expressed his offbeat outlook on life. He once declared, "Were I a god, I would found an order whose banner consisted of tears doing a gay dance."

Klee's work, like Matisse's, is deceptively simple, and for both this was the desired effect. Klee consciously imitated the dreamlike magic of children's art by reducing his forms to direct shapes full of ambiguity. "I want to be as though newborn," he

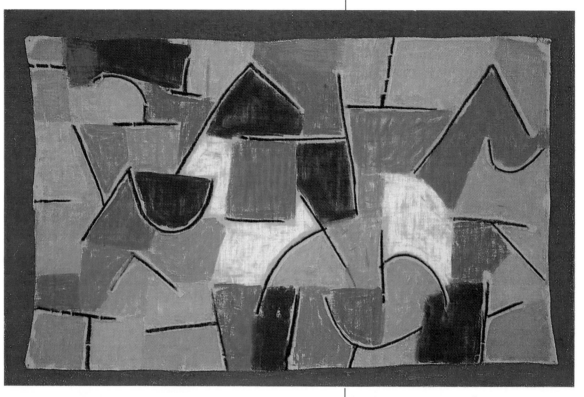

Klee, **"Blue Night,"** 1937, Öffentliche Kunstsammlung, Kunstmuseum, Basel. *Klee went beyond realism in humorous, childlike paintings designed to plumb the depths of the subconscious.*

wrote, "to be almost primitive." Klee mistrusted rationality, which he felt simply got in the way and could even be destructive. In search of a deeper truth, he compared his art to the root system of a tree, which, nourished by subterranean imagery, "collects what comes from the depth and passes it on."

The respect for inner vision made Klee study archaic signs such as hex symbols, hieroglyphics, and cave markings, which he felt held some primitive power to evoke nonverbal meanings. His later paintings use rune-like ideograms to encode his reaction to the world. "Blue Night" divides the sky into patchwork planes of cool to warm color, bounded by mysterious lines. The lines could mark constellation patterns or represent some forgotten alphabet. They illustrate Klee's belief that "art does not reproduce the visible, it makes visible."

HITLER'S ART SHOW

First the Nazis banned jazz from the airwaves, then they burned books by Hemingway, Thomas Mann, and Helen Keller. "Where books are burned, people are burned," warned the writer Heinrich Heine. Artists felt the atmosphere of terror and oppression acutely, causing painter George Grosz to flee Germany in 1933. "I left because of Hitler," Grosz said of the frustrated artist become dictator. "He is a painter too, you know, and there didn't seem to be room for both of us in Germany."

Those modern artists who stayed saw their works confiscated and, in 1937, exhibited as objects of ridicule. Hitler and his propaganda minister, Joseph Goebbels, organized a show of what they called "Degenerate" art (Entartete Kunst), consisting of masterpieces by the century's most brilliant artists: Picasso, Matisse, and Expressionists like Kandinsky, Klee, Nolde, Kirchner, Kokoschka, and Beckmann.

The object was to discredit any work that betrayed Hitler's master race ideology; in short, anything that smacked of dangerous free-thinking. Nazi leaders considered Modernist art so threatening they prohibited children from the show and hired actors to roam the halls loudly criticizing modern art as the work of lunatics. They scrawled derogatory slurs on the walls beside the paintings, which were grouped into categories like "Insults to German Womanhood" and "Nature as Seen by Sick Minds." Price tags displayed how much public museums had paid for the works with signs: "Taxpayer, you should know how your money was spent." Despite the effort to suppress "offensive" modern art, with an estimated three million in attendance, the exhibit may have been one of the biggest successes ever.

MONDRIAN: HARMONY OF OPPOSITES

While German Expressionists wallowed in angst, a Dutch group of Modernists led by painter Piet Mondrian (pronounced MOWN dree ahn; 1872–1944) tried, from 1917 to 1931, to eliminate emotion from art. Called De Stijl (pronounced duh STEHL), which means "The Style," this movement of artists and architects advocated a severe art of pure geometry.

Mondrian came from a neat, Calvinist country where the severe landscape of interlocking canals and ruler-straight roads often looked mechanically laid out. During the chaos of World War I he concluded, "Nature is a damned wretched affair." Mondrian decided to jettison "natural," messy art for a new style called Neo-Plasticism. The goal: to create a precise, mechanical order lacking in the natural world.

LINING UP. Mondrian based his style on lines and rectangles. Theorizing that straight lines do not exist in nature, he decided to use straight lines exclusively to create an art of harmony and order — qualities conspicuously missing from the war-torn world. When De Stijl was transferred to architecture, it would supposedly bring all chaotic forces into line, achieving a balance of opposites as in the Cross.

For Mondrian, vertical lines represented vitality and horizontal lines tranquility. Where the two lines crossed in a right angle was the point of "dynamic equilibrium." In his trademark paintings, Mondrian restricted himself to black lines forming rectangles. He used only the primary colors of red, blue, and yellow and three noncolors: white, black, and gray. By carefully calculating the placement of these elements, Mondrian counterpointed

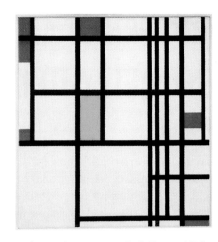

Mondrian, "Composition in Red, Blue, and Yellow," 1920, MoMA, NY. *One of the most important proponents of abstract act, Mondrian painted geometric designs in limited colors.*

competing rhythms to achieve a "balance of unequal but equivalent oppositions." Although his grid paintings look similar, each one is precisely — and differently — calibrated.

The major contribution of De Stijl to art was its drive toward absolute abstraction, without any reference whatsoever to objects in nature. "Art systematically eliminates," Mondrian said, "the world of nature and man." He wanted art to be as mathematical as possible, a blueprint for an organized life.

A control freak, Mondrian even transformed his own environment into one of his paintings. He covered his studio walls with rectangles in primary colors or gray, white, and black. Although the studio was as sparsely furnished as a monk's cell, he kept an artificial tulip in a vase, its leaves painted white (since he had banned the color green). He painted all furniture white or black and his record player bright red.

Mondrian was important in the history of art for opposing the cult of subjective feeling. By the 1950s his easily identifiable style was so famous that for many it became a symbol of modern art.

BRANCHING OUT

Mondrian arrived at his mature style through progressively simplifying natural forms. In a famous series of tree paintings done in Paris in 1911—12 under the influence of Cubism, his advance from description to abstraction is clear. In both paintings shown, the motif is a bare-branched tree. In the earlier painting at left, the image of spreading branches and thick trunk is discernible, while in the later work, Mondrian dissolves the tree in a web of lines until it is virtually unrecognizable. The space between the lines becomes as important as the lines themselves to balance the painting. It was a short, but significant, step from the second painting to making lines and the spaces between them the sole subject of his work.

Mondrian, "Gray Tree," 1912, Haags Gemeentemuseum, The Hague.

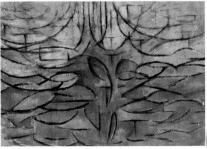

Mondrian, "Flowering Apple Tree," 1912, Haags Gemeentemuseum, The Hague.

MODERNIST ARCHITECTURE: GEOMETRY TO LIVE IN

Before the twentieth century, "prestige" architecture always meant rehashing the past. Victorian homes were bulky and complicated, with turrets and carved gingerbread. The new International Style of the 1920s, so called because it transcended national boundaries, changed all that. For these architects, science and industry were almost a religion. Their streamlined designs gave form to the Machine Age by rejecting all historical ornament. It was like shedding a Victorian bathing costume, complete with bloomers, parasol, and ruffled cap, for a string bikini.

GROPIUS: **BAUHAUS DESIGN.** Walter Gropius (pronounced GROW pee us; 1883–1969), director of Germany's influential Bauhaus school of design, probably had more indirect influence on the look of modern cities than any single man. He was mentor to generations of architects who radically changed the look of metropolises everywhere. Gropius conceived buildings totally in terms of twentieth-century technology, with no reference to the past. The Bauhaus buildings he constructed are simple glass boxes, which became a worldwide cliché.

"Architecture is a collective art," Gropius believed, urging his Bauhaus colleagues to collaborate like medieval cathedral-builders. The architecture he envisioned obliterated individual personality in favor of designs that could be mass-produced. In a debased form, Gropius knock-offs became the anonymous, high-rise buildings in every city from Topeka to Tokyo.

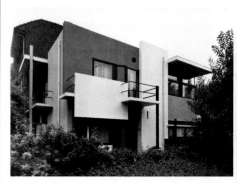

Rietveld, Schroeder House, 1924, Utrecht. *Rietveld used only primary colors with black, white, and gray to design this International Style house of flat planes and straight lines like a Mondrian painting.*

THE INTERNATIONAL STYLE

GOAL: High-tech, clean design

ENEMIES: Ornament, historical reference

HOUSE: Machine for living

STYLE: Glass and steel boxes

FAVORITE SUBJECT: Geometry

CULMINATION: Seagram Building

QUOTE: Mies van der Rohe, while strolling the Chicago lakeshore surveying his work: "Well, they will know we were here."

MIES: **LESS IS MORE.** Gropius's most famous colleague was German architect Mies (rhymes with "please") van der Rohe (1886–1969). Son of a stonemason, Mies designed bare towers with glass curtain walls. His materials like steel frame and plate glass determined the form of his structures. New York's Seagram Building (1956–58) is a monument to purity, its straight lines expressing perfectly the famous Miesian dictum: "Less is more."

Mies is equally famous for another saying: "God dwells in the details." In the Seagram Building, despite its thirty-eight-story scale, he showed his superb craftsmanship by custom-designing details like lettering on lobby mailboxes. "A beautiful lady with hidden corsets," American architect Louis Kahn called the Seagram Building. Although it seems light and simple structurally, its bronze sheathing covers a skeleton of steel.

LE CORBUSIER: **A MACHINE FOR LIVING.** The third International Style pioneer was Swiss architect Le Corbusier (1887–1965), known for defining a house as "a machine for living." From the 1920s through the forties, Le Corbusier designed homes to resemble the machines he so admired and Cubist art he formerly painted. His clean, precise, boxy houses had machine-planed surfaces and ribbonlike strips of windows. They illustrate the International Style trademark of flow — with interior and exterior mingling in an open floor plan.

FRANK LLOYD WRIGHT. "Not only do I intend to be the greatest architect who has yet lived," Frank Lloyd Wright (1867–1959) once said, "but the greatest architect of all time." He may well have achieved his ambition, for this American architect designed some of the most original and beautiful structures in history. Among Wright's gifts to the American home are cathedral ceilings, built-in furniture and lighting fixtures, casement windows, carports, the massive fireplace, and split-level ranches. His most far-reaching contributions were busting wide open boxy floor plans and designing site-specific buildings that seem to grow naturally out of their location.

GO WITH THE FLOW. Wright drew layouts with continuity in mind, so that walls, ceilings, and floors flow seamlessly just as rooms merge with each other and the outside environment. He wanted "no posts, no columns" because "the new reality," he said, "is space instead of matter." The International Style architects borrowed this concept of flowing space from Wright, as well as his clean-cut rectangular shapes radiating from a central core (often a massive hearth).

Wright differed from the International Style in his insistence on natural forms and materials and his respect for the environment. In fact, his early "Prairie Houses" designed for the Midwest got their name because of their low-slung, horizontal lines that hug the flat land and blend with the natural setting.

Wright's style is impossible to categorize, for he skipped from Japanese to Aztec to purely imaginative motifs, as inspiration and whim dictated. Opposed to the worship of technology, Wright celebrated the individual. Claiming the prerogative of genius, he insisted on designing every last detail of his work. He created stained glass windows, dishes, fabrics, furniture, rugs, drapes — he even designed gowns for one client's wife.

Unfortunately, some of his designs were too abstract for, quite

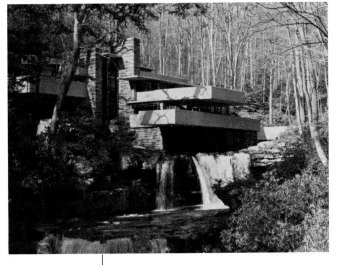

Wright, "Fallingwater" (Kaufmann House), 1936, Bear Run, Pennsylvania. *Illustrating Wright's "organic architecture," this house seems to sprout out of living rock. Built mostly of rough stone, the house's form echoes the native rock ledges. Cantilevered terraces hover over a rushing waterfall. The house's irregular spaces flow as easily as water, illustrating Wright's adage: "No house should ever be on any hill or on anything. It should be of the hill, belonging to it, so hill and house should live together and each be happier for the other."*

literally, comfort. Executives of the Wright-designed Price Tower said his chairs "make you feel like you are about to fall on your face." Wright himself admitted, "I have been black and blue in some spot, almost all my life from too intimate contact with my own furniture."

A GENIUS IN HIS OWN MIND

The only thing Frank Lloyd Wright, child of the Midwest prairie, remembered about elementary school was building with blocks. At age 18, with innovative Chicago architect Louis Sullivan, Wright was building for real. "When Sullivan and I came to architecture it had been sleeping a hundred years," Wright boasted. "We woke it up." An implacable foe of imported European styles, Wright preached the need for a new, native architecture. His signature became the low-slung, uniquely American, single-family home.

Wright's life was as precedent-shattering as his buildings. The "master," as he called himself, enjoyed outraging the public. His seventy-year career was punctuated by one tabloid headline after another: bankruptcies, scandalous divorces, and three marriages. In 1909 he deserted his wife and six children for an affair in Europe with a client's wife. During a bitter courtroom battle, Wright named himself when asked to identify the world's best architect. He later explained, "I was under oath, wasn't I?"

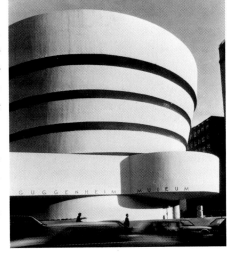

Wright, Guggenheim Museum, 1959, NY. *The most radical of his buildings, the Guggenheim substitutes curves for right angles, making the whole a giant abstract sculpture.*

DADA AND SURREALISM: ART BETWEEN THE WARS

DADA: A WORLD GONE GAGA. Founded in neutral Zurich in 1916 by a group of refugees from World War I, the Dada movement got its name from a nonsense word. Throughout its brief lifespan of six years, Dada often seemed nonsensical, but it had a no-nonsense aim. It protested the madness of war. In this first global conflict, billed as "the war to end all wars," tens of thousands died in trenches daily to gain a few scorched yards before being driven back by counterattacks. Ten million people were slaughtered or maimed. It's no wonder Dadaist artists felt they could no longer trust reason and the establishment. Their alternative was to overthrow all authority and cultivate absurdity.

Dada was an international attitude that spread from Zurich to France, Germany, and the United States. Its main strategy was to denounce and shock. A typical Dada evening included several poets declaiming nonsense verse simultaneously in different languages with others yapping like dogs. Orators hurled insults at the audience, while absurdly costumed dancers flapped about the stage and a young girl in communion dress recited obscene poetry.

Dadaists had a more serious purpose than merely to shock. They hoped to awaken the imagination. "We spoke of Dada as a crusade that would win back the promised land of the Creative," said Alsatian painter Jean Arp, a founder of Dada.

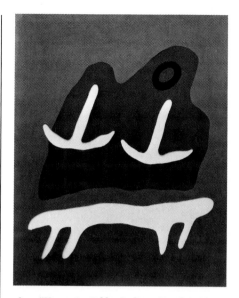

Arp, "Mountain, Table, Anchors, Navel," 1925, MoMA, NY. *Arp shared the Dada faith in accident, creating "free" forms by chance.*

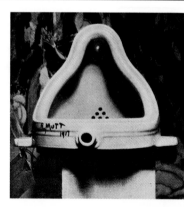

Duchamp, "Fountain," 1917 Photograph by Alfred Stieglitz, Philadelphia Museum of Art.

DUCHAMP: THE "DADA" OF SURREALISM

French artist Marcel Duchamp (pronounced doo SHAHN 1887–1968) was one of the most influential figures in modern art. A prime mover of both Dada and Surrealism, he also inspired diverse movements from Pop to Conceptualism. Duchamp became a legend without actually producing much art. Although his "Nude Descending a Staircase" (see p. 150) was notorious, Duchamp abandoned painting at the height of his celebrity. "I was interested in ideas — not merely in visual products," he said. "I wanted to put painting once again at the service of the mind."

For Duchamp, conceiving a work of art was more important than the finished work. In 1913 he invented a new form of art called "readymades" by mounting a bicycle wheel on a kitchen stool. His most controversial readymade was a porcelain urinal he signed R. Mutt. Duchamp defended the unconventional objet d'art, saying, "Whether Mr. Mutt with his own hand made the fountain or not has no importance. He CHOSE it [he] created a new thought for that object." Duchamp's readymades opened the floodgates for art that was purely imaginary rather than merely "retinal" (interpreting the visual world). He changed the concept of what constitutes art.

ARP: GAME OF CHANCE. In his work, Arp (1887–1966) exploited the irrational. He discovered the principle of random collage by accident, when he tore up a drawing and threw the pieces on the floor. Admiring the haphazard pattern the scraps formed, Arp began to make "chance" collages. "We declared that everything that comes into being or is made by man is art," said Arp. He constantly experimented to evolve new forms. His characteristic works include playful, egglike shapes that suggest living creatures. Arp stated his aim: "To teach man what he had forgotten: to dream with his eyes open."

SCHWITTERS: A MATTER OF MERZ. German collagist Kurt Schwitters (1887–1948) also subverted accepted concepts. When asked, "What is art?" he replied, "What isn't?" Schwitters cruised the streets of Hanover scouring gutters for discarded junk like bus tickets, buttons, and shreds of paper. He then combined this refuse into assemblages he called "merz." Arp and Schwitters used these "nonart" materials instead of oil on canvas "to avoid any reminder of the paintings which seemed to us to be characteristic of a pretentious, self-satisfied world," Arp said.

By 1922, Dada — admittedly "against everything, even Dada"— dissolved into anarchy. Its contribution was to make art less an intellectual exercise and more a foray into the unpredictable.

SURREALISM: POWER OF THE UNCONSCIOUS.

Two years later a direct offspring of Dada, Surrealism, was born. Surrealism, which flourished in Europe and America during the twenties and thirties, began as a literary movement, fostered by its godfather, poet André Breton. It grew out of Freudian free-association and dream analysis. Poets and, later, painters experimented with automatism — a form of creating without conscious control — to tap unconscious imagery. Surrealism, which implies going beyond realism, deliberately courted the bizarre and the irrational to express buried truths unreachable by logic.

Surrealism took two forms. Some artists, like Spanish painter Joan Miró and German artist Max Ernst, practiced improvised art, distancing themselves as much as possible from conscious control. Others, like the Spaniard Salvador Dalí and Belgian painter René Magritte, used scrupulously realistic techniques to present hallucinatory scenes that defy common sense.

MIRO: THE JOY OF PAINTING.

"Miró may rank," said Surrealist guru André Breton, "as the most surrealist of us all." Joan Miró (1893–1983) consistently tried to banish reason and loose the unconscious. Working spontaneously, he moved the brush over the canvas drawing squiggles in a trancelike state or slapped on paint in a creative frenzy intensified by hunger, since he could afford only one meal a day. His goal, he said, was "to express with precision all the golden sparks the soul gives off."

Miró invented unique biomorphic signs for natural objects like the sun, moon, and animals. Over the years these forms were progressively simplified into shorthand pictograms of geometric shapes and amoebalike blobs — a mixture of fact and fantasy. "Miró could not put a dot on a sheet of paper without hitting square on the target," the Surrealist sculptor Giacometti said.

Miró's semiabstract shapes, although stylized, always playfully alluded to real objects. Brilliantly colored and whimsical, they seem like cartoons from another planet. "What really counts is to strip the soul naked," Miró said. "Painting or poetry is made as one makes love — a total embrace, prudence thrown to the winds, nothing held back."

DARK SHADOWS

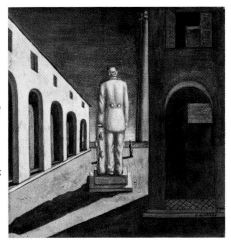

de Chirico, "The Mystery and Melancholy of a Street," 1914, Öffentliche Kunstsammlung, Kunstmuseum, Basel. *Hailed by the Surrealists as their precursor, Italian painter Giorgio de Chirico (pronounced KEY ree coh; 1888–1978) was painting nightmare fantasies fifteen years before Surrealism existed. Drawing on irrational childhood fears, de Chirico is known for his eerie cityscapes with empty arcades, raking light, and ominous shadows. The skewed perspective and nearly deserted squares inhabited by tiny, depersonalized figures project menace. In fact, with these paintings as his best evidence, de Chirico was exempted from military service as mentally unstable. On an early self-portrait he inscribed, "What shall I love if not the enigma?"*

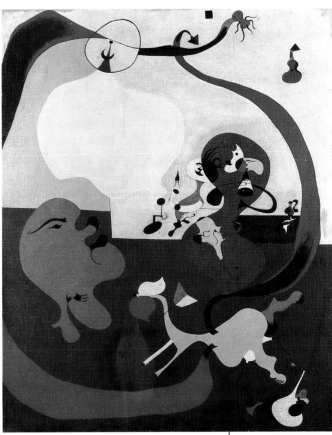

Miró, "Dutch Interior II," c. 1920, Guggenheim collection, Venice. *Miró improvised geometric shapes and biomorphic forms in playful dream imagery.*

ERNST: MOTHER OF MADNESS. Both a Dadaist and Surrealist, Max Ernst (1891–1976) best exemplifies how Surrealists employed ambiguous titles. With labels like "The Preparation of Glue from Bones" and "The Little Tear Gland That Says Tic Tac," Ernst tried to jolt the viewer to mental attention. In one of his most well-known works, "Two Children Threatened by a Nightingale" (1924), the title induces a shocked double-take. Although it seems straight out of a Hitchcock scenario, Ernst said the picture derived from his pet cockatoo's death when he was a child and that for years he suffered from "a dangerous confusion between birds and humans."

Ernst referred to himself as "the male mother of methodical madness." He first experienced hallucinations when he saw fevered visions during a bout of childhood measles. He found he could induce similar near-psychotic episodes (and adapt them in art) by staring fixedly until his mind wandered into some psychic netherworld. With so many unusual inner sights to see, it's not surprising Ernst described his favorite pastime as "looking." Ernst invented "frottage," a new method for generating surprising imagery. He placed a sheet of paper over rough surfaces like wood planks and rubbed with a soft pencil. He then elaborated on these patterns to produce fantastic, sometimes monstrous, imagery.

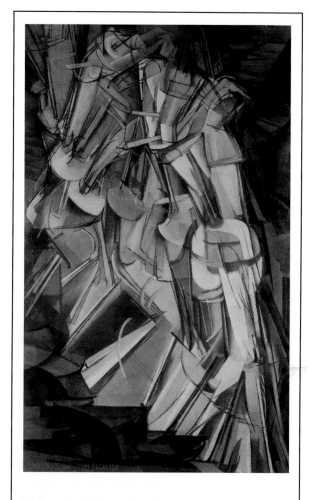

Duchamp, "Nude Descending a Staircase, No. 2," 1912, Philadelphia Museum of Art.

THE GREATEST SHOW ON EARTH

The most significant art show in American history, called the Armory Show because it took place in New York's 69th Regiment Armory building, burst the bubble of American provincialism in 1913. It included works by the most controversial modern masters of Europe. Americans were clearly unprepared for Matisse's bold colors, Picasso's fractured forms, and Duchamp's Dadaist spirit. "Nude Descending a Staircase" was the show's runaway sensation. A portrait of a nude in overlapping stages of movement, it came to symbolize the essence of modern art. An "explosion in a shingle factory," one journalist dubbed it.

Unprecedented ridicule, hostility, and indignation greeted the show, called "pathological" by the New York Times. Critics lampooned the artists as "bomb-throwers, lunatics, depravers," calling the room of Cubist paintings a "Chamber of Horrors." Public officials demanded the show be shut down to safeguard public morals.

The show had two major, lasting effects. On the positive side, American artists learned of the artistic revolution happening in Paris studios an ocean away. "Progressive" art became a force to be reckoned with, modern galleries sprang up, and artists experimented with abstract forms. The downside was that the American public initially perceived modern art as a bad joke, even a fraud — a perception which partially continues today.

CHAGALL

Chagall, "I and the Village," c. 1911, MoMA, NY. *Russian-born French painter Marc Chagall (1887–1985) was inspired by two sources of imagery: the Jewish life and folklore of his Russian childhood and the Bible. Although his imaginative fantasies were hailed as a precursor to Surrealism, Chagall insisted he painted actual memories, not irrational dreams.*

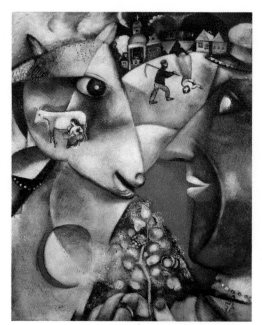

DALI: PAINTING PARANOIA. The painter who based his technique, which he called "critical paranoia," on exploiting his own neuroses was Salvador Dalí (1904–89). When Dalí came to Paris in 1928 and joined the Surrealists, he had plenty of obsessions to draw on. He was terrified of insects, of crossing streets, of trains, boats, and airplanes, of taking the Métro — even of buying shoes because he couldn't bear to expose his feet in public. He laughed hysterically and uncontrollably and carried a piece of driftwood at all times to ward off evil spirits. "The only difference between a madman and myself," Dalí said, "is that I am not mad."

With so rich a lode of irrational fears fueling his art, Dalí placed a canvas beside his bed, staring at it before sleep and recording what he called "hand-painted dream photographs" when he awoke. He claimed he cultivated paranoid delusions deliberately to make himself a "medium" for the irrational, but that he could snap back to control at will.

Dalí differed from Ernst and Miró in that, instead of inventing new forms to symbolize the unconscious, he represented his hallucinations with meticulous realism. His draftsmanship is so skilled it almost has a miniaturist's precision, but he distorted objects grotesquely and placed them in unreal dream landscapes. When Dalí attended a costume party where everyone came "as their dreams," Dalí dressed as a rotting corpse. This recurrent nightmare often appeared in his work. His most famous, "The Persistence of Memory," shows limp watches and a strange lump of indefinable flesh. Although metallic, the watches appear to be decomposing. A fly and cluster of jewellike ants swarm over them. "With the coming of Dalí, it is perhaps the first time that the mental windows have been opened really wide," Breton said, "so that one can feel oneself gliding up toward the wild sky's trap."

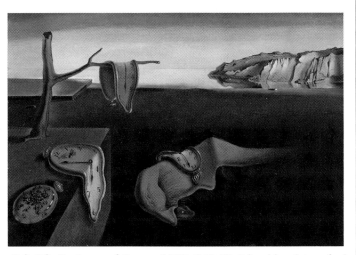

Dalí, "The Persistence of Memory," 1931, MoMA, NY. *Dalí used the techniques of realism for a surreal effect by distorting familiar objects and placing them in a hallucinatory context.*

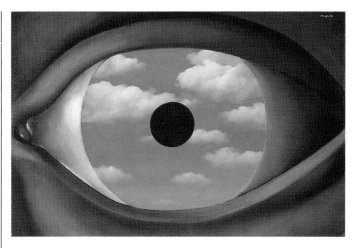

Magritte, "The False Mirror," 1928, MoMA, NY. *Magritte gave ordinary objects an irrational twist by juxtaposing elements of the absurd.*

MAGRITTE: DREAM VISIONS. René Magritte (pronounced Mah GREET; 1898–1967), like Dalí, painted disturbing, illogical images with startling clarity. Magritte began as a commercial artist designing wall paper and fashion ads. In his Surrealist work, he used this mastery of realism to defy logic. He placed everyday objects in incongruous settings and transformed them into electric shocks, such as the flood of bowler-hatted gentlemen falling like raindrops or a piece of fried ham on a plate that is also an eyeball. These disturbing juxtapositions of familiar sights in unnatural contexts compel a new vision of reality beyond logic.

DALI: OFF THE DEEP END

An inventive self-promoter, Dalí became Mr. Surrealism more through publicity gimmicks than art. Who else but Dalí would lecture at the Sorbonne with his foot in a pail of milk or give a press conference with a boiled lobster on his head? "If you play at genius," Dalí said, "you become one."

At the 1936 London Surrealist exhibit, Dalí made a striking entrance with two white Russian wolfhounds. Wearing a diving suit topped by a Mercedes Benz radiator cap, Dalí began to lecture. Since the suit was bolted shut, no one could hear him. The seal was also nearly air tight, and Dalí began to gasp for breath, flailing his arms and begging the audience to extricate him. The spectators — thrilled with this exhibition of asphyxiation — applauded wildly until someone finally popped his lid off. All agreed the performance had been highly convincing.

PHOTOGRAPHY COMES OF AGE

In the Victorian era, photographers responded to critics who said their work was not art by imitating academic painting. Through darkroom gimmickry, they produced prettified, soft-focus scenes. Around the turn of the century, the tide of Modernism influenced avant-garde photographers to express their personal views of the world. They shook off their inferiority complex and concentrated on taut compositions and pure form.

Atget, "Luxembourg, Fontaine Corpeaux," 1901–2, MoMA, NY. *Atget was one of the first to record everyday objects as mysterious and evocative.*

MAN RAY (1890–1977). A charter Dada and Surrealist artist was American photographer/painter Man Ray. One of the most inventive photographers of his day, he developed a technique around 1921 he called "rayographs." In this method, he placed objects on photo-sensitive paper, then exposed it to light. The mischievous result resembled Cubist collages.

ATGET (1857–1927). Hailed by Surrealists as a forefather, Eugène Atget was really the father of modern photography. Surrealists like Man Ray (and his colleague, photographer Berenice Abbott) rescued Atget from oblivion, finding a kindred spirit in his mysterious, concentrated images that have de Chirico's deadpan quirkiness. Atget never considered himself an "art" photographer but a chronicler of Paris—its residents and street life. He took straightforward photos of subjects like iron grillwork, shop windows, and fountains. Like Duchamp with

Man Ray, "Rayograph 1928," 1928, MoMA, NY. *Surrealist Man Ray experimented to transcend surface realism and created this witty photo-assemblage of string, cotton, and strips of paper.*

his readymades, Atget raised the mundane to the magical. Through his clean, uncluttered style and eye for the telling detail, Atget charged his most commonplace images with significance. His arresting scenes often look haunted. The bold reduction to essentials lends a hyperclarity that makes the ordinary seem extraordinary.

CARTIER-BRESSON (1908–2004). French photographer Henri Cartier-Bresson began as a Cubist painter before turning to photography in 1932. His great contribution to photojournalism was his ability to capture what he called the "decisive moment." More than just recording, Cartier-Bresson snapped the most intense instant of action or emotion to reveal an event's inner meaning. "There is one moment at which the elements in motion are in balance," he said. "Photography must seize upon this moment." Many Cartier-Bresson photographs have a Surrealist element of the unexpected. His odd juxtapositions within the camera frame make reality seem unreal. Some of his images are so startling they seem to be the result of pure chance, but Cartier-Bresson's odd croppings were carefully composed.

Cartier-Bresson, "Children Playing in Ruins," 1933, Magnum, NY. *A genius of timing, Cartier-Bresson captures the peak moment when movement crystalizes to convey many levels of meaning or the essence of a character.*

Stieglitz, "The Steerage," 1907, MoMA, NY. *The diagonal gangway splits the scene into upper and lower classes, using composition and lighting to make a point about society.*

STIEGLITZ (1864–1946). Besides championing modern art at his 291 Gallery (named for its Fifth Avenue address), Stieglitz revolutionized camera work by stressing "straight," unretouched photography. He urged progressive photographers not to mimic painting or resort to lens and lighting tricks but to exploit the direct honesty of their medium.

Stieglitz's classic shot, "The Steerage," represents the first time a documentary photo reached the level of conscious art in America. Stieglitz was on the first-class deck of an ocean liner when he saw, he later said, "a picture of shapes and underlying that the feeling I had about life." The geometric shapes and composition tell the human story. The diagonal gangway cleaves the scene visually into upper (upper-class passengers, mostly in the dark, who seem formal and faceless) and lower levels (the steerage, or cheapest fares, composed of poor immigrant families, with strong light spotlighting their humanity). "Photography is my passion," Stieglitz said, "the search for truth my obsession."

WESTON (1886–1958). Edward Weston started as a commercial photographer shooting romantic Hollywood portraits of starlets. In the 1920s he gave up darkroom gimmicks for stark images of nudes, sand dunes, and vegetables. Weston brought out the strong sensuality of simple shapes like peppers, while reducing other forms, like a palm tree trunk, to semiabstract simplicity. From immediate foreground to deep distance, detail is sharp. He tried, he said, to get the quality of a subject "rendered with the utmost exactness: stone is hard, bark is rough, flesh is alive."

Weston, "Leeks," 1927, Center for Creative Photography, Tucson, AZ. *This closeup of leeks shows how expressive pure form can be when arranged in a powerful, simple composition.*

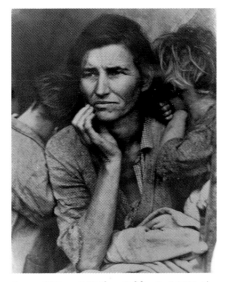

Lange, "Migrant Mother, California," 1936, Library of Congress. *Lange's documentary photos of the poor brought social problems to the attention of a wide audience.*

LANGE (1895–1965). After the 1929 stock market crash, photographers focused on the suffering caused by the Depression. Dorothea Lange followed the homeless who had been tractored off their Dust Bowl farms. Her compassion helped her capture poignant moments that tell about human lives and feelings. Her field notes for the unposed, uncropped "Migrant Mother" read: "Camped on the edge of a pea field where the crop had failed in a freeze. The tires had just been sold from the car to buy food. She was 32 years old with seven children." The dignity and total honesty of Lange's photographs shocked Americans into recognizing the plight of the poor. As photo historian Robert J. Doherty wrote, "This small, shy, insecure woman had a strong sense of justice which sparked a silent fury that came to light in the strong emotion of her photographs. With a camera in her hand, she became a giant."

AMERICAN ART: 1908–40

While artists elsewhere moved increasingly toward abstraction, American painters kept alive the realist tradition and portrayed American life with utmost fidelity.

ASHCAN SCHOOL: TRASHY TALES. "Guts! Guts! Life! Life! That's my technique!" said painter George Luks. "I can paint with a shoestring dipped in pitch and lard." The prudish American public did not, however, consider "guts" and contemporary urban life suitable for art. They dismissed such "raw" scenes of real people shopping and carousing as fit only for the ash can. This insult gave the name to a group of American painters who bashed the stuffy art monopoly with the same gusto that Theodore Roosevelt busted trusts.

***SLOAN:* STREET LIFE.** John Sloan (1871–1951) — like other Ashcanners Luks, William Glackens, and Everett Shinn — started as a newspaper sketch-artist. He was accustomed to racing to a fire or train derailment to record the scene in a straightforward but dramatic fashion. A slapdash, you-are-there approach, using broad brushstrokes to capture the tumult and verve of city life, characterizes his mature work. Because Sloan insisted on painting "low-life" subjects, his work didn't sell until he was past 40. Sloan was such an ardent advocate of the masses that he ran for state office in 1908 as a Socialist but was defeated. Despite setbacks, Sloan remained convinced that art should be down-to-earth, rooted in daily life. "It is not necessary to paint the American flag to be an American painter," Sloan said. "As if you didn't see the American scene everytime you opened your eyes."

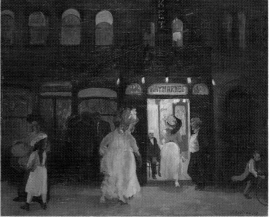

Sloan, "Haymarket," c. 1907, Brooklyn Museum. *Ashcan School painters injected realism into American art by taking ordinary people as their subject.*

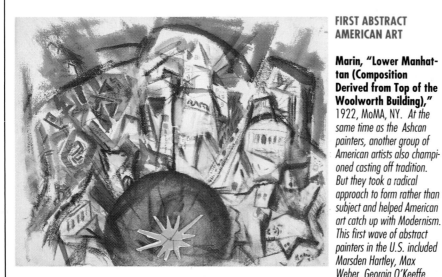

FIRST ABSTRACT AMERICAN ART

Marin, "Lower Manhattan (Composition Derived from Top of the Woolworth Building)," 1922, MoMA, NY. *At the same time as the Ashcan painters, another group of American artists also championed casting off tradition. But they took a radical approach to form rather than subject and helped American art catch up with Modernism. This first wave of abstract painters in the U.S. included Marsden Hartley, Max Weber, Georgia O'Keeffe, Arthur Dove, Stuart Davis, and John Marin. The dominant force in the 1920s toward abstraction was John Marin (1870–1953). He is often called the greatest watercolorist ever. A perfectionist, Marin compared painting to golf: the fewer strokes the better. His views of skyscrapers, broken into cubistic planes and angles, explode with vitality, proving that watercolor need not be synonymous with washed-out landscapes.*

ASHCAN SCHOOL, OR THE EIGHT

LOCALE:
New York City, 1908–13

BEST-KNOWN ARTISTS:
Henri, Sloan, Bellows

STYLE:
Realistic, sketchlike

SUBJECT:
Urban grit and vigor

WHY CONDEMNED:
"Sordid," low-life subjects

WHY PRAISED:
First uniquely American art

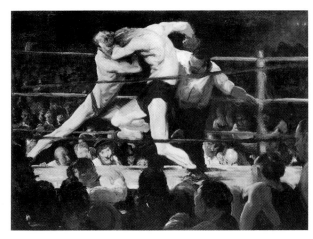

BELLOWS: BOXING. George Bellows (1882–1925) is perhaps the only artist who gave up stealing bases for painting faces. Although he sacrificed a career as a professional baseball player, as a painter he translated the vigor and exuberance of sport into art. "Stag at Sharkey's" shows the dynamic energy that marked both the subject and style of the Ashcan School. Bellows portrayed the pulsating life of New York docks, gutters, and bars with a heroic vitality. "The ideal artist is the superman," Bellows proclaimed. Sadly, with macho stoicism, he ignored stomach cramps until his appendix ruptured and he died at age 42.

Bellows, "Stag at Sharkey's," 1909, Cleveland Museum of Art.
Bellows captured the dynamism of the city that the Ashcan painters glorified.

ART AS ACTIVISM: AMERICAN SCENE AND SOCIAL REALISM. During the Depression, realism took two forms. The American Scene School, or Regionalism, enshrined Midwest values as the essence of American character. "American art," said painter Edward Hopper, "should be weaned from its French mother." Meanwhile, Social Realism exalted the struggles of the working class. Both trends portrayed simple folk, reacted against the growing prestige of abstract art, and tried to stir up either pride or protest during a decade of national trouble.

AMERICAN SCENE: CORNY AS KANSAS IN AUGUST. Those known as "American Scene" painters, Thomas Hart Benton, John Steuart Curry, and Grant Wood, took life on the plains as their subject, elevating its inhabitants to heroic stature. In WPA murals produced during the Depression, they romanticized the can-do pioneer spirit in an attempt to inspire optimism in a time of despair.

BENTON: AMERICAN HEROES. Thomas Hart Benton (1889–1975), leader of the American Scene, believed hometown reality should inspire art. Benton consciously rejected European styles he had briefly absorbed during a trip to Paris. "I wallowed in every cockeyed ism that came along," he said, "and it took me ten years to get all that modernist dirt out of my system." Once he purged himself of foreign influence, Benton produced sinuous paintings of Americans at work and play that idealized the American past.

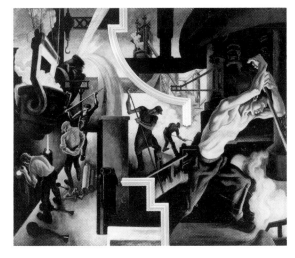

Benton, "Steel," 1930, collection of Equitable Art Advisory, NY. *Benton glorified American workers as muscular, powerful figures.*

MOUNT RUSHMORE

At the same time that American Scene painters idealized legendary exploits like Paul Revere's ride or George Washington's encounter with a cherry tree, an ambitious project transformed an entire mountain wall into the ultimate patriotic monument. At Mount Rushmore, South Dakota, jackhammers and dynamite blasted four 1,300-foot-high presidents' faces (of Washington, Jefferson, Lincoln, and Theodore Roosevelt, each with 20-foot-long noses) into a cliff. Its $1.5-million cost was a mountain of money during the Depression. Gutzon Borglum, the sculptor, defended the price, saying, "Call up Cheops and ask him how much his pyramid in Egypt cost and what he paid the creator. It was inferior to Mount Rushmore."

WOOD: GOTHIC GARGOYLES. Grant Wood (1892–1942) adopted the most primitive style among American Scene realists. His greatest inspiration, he said, came when he was milking a cow, but he produced his homages to the heartland from a Connecticut studio. His reverence for country life drove him to chronicle the people and landscape of his native Iowa in almost obsessive detail. "American Gothic" is Wood's most famous work, modeled on his sister and dentist. When it appeared, Iowans feared he was mocking their homespun looks. "To me," Wood insisted, "they are basically good and solid people." He elongated their faces almost to the point of caricature, he said, "to go with this American Gothic house." Once the uproar subsided, the picture, along with "Whistler's Mother," became one of the most popular paintings in America.

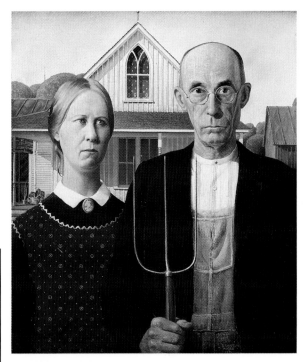

Wood, "American Gothic," 1930, Art Institute of Chicago. *American Scene painters like Wood portrayed simple country folk in a realistic style.*

ONLY THE LONELY

EDWARD HOPPER *(1882–1967) was out of sync with the home-of-the-free-and-the-brave, booster spirit of American realism. In his meticulously described paintings of American vernacular architecture — storefronts, diners, gas stations — he expressed one theme:*

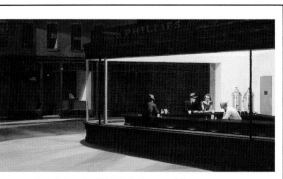

Hopper, "Nighthawks," 1942, Art Institute of Chicago.

loneliness. While Ashcan School pictures vibrate with energy and American Scene canvases drip Apple Pie patriotism, Hopper's work seems drained of energy and hope. Others waved the flag; Hopper showed the void behind the hoopla. Hopper took his cue from writer Theodore Dreiser, who observed, "It was wonderful to discover America but it would have been even more wonderful to lose it." His scenes are cold and empty, as bleak as the Depression. His scathing look at small-town life illustrates Sinclair Lewis's Main Street, where "dullness is made God."

SOCIAL REALISM. With one quarter of the labor force unemployed, banks bankrupt, and the Midwest Bread Basket turned into a Dust Bowl, the Depression-era United States was on the skids. A group of artists like Ben Shahn, Reginald Marsh, and Jacob Lawrence used art to highlight injustice and motivate reform. In Mexico and the U.S., Latino artists (José Orozco, David Siqueiros, and Diego Rivera — see p. 21) produced vast murals celebrating the working class. Deeply committed to social change, these painters attacked evils of capitalism in a semi-realistic style that exaggerated features, color, and scale for emotional impact.

AMERICA'S GREATEST BLACK ARTIST

ROMARE BEARDEN *(1912–1988) began as a Social Realist in Harlem during the 1930s. Aspiring, he said, "to paint the life of my people as I know it," he portrayed card games on the street and children taking piano lessons in New York as well as roosters, washtubs, and voodoo women from his North Carolina childhood. In 1964 he found his mature style: photocollage. Picasso had told him in the 1950s, "You've got to tell a lie to get to a stronger truth." Bearden began to express the collective history of the*

African-American experience through a patchwork of photographed figures. The combined snippets create a jazzy hybrid larger than its parts.

Bearden, "The Woodshed," 1970, MMA, NY.

SOCIAL PROTEST ART

Although Hogarth originated the form, socially conscious paintings were few before the nineteenth century. Artists were generally interested in grander themes and besides, political statements didn't look good hanging on the wall. Some who challenged the status quo were:

HONORÉ DAUMIER, in "Rue Transnonain, April 15, 1834," portrayed a heap of civilian bodies executed by state troops. Here, in "The Third-Class Carriage," he implies the deadening effect of Machine Age transportation.

FRANCISCO GOYA, scathingly denounced man's follies in paintings like "The Third of May, 1808," part of a series entitled The Disasters of War.

JACOB RIIS, a pioneering photojournalist, exposed scandalous conditions like homelessness among immigrants.

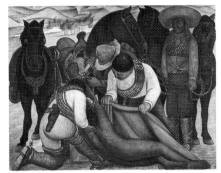

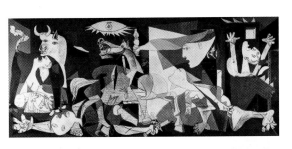

PABLO PICASSO, attacked the destructiveness and cruelty of war in works like "Guernica."

DIEGO RIVERA, in "The Liberation of the Peon," portrayed an executed Mexican peasant as Christ being taken from the cross.

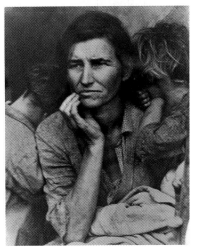

ANSELM KIEFER, in "To the Unknown Painter," used fiery imagery to protest the horror of the Holocaust.

DOROTHEA LANGE, highlighted poverty among the dispossessed during the Depression.

ABSTRACT EXPRESSIONISM

With Abstract Expressionism, for the first time, the metacenter of what was happening in world art shifted to American shores. And a "happening" is largely what Abstract Expressionism was all about, encompassing as "art" not just the product of artistic creation but the active process of creating it.

Also called "action painting" and the New York School, Abstract Expressionism stressed energy, action, kineticism, and freneticism. It used much of what had been defined as art as little more than a point of departure. Indeed, Abstract Expressionism is to conventional artistic technique what jazz is to 4/4 time. While one might look at a painting by Jackson Pollock or Franz Kline and say, "I don't get it," that would be like criticizing jazz great Charlie Parker for not following a tune.

Abstract Expressionism began to take form in the late 1940s and early '50s partially as a reaction to a war that devastated two continents, destroyed 16 million people, and left in its wake a world out of whack. When the Surrealists arrived in America during World War II, the new generation of American painters discovered from them the art of anarchy. But where Dada and Surrealism revolted against logic, the Americans took "automatism" one step further, relying on instinct to shape works of art that were not only irrational but were, at their core, unpremeditated accidents.

Pioneered by such artists as Arshile Gorky, Hans Hofmann, and Jackson Pollock, the Abstract Expressionists liberated themselves from geometric abstraction and the need to suggest recognizable images. Giving free rein to impulse and chance, the impassioned act of painting became an absolute value in itself.

No one better epitomized this wildly subconscious approach than Pollock. Labeled "Jack the Dripper" by *Time* magazine, Pollock made a revolutionary breakthrough by abandoning the paintbrush altogether, sloshing, pouring — and dripping — commercial paints onto a vast roll of canvas on the floor of his studio/barn. With Herculean ambition, he also abandoned the easel format for a monumental, murallike scale. The image of Pollock is of a man possessed — possessed by his own subconscious — as he flung and slung skeins of paint in an all over configuration, throwing out in the process such conventional artistic considerations as foreground, background, focal point, and perspective like so many empty paint cans.

The resulting highly improvisational canvases by Pollock and friends not only stole Europe's position as Keeper of the Cultural Flame, it expanded the very definition of what was thought to be "Art." No longer was art required to imitate tame visual appearance; the energy and emotion of Abstract Expressionism smashed conventions and laid the groundwork for much of what was to follow.

ABSTRACT EXPRESSIONISM

PERIOD: Late 1940s, early '50s

LOCALE: New York, East Hampton

AIM: Express inner life through art

TECHNIQUE: Free application of paint, no reference to visual reality

THEORY: Image not result of preconceived idea, but of creative process

WHAT IS "ART"?

For centuries, a debate has raged over what art is. A lot of what is called art is so outlandish, it stretches the credulity and sabotages one's appreciation of it. Here are some attempts by a number of people to define art.

Proto-abstractionist Arthur Dove (before 1920): "[Art] is the form that the idea takes in the imagination rather than the form as it exists outside."

Expressionist Oskar Kokoschka (1936): "[Art is] an attempt to repeat the miracle that the simplest peasant girl is capable of at any time, that of magically producing life out of nothing."

Realist Ben Shahn (1967): "[Art is] the discovery of images during work, the recognition of shapes and forms that emerge and awaken a response in us."

Or, as Pop artist Andy Warhol said when asked if his six-hour-long film of a man sleeping was art: "Well, first of all, it was made by an artist, and second, that would come out art."

ACTION PAINTING

Critic Harold Rosenberg first used the term "action painting" to explain the Abstract Expressionist working method when he wrote: "the canvas began to appear . . . as an arena in which to act. . . . What was to go on the canvas was not a picture but an event." According to theory, the painter improvises an image as he goes along. The resulting painting records a moment in the artist's life.

The best known, most widely appreciated Abstract Expressionists are:

ARSHILE GORKY (1904–48) pioneered "automatic" painting in the U.S. Called "a Geiger counter of art" by de Kooning, Gorky typified the development of American vanguard artists as he shifted from Cubism to Surrealism, then broke free of European models. The Armenian-American painter freely brushed washes of glowing color inside clearly outlined biomorphic shapes. He favored oval splotches of flowing primary colors like yellow and red, reminding some of runny eggs. Children fled in terror from this 6'3" painter, habitually dressed in black from head to toe like Count Dracula. After a series of setbacks — losing his wife, his health, and his work in a fire — Gorky hung himself in a woodshed. His scrawled message: "Goodbye my 'Loveds."

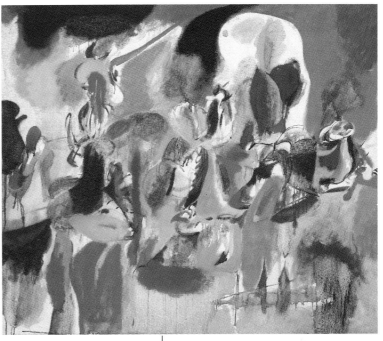

Gorky, "Water of the Flowery Mill," 1944, MMA, NY.

JACKSON POLLOCK (1912–56) conveyed what he called "energy made visible" in his mural-sized, abstract paintings that embodied his psychic state at the moment of their creation. "New needs demand new techniques," he said, throwing out easel, palette, paintbrushes, and artistic convention to pour and fling commercial paints on a roll of unprimed canvas spread on his barn floor. The resulting "drip" paintings, begun in 1947, are a dense network of fluid, interlacing lines. Like the expanding universe after the Big Bang, the sweeping threads of black, white, and silver paint seem to surge in complex visual rhythms, offering no center of interest or sense of boundary. Pollock's unique contribution was to express emotion through abstraction. "In him," said critic Clement Greenberg, "we had truth."

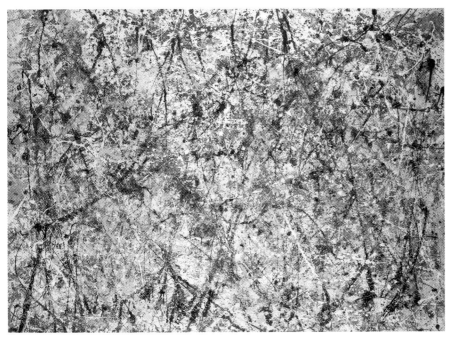

Pollock, "No. 1, 1950 (Lavender Mist)," NG, Washington, DC.

PAINT HARD, LIVE HARD

Jackson Pollock attacking the keys of a grand piano with an ice pick. Pollock shattering a table full of glasses, then fingering the shards to drip blood in designs on the tabletop. Pollock pounding a table so ferociously that a box of matches burst into flames. Burning with intensity, Pollock convinced a generation of artists that art comes from within rather than without. His loutish behavior is legendary. He brawled in bars, urinated in potted plants, ripped doors off their hinges, and died drunk in a car crash at the age of 44.

Regardless of how turbulent his personal life or how unstructured his canvases, Pollock's art was anything but mindless. "NO CHAOS DAMN IT," he once wired a critic who failed to see how a canvas squirted with ink-filled basting syringes could be art.

When Hans Hofmann first visited Pollock's studio he was startled by the absence of any models or sketches. "Do you work from nature?" he asked. Pollock replied, "I am nature."

WILLEM DE KOONING (1904–97), the Old Master of Abstract Expressionism, came to the U.S. from Holland as a stowaway. With his solid background in academic painting and an ability to draw like Ingres, he worked in a realistic style until 1948, when he developed his mature style of slashing brushstrokes. Unlike his colleagues, de Kooning kept his interest in the human figure and is known for a series of "Woman" paintings (which he compared to the Venus of Willendorf). These frontal images appear to both dissolve into and emerge out of fiercely brushed paint. His canvases look raw and unfinished, but de Kooning constantly reworked them in his trademark yellow, pink, and buff colors.

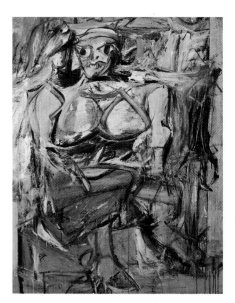

de Kooning, "Woman I,"
1950–52, MoMA, NY.

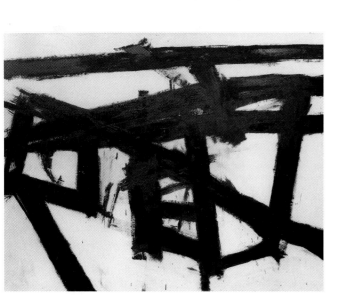

Kline, "Mahoning," 1956, Whitney, NY.

FRANZ KLINE (1910–62) was converted to abstraction after viewing his normal-sized sketches blown up on a wall with a slide projector. He was overwhelmed by the power of these giant black brushstrokes against a stark white background, and began to paint black enamel bars using a housepainter's brush on huge, white canvases. Kline derived his massive linear forms from industrial shapes like trains and girders. "The final test of a painting," he said, "is: does the painter's emotion come across?"

BLACK MOUNTAIN COLLEGE

The hands-down winner among all-star art schools was the experimental Black Mountain College in North Carolina during its brief heyday of 1933–57. Its staff and alumni were like a Who's Who of the American avant-garde, including painters Albers, Shahn, de Kooning, Kline, Motherwell, composer John Cage, dancer Merce Cunningham, architect Buckminster Fuller, and poets Charles Olson and Robert Creeley. It was at Black Mountain that Rauschenberg first conceived his object-plus-canvas composites. One morning Rauschenberg was stunned by a canvas he had been working on the night before. He called fellow student Cy Twombly to see what had happened. Trapped in the thick black paint was a white butterfly. The "combine" was born.

HANS HOFMANN (1880–1966) was an early advocate of freely splashed pigment. A highly influential teacher, he influenced a generation of disciples with his "push-pull" (repulsion/attraction of certain colors) theory. One of the first to experiment with pouring paint, the German-American painter is known for rectangles of high-keyed, contrasting colors that seem to collide.

Hofmann, "The Gate," 1960, Guggenheim, NY.

CLYFFORD STILL (1904–80) was as intense and jagged as his paintings. A pioneer of nearly monochromatic painting, Still troweled on uneven shapes of paint with a palette knife. His early work consisted of vertical, ragged areas of color in earth tones. Later he used brighter colors but always with a "ripped curtain" pattern lacking any central focus.

Motherwell, "Elegy to the Spanish Republic, No. 34," 1953–54, Albright-Knox Art Gallery, Buffalo.

ROBERT MOTHERWELL (1915–91) was the wealthy intellectual of the group. After studying philosophy at Harvard and Stanford, he took up abstract painting inspired by European Modernism. Motherwell is known for the more than 100 paintings he called "elegies" for the doomed Spanish Republic. These works feature oval shapes wedged between irregular, vertical bands in black, white, and brown.

Other lesser-known but not necessarily less-important Abstract Expressionists are: Adolph Gottlieb (1903–74), best known for stylized "burst" paintings in which circular forms float above exploding masses of paint. James Brooks (1906–92) invented stain painting (painting on unprimed, absorbent canvas which gives a "fuzzy" effect). William Baziotes (1912–63) portrayed an imaginary underwater world. Ad Reinhardt (1913–67) combined Mondrian with Abstract Expressionism into geometric abstractions, and later did the famous "black-on-black" paintings. Bradley Walker Tomlin (1899–1953) is known for calligraphic strokes like bird scratchings. Philip Guston (1913–80) thickly overlapped brushstrokes in a crosshatching of luminous colors. He became a figurative artist in later years. Lee Krasner (1911–84), Pollock's wife, suggested human forms without literally depicting them. Ibram Lassaw (1913–2004), one of the first Americans to make abstract sculpture, in 1950 welded open grids and latticed metal sculpture. Esteban Vicente (1903–2001) used an air compressor to spray luminous colors in abstract paintings.

Still, "Untitled," 1946, MMA, NY.

FEDERAL ART PROJECT

During the darkest days of the Depression, President Roosevelt put 10,000 artists to work. "Hell! They've got to eat just like other people," said FDR's aide Harry Hopkins. In the most ambitious program of government art patronage ever, the U.S. Treasury doled out $23.86 a week to artists like Thomas Hart Benton, John Steuart Curry, Ben Shahn, Isamu Noguchi, and Arshile Gorky and Jackson Pollock who would become known as Abstract Expressionists. During the program's tenure of 1935–43, these artists — many young and unknown — produced one work every two months, for a total of 100,000 easel paintings, 8,000 sculptures, and more than 4,000 murals for public buildings. The subsidy allowed a generation of artists the luxury of experimenting with new styles. Painter Stuart Davis traced "the birth of American art" to the Federal Art Project. Its support catalyzed a burst of innovation and catapulted New York to the forefront of advanced art.

JOAN MITCHELL

A second generation member of the Abstract Expressionist group who kept the flame alive was Chicagoan Joan Mitchell (1926–92). Her scribbly, darting brushstrokes on a plain white field are abstract versions of landscapes in gold, yellow, and blue. Although the loose brushstrokes seem quickly applied, as if the whole painting were produced in a blaze of improvisation, Mitchell insisted, "The idea of 'action painting' is a joke. There's no 'action' here. I paint a little. Then I sit and I look at the painting, sometimes for hours. Eventually the painting tells me what to do."

FIGURAL EXPRESSIONISM: NOT JUST A PRETTY FACE

Reacting against the prevailing trend of complete abstraction, a few postwar painters kept figurative painting alive. They began, however, with the Modernist principle that art must express a truth beyond surface appearance. These painters retained the figure only to bend it to their will.

DUBUFFET: BRUTE STRENGTH. While art leadership shifted from Paris to New York, Jean Dubuffet (1901–85) made his mark as the most original Continental artist by completely overthrowing European tradition. To "replace Western art with that of the jungle, the lavatory, the mental institution" is how Dubuffet described his aim. He invented a new term for this new art: "L'Art Brut" (pronounced Lar BROOT), which means raw or crude art.

Dubuffet believed art as practiced for centuries had run out of steam. It was dry and lifeless compared to the compelling images he discovered scrawled in graffiti or turned out by people on the margins of society, like mental patients and criminals. "It was my intention to reveal," he said, "that it is exactly those things [others] thought ugly, those things which they forgot to look at, which are in fact very marvelous."

For Dubuffet, only amateurs could tap the imagination without self-censorship. Professional art was, he thought, "miserable and most depressing." Art by social outcasts is "art at its purest and crudest, springing solely from its maker's knack of invention and not, as always in cultured art, from his power of aping others."

OUTSIDER ART. Like Dubuffet's L'Art Brut, Outsider Art, or work outside the mainstream of professional art, is produced by self-taught, inwardly driven artists. Their work includes not only entire environments like Simon Rodia's Watts Towers in Los Angeles, but paintings and sculptures of outrageous inventiveness.

Outsider art encompasses work by the insane and criminals as well as by unschooled artists. Often its practitioners are obsessively committed to their work, using whatever means and materials are at hand, such as cast-off metal and roots or stumps of trees. Swiss mental patient Adolf Wolfli, for example, was unstoppable, compulsively covering any surface in reach with dense drawings. North Carolina artist Jimmie Lee Sudduth paints with mud and sugar water from plastic bags of thirty-six different colors of dirt. When he can't find exactly the right earth-tone he needs, Sudduth mixes up a batch of rose petals for red or wild turnip greens for — what else? — green. "I don't like to use paint too much," he says.

Dubuffet, "The Cow with the Subtile Nose," 1954, MoMA, NY. *Dubuffet's work represented, he said, the "values of savagery." Throwing out conventional oil-on-canvas, Dubuffet used new materials as well as a new mindset. He incorporated mud, ashes, banana peels, butterfly wings, and chicken droppings into his paintings. With these, he mixed oil, cement, asphalt, or putty to build up a thick paste, then scratched deliberately primitive designs into the thick surface.*

Hampton, "Throne of the Third Heaven of the Nation's Millennium General Assembly," c. 1950–64, National Museum of American Art, Washington, DC. *A janitor who created this work in his spare time in a garage, James Hampton intended the gold-and-silver-foil-covered structure as a throne for the Messiah.*

***BACON*: THE POPE OF PAINT.** London artist Francis Bacon (1909–92), a descendant of the Elizabethan Sir Francis Bacon, was known for his twisted, horrifying figures that look like melting monsters. First widely seen in 1945, the images were "so unrelievedly awful" said art critic John Russell, "that the mind shut with a snap at the sight of them." Bacon painted human figures as freakish half-human, half-beast embryos, with snouts for noses, bloody eye sockets, mouths with no heads, and feet that dissolved into puddles. At the same time as the eye recoils from the image, Bacon's handling of paint is so seductively beautiful, it's hard to look away.

A self-taught painter, Bacon consciously searched for forms that would have a visceral impact on viewers' emotions. He believed photography eliminated the artist's need to report reality. He hoped his deformed portraits would leave "a trail of the human presence," he said, "as the snail leaves its slime." To suggest the truth, he distorted it. "Fact leaves its ghost," he said. Typically, Bacon placed figures in realistic settings and glaring light but smudged and twisted them. "I get nearer," he said, "by going farther away."

BODY LANGUAGE. Bacon never worked from live models, although he did many portraits of friends based on memory or photos. "Who can I tear to pieces," he asked, "if not my friends?" Often he drew inspiration from color plates of hideous wounds or disfiguring diseases, which accounts for the impression of flayed flesh his images convey. Themes of war, dictators, and meat appear frequently in his work, as do images of tubular furniture, a red rug, window shades with dangling cords, an umbrella, a rabid dog, and a bloodied human figure on a bed.

An eccentric who spent his time painting, gambling, drinking, or curled up in a fetal position daydreaming, Bacon called his work "exhilarated despair." Although museum curators admired his work, Bacon was aware it appalled most collectors. He imagined new acquaintances thinking, "Ha! Slaughterhouses!" when they met him. He never toned down his style, admitting, "Whoever heard of anyone buying a picture of mine because he liked it?"

PARADISE GARDEN: A SHRINE OF OUTSIDER ART

"A man of visions" is how painter Howard Finster (1916–2001) signed his work. He had his first vision at age three in a tomato patch. An apparition of his sister, recently deceased from rabies, appeared announcing he would be a man of visions. After that, he had thousands of visions, some of the Biblical sort like bands of angels, others more futuristic like spaceships.

For forty-five years, Finster preached as a fundamentalist minister, then one day he got paint on his finger and a face told him to paint sacred art. Finster filled in a two-and-a-half-acre swamp in Summerville, Georgia, to create an environment of evangelism he called Paradise Garden. He paved the walkways with bits of colored glass, rhinestones, mirror fragments, marbles, and rusty tools. He made a 20-foot-high structure called Bicycle Tower of discarded bike frames, lawn mowers, and wheels. What others call junk was a jewel to Finster. "Lots of people said I was crazy," he admitted. "Noah couldn't get any support on the ark because it looked crazy to people."

A WOMAN'S LIFE

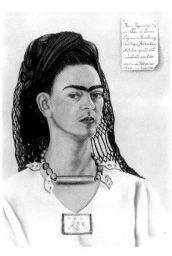

Kahlo, "Self-Portrait," 1940, Private collection. *The work of Mexican painter Frida Kahlo (1907–54) was shocking in its candor. The bulk of her 200 paintings were fantasized self-portraits, dealing with subjects seldom treated in Western art: childbirth, miscarriage, abortion, and menstruation. She delighted in role-playing and wore colorful Mexican costumes, basing her painting style on indigenous folk art and Roman Catholic devotional images. An invalid who had thirty-two operations in twenty-six years, she had a red leather boot encrusted with Chinese gold trim and bells made for her wooden leg after her leg was amputated so she could "dance her joy."*

At her first one-woman show, Kahlo's doctor said she was too ill to attend, so she had herself carried in on a stretcher as part of the exhibit. Kahlo died soon after. When they pushed her body into the oven to be cremated, the intense heat snapped her corpse up to a sitting position. Her hair blazed in a ring of fire around her head. She looked, painter David Siqueiros said, as if she were smiling in the center of a sunflower.

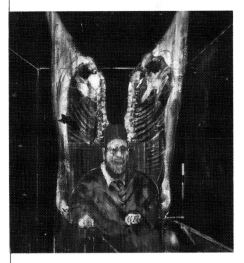

Bacon, "Head Surrounded by Sides of Beef," 1954, Art Institute of Chicago. *Bacon was fascinated with Velázquez's portrait of Pope Innocent X and did a series of grotesque versions, sometimes with the pope shrieking amid blurred shafts of spectral paint. Bacon reworked the Velázquez portrait in many studies but insists he never saw the original. The screaming pope is hemmed in by luminescent sides of meat, suggesting Bacon's belief that "we are all carcasses."*

POSTWAR SCULPTURE

Postwar sculptors worked with new materials like scrap metal, new techniques like welding, and new forms like assemblage and mobiles. Although abstraction was their dominant mode, the chief feature of their art was experimentation.

MOORE: ENGLAND'S MOST FAMOUS SCULPTOR. Henry Moore (1898–1986) clearly built on the biomorphic shapes of Surrealists Jean Arp and Joan Miró. He also based his work on natural forms like shells, pebbles, and bones. Subjects that preoccupied him throughout his career were the reclining figure, mother and child, and family. Although he minimized surface detail and greatly simplified forms, Moore's large, open shapes are semi-naturalistic, perforated by holes that are as important as the solid parts of his works.

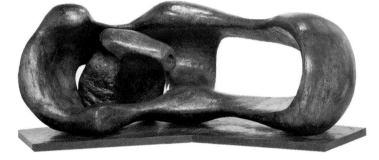

Moore, "Reclining Mother and Child," 1960–61, Walker Art Center, Minneapolis. *Moore did stylized single and grouped figures with characteristic hollows.*

To discover evocative forms, Moore studied artifacts like Anglo-Saxon, Sumerian, and pre-Columbian objects as well as nature. He aimed not for beauty but power of expression. "Truth to the material" was another principle. Whether he worked in wood, stone, or bronze, Moore respected his medium. His figures seem to emerge out of their materials, his designs harmonized with natural textures and streaks.

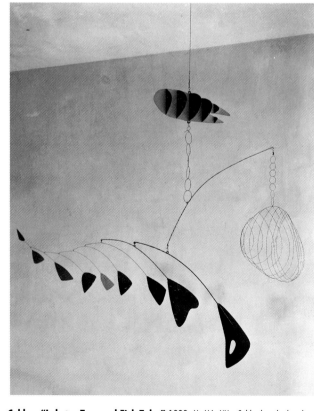

Calder, "Lobster Trap and Fish Tale," 1939, MoMA, NY. *Calder knocked sculpture off its feet by inventing the mobile, which combines spontaneity and playfulness.*

CALDER: DEFYING GRAVITY. "The least one can expect of sculpture," Dalí said, "is that it stand still." American artist Alexander Calder (1898–1976) disagreed and invented a new art form: sculpture in motion. Dubuffet named Calder's floating sculpture "mobiles."

Calder got the idea when he visited Mondrian's studio and admired the colored rectangles covering the walls. He wanted to make, he said, "moving Mondrians." In 1932 Calder succeeded by suspending discs of sheet metal painted black, white, and primary colors from wires and rods. Since the barest wind set them dancing, the result was a constantly shifting set of shapes that Calder called "four-dimensional drawings." In "Lobster Trap and Fish Tale," the forms swim in space, realigning themselves with the slightest breath of air. In 1953 Calder invented what Jean Arp dubbed "stabiles," or nonmoving steel structures whose intersecting planes spring from the ground on tiny points.

Calder intended his work to delight and surprise. While sculpture was traditionally heavy and massive, his was airy and open. He was as unpredictable as his work. A friend once discovered him working in his studio with a clothespin and piece of cotton clamped on his nose because he had a cold and wouldn't stop to wipe. When asked by an earnest visitor how he knew that a piece was finished, "When the dinner bell rings," was Calder's reply.

SMITH: MAN OF STEEL. The most important sculptor associated with the New York School was David Smith (1906–65). "When I begin a sculpture I am not always sure how it is going to end," he said. Smith invited chance and surprise to enter the process of creation, believing that sculpture should pose a question, not offer a solution.

"Now steel, that's a natural thing for me," Smith, the descendant of a blacksmith, admitted. He called his work site Terminal Iron Works because it was more a machine shop than an artist's studio. Smith learned his craft on a Studebaker auto assembly line where he picked up welding and riveting skills. Untrained in sculpture, he fused machined metal parts into open, linear designs. Smith is best known for his Cubi series of balanced stainless steel cubes and cylinders. Cantilevered into space, the squares and rectangles seem momentarily poised but on the brink of collapse. Although semiabstract, they often suggest the human form.

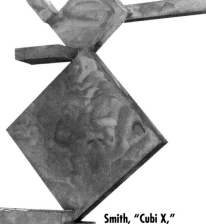

Smith, "Cubi X," 1963, MoMA, NY. *Smith was among the first to use welding in sculpting his geometric compositions.*

After Smith's death in a car crash, his friend Robert Motherwell eulogized him, "Oh David, you were as delicate as Vivaldi and as strong as a Mack truck."

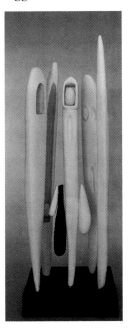

Bourgeois, "Quarantania, I," 1948–53, MoMA, NY. *Bourgeois is known for her carved wood ensembles.*

BOURGEOIS: THE LONELY CROWD. While Calder and Smith pioneered new forms in metal, French-American sculptor Louise Bourgeois (1912–2010) did groundbreaking work in wood. Her first exhibition in 1949 included constructions of six-foot-tall wooden posts that were thin like asparagus. She clustered several tapering columns together and often painted them black because, she said, "the world is in mourning."

The relation — or its lack — between individuals had long been Bourgeois's preoccupation. She titled a sculpture "One and Others," saying, "This is the soil from which all my work grows."

During her 65-year career, Bourgeois transformed painful memories into groundbreaking sculptures and installations. Shifting between abstract and figurative styles, her constant is a fixation on psychological themes — like the need to expose, then heal, inner wounds. Her art incorporates ghosts, guilt, and rage stemming from her childhood. "The gift of the artist," Bourgeois said, "is access to what makes us tick deep in the unconscious."

NEVELSON: BEYOND THE WALL. "I didn't want it to be sculpture and I didn't want it to be painting," said American sculptor Louise Nevelson (1900–88) of her work. "I wanted something else. I wanted an essence." The "essence" Nevelson created is a novel art form. Her characteristic "sculptured walls" consist of cubicles crammed full of carpenter's cast-offs: newel posts, balusters, finials, and pieces of molding. She painted an entire 11-foot-high wooden wall, composed of many boxy compartments, one color: usually flat black, later white or gold. "I have given shadow a form," said Nevelson.

As a child newly arrived from Russia, in Rockland, Maine, where her father ran a lumber yard, Nevelson was always sure of her artistic calling. "My life had a blueprint from the beginning, and that is the reason that I don't need to make blueprints or drawings for my sculpture. What I am saying is that I did not become anything. I was an artist." Through years without recognition, "the only thing that kept me going," Nevelson said, "was that I wouldn't be appeased."

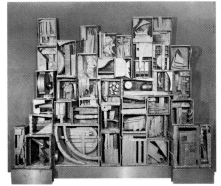

Nevelson, "Sky Cathedral," 1958, Albright-Knox Art Gallery, Buffalo. *A pioneer of environmental sculpture, Nevelson made wall-sized collages of discarded wood scraps.*

COLOR FIELD

In the late 1940s and early '50s a few New York School painters spun off a variation on Action Painting where vast expanses, or "fields" of color became the focus. "Color Field" painting was invariably abstract, and canvases were huge, almost mural-size.

Rothko, "Blue, Orange, Red," 1961, Hirshhorn Museum and Sculpture Garden, Smithsonian Institution, Washington, DC. *Rothko painted bars of color that seem to dissolve into each other.*

ROTHKO: **BLURRED RECTANGLES.** "There are some painters who want to tell all," said Russian-American Mark Rothko (1903–70), "but I feel it is more shrewd to tell little." While Rothko told little, he suggested volumes in his eight-foot-high paintings consisting of two or three soft-edged, stacked rectangles.

Interested in the relation between one color and another, Rothko built up large patches of pigment that seem to hover within their color fields. Erasing all evidence of brushstrokes, he also eliminated recognizable subject matter. In a joint statement with painter Adolf Gottlieb, Rothko wrote, "We favor the simple expression of the complex thought." As his paintings became simpler, they became larger. "A large picture is an immediate transaction," Rothko said, "it takes you into it."

As Rothko slipped into depression and alcoholism, his paintings lost their hushed, calm aura, becoming dark and melancholy. His murals for the St. Thomas University chapel in Houston are black, brown, and eggplant purple. A year later, he took his life.

Barnett Newman, "Day One" 1951–1952, oil on canvas, overall: 132 x 50¼ in. (335.3 x 127.6 cm); Whitney Museum of American Art, New York; Purchase, with funds from the Friends of the Whitney Museum of American Art 67.18; *Newman is known for monochromatic fields of color relieved by a contrasting stripe.*

NEWMAN: **ZIP STRIPS.** Barnett Newman (1905–70) was the most radical abstractionist of the New York School. He gave up texture, brushwork, drawing, shading, and perspective for flat fields of pure color sliced by one or two off-center stripes ("zips," he called them). While Abstract Expressionist paintings seem to explode with energy, Newman's are condensed, relying wholly on the evocative power of color.

An intellectual who wrestled with profound philosophic and religious issues, Newman tried to find innovative visual equivalents for his mystical concerns, as in his Stations of the Cross series at Washington's National Gallery of Art. The colossal scale of his canvases (one painting is 17 feet wide) was indispensable to his meaning. "Scale equals feeling," Newman said. To him the "void" relieved only by a stripe looked sublime, full of light, meaning, and "the chaos of ecstasy."

Frankenthaler, "The Bay," 1963, Detroit Institute of Arts. *Frankenthaler developed stain painting because, she said, the paint "cried out to be soaked, not resting" on top of the canvas.*

FRANKENTHALER: STAIN PAINTING. When New York painter Helen Frankenthaler (1928–2011) first saw Jackson Pollock's black-and-white work, she was stunned. "It was as if I went to a foreign country but didn't know the language," she said, "but was eager to live there . . . and master the language." Soon after, she visited Pollock's studio and learned his pouring technique. In 1952 she combined two sources of inspiration: Pollock's methods and John Marin's watercolors. With oil thinned to the consistency of watercolor and unprimed sailcloth tacked to the floor, she poured paint from coffee cans, guiding its flow with sponges and wipers.

The unique stain paintings that resulted exist at the crossroads between chance and control. "I think accidents are lucky," Frankenthaler said, "only if you know how to use them." Frankenthaler's colorful shapes float like swollen calligraphy. Because the thin washes of pigment soak into the canvas rather than rest on top of it, the white fabric shines through, irradiating the color with light like stained glass. Denser zones contrast vividly against the open, expansive field of lush color.

LOUIS: VEILS AND VARIATIONS. American artist Morris Louis (1912–62) discovered his style when he saw what Frankenthaler was doing. Her work, he said, was "a bridge between Pollock and what was possible." Morris perfected the spontaneous-but-composed method of staining canvas. He poured diluted acrylic paint, tilting his unprimed canvas to guide the flow into several characteristic forms: veils, stripes, and florals. By relying solely on the directed fall of paint, Louis produced paintings without a single brushstroke. With the "handwriting" of the painter gone, his works communicated purely through color.

A Louis trademark was the "veil" painting: overlapping fans of color produced by pouring pigment down vertically placed canvases. He also created "floral" patterns of smoky color that flare out in scallops. His "stripes" run from top to bottom in multicolored canals of color. Louis experimented with leaving a huge empty space in the middle of his canvases, framed by diagonal bands of color at the corners. The central white space, more than a negative void, packs a positive punch.

NEWMAN'S PASSION

Barnett Newman painted a fourteen-work series (1958–66) on unprimed canvas using only black and white paints. The austere pictures, each composed of a couple of stripes, indicate the fourteen stages of Christ's Passion from trial to entombment. When attending a formal dinner at New York's Plaza Hotel, Newman, dignified in his tuxedo and monocle, spotted a priest and asked, "Have you seen my Stations of the Cross paintings? I showed them at the Vatican, and the Pope told me I had brought Christianity into the twentieth century." The painter Lee Krasner, for whom art was the one true religion, snapped, "For Christ's sake, Barney, isn't that a little pretentious?"

Louis, "Point of Tranquility," 1959–60, Hirshhorn Museum and Sculpture Garden, Smithsonian Institution, Washington, DC. *Louis poured paint in several distinct patterns that resemble veils, stripes, or floral designs.*

The Twentieth Century: Contemporary Art

The problem with assessing Contemporary art is that it's still alive and growing. History has yet to tell the tale of who will fade from memory and who prevail. What is clear, however, is that movements have come and gone since 1960 at a brisk clip. A common thread linking them is their opposition to Abstract Expressionism. It's as if the shadow cast by Jackson Pollock loomed so large that future offshoots had to hack down the tree to find their own spot in the sun. Hard Edge painters and Minimalist sculptors annihilated Action Painting's cult of personality by creating machinelike forms. Pop artists embraced commercial imagery, and Conceptualists pared the idea of a hand-wrought art object to ground zero, where art existed in the mind more than on canvas. All these movements centered in New York, where it began to seem as if painting was terminally passé.

Then around 1980 Europe seized the spotlight. German and Italian painters known as Neo-Expressionists returned figure painting and recognizable images to the mainstream, infusing their intense, emotional canvases with autobiographical and social concerns. In Post-Modern art of the next generation, everything was up for grabs. Allowable forms, materials, media, and content were expanded to such a degree that nothing seemed off limits, and artists grappled with the challenge of being truly original rather than merely novel. As the twentieth century drew to a close, art was more international, with no geographical area dominating, and more diverse than ever before. After a century of experimentation, the legacy was wide-open freedom.

WORLD HISTORY		ART HISTORY
	1959	"Street Photography" in vogue
John F. Kennedy elected president	1960	Stella exhibits shaped "Hard Edge" canvases; Minimalism begins; Yves Klein makes paintings with nude women as "brushes"
First man orbits earth; Berlin Wall erected; birth control pills available	1961	
	1962	First Pop Art exhibit
John F. Kennedy assassinated	1963	
Civil Rights Act passed; Beatles win fame	1964	Op Art begins
	1965	Minimalism recognized
Cultural Revolution begins in China	1966	
Students demonstrate against Vietnam War	1967	Conceptual Art developed; Venturi describes Post-Modern architecture
Robert Kennedy, Martin Luther King, Jr., assassinated	1968	Earth Art documented; Process Art exhibited
Neil Armstrong walks on moon; Woodstock festival held	1969	Judy Chicago founds feminist art program
First Earth Day launches environmental movement	1970	Earthworks sculpt art from landscape
	1972	Photo-Realism shown
Women win abortion rights	1973	Auction escalates art prices
Richard Nixon resigns U.S. presidency	1974	
Vietnam War officially ends	1975	Graffiti art exhibited
	1976	Performance Art shown
Israel and Egypt sign treaty	1977	Beaubourg opens in Paris; Blockbuster King Tut show tours
	1979	Appropriation art begins
Ronald Reagan elected president	1980	
MTV debuts	1981	Neo-Expressionism exhibited
AIDS identified	1982	Post-Modern architecture recognized
Apple introduces Macintosh personal computer	1984	
Mikhail Gorbachev begins reform	1985	New Wave movement takes off in China
Challenger explodes; Chernobyl nuclear reactor erupts	1986	Installations become trend
U.S. stock market crashes; recession begins	1987	AIDS crisis causes early deaths in art world
Exxon Valdez oil spills; Democracy crushed in China; Berlin Wall opens	1989	Senator Jesse Helms attacks "obscene" art
Iraq invades Kuwait	1990	Cynical Realism starts after Tiananmen Square crackdown
Operation Desert Storm defeats Iraq; Soviet Union collapses	1991	
Bill Clinton begins eight-year presidency	1992	Artists create digital, new-media art
Use of Internet booms	1993	Political art dominates Whitney Biennial
Nelson Mandela wins presidency in South Africa	1994	Hot "YBAs" (Young British Artists) exhibit
1st cloned adult mammal (Dolly the sheep) created	1997	Gehry's Guggenheim Bilbao opens in Spain
	1998	Artists create immersive video environments
George W. Bush named president in controversial election	2000	Photography-based imagery widespread
Terrorist attacks on U.S. and assault on Taliban in Afghanistan	2001	Computer art expands
	2002	Trend in collaborative art evident
Iraq War begins; Saddam Hussein deposed	2003	Cartoons influence painting
	2004	Artists resume craft of painting
Hurricane Katrina devastates New Orleans, Gulf Coast	2005	21st century's first "art phenomenon": New Leipzig School
	2006	Market for contemporary Chinese art soars
Recession began as housing boom goes bust	2008	Post-Internet art spreads
Barack Obama inaugurated first African-American U.S. president	2009	
Arab Spring rebellions begin in the Middle East	2010	
Donald Trump elected U.S. president	2016	Social practice art spreads

HARD EDGE

Around 1948, Abstract Expressionism burst on the scene with fierce emotionalism, impulsiveness, and signature brushstrokes. The painters of ten years later defined themselves as everything Abstract Expressionists were not. It was as if they took to heart Minimalist painter Ad Reinhardt's slogan, "a cleaner New York is up to you." Hard Edge painters cleaned up the act of Action Painters.

Hard Edge took the Expressionism out of Abstract Expressionism. What it offered instead of spontaneous, subjective abstraction was calculated, impersonal abstraction. Hard Edge painting uses sharply contoured, simple forms. The paintings are precise and cool, as if made by machines. It took even further the Modernist tendency to view the artwork as an independent object rather than a view of reality or the painter's psyche. In Hard Edge, the painted surface is nothing more than a pigment-covered area bordered by canvas stretchers. Frank Stella summed it up best: "What you see is what you see."

Albers, "Homage to the Square: 'Ascending,'" 1953, Whitney, NY. *A color theorist, Albers demonstrated the effect of one color on another. Here the bottom and side bands of gray and blue rectangles appear darker than the upper bands, even though the shades are uniform throughout.*

ALBERS: THE SQUARE SQUARED. The patron saint of Hard Edge painting was German-American painter and color theorist Josef Albers (1888–1976). After teaching at the Bauhaus, Albers came to the United States and taught a course called "Effect Making" at the experimental Black Mountain College in North Carolina. Throughout Albers's long career as a teacher, his obsession was one color's effect on another or, as he said, "how colors influence and change each other: that the same color, for instance, — with different grounds or neighbors — looks different."

At Albers's first class he asked the students, "Vich of you children can draw a straight line?" Facing the blackboard, Albers then walked sideways, dragging a piece of chalk across the board until he produced a perfectly level line ten feet long. Soon thereafter he set his pupils to mastering nearly impossible technical tasks like drawing letters and numbers backward with a pencil gripped between their toes. He taught technical control, not freedom.

Albers's own work reflected such extreme discipline. From the 1950s he concentrated on variations of the most neutral, stable form he could find: the square. His Homage to the Square series consists of superimposed squares of subtly varied hues, a textbook demonstration of how colors interact. Albers wanted his viewer to be aware of "an exciting discrepancy between physical fact and psychic effect of color" — the optical illusion of color.

NOLAND: ON TARGET. Kenneth Noland (1924–2010), an American pupil of Albers, learned his color lessons well. But instead of squares, he first specialized in concentric circles. By confining himself to the circle (called his "target" paintings, begun in 1958), Noland established the center of the canvas (the "bull's eye") as a structuring device, forcing the viewer to focus on other formal elements. "With structural considerations eliminated," he said, "I could concentrate on color."

By the mid-'60s, Noland moved on to another trademark shape: immense, brightly colored chevrons. In traditional composition, forms cohere around a central focal point, but in Noland's, the wing-shaped chevrons seem to fly off toward the canvas edge. Noland also defied tradition by breaking the picture's rectangular format. A pioneer of the shaped canvas, he used diamonds, triangles, and irregular shapes.

Noland attempted to erase his personal identity from his canvases by the use of controlled designs, intense colors, and geometric compositions he called "self-cancelling," rather than "self-declaring." Instead of screaming "Look at me!" to draw attention to an artist's inner vision as

Noland, "Bend Sinister," 1964, Hirshhorn Museum and Sculpture Garden, Smithsonian Institution, Washington, DC. *Noland divided space with sharply defined shapes and colors to evoke calculated visual sensations.*

in Abstract Expressionism, up-front Hard Edge paintings quietly state, "Look for yourself." It was not about interior angst, only exterior surface.

KELLY: PERFORMING MASSES. More than a brush, the tools of the Hard Edge painter's trade are quick-drying acrylic paint and masking tape for clear, crisp outlines. American artist Ellsworth Kelly (1923–2015) outlined his shapes so sharply, they looked like razor cuts. Yet he claimed, "I'm not interested in edges . . . I want the masses to perform."

And perform they do. Kelly combines giant, simple shapes so they almost oscillate. The viewer is hard put to say which is forefront and which is background. In some of his paintings, a large shape seems barely confined within the canvas, while in others the image seems to continue outside the picture frame. In both cases, Kelly sets up a fluctuating tension between static/dynamic and closed/open forms. In "Blue, Red, Green," the cut-off, irregular blue ellipse slices across a green rectangle like a water hazard on a putt-putt course. The green form seems both a flat plane and a slightly receding background.

Kelly also used shaped canvases in irregular, geometric, and curved formats. He typically combined two bold, intense colors and basic shapes in mural-sized canvases.

STELLA: MECHANICAL DRAWING. One of the most original of contemporary American artists is Frank Stella (b. 1936). Stella insists on the painting as a self-sufficient object. "All I want anyone to get out of my paintings, and all I ever get out of them," Stella said, "is the fact that you can see the whole idea without any confusion."

Stella first established his identity with a series of black-striped paintings consisting of sooty pinstripes separated by narrow white bands. Breaking the rectangle with shaped canvases was a way for him to overcome the illusion that a painting is a window into illusionistic space. Instead of traditional easel paintings that told a story, made a "statement," or presented a metaphor for something else, Stella said his painting was a "flat surface with paint on it — nothing more."

Stella deliberately sacrificed personal handling, using commercial house paint and metallic paint. In his large-scale "protractor" series of paintings based on intersecting protractor arcs in fluorescent colors, he based both the shape of the canvas and design on a mechanical drawing tool. From the 1960s through the '80s, in series after series, Stella determined his composition by such mechanical means, using rulers, T-squares, and French-curve templates to sketch on graph paper. In the '70s, Stella entered what he called his "baroque phase" and developed a new, 3-D format straddling the border between painting and sculpture.

Kelly, "Blue, Red, Green," 1962–63, MMA, NY. *Hard Edge painters used simple forms and limited colors in precise, impersonal designs.*

Stella, "Star of Persia II," 1967, Hirshhorn Museum and Sculpture Garden, Smithsonian Institution, Washington, DC. *Stella emphasizes the painting as an independent object in his canvases fusing design and shape.*

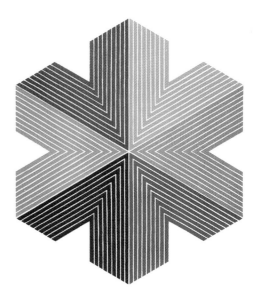

PRE-POP ART

For an art movement that began so far outside the mainstream, Abstract Expressionism entrenched itself surprisingly fast. Within ten years, its founders and its style seemed overbearingly trite. Wannabe Action Painters, in shameless imitation, were splashing gallons of paint, cashing in on what rapidly became a standardized schtick. Innovative young painters of the mid-fifties rebelled against these faux abstractions. "It was not an act of hostility," said Jasper Johns, explaining why he chose a different path from Pollock. "It was an act of self-definition."

As Robert Rauschenberg, Johns's co-leader in the breakaway, said, "I had decided that ideas are not real estate. There's enough room to move in that you don't have to stand in the same place or imitate. Everyone was doing de Kooning, Newman, Reinhardt. There were only two artists that didn't copy other artists: Jasper Johns and I." In a quintessential act of defiance, Rauschenberg in 1953 produced a work of art by erasing a de Kooning drawing. This off-with-their-heads gesture symbolized how the movement Rauschenberg and Johns began wiped out Abstraction's dominance of world art.

RAUSCHENBERG: FORM EQUALS FACT.

Rauschenberg (1925–2008) was the postwar artist most responsible for liberating the artist from a compulsion to record his own emotions. A recycler of throwaways before salvage was chic, Rauschenberg invented a hybrid form of art, half-painting and half-sculpture, he called "combines." After combing New York streets for junk, or sculpture-waiting-to-be-discovered in his opinion, Rauschenberg attached eccentric materials like rusted traffic signs, frayed shirt cuffs, and a stuffed eagle to his expressionistically painted canvases. "A pair of socks is no less suitable to make a painting with," he said, than oil and canvas. "I wanted the images to still have the feeling of the outside world rather than cultivate the incest of studio life."

In a famous statement that explains his appropriation of found objects, Rauschenberg said, "Painting relates to both art and life. . . . I try to act in the gap between the two." Acting in the gap meant nothing was off-limits. "A picture," he said, "is more like the real world when it's made out of the real world." In this equal-opportunity approach, Rauschenberg resembles his mentor, avant-garde composer John Cage, who made music out of silence (actually, the sounds of the restless audience). When once complimented on a composition, Cage stared out the window, saying, "I just can't believe that I am better than anything out there."

MERGERS AND ACQUISITIONS. "Multiplicity, variety, and inclusion" Rauschenberg called the themes of his art. During fifty prolific years he has merged Dada's radical questioning of accepted practice with an energetic, Abstract Expressionist brushstroke and Surrealist faith in accident. In the process, he acquired his own distinct style based on risk-taking. "If art isn't a surprise," Rauschenberg has said, "it's nothing."

An example of his openness to possibility occurred one May morning when Rauschenberg woke up inspired to paint but had no money for canvas. Surveying his bedroom, he seized an old quilt and tacked it and his pillow to the stretcher before splashing them with paint. Although shocked Italian officials refused to display the work that resulted ("Bed"), Rauschenberg considered it "one of the friendliest pictures I've ever painted. My fear has always been that someone would want to crawl into it." He habitually bought discount paint without labels at a hardware store. He never knew what color he would use until he pried off the lid. "It's the sport of making something I haven't seen before," he said. "If I know what I'm going to do, I don't do it."

During the '80s, Rauschenberg launched a self-funded crusade called ROCI (pronounced Rocky, after his pet turtle) — Rauschenberg Overseas Culture Interchange — to promote peace through art.

Rauschenberg, "Monogram," 1955–56, Moderna Museet, Stockholm. *In this "combine," Rauschenberg mounted a stuffed angora goat wearing an automobile tire on a collaged canvas base to prove that all materials are equally worthy of art.*

JOHNS: ZEN MASTER OF AMERICAN ART.

The opposite of Rauschenberg's passionate, Jack Daniels-swilling welcome of chaos is the cool calculation of Jasper Johns (b. 1930). "Jasper Johns was Ingres, whereas Rauschenberg was Delacroix," according to their long-time dealer Leo Castelli. Yet the two swapped ideas when both had studios in the same New York loft building from 1955 to 1960. Both returned recognizable imagery to art. They even collaborated on window displays for Tiffany and Bonwit Teller. One Tiffany window featured fake potatoes, real dirt, and real diamonds. Like a Johns painting, it combined artifice and reality that glittered with unexpected gems.

SEEING, NOT JUST LOOKING.

For Johns, as for Duchamp, art was an intellectual exercise. During the '50s and '60s he chose familiar two-dimensional objects like flags, targets, and maps as subjects, "things the mind already knows," he said, which "gave me room to work on other levels." In "Three Flags," each successive, stacked canvas of decreasing size realistically portrays a familiar object. At the same time, with its richly textured surface of encaustic (pigment mixed with wax), it is also patently artificial. By contrasting the flag's impersonal structure to his personal artistic handwriting, Johns gave a new identity to an object which, as with O'Keeffe's flowers, is routinely seen but "not looked at, not examined."

Speaking of Leo Castelli's success, de Kooning once said, "He could even sell beer cans," which prompted one of Johns's most provocative works: "Painted Bronze" (1960), two cylinders cast in bronze with painted trompe l'oeil Ballantine Ale labels. Here were disposable beer cans transformed, like bronzed baby shoes, into permanent trophies. Johns challenged the viewer: Are they ale cans or sculpture? Reality or art? "I was concerned with the invisibility those images had acquired," Johns said, "and the idea of knowing an image rather than just seeing it out of the corner of your eye."

His art is a study of ambiguity and metamorphosis. Johns sometimes covered the canvas with crosshatching traditionally used by draftsmen to indicate depth but for Johns a flat surface pattern. "Take an object. Do something to it. Do something else to it," was Johns's credo. His art is intentionally oblique, cool, and detached yet open to multiple interpretations.

In 1985, acknowledged as one of the most esteemed living artists, Johns began to make his paintings more personal. He introduced a figure (a shadowy self-portrait) in Four Seasons, a series exploring the passage of time. Although this work has clear autobiographical implications, as usual, Johns's symbols puzzle more than illuminate.

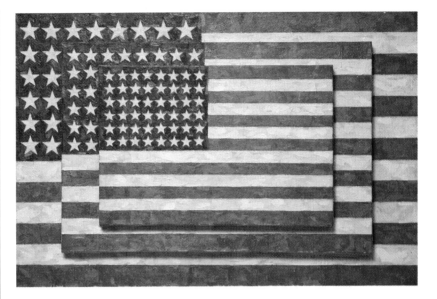

Johns, "Three Flags," 1958, Whitney, NY. *Johns, with Rauschenberg, was first to rebel against Abstract Expressionism by returning recognizable imagery to art.*

HAPPENINGS

As part of the Pop scene, artists like Allan Kaprow and Jim Dine staged happenings, designed to take art off the canvas and into life.

Robert Rauschenberg rented thirty large desert turtles for one happening, "Spring Training." The turtles roamed a darkened stage with flashlights strapped to their backs, sending light flashing in all directions, while Rauschenberg, clad in jockey shorts, traipsed around wiggling his toes and fingers. Then he and a friend toted each other around like logs. For the climax, Rauschenberg, in a white dinner jacket and on stilts, poured water into a bucket of dry ice harnessed to his waist. Clouds of vapor coiled around him, a finale he later pronounced "too dramatic." Afterward, returning the turtles in a taxi, Rauschenberg praised their performance. "But the turtles turned out to be real troupers, didn't they? They were saving it all for the performance. They don't have very much, so they saved it."

POP ART

Once Rauschenberg and Johns re-introduced recognizable imagery, the stage was set in the early 1960s for artists to draw their subjects directly from popular ("pop") culture. With a resounding WHAAM! Roy Lichtenstein's comics-derived paintings took direct aim at the abstract art of the '50s. Besides Lichtenstein, artists like Andy Warhol, Claes Oldenburg, and James Rosenquist, who all had commercial art backgrounds, based their work on images from Times Square neon signs, the mass media, and advertising.

This return to pictorial subject matter was hardly a return to art tradition. Pop art made icons of the crassest consumer items like hamburgers, toilets, lawnmowers, lipstick tubes, mounds of orange-colored spaghetti, and celebrities like Elvis Presley. "There is no reason not to consider the world," Rauschenberg said, "as one large painting." Pop artists also made art impersonal, reproducing Coke bottles or Brillo boxes in a slick, anonymous style. With playful wit, the new art popped the pomposity of Action Painting.

Pop artists blazed into superstardom in 1962 like comets in a Marvel comic. Pop was easy to like. Its shiny colors, snappy designs — often blown up to heroic size — and mechanical quality gave it a glossy familiarity. Pop became as much an overnight marketing phenomenon as a new artistic movement. Collectors compared the skyrocketing prices of their acquisitions to IBM stock. Meanwhile, galleries chock full of passé Abstract Expressionist inventory were out of the action. One jealously posted a sign next to an exhibit of Warhol soup cans: "Get the real thing for 29 cents."

For architect Philip Johnson, a Pop collector, the art was more than monetarily enriching. "What Pop art has done for me is to make the world a pleasanter place to live in," he said. "I look at things with an entirely different eye — at Coney Island, at billboards, at Coca-Cola bottles. One of the duties of art is to make you look at the world with pleasure. Pop art is the only movement in this century that has tried to do it."

LICHTENSTEIN: COMIC STRIP IMAGERY

From 1962, American Pop artist Roy Lichtenstein (pronounced LICK ten stine; 1923–97), parodied the mindless violence and sexless romance of comic strips to reveal the inanity of American culture. Lichtenstein said he painted war comics and tawdry romance melodramas because "it was hard to get a painting that was despicable enough so that no one would hang it. Everyone was hanging everything. It was almost acceptable to hang a dripping paint rag. [But] the one thing everyone hated was commercial art. Apparently they didn't hate that enough either."

Lichtenstein, "Whaam!" 1963, Tate Gallery, London. *Lichtenstein's trademark style borrowed comic book techniques as well as subjects. Using bright primary colors with black and white, he outlined simplified forms, incorporating mechanical printer's (benday) dots and stereotyped imagery. By enlarging pulp magazine panels to billboard size, Lichtenstein slapped the viewer in the face with their triviality.*

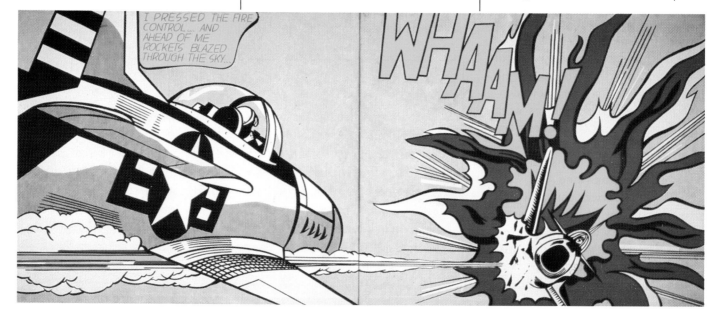

WARHOL: THE POPE OF POP. People who have never been inside an art museum know American painter Andy Warhol (1930–87). Warhol picked his subjects off supermarket shelves and from the front pages of the tabloids. He would then mass-produce images like Marilyn or Campbell's Soup cans in assembly-line fashion, repeating them by silkscreen duplication. These well-known images pushed art out of the museum and into the mainstream.

"Once you begin to see Pop," Warhol said, "you can't see America in the same way." Not only did Warhol force the public to reexamine their everyday surroundings, he made a point about the loss of identity in industrial society. "The reason I'm painting this way is that I want to be a machine," he said. Warhol delighted in deadpan, outrageous statements: "I think it would be terrific if everyone looked alike," he said, and, "I want everybody to think alike. I think everybody should be a machine." Just when critics concluded his platinum fright wig, pale makeup, and dark glasses concealed an incisive social commentator, Warhol punctured their balloons: "If you want to know all about Andy Warhol, just look at the surface of my paintings and films and me, and there I am. There's nothing behind it."

Warhol began as a very successful shoe illustrator for print ads. He lived with his mother in New York with twenty-five cats. Then in 1960 Warhol made acrylic paintings of Superman, Batman, and Dick Tracy. From 1962–65 he added the famous soup cans, Coke bottles, dollar signs, celebrity portraits, and catastrophe scenes straight out of the *National Inquirer*. A natural self-promoter, Warhol made himself into a media sensation. He installed his retinue at a downtown studio called The Factory.

From 1963–68 Warhol made more than sixty films which reached new depths of banality. One silent film, "Sleep," runs six hours, capturing every non-nuance of a man sleeping. "I like boring things," Warhol said.

Although Warhol works are instantly recognizable, he opposed the concept of art as a handmade object expressing the personality of the artist. In his multiple images, endlessly repeated as in saturation advertising, Warhol brought art to the masses by making art out of daily life. If art reflects the soul of a society, Warhol's legacy is to make us see American life as depersonalized and repetitive. "Andy showed the horror of our time as resolutely as Goya in his time," said contemporary painter Julian Schnabel.

Warhol, "100 Cans of Campbell's Soup," 1962, Albright-Knox Art Gallery, Buffalo. *Best known for his serial images of consumer items in a hard-edged graphic style, Warhol wanted a machinelike art without social comment or emotion.*

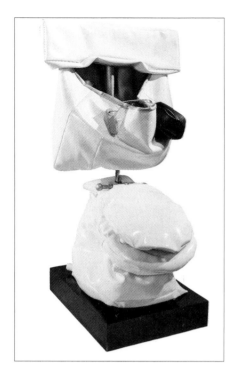

Oldenburg, "Soft Toilet," 1966, Whitney, NY. *By transforming commonplace objects, Oldenburg hoped to make the viewer appreciate their qualities as design objects.*

OLDENBURG: METAMORPHOSIS.

Involved from 1959 to 1965 with Happenings, an early form of performance art, American sculptor Claes Oldenburg (b.1929) developed three-dimensional, large-scale blowups of familiar objects. "I want people to get accustomed to recognize the power of objects," Oldenburg said. Ordinary objects, he believes, "contain a functional contemporary magic," but we have lost any appreciation of this because we focus on their uses.

Oldenburg magnified the scale of objects like clothespins, baseball bats, and lipstick tubes to the epic size of Times Square billboards. He also altered their composition, constructing a typewriter out of soft vinyl, clothespin out of steel, or icepack out of painted canvas stuffed with kapok.

Oldenburg's soft sculptures are like 3-D versions of Dalí's limp watches. His magnifications and transmogrifications "give the object back its power," he said, by disorienting viewers and shocking them out of their torpor. "Soft Toilet," for instance, turns all expectations topsy-turvy. What should be hard is soft and sagging, what should be sanitary looks unhygienic. "Gravity is my favorite form-creator," Oldenburg said.

Besides his soft sculpture, Oldenburg is also known for his proposed civic monuments, most of which exist only as witty sketches. He has suggested replacing standard memorials like soldiers and cannons with colossal enlargements of everyday items like spoons, cigarette butts, or peeled bananas. For the Thames River in London, Oldenburg proposed huge toilet bowl floats to rise and fall with the tides.

Like James Rosenquist, who painted billboards before becoming a Pop artist, Oldenburg was interested in the power of scale as a property in art. "I alter to unfold the object," Oldenburg said, to make us "see," perhaps for the first time, an object we look at every day.

OP ART

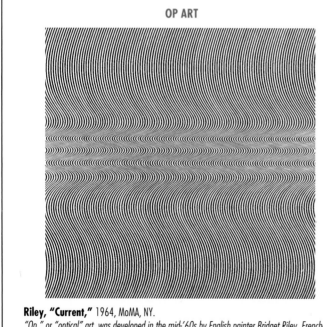

Riley, "Current," 1964, MoMA, NY.
"Op," or "optical" art, was developed in the mid-'60s by English painter Bridget Riley, French-Hungarian Victor Vasarély, and the Americans Richard Anuszkiewicz and Lawrence Poons. It combined color and abstract patterns to produce optical illusions of pulsating movement.

CASTING CALL

Segal, "Walk/Don't Walk," 1976, Whitney, NY.
Around 1960 American sculptor George Segal (1924–2000) created a new art form: plaster casts of figures set in actual environments. By wrapping surgical bandages around living people, he created eerily lifelike, stark white sculptures. Although cast from the living image, Segal's molded people are ghostly and depersonalized. Often in a group, as on a bus, they project loneliness and alienation. Segal's joyless sculpture is to Pop what Hopper's grim pictures are to upbeat American Scene paintings. Like the Pop artists, however, Segal fused reality with unreality to intensify the impact of ordinary experience.

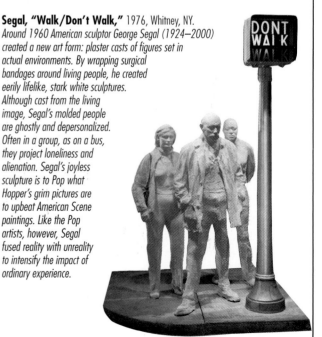

MINIMALISM: THE COOL SCHOOL

The inevitable conclusion of the modern artist's urge to reduce art to basics was Minimalism. Although monochrome canvases by painters like Robert Ryman, Brice Marden, Robert Mangold, and Agnes Martin are called Minimalist, it is primarily a school of sculpture. The founding fathers are all American sculptors like Donald Judd, who defined Minimalism as "getting rid of the things that people used to think were essential to art."

SOLID GEOMETRY. Minimalists, like Hard Edge painters, eradicated the individual's handprint, as well as any emotion, image, or message. To attain such a "pure," anonymous effect, they used prefab materials in simple geometric shapes like metal boxes or bricks.

Minimalism was a reaction against both the swagger of Abstract Expressionism and vulgarity of Pop. After they jettisoned both personality and consumerism, what Minimalists had left were cold, mechanical forms for the viewers to make of them what they would. Metal shelves attached to a gallery wall, panes of glass on a gallery floor, a plank leaning against a wall are all Minimalist art. The ultimate Minimalist exhibit was French artist Yves Klein's show of nothing at all, just a freshly whitewashed gallery containing no object or painting (two patrons even bought nonexistent canvases — Klein demanded payment in gold). "Compared to them," art dealer Leo Castelli said, "Mondrian is an expressionist painter."

For these sculptors, minimum form ensured maximum intensity. By paring away "distractions" like detail, imagery, and narrative — i.e., everything — they forced the viewer to pay undiluted attention to what's left. "Simplicity of shape does not necessarily equate," said Robert Morris, "with simplicity of experience."

MINIMALISM

LOCALE: U.S. in 1960s–70s

FORM: Abstract, geometric modules

LOOK: Clean, bare, simple

TECHNIQUE: Machine-made

MEANING: You be the judge

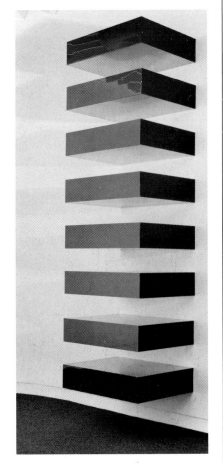

Judd, "Untitled," 1969, Norton Simon Museum of Art, Pasadena, CA. *Minimalism is art reduced to the absolute minimum, totally abstract and commercially manufactured, without reference to the artist's emotions, personality, or any recognizable image.*

A MINI-ROUNDUP OF THE MOST PROMINENT MINIMALISTS

DONALD JUDD (1928–94) fabricated machine-made stainless-steel, Plexiglas, and plywood boxes arranged in horizontal or vertical rows on walls. "A shape, a volume, a color, a surface is something in itself," he said.

CARL ANDRE (b. 1935) went to the opposite extreme from traditional vertical, figurative sculpture on a pedestal. Instead, he arranged bricks, cement blocks, and flat slabs on the floor in a horizontal configuration, as in his 29-foot-long row of bricks on the ground.

DAN FLAVIN (1933–96) sculpted with light, attaching fluorescent tubes to the wall in stark geometric designs giving off fields of color. Hint: Look at the light, not at the tubes.

SOL LEWITT (1928–2007) created simple forms in series like white or black cubes, either open or closed. Although he later added primary colors, LeWitt insisted that art should "engage the mind rather than the eye or emotions."

ROBERT MORRIS (b. 1931) is known for large-scale, hard-edged geometric sculptures like big, blocky right angles. "Unitary forms do not reduce relationships," he said. "They order them." Morris also does antiform sculpture in soft, hanging material like felt. The pieces droop on the wall, sculpted by gravity.

RICHARD SERRA (b. 1939) became infamous for his huge metal sculpture "Tilted Arc," which aroused such hatred in a public square in New York that it was removed in 1989. Serra's huge sculptures impress with their physicality, carving out and trapping space. The gigantic, curving, steel plates of "Torqued Ellipses" (1996–99) tilt with a visceral, gravity-defying effect.

CONCEPTUAL ART: INVISIBLE VISUAL ART

"Painting is dead," the art world proclaimed in the late 1960s and early '70s. Not just painting — sculpture, too, in the opinion of a group called Conceptual Artists. "Actual works of art are little more than historical curiosities," said Joseph Kosuth. This didn't mean that Art was dead. This development was just part of a trend called "dematerialization of the art object." In simple terms: if a creative idea is fundamental to art, then producing an actual object provoked by that idea is superfluous. Art resides in the core concept, not the practical work. Minimalists scrubbed their art clean of image, personality, emotion, message, and handcrafting. Conceptualists went a step further and eliminated the art object altogether. "The idea itself, even if not made visual, is as much a work of art as any finished product," said sculptor Sol Le Witt, who gave the movement its name.

Conceptual Artists include Germans Joseph Beuys (1921–86), Hanne Darboven, and Hans Haacke; Americans Le Witt, Kosuth, John Baldessari, Jenny Holzer, Bruce Nauman, Chris Burden, Jonathan Borofsky; and Bulgarian-American Christo. In fact, Conceptual Artists do create works, but they barely resemble traditional art. The label is an umbrella term covering diverse movements — anything that is neither painting nor sculpture, which emphasizes the artist's thinking, not his manipulation of materials.

Any action or thought can be considered Conceptual Art. Japanese-American artist On Kawara, for instance, has painted a date on a small gray panel each day since January 25, 1966, and exhibits randomly selected dates. Les Levine ran a Canadian kosher restaurant as an artwork. Morgan O'Hara obsessively records how she spends each moment of her life. John Baldessari placed the letters C-A-L-I-F-O-R-N-I-A at different locations around the state. It's all Conceptual Art, as long as the idea rather than the art object is paramount. Here are some of its forms.

PROCESS ART. While Minimalist sculptors went about assembling prefab parts, Robert Morris decided that the process of creating art was more important than the finished piece. Like existentialism — but also taking a page from the Abstract Expressionists — the artist discovers meaning by doing. Walter De Maria in 1961 described a Process Art project: "I have been thinking about an art yard I would like to build. It would be sort of a big hole in the ground. Actually, it wouldn't be a hole to begin with. That would have to be dug. The digging of the hole would be part of the art."

ENVIRONMENTAL ART. Conceptual Artists frequently do their thing far from museums and galleries. Earth-

MEDIA IS THE MESSAGE

Holzer, "Selections," 1989, Solomon R. Guggenheim, NY. *A subset of Conceptual Art since the 1970s is media art. American artist Jenny Holzer (b.1950) uses mass media like billboards to push art out of the museum and into public spaces. She began by posting small, anonymous stickers with ambiguous, fortune-cookie epigrams like "MONEY CREATES TASTE" on garbage can lids and parking meters. Then she graduated to 20' x 40' electronic signs flashing from Las Vegas to Times Square. From impersonal electric ribbon signs and banal sayings, she constructs a form of emotional theater to combat public apathy toward most art.*

CONVERSATIONS WITH A COYOTE

Much of the public's you-call-that-art? skepticism has been in direct response to the extremism of some contemporary art. But for the generation that emerged in the late '60s, art could be made out of absolutely any event, idea, or material. One artist telephoned instructions to museum workers, who put together a work of art the "artist" had not seen or touched. Joseph Beuys held a weeklong conversation with a coyote. Vito Acconci crushed live cockroaches on his belly, and Piero Manzoni canned his own excrement to display at a New York gallery. Kim Jones earned the name "Mudman" by roaming SoHo streets wearing nothing but a loin cloth and mud. Julian Schnabel dragged a tarp behind his Jeep to weather it, then whacked the canvas with a tablecloth soaked in paint to create an image.

works artists like Robert Smithson (see p. 21) devised vast projects requiring bulldozers moving tons of earth. Wrap artist Christo (b. 1935) specializes in temporarily wrapping bridges and buildings — even one million square feet of Australian coast — in plastic. In 1983 he surrounded eleven islands in Florida's Biscayne Bay with pink polypropylene tutus.

PERFORMANCE ART. A staged event involving the artist talking, singing, or dancing, Performance Art requires artists to use their bodies in front of an audience. Joseph Beuys walked around a Düsseldorf gallery performing "How to Explain Pictures to a Dead Hare" (1965). His face covered in gold leaf and honey, he explained various paintings to a dead rabbit cradled in his arms. Performance artist Marina Abramovic once lay down surrounded by fire, passed out from lack of oxygen, and was rescued by the audience. Her message: viewer participation required.

INSTALLATIONS. Room-size exhibitions crammed with a conglomeration of disparate objects like words, videos, photos, and ordinary objects like beer cans comment on topical political issues like AIDS. Although the objects seem unrelated, the viewer is intended to enter the environment ignorant and emerge enlightened about some pressing social theme the artist has revealed.

Jonathan Borofsky turned the Paula Cooper Gallery into a studio by drawing on walls and inviting visitors to play ping-pong on a black-and-white painted table. A four-foot stack of paper scrawled with numbers from zero to 2,687,585 stood on the floor (Borofsky undertook to count to infinity). Hundreds of copies of an antilittering handbill littered the floor. (The artist's mother started picking them up before the opening until someone stopped her, explaining that the idea was to have them underfoot.)

IT'S THE THOUGHT THAT COUNTS.

Conceptual Art critiques the art market. It often relies on words more than images to communicate ideas. Conceptualism attacks the tradition of valuing art objects as precious commodities.

DANGER ZONE

California performance artist/sculptor Chris Burden (1946–2015), called "the Evel Knievel of the avant-garde," made his displays a life-or-death affair to take art out of elitism into the real world of looming danger. To "explore" violence, he had a friend shoot him in the arm while guests at a Los Angeles gallery watched. In "Doorway to Heaven" (1973), Burden grounded two electric wires on his bare chest, recording the aura of sparks in a striking photograph. A Viennese group went too far when they smeared sheep blood and entrails on participants and crucified them upside down in a gallery. One died from self-mutilation.

PROCESS NOT PRODUCT

Haacke, "Condensation Cube," 1963–65, John Weber Gallery, NY.

Hans Haacke (b.1936), a left-wing artist who works in the United States, concentrates on the act of making a work rather than the work itself. In "Poll of MoMA Visitors" (1970), he gathered museum-goers' opinions on the Vietnam War. From 1963 he constructed transparent boxes containing fluids that fluctuate with temperature and air pressure. Incorporating the behavior of wind, air, and water into his work, Haacke's "collaborator" became the surrounding "climate," which varied from hour to hour.

CONTEMPORARY ARCHITECTURE

In the 1970s and '80s designers traded in Miesian-inspired Barcelona benches and Breuer chairs (honestly, they were never very comfortable) for Adirondack benches and Shaker rockers. A consensus formed that Bauhaus-inspired Modernism was, as one critic said, "polished death." International Style buildings based on the grid and glass skin had multiplied so widely, they were the House Style of corporate headquarters throughout the world. Critics denounced their anonymity and hungered for passion and personality.

Modernism seemed like a dead end, and Post-Modernism arose as its alternative. In place of T-square-straight, antiseptic forms, the new architecture used curvilinear, complex shapes. Post-Modernism resurrected color, ornament, and historical touches like the dome, arch, and vault. While one particular style has not yet jelled, architects today experiment with a variety of novel forms with an almost Baroque flair. What is clear about Post-Modern architecture is its pluralism.

PEI: THE LAST MODERNIST. I. M. Pei (pronounced PAY; b. 1917) became the International Style's leading exponent in the postwar period. Pei's buildings declare their identity as abstract objects first, then as refined monuments. Frequently triangular in shape with an oversized Henry Moore sculpture out front, they are monochromatic and severe like Minimalist sculpture.

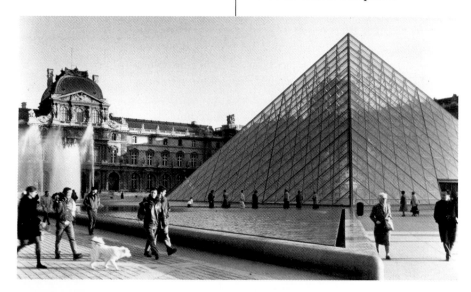

Pei, Entrance to the Louvre, 1989, Paris. *Pei's buildings use simple, uncluttered, geometric forms.*

Johnson and Burgee, Pennzoil Place, 1976, Houston. *Initially an advocate of the International Style, Johnson later designed buildings that broke from the white box format and added historical references.*

JOHNSON: THE TURNING POINT. For the first half of his career, American architect Philip Johnson (1906–2005) was apprentice to his master Mies van der Rohe's International Style. In 1956, they collaborated on the landmark Park Avenue Seagram Building (at 53rd Street). In 1949, Johnson built the penultimate glass box, Glass House, in New Canaan, Connecticut, where sheets of glass comprise the whole exterior. He had reached the maximum of minimum: pure, clean, abstract — all qualities of "The International Style" that he also championed in an influential book of the same title.

In the mid-'70s, Johnson sniffed a change in the air and seized the Post-Modern banner. Pennzoil Place in Houston (1976) looks like a gigantic Minimalist sculpture but diverges from the bland, rectangular anonymity of the International Style in its daring shape and dark color. It consists of two towers separated by a ten-foot slot, joined at the bottom by a glass wedge housing a lobby. Johnson tapered the roof to a rakish 45-degree angle. Johnson's P.P.G. Place in Pittsburgh is a Post-Modern masterpiece with its Gothic tower and turrets — like the Houses of Parliament executed in sleek, mirrored glass. The "Chippendale skyscraper" that Johnson and partner John Burgee designed for AT&T recalls Brunelleschi's fifteenth-century Pazzi Chapel in its arch-and-colonnaded base. Its broken pediment top is like an eighteenth-century grandfather clock. Thanks to Johnson, it became chic to quote from the past. As Johnson told his students, "You cannot not know history."

BEAUBOURG: CONTEMPORARY CUL-TURE PAR EXCELLENCE. A building that fits no category except maybe futuro-fantasy is the Centre Pompidou, known as the Beaubourg, in Paris. If Johnson's Pennzoil resembles Minimalist sculpture, the Beaubourg is a Dada funfest. Dedicated to putting Paris back at the helm of contemporary art, the Beaubourg houses labs and display spaces dedicated to modern art, industrial design, avant-garde (especially computer-generated) music, and film. After the Eiffel Tower, it's the most popular attraction in Paris.

The building wears its technology on its sleeve, with all service functions turned inside out. Heating and cooling ducts, stairs, elevators, escalator, water and gas pipes crisscross the exterior steel skeleton. Color is a vital element, with components color-coded according to function: red for ramps and conveyances that move people, green for water, blue for air conditioning, and yellow for electrical wiring. Could anyone but Parisians make plumbing so stylish?

Its designers sought to create a radically new kind of building for an institution that goes far beyond ho-hum museum activities. Anyone wandering into the corridor where composers push buttons to create music of squawks and bleeps knows right away he's entered a new French Revolution. The public plaza outside throbs with performers juggling, singing, miming, and breathing fire. "If the hallowed, cultlike calm of the traditional museum has been lost, so much the better," said then-director Pontus Hulten. "We are moving toward a society where art will play a great role, which is why this museum is open to disciplines that were once excluded by museums. . . ."

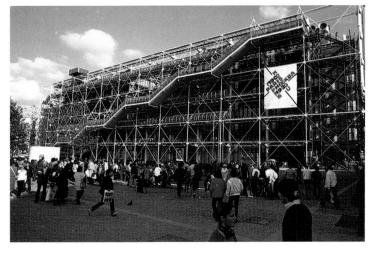

Piano and Rogers, Centre Pompidou, 1977, Paris. *This building celebrates technology by putting beams, ductwork, pipes, and corridors on the outside.*

GRAVES: THE TRIUMPH OF POST-MODERNISM. A Post-Modern American architect for whom color was a central component was Michael Graves (1934–2015). Instead of basing color on technical function as at the Beaubourg, Graves keyed it to nature: to earth, foliage, and sky. "My color sense is very childlike," Graves said. "I don't want to upset the code." Graves used "representational" color, shielding the base of buildings in earth hues like terra cotta and dark green, graduating to sky tones above, like an azure-blue soffit.

In the late 1970s Graves converted to Post-Modernism and mixed Classical elements and fantasy (he designed the new Mickey Mouse–inspired Disney headquarters). Now he dots his multicolored facades with architectural flashbacks ranging from Beaux-Arts Classicism to Egyptian revival to streamlined Modernism. In his Portland Public Services Building (1983), dubbed "The Temple," Graves divided the tower into three separate sections suggesting the base, shaft, and capital of a Classical column.

Dramatic entrances are a Graves trademark. Instead of the interior/exterior free flow of Modernism, he amplifies the passage between public and private, outside and inside. A typical device is the "voided keystone." Where a traditional arch has a keystone at its apex, Graves places a window, heightening the drama of the central portal as focal point.

Graves, Clos Pegase Winery, 1987, CA. *Graves reintroduced color and historical detail to architecture.*

***GEHRY:* CALIFORNIA DREAMIN'.** The most provocative Post-Modern architect working today is indisputably Frank O. Gehry (b. 1929). Canadian born, Gehry put himself through architecture school by working as a truck driver. Now he works out of Los Angeles, a pioneer of what he has called "cheapskate architecture." Gehry buildings are instantly identifiable for their use of unpretentious, industrial materials like plywood, chain-link fencing, corrugated cardboard, and cinderblock. Why? "I had a lot of poor clients," Gehry said.

An experimental urge also entered his calculations. When he saw the Minimalist sculpture of Carl Andre and Donald Judd, made of firebricks and plywood, Gehry said he got interested in "the idea that you could make art out of anything." He also liked the informal air these "anti-aesthetic" materials gave a design.

Gehry has also designed Post-Modern buildings that express their purpose through form. His Loyola Law School in Los Angeles (1985) has sleek columns and spaces that echo the stoa (columned pavilion) and agora (open meeting area) of ancient Greece, the birthplace of Western law. The California Aerospace Museum bursts with dynamism in jutting angles that suggest flight.

A quirky individual who tries to insinuate a fishlike form into every building, Gehry's work is as unique as his outlook. "I am trying to respond to a particular time," he said, "because I don't think you can escape."

Gehry & Associates, California Aerospace Museum, 1984, Los Angeles. *Gehry's forms seem on the verge of lift-off in this design that reflects the building's purpose.*

***VENTURI:* LESS IS A BORE.** If Frank Gehry is the wild man of Post-Modernism, American architect Robert Venturi (b. 1925) is Everyman. The leading theoretician of Post-Modernism, Venturi demolished Mies's famous "less is more" with his counterattack: "less is a bore." In several influential books like *Learning from Las Vegas* he argued that architecture should accept not only historical styles but respect "dumb and ordinary" vernacular buildings. As Venturi put it, "Main Street is almost all right."

Venturi practices what he preaches. He believes architecture should accommodate a multiplicity of styles, so in one structure (a vaca-tion lodge in Vail, Colorado) he combined sources as diverse as the Swiss chalet, Palladio, Art Nouveau, and the International Style of Le Corbusier. More than anyone, he is credited with inventing the jaunty pluralism of Post-Modern architecture.

In Guild House, a home for retirees in Philadelphia, Venturi deliberately made the design unassuming and unpretentious. He used Pop poster-style lettering and crowned the arch that serves as focal point with a television antenna. The brick building puts on no airs, makes no big statement, and blends in thoroughly with its undistinguished neighbors. Critics have faulted this intentional banality. "Don't take it so hard," his partner John Rauch told Venturi when they lost another commission. "You're only a failure. I'm an assistant failure."

Venturi and Denise Scott Brown have completed major projects, such as buildings for the Princeton University campus faced with a red-and-white checkerboard motif like the Purina Dog Chow logo. His Sainsbury Wing of London's National Gallery (1991) is a collection of irreverent historical allusions, and his colorful Seattle Art Museum (1991) has the same playful quality.

AN ARCHITECTURAL SURVEY

Throughout the book, references to the evolution of architecture appear. Page 39 covered Renaissance architecture, for instance, and page 146 dealt with the International Style. Here's a quick rundown of major names in the history of Western architecture.

BIRTH OF ARCHITECTURE

STONEHENGE — most famous megalithic monument used for ritual purposes, c. 2000 B.C.

ZIGGURAT — stepped, mudbrick temple designed as meeting place for man and gods in Sumer, c. 2100 B.C.

PYRAMID — gigantic monument for dead pharaoh; first named architect, Imhotep, built stepped pyramid for Egyptian King Zoser, c. 2780 B.C.

PARTHENON — Iktinos and Phidias perfected Greek Doric temple style, 447–432 B.C.

PANTHEON — best example of Roman monumental architecture, fully exploited arch, vaults, dome, concrete, c. A.D. 118–28

BYZANTINE — Anthemius of Tralles and Isidore of Miletus supported dome of Hagia Sophia by pendentives to allow flood of light, 532–37

ROMANESQUE — church style with massive piers and towers, round-topped arches like St. Sernin, begun c. 1080

GOTHIC — vault supported by flying buttresses, strong vertical orientation and pointed arches like Chartres Cathedral, 1194–1260

RENAISSANCE AND BAROQUE

BRUNELLESCHI (1377–1446) — first great Italian Renaissance architect, rediscovered Classical forms and simplicity

ALBERTI (1404–72) — formulated architectural theory based on rules of proportion

BRAMANTE (1444–1514) — High Renaissance architect who redesigned St. Peter's Cathedral

MICHELANGELO (1475–1564) — remodeled Capitoline Hill in Rome

PALLADIO (1508–80) — arch-and-column compositions of symmetrical villas copied around the world

BERNINI (1598–1680) — designed Roman churches, chapels, fountains for theatrical effect

BORROMINI (1599–1667) — used curves and countercurves, rich surface decoration

CUVILLIÉS (1695–1768) — designed extravagant Rococo rooms based on mirrors, gilt, profusely carved stucco

NINETEENTH CENTURY

JEFFERSON (1743–1826) — revived Classical/Palladian style in neo-temples

EIFFEL (1823–1923) — devised namesake tower in 1889 as triumph of engineering and industrial materials

SULLIVAN (1856–1924) — developed modern architecture with form-follows-function concept

GAUDI (1852–1926) — Spanish Art Nouveau architect based fluid, linear style on organic forms

TWENTIETH CENTURY

WRIGHT (1869–1959) — American innovator who pioneered "organic" buildings with flowing lines

GROPIUS (1883–1969) — led Bauhaus trend toward functionalism

MIES VAN DER ROHE (1886–1969) — perfected simple, unornamented skyscraper with glass curtain walls

LE CORBUSIER (1887–1965) — shifted from sleek, International Style buildings to sculptural fantasies

JOHNSON (1906–2005) — evolved from International Style to Post-Modernism

PEI (b. 1917) — stark, geometric buildings like abstract sculpture

GEHRY (b. 1929) — "Deconstructivist" architect whose buildings of disconnected parts had unfinished, semipunk look, evolved to sculptural expressionism

GRAVES (b. 1934) — introduced color and historical references into modern design

VENTURI (b. 1925) — leading theoretician for diversity in architecture

PHOTOGRAPHY: WHAT'S NEW

"Straight," undoctored photography, as championed by Alfred Stieglitz, retained its advocates until World War II, then gradually gave way to a more subjective use of the medium. In the new, introspective style, rather than just presenting objective information in documentary form, the camera expressed feelings and manipulated reality to create fantasies and symbols. Photojournalist W. Eugene Smith, in his moving portraits of Japanese children crippled by mercury poisoning, used pictures to comment on society with what he termed "reasoned passion." Rather than a single trend or movement, the most important trait of contemporary photography is diversity. The following photographers represent some of the types of photography being practiced from late Modernism through Post-Modernism.

ABBOTT: "THE PAST JOSTLING THE PRESENT."

American photographer Berenice Abbott (1898–1991) began her career in the heroic age of photography, when it was first established as an art form. She produced a series of New York street scenes in the 1930s for which she is best known. In her Modernist photographic style, Abbott framed compositions dynamically, shooting up or down at dizzying angles to capture the city's vitality. She wanted to show the "spirit of the metropolis, while remaining true to its essential fact, its hurrying tempo," to evoke "the past jostling the present."

BOURKE-WHITE: THE PHOTO-ESSAY.

When Henry Luce hired American photographer Margaret Bourke-White (1904–71) for *Fortune* magazine, he taught her that pictures had to be both beautiful and factual. In her obsessive drive for the perfectly composed photograph, she never forgot to include the essential truth of a situation. Bourke-White shot classic photo-essays that brought the reality of American and Soviet industry and the Depression home to millions of readers. An aggressive, fearless reporter, she flew in planes and dangled from cranes to get exactly the right shot. Her colleague Alfred Eisenstaedt said she had "the ideal attitude" for a photojournalist:

Abbott, "Nightview, NY," 1932, Commerce Graphics Ltd., Inc. *Shot from atop the Empire State Building, this panorama conveys the energy and romance of the city.*

"At the peak of her distinguished career," she "was willing and eager as any beginner on a first assignment. She would get up at daybreak to photograph a bread crumb, if necessary." "Sometimes I could murder someone who gets in my way when I'm taking a picture," Bourke-White said. "I become irrational. There is only one moment when a picture is there, and an instant later it is gone — gone forever."

In World War II and the Korean War, Bourke-White, heeding war photographer Robert Capa's advice: "If your pictures are no good, you aren't close enough," faced danger on the front lines. She unflinchingly recorded the dazed faces of survivors when Buchenwald was liberated. Her work for *Life* magazine both popularized the photo-essay and opened the way for women to compete with male journalists, proving women were physically and technically capable of such a demanding task.

Bourke-White, "At the Time of the Louisville Flood," 1937, collection of the George Arents Research Library, Syracuse University, NY. *Bourke-White's broad, poster like style shows the unemployed on a breadline during the Depression, ironically revealing the gap between the American dream and reality.*

Adams, "Sand Dunes, White Sands National Monument, N.M.," c. 1942, Courtesy of Trustees for Ansel Adams Trust, NY. *A master of landscape photography, Adams was legendary for his technical skill, as seen in this balanced, controlled picture composed with precise clarity.*

ADAMS: THE AMERICAN WEST. When he was 14, Ansel Adams (1902–84) took his first picture with a Brownie box camera of mountain peaks in the Yosemite Valley. For the next six decades, he took pictures of Yosemite, each a technically perfect rendition of unspoiled nature. "Big country — space for heart and imagination," he described it. The preeminent photographer of the American West, Adams never grew bored with these scenes. A conservationist and mountaineer, he loved the wilderness intensely and believed "a great photograph is a full expression of what one feels."

With Stieglitz, Weston, and Paul Strand, Adams was a leading advocate of "straight" photography. Avoiding tricky camera angles, he previsualized his final image in a large-format view camera. This allowed him to capture the scene with rich texture, meticulous detail, and an infinite tonal range from light to dark. Above all, the quality of light infuses Adams's scenes with drama. Shades vary from clear white to inky black, dividing his photographs into distinct zones. Trained as a pianist, Adams brought the same technical control to photography and achieved virtuoso prints that shine with clarity. A photograph, he believed, is "an instrument of love and revelation."

STREET PHOTOGRAPHY. In the '60s, with the rise of Pop art and Venturi's stress on vernacular architecture, a new style of photography arose called "snapshot aesthetic." Professionals deliberately framed casual, unposed photos resembling amateur efforts in order to banish traces of artifice. In this head-on approach, "street photographers" like Diane Arbus, Robert Frank, Bruce Davidson, Garry Winogrand, Lee Friedlander, and Joel Meyerowitz documented the "social landscape" of cities.

Arbus, known for her images of "freaks"— transvestites, hermaphrodites, giants, and dwarfs—brought the most harrowing eye to this task. Yet she approached these marginal people without prejudging them. What seems most bizarre in her work are the shots of "normal" people, fixed in unrehearsed poses that transform them into grotesques. In one picture of a mother and child, the mother's fingers seem to be squeezing the life out of her son, who drools a river of spittle and glares at the camera. In a 1972 retrospective at the Museum of Modern Art, Arbus's images made her subjects look so ugly that viewers spit on the pictures.

Levitt, "New York (Broken Mirror)," 1942, Laurence Miller Gallery, NY. *Helen Levitt's straightforward style shows both the complexity and humanity of the best "street photography."*

UELSMANN: FANTASYLAND. An American photographer who exploits the bizarre in a totally different vein than Arbus is Jerry N. Uelsmann (b. 1934). Uelsmann sandwiches half a dozen or more negatives superimposed on one another into one print. He combines these images seamlessly to make a totally unreal scene out of real objects. "The mind knows more than the eye and camera can see," he has said. Early in his career, Uelsmann portrayed women as fertility figures, with their nude bodies growing out of grass, embedded in rocks, or floating over the ocean. His work succeeds best when he transmutes ordinary objects into uncanny, startling symbols to bring out what he calls "an innermost world of mystery, enigma, and insight."

Uelsmann, "Navigation without Numbers," 1971, Courtesy of the artist. *Uelsmann layers different negatives to produce a photomontage that restores magic to photography.*

THE STORY OF ONE WHO SET OUT TO STUDY FEAR

Baldessari, "The Story of One Who Set Out to Study Fear," 1982, Sonnabend Collection, NY.

Conceptual artist John Baldessari is considered a pioneer of Post-Modernism. This narrative photo sequence shows the Contemporary tendency to combine images with text.

PHOTO-REALISM

Also known as Hyper-Realism, Photo-Realism thrived in the United States from the mid-'60s to mid-'70s. Influenced by Pop art, it reproduced photographs in painting with such fidelity one critic called it "Leica-ism." To achieve near-exact likenesses, artists projected photo slides on canvas and used commercial art tools like the airbrush. Their painted reproductions of reality are so detailed, the work rivals fifteenth-century master Jan van Eyck's. Despite this surface factualness, however, Photo-Realists differ from their predecessors. Post-Modern realism adopts the flattened effect of a camera image and treats objects as elements in an abstract composition.

HANSON: PHOTO-REAL SCULPTURE

If you ask a museum guard a question and he doesn't respond, don't be upset. It could be the "guard" is a Duane Hanson statue. Hanson's life-size works, dressed in real clothes, are so lifelike they make wax museum replicas seem abstract.

From plaster casts of real people, Hanson (1925–96) constructed tinted fiberglass models, which he outfitted with wigs, glasses, and jewelry so they're nearly indistinguishable from the real thing. His "Tourists" (1970) portrays an elderly man in plaid bermuda shorts and flowered shirt, festooned with camera, tripod, and film cannisters. His wife sports a tacky scarf, gold sandals, and tight polyester pants. On the street, viewers would ignore such tourists, but they stare with fascination at this familiar species in a gallery.

Most Photo-Realists specialize in one subject. Richard Estes does highly reflective city windows. Audrey Flack paints symbolic still lifes, Malcolm Morley portrayed travelers on cruise ships during his Photo-Realist phase, and Chuck Close paints large-scale mug shots.

ESTES: WINDOWS ON THE WORLD.

Richard Estes (b. 1936) goes the camera one better. His sharp-focus street scenes have even more depth of field and precise long-distance detail than a camera could ever capture. Estes projects a photo on a canvas and paints over it in a procedure similar to that other master of realism, Vermeer, with his camera obscura. But where Vermeer's subject was light, Estes specializes in reflections. His luminous plateglass windows contain a labyrinth of layered images. The paintings portray a clear, glossy world but, at the same time, a world of distortions and ambiguity.

Another Photo-Realist who paints reflections in shop windows is Don Eddy (b. 1944). Eddy airbrushed gaudy designs on surfboards and hotrod cars as a California teenager, then worked as a photographer. His technicolor paintings fuse the two skills, highlighting precise details with hyperclarity.

FLACK: POST-MODERN STILL LIFES.

Audrey Flack (b. 1931) also borrows a trick from Dutch Renaissance artists: the "vanitas" painting, or still life with objects symbolizing the brevity of life. Yet Flack's paintings deal with twentieth-century issues like feminism. Each object is an allegory for women's role in the modern world — like the queen chess piece in "Queen" — versatile, powerful, but ultimately subordinate.

Close, "Fanny/Fingerpainting," 1985, Pace Gallery, NY. Working from photos, Close builds remarkable likenesses from a variety of tiny marks.

CLOSE: CLOSE-UP.

Since 1967, Chuck Close (b. 1940) has painted gigantic passport photos of his friends' faces. With dazzling technique, he produces detailed portraits that — seen from a distance — look uncannily like giant blown-up photographs. Yet up close, the viewer becomes aware of the process of representing the image, for Close often paints with unorthodox means, such as building an image out of his own inked fingerprints. This gives an impression of fluctuation. Like Seurat's pointillist technique, the many small dots forming the image flicker back and forth in the spectator's mind. One moment, it's a spitting image of a person, the next it's an animated pattern of spots.

Continuing his focus on large-scale portraits, Close transforms monumental Polaroid prints into images composed of thousands of tiny bursts or swirls of paint. His canvases have evolved to colorful head-shots whose mosaic-like patterns border on abstraction.

NEO-EXPRESSIONISM

The Minimalists in 1975 wrote obituaries for painting, insisting the future belonged to video, performance art, and Conceptual Art — things like ball bearings scattered on the floor. Well, like Mark Twain's death, the Demise of Painting was greatly exaggerated. In the eighties painting was back with a bang. And not zero-content, no-color painting but painting that bashes you over the head like heavy metal music.

The new movement was born in Germany and reached a climax of international esteem in the 1980s. It was termed Neo-Expressionism because it revived the angular distortions and strong emotional content of German Expressionism. Neo-Expressionism brought back such banished features as recognizable content, historical reference, subjectivity, and social comment. It resurrected imagery, the easel painting, carved or cast sculpture, and the violent, personalized brushstroke. Bricks on the floor or shelves on a wall weren't going to cut it any more. Where art of the '70s was cool as ice, art of the '80s was hot, hot, hot. The leaders were Germans like Anselm Kiefer, Gerhard Richter, Sigmar Polke, and Georg Baselitz and Italians like Francesco Clemente, Sandro Chia (pronounced KEY ah), and Enzo Cucchi. Neo-Expressionism marked the rebirth of Europe as an art force to be reckoned with.

Kiefer, "To the Unknown Painter," 1983, Carnegie Museum of Art, Pittsburgh. *Kiefer uses thick, dark paint to represent charred earth, evoking the horror of the Holocaust.*

***KIEFER:* SCORCHED EARTH.** Called by art critic Robert Hughes "the best painter of his generation on either side of the Atlantic," Anselm Kiefer (b. 1945) became an '80s star due to the new taste for narrative art. The subject he deals with provokes a strong response: German and Jewish history from ancient times through the Holocaust. Kiefer represents his central motif — charred earth — through thick, dark paint mixed with sand and straw. Kiefer showed an early fascination with Nazi atrocities. As a young artist doing Conceptual work, he took photos of himself in Nazi regalia giving the Sieg Heil salute. "I do not identify with Nero or Hitler," he explained, "but I have to re-enact what they did just a little bit in order to understand the madness."

The means Kiefer chooses to portray fascism are unorthodox. Besides sand and straw, his paintings are collages of acrylic paint, tar, epoxy, copper wire, melted and hardened lead, and ceramic shards.

BEUYS: GURU OF NEO-EXPRESSIONISM

The father-figure of Neo-Expressionism was Joseph Beuys (1921–86). As a teacher and artist, Beuys taught a generation of young German artists to reexamine their history without illusion. Beuys was a radical in both art and politics. A member of the left-wing Green party who believed everyone was an artist, Beuys wanted to regenerate humanity. He shifted attention from art as an object to the artist as activist. He created a mythic persona for himself, spouting his revolutionary credo to young followers and the press with religious fervor.

Part of Beuys's heroic status derived from his war experience. As a Lüftwaffe pilot he crashed in the Crimea (the hat he always wore hid scars). Tartar nomads cared for him, wrapping him in felt and fat to keep him warm in subzero temperatures. Beuys used these materials in his work, as well as industrial substances. At his Guggenheim show, Beuys exhibited a large tub of pork fat; he often heaped piles of felt and stacks of iron, copper, or lead as art displays. Beuys was also a performance artist who staged irrational spectacles like chatting with a dead rabbit. Like Germany's postwar Economic Miracle, Beuys re-energized German art.

Clemente, "Francesco Clemente Pinxit," 1981, Virginia Museum of Fine Arts, Richmond. *Clemente distorts the body to express irrational fears and fantasies.*

***CLEMENTE:* BODY LANGUAGE.** Another European who employs the Expressionist mode successfully is Francesco Clemente (b. 1952). In various media (watercolor, pastel, fresco, and oil), Clemente portrays nightmarish, hallucinatory states of mind through images of fragmentary body parts. "I'm interested in the body as a conductor between what we show on the outside and what we feel within," Clemente said.

Clemente's portraits uncover more than the naked human body. They suggest repressed urges and fantasies that both repel and fascinate. His faces are typically distorted with psychic strain, à la Munch, and rendered in unnatural color. In one painting, a pair of feet exudes a brown substance resembling blood, feces, and mud.

***BASELITZ:* THE WORLD TURNED UPSIDE DOWN.** Painter-sculptor Georg Baselitz (b. 1938) led, with Beuys, the revival of German Expressionism. A controversial artist, since 1969 he has portrayed figures upside down to show his disdain for convention.

Like Kiefer, Baselitz deals with World War II and its aftermath. In the '60s he painted despondent pilots and pink, gangrenous feet. As a child Baselitz witnessed the firebombing of Dresden in 1945, which inspired a major work, "45." The piece consists of twenty large paintings of women's faces (upside down) on wood. The faces are purposely distorted, looking like terrified Raggedy Ann dolls with their pink skin and red hair. Transcending the comic effect is Baselitz's violently scarred wood. With chisel, chainsaw, and wood plane he attacked the images, making them look under fire. Violent vortexes of slashes and gouges spin out from the faces as if victims of strafing.

***BASQUIAT:* THE WILD CHILD.** Jean-Michel Basquiat (pronounced BAHS kee aht; 1960–88) died at age 28 of a drug overdose. The enfant terrible of '80s art, he lived, painted, and died hard.

A high school dropout and self-taught painter, Basquiat first made his mark around 1980 in downtown New York scrawling graffiti slogans on walls. As part of a two-man team known as SAMO (for "same old shit"), he left anonymous social observations like: "riding around in Daddy's convertible with trust fund money" and "SAMO as an antidote to nouveau-wavo bullshit." In 1981 Basquiat, of mixed Haitian and Puerto Rican descent, turned to painting and was instantly taken up by the art world. His intense, frenetic canvases, crammed with graffiti lettering and cartoonish figures, made him a Neo-Expressionist superstar.

Basquiat's street-smart work conveys the fierce energy and jazzy spontaneity of rap music. He collaborated with his friend and mentor, Andy Warhol, for a few years before Warhol's death in 1987. Basquiat, with his fast-track personality and self-destructive life-style, had the fifteen minutes of fame Warhol predicted. He was both a legend and a casualty of the superheated '80s art scene.

THE NEW BREED: POST-MODERN ART

Art in the '90s was as diverse as the post–Cold War world. With nations changing their stripes as rapidly as a chameleon on plaid, art too was in a state of flux. Certain attitudes recurred with enough frequency to note as significant. For example, art in the '90s was nothing if not political. Text-heavy installations exhorted viewers to consider issues like the AIDS epidemic, environmental problems, homelessness, racism, sex, and violence. The materials and formats of art were as varied as the subjects, with alternative art forms, like performance art and hybrid genres like photo-derived art, multiplying. Post-Modernists may declare that modernism's rejection of reality is obsolete, but the process of reinventing art continues unabated.

APPROPRIATION ART: THE ART OF RECYCLING. A key Modernist concept undermined by '80s art was the idea of the art object as a hand-made original. This magnum opus was supposed to be a culminating statement, the product of an artist's gradual progress. Forget progress, said the Post-Modernists, for whom "new" did not automatically equate with "improved." The future of art lay in the past more than in the individual imagination.

Artists began to appropriate images from diverse sources, as Pop artists had done, but drew on art history and mythology as well as the mass media. They combined pre-existing images with their own (as in the work of Julian Schnabel and David Salle) or presented the appropriated images as their own (Louise Lawler's montages of famous art works, Mike Bidlo's obvious forgeries of masterpieces, and Sherrie Levine's photographs of Edward Weston photographs). Jeff Koons recast kitsch images like an inflatable bunny in stainless steel. By retreading familiar ground, Appropriation Artists sought to annex both the power of the original image and reveal its manipulative force as propaganda.

Schnabel, "Hope," 1982, Whitney, NY. *Schnabel layers different images and objects, showing how Appropriation Art recycles pre-existing elements into new statements.*

PHOTOGRAPHY-DERIVED ART: RERUNS. A form of Appropriation Art uses photographic images in unexpected combinations to re-interpret history and comment on socio-political issues. Relying on mechanical reproduction rather than handmade imagery, this new hybrid art form fragments, layers, and juxtaposes photographed images (as in the torn, yellowed photo-assemblages of Doug and Mike Starn, known as the Starn Twins) to change their context and meaning.

***KRUGER:* BILLBOARD BARRAGE.** New Jersey-born Barbara Kruger (b. 1945) splices cropped photographic images with text in an impassioned, punchy, feminist art. Kruger's aggressive polemics use a mock-advertising graphic style of blown-up images with confrontational messages that assault the viewer. "I want to speak and hear impertinent questions and rude comments," Kruger said. "I want to be on the side of surprise and against the certainties of pictures and property."

Kruger, "Untitled (What big muscles you have!)," 1986, Centre Pompidou, Paris. *Kruger's jolting combination of language and image speaks out on political issues like censorship, abortion, domestic violence, and bigotry.*

Sherman, "Untitled #228," 1990, Metro Pictures, NY. *Sherman photographs herself as characters based on Old Master portraits.*

SHERMAN: COSTUME MELODRAMAS.

American artist Cindy Sherman (b. 1954) specializes in fabricated self-portraits in which she dresses up like Hollywood or Old Master stereotypes and photographs herself. In the 1970s she "starred" in imaginary black-and-white movie stills based on '50s film noir clichés. The sham images of terrified, wide-eyed ingenues often implied sex and violence as well as the limitations of traditional female roles — always the victim, never the victor.

Her '80s work shifted to large-scale color prints in which she masqueraded as both male and female characters derived from art masterpieces. Yet, though she closely resembled a Holbein monk, Fragonard courtesan, or van Eyck matron, the re-creations were deliberately artificial, emphasizing obvious bits of fakery like false noses, wigs, or latex bosom. Although the sham self-portraits seem like narcissistic role-playing, they are "pictures of emotions personified," Sherman insisted, "not of me." Her stated goal: "I'm trying to make other people recognize something of themselves rather than me."

LONGO: THE CITY AS CINEMA.

American artist Robert Longo (b. 1953) calls himself "the anti-Christ of media, coming back at the culture that created me." A leading image-appropriator, he transforms commercial and cinematic images into high-impact, billboard-sized paintings that project the menace and violence of the city at night. Longo's huge, powerful, mixed-media works seethe with intensity, using high-contrast, mass-media style to manipulate audience response. "I want the viewer to look at something that is both beautiful and horrifying," Longo said. "I am looking for a positive force in negative imagery."

Longo, "Cindy," 1984, Whitney, NY. *Longo draws on cinematic and commercial imagery to project a sense of menacing urban life.*

NARRATIVE ART: STORY TIME. Art in the '80s saw the rebirth of the painting as an accessible form of storytelling. Mark Tansey's monochrome canvases portrayed an imaginary version of history, such as the occupation of SoHo by German troops (a sly dig at the takeover of art by German Neo-Expressionists). Faith Ringgold combines text and imagery in her patchwork quilts recounting the life of black women. Sue Coe's feminist paintings memorialize events like "Woman Walks into Bar — Is Raped by 4 Men on the Pool Table — While 20 Men Watch." Leon Golub's overtly political paintings protested war and the abuse of power. For Golub, art was not comfortable or pleasurable but unsettling: "The work should have an edge." Others who use recognizable imagery to convey autobiographical concerns are David Hockney (with his California pools, palms, and photomontages), Jennifer Bartlett (who explores multiple facets of a scene in serial images), Susan Rothenberg (in her feathery paintings of dancers), and Elizabeth Murray (who fragments domestic objects into mysterious, detonated puzzles).

FISCHL: SUBURBAN PSYCHODRAMA.
New York painter Eric Fischl (b. 1948) burst into notoriety with "Sleepwalker" in 1979, a painting in which a surly teenage boy masturbated in a backyard wading pool. Critics hailed his disturbing images as exposés of the failure of the American dream. Like John Cheever short stories, on the surface his paintings portrayed ordinary suburbanites, but their subtext reeked loneliness, desperation, and dread. Sexually loaded, Fischl's images of middle-class life have "What's wrong with this picture?" undertones. The stories alluded to on canvas require viewer participation to resolve their ambiguities.

After envisioning Levittown as Gomorrah, Fischl turned to exotic locales, setting his lushly painted scenes in the Caribbean, Morocco, India, and the Riviera. Despite the mock-travelogue gloss, the same danger and enigma lurk. "The new paintings are about me in the world; the other was about the world in me," Fischl said. "They're equally terrifying."

"A Visit To/A Visit From/The Island," for instance, contrasts indolent, affluent tourists basking in ignorance of the violent world that threatens the black working class. What links the two halves of the diptych is the storm cloud gathering over the frolicking white vacationers, a storm that brings death to the vulnerable natives. In Fischl's words: "I try to create the effect of something unsaid."

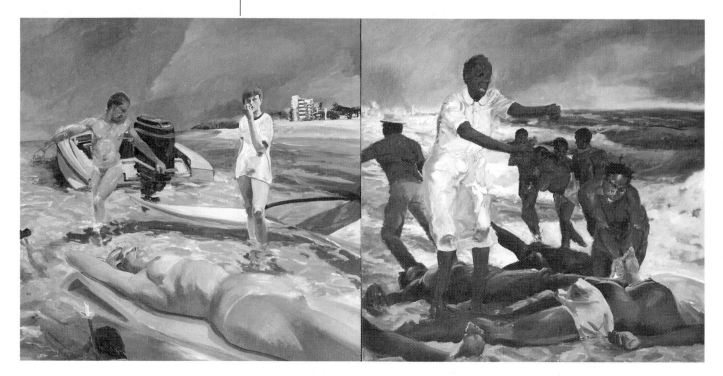

Fischl, "A Visit To/A Visit From/The Island," 1983, Whitney, NY. *Fischl's narrative paintings — psychologically tense and emotionally complex — require viewer participation to decipher their meaning.*

GRAFFITI ART.

Based on the Italian word for "scratch," graffiti are scribbled words or doodles on walls. Even found in ancient Egyptian tombs, graffiti first appeared in the artist's studio with American painter Cy Twombly, Frenchman Jean Dubuffet, and the Spaniard Antoni Tàpies. Real graffiti art is an art of the streets. Armed with felt-tip markers and aerosol spray cans, in the 1970s and '80s hundreds of graffiti "bombers" made their mark on the urban scene, often covering entire subway cars in New York with cartoon-derived words and images.

POLITICAL ART.

In art of the '80s and '90s, words are often as important as images, and tirades of text confront gallery-goers. Much purely visual art has an overtly feminist slant, as in Mary Kelly's work. Judy Chicago's "The Dinner Party" (1979) installation includes a "table" and place settings representing great women of history. Performance artists like Laurie Anderson, Karen Finley, and Eric Bogosian also speak out against sexism, racism, and economic injustice in mixed-media, theatrical monologues. In her performance piece "The Black Sheep," Finley shrieked her outrage against the white, male power structure. Stripped to her underpants and smeared with chocolate simulating excrement, Finley used her body as a symbol of women's degradation.

POST-MODERN SCULPTURE.

Oil on canvas may have made a comeback in painting, but the only thing certain about Contemporary sculpture is that the figure on a pedestal is long gone — probably for good. Several trends are evident, however, such as the use of a wide range of materials, from dolls to furniture to

GRAFFITI GRAPHICS. *The first professionally-trained artist to use the graffiti style was New Yorker Keith Haring (1958–90). Although he was frequently arrested for defacing public property, commuters soon began to appreciate Haring's trademark images scrawled in subways: the "radiant baby," barking dog, zapping spaceships, and winged television set. "Everything I ever dreamed I could accomplish in art was accomplished the first day I drew in the subways and the people accepted it," he said. When Haring died of AIDS, graffiti art, which had rapidly become commericalized, was finished as a force in art.*

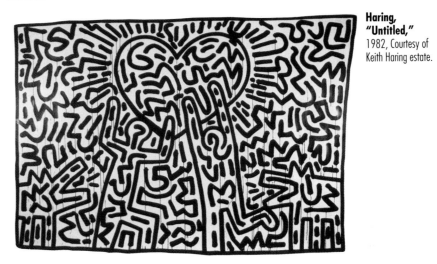

Haring, "Untitled," 1982, Courtesy of Keith Haring estate.

industrial products. Mario Merz, leader of Italy's Arte Povera (pronounced AR tay po VAIR uh, which means "poor art") movement, used rubber, newspapers, bales of hay, and neon tubing in his igloo-shaped works.

Reflecting the era's infatuation with speed and technology, other sculptors use machine parts to incorporate movement into their work. Mark di Suvero, a former crane operator, welds steel girders into abstract kinetic forms that gyrate like lumbering mastodons.

Both the American John Chamberlain and French sculptor César found gold in auto junkyards. They twisted demolition derby debris like warped fenders and squashed cars into macabre metal forms, as arresting as a roadside pileup.

Installations are in vogue, ranging from Chilean artist Alfredo Jaar's (b. 1956) pleas for justice in the Third World to American Judy Pfaff's fantasy environments like

colorful underwater gardens.

Semiabstract sculpture that refers to recognizable objects is alive in the hands of black American Martin Puryear (b. 1941) and American Nancy Graves (1940–95). Graves's painted, cast bronze pieces are playful explosions of oddly grafted forms like lavender and orange palmetto leaves pinwheeling into the air. Puryear is known for his virtuoso handling of wood.

Figurative art is eerily evocative in the work of American Kiki Smith (b. 1954), who bases her sculpture on the human body, "our primary vehicle," she said, "for experiencing our lives." Soon after the death of her father, Abstract Expressionist artist Tony Smith, Kiki produced a piece both disturbing and consoling: an algae-coated wax hand floating in a mason jar of dark green water. A certified Emergency Medical Technician, Smith presents the body as a frail clinical specimen and, at the same time, a resilient spiritual vessel.

END OF THE MILLENNIUM. Art in the '90s reflected the unsettled twilight of the twentieth century. It offered questions more than answers, challenges more than certainty. As Contemporary painter Mark Tansey put it, "A painted picture is a vehicle. You can sit in your driveway and take it apart or you can get in it and go somewhere." Art in the '90s ranged from figurative to abstract, funky to "serious," handmade to mechanically produced. Some intriguing artists on the scene, and the style that put them on the map, were:

ROBERT ARNESON (1930–92) — California artist who founded Funk Art with intentionally vulgar ceramic busts

ASHLEY BICKERTON (b. 1959) — known for abstract wall sculptures, thickly encrusted with paint

ROSS BLECKNER (b. 1949) — paints large-scale abstractions with subtle variations in color and pattern

CHRISTIAN BOLTANSKI (b. 1944) — French Conceptual artist specializing in installations

JONATHAN BOROFSKY (b. 1942) — creates large, mixed-media installations of painting, sculpture, text, video, and found objects

SOPHIE CALLE (b. 1953) — French artist known for narrative photosequences

JIM DINE (b. 1935) — paints Pop images like tools, robes, hearts

ROBERT GOBER (b. 1954) — explores flesh and the body in sculptures made of wax and human hair

GROUP MATERIAL AND GRAN FURY (included David Wojnarowicz, 1954–92) — two activist artists' collectives dealing with issues relating to AIDS

GUERRILLA GIRLS — left-wing artists' collective that produces posters protesting censorship, sexism (example: Mona Lisa with fig leaf covering mouth)

REBECCA HORN (b. 1944) — combines moving mechanical parts in feminist installations

JÖRG IMMENDORFF (1945–2007) — German Neo-Expressionist obsessed with socio-political issues

ALEX KATZ (b. 1927) — radically stylizes imagery in clean, figurative paintings

MIKE KELLEY (1954–2012) — signature work: bedraggled stuffed animals and dolls

BRUCE NAUMAN (b. 1941) — Conceptual artist known for wax-cast heads and video installations

NAM JUNE PAIK (1932–2006) — "father" of video art

ANTOINE PREDOCK (b. 1937) — quirky New Mexico architect who reveres landscape and site

RICHARD PRINCE (b. 1949) — Appropriation artist who invented "re-photography," or making photographs of photographs; also does silk screen paintings of cartoons

TIM ROLLINS (b. 1955) and K.O.S. (Kids of Survival) — collaboration between artist and South Bronx teenagers who paint on pages of books

LUCAS SAMARAS (b. 1936) — creates surreal images by altering photographs

NANCY SPERO (1926–2009) — feminist artist who layered visual images and written language

DOUG AND MIKE STARN (the Starn Twins, b. 1961) — manipulate, deface, recombine photographs

PAT STEIR (b. 1940) — known for abstract streams of paint inspired by waterfalls

PHILIP TAAFFE (b. 1955) — does abstract paintings composed of Byzantine patterns

CARRIE MAE WEEMS (b. 1953) — combines oddly lit, blurred black-and-white photos with text (example: "I sided with men so long I forgot women had a side.")

TERRY WINTERS (b. 1949) — paints organic forms in earthy colors

MASTER BUILDERS

Outstanding contemporary architects who've won the Pritzker Prize, called the "Nobel Prize" of architecture, come from all over the globe:

1990 Aldo Rossi, Italy	1998 Renzo Piano, Italy	2005 Thom Mayne, U.S.A.	2012 Wang Shu, China
1991 Robert Venturi, U.S.A.	1999 Sir Norman Foster, U.K.	2006 Paulo Mendes da Rocha, Brazil	2013 Toyo Ito, Japan
1992 Alvaro Siza, Portugal	2000 Rem Koolhaas, the Netherlands	2007 Richard Rogers, U.K.	2014 Shigeru Ban, Japan
1993 Fumiko Maki, Japan	2001 Jacques Herzog and Pierre de	2008 Jean Nouvel, France	2015 Frei Otto, Germany
1994 Christian de Portzamparc, France	Meuron, Switzerland	2009 Peter Zumthor, Switzerland	2016 Alejandro Aravena, Chile
1995 Tadao Ando, Japan	2002 Glenn Murcutt, Australia	2010 Kazuyo Sejima & Ryue Nishizawa,	
1996 Rafael Moneo, Spain	2003 Jørn Utzon, Denmark	Japan	
1997 Sverre Fehn, Norway	2004 Zaha Hadid, Iraq and U.K.	2011 Eduardo Souto de Moura, Portugal	

CONTEMPORARY ART

VIDEO AND NEW-MEDIA ART

It used to be that the pictures stood still at an art museum while viewers circulated at a brisk trot. Starting around 1995, video art caused viewers to stand still while images unfurled before their eyes. When artists combined computer-generated images, digital video, film, animation, text, sound, and special effects—often in ambient environments that engulfed the viewer—a reinvention of the language of art transpired.

The video medium is a blurry term for a host of moving-image works in multimedia installations. Editing software allows the artist to manipulate and morph digital imagery, collaging "real" and invented images to explore interior and exterior states. One video superstar, Bill Viola (b. 1951), who projects fresco-sized, immersive video loops simultaneously on four walls of a darkened room, calls it "a walk-in movie."

The genre runs the gamut from "rough and ready," low-tech videos made with handheld cameras to the slickest Hollywood-style production values. (Viola shoots on a Hollywood soundstage with a crew of eighty.) Sometimes video comprises a nonlinear, plotless sequence of images. In other hands, it incorporates Conceptual (as opposed to dramatic) narrative, as in Matthew Barney's epic five-part "Cremaster" (1994–2002). Barney (b. 1967) combined video footage of actors, objects crafted from bizarre materials such as petroleum jelly or tapioca, elaborate costumes, sets, and makeup in a hallucinogenic montage without spoken dialogue.

Viola, "Nantes Triptych," 1992, video/sound installation. *Slow-motion video projections on three ten-foot-high screens show a cradle-to-grave panorama of life: a woman giving birth, a woman dying, and in the center a man floating underwater.*

MOTION PICTURES. A growing number of multimedia works use sound and moving images in installations, drawing on a range of modern technology from digital video to the Internet. Gary Hill (b. 1951) creates video-sculptures, as in "Tall Ships" (1992). Viewers walk through a dark passage where silent, insubstantial images of people appear and disappear in response to the walkers' movements. Tony Oursler (b. 1957) projects faces on dolls and puppets, which seem eerily alive and chatty.

Gillian Wearing (b. 1963) makes deeply affecting, realistic videos. Doug Aitken (b. 1968) made the concept of mural-sized projections literal when he used seven facades at New York's Museum of Modern Art as screens for his video narrative "sleepwalkers" (2007). Iranian-born Shirin Neshat (b. 1957), who has lived in the United States since 1974, explores the status of women in Islam with evocative metaphors and stunningly beautiful compositions.

As our visual culture increas-

Barney, "De Lama Lâmina," 2004, production still, courtesy of Gladstone Gallery. *The uprooted tree in this Afro-Brazilian fable symbolizes deforestation. Forms in Barney's videos are endlessly allusive and elusive. He translates live action into sculpture, using materials as metaphor.*

ingly becomes a media culture, art continues to pour out of the video spigot. For the generation that grew up with TV and the Internet, video is easier than making a painting and almost as flexible as a sheet of paper. Since video speaks the media language of globalism, Viola believes,

this "art can go out through the whole world and link us together as human beings."

PHOTO-BASED IMAGERY

In the past decade, photography has shot to the forefront of the art world. Many of the new breed don't consider themselves strictly photographers but artists who use photography as one tool in their multimedia arsenal.

Contemporary photography divides into two camps: "straight" photographers, who treat the photograph as an objective record of reality, and neo-Pictorialists, who aspire to the art of painting. Their images are invention, not documentation. They don't take photos; they make them, but—this time around—with hyperclarity instead of soft focus.

THE SCHOOL OF DÜSSELDORF: NOTHING BUT THE TRUTH.
Photography emanating from the Academy of Fine Arts in Düsseldorf adheres to the nonfiction model. A host of German artists including Andreas Gursky, Candida Höfer, Thomas Struth, and Thomas Ruff spin off from the deadpan style of their professors, husband and wife Bernd (1931–2007) and Hilla (1934–2015) Becher. The Bechers photographed industrial structures, such as water towers or silos, which they called "anonymous sculptures." Exhibited in a series arranged in a grid format, the images are neutral records of disappearing artifacts.

Andreas Gursky (b. 1955) adapts his mentors' precise, studied, systematic compositions to large-scale color images of late capitalism. He differs in that he reorders the found geometry through digital manipulation to make "assisted realism," imposing coherence on chaos. Thomas Struth (b. 1954) spe-

cializes in large color photos of visitors in art museums, rendered with glossy clarity, saturated color, and lucid details. Thomas Ruff (b. 1958) blows up oversized head shots of his friends that look like artless passport photos.

Images by American photographer Nan Goldin (b. 1953) of her bohemian friends have the informal look of spontaneous snapshots. The American Philip-Lorca diCorcia (b. 1953) updates "street photography" by using a radio-activated flash trap to capture an image of a passerby from a distance. Amid the crowd scenes, his dramatically framed subjects have a lonely, alienated air, matching his goal to reveal "that which was never really hidden, but rarely is noticed."

DAWN OF THE DIGITAL AGE: "TRUTHINESS."
In the mid-1990s, advances in digital technology allowed artists to use the camera to explore allegory and fantasy, creating a simulated reality the comedian Stephen

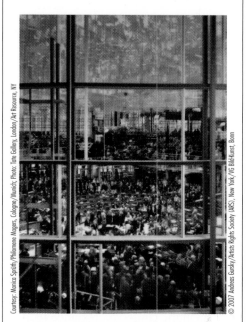

Gursky, "*Bundestag (Parliament),*" 1998, Tate Gallery, London. *Gursky digitally adjusts composition, eliminating details, enhancing color, and blurring the human presence to emphasize patterns and structure in this impersonal view inside the German parliament building.*

Colbert calls "truthiness." With the ability to seamlessly montage different images and to color-correct every individual pixel came the freedom to stage scenes that exist only in the artist's imagination. Adapting cinematic techniques of lighting, set design, and costume, and employing actors to stage their visions, artists produce large-scale color prints that show a fictional world.

Among the masters of photographic stagecraft are Tina Barney, Hiroshi Sugimoto, Yasumasa Morimura, Sam Taylor-Wood, and Gregory Crewdson. The African-American artist Lorna Simpson (b. 1960) creates elegant, high-impact black-and-white photos with a graphic punch. Her subject is racial and gender stereotypes, presented in posed scenarios accompanied by evocative text.

The Canadian Jeff Wall (b. 1946) takes the task of fabricating reality within a single frame to the greatest lengths. He calls his huge color transparencies (some as wide as sixteen feet), mounted in a glowing light box, "cinematographic photography." Wall carefully composes each image after taking hundreds of shots to present a complexly layered narrative. His images often re-create iconic paintings from art history but with contemporary characters, which he calls "the painting of modern life." Although his images are constructed versions of reality, the goal is still to convey an unseen truth.

A SINGULAR SENSATION: YOUNG BRITISH ARTISTS

In 1988, London art student Damien Hirst organized an exhibition of work by his classmates in an abandoned building. The show, called "Freeze," ignited a white-hot frenzy of media attention, controversy, and sky-high prices for these artists, known as the

229 x 377 cm

Wall, "A Sudden Gust of Wind (After Hokusai)," 1993, Tate Gallery, London. *Wall used more than one hundred shots to compose this seven-foot-by-twelve-foot photo, displayed in a light box. He transplants a scene from a nineteenth-century Japanese print to a cranberry bog near Vancouver to make an invisible natural force visible.*

Young British Artists. Fueled by collector Charles Saatchi, who bought YBA work in bulk, the antics and attitudes of this group became *the* major art phenomenon of the '90s. Their works—primarily Conceptual and in various media—share common threads of Cockney punk and nihilism. YBA art has a "freak show" aura—grungy, ironic, and super-cool.

SHARK-INFESTED WATERS.

Damien Hirst (b. 1965), who once worked in a mortuary, explores death and decay in installations of pickled animals suspended in formaldehyde. His first major animal installation was a glass vitrine with maggots and flies feeding on a rotting cow's head, a riff on the traditional "Vanitas" painting. His most famous work, "The Physical Impossibility of Death in the Mind of Someone Living" (1991), features a twelve-foot tiger shark floating in an aquarium. He has also posed and dissected fish, sheep, pigs, cows, and calves in glass cases.

One work conceptualized but never made consisted of rotting carcasses of a cow and a bull. The idea met with resistance from New York public health officials in 1995 because of fears of "vomiting among the visitors."

THE BROTHERS GRIM.

Jake (b. 1966) and Dinos (b. 1962) Chapman, two brothers who've worked together since 1992, place fiberglass mannequins and plastic models of human beings in disturbing tableaux. Combining shock tactics with dark humor, their sculptures of nude, dismembered bodies reflect the horror of modern life and the mass media's obsession with violence. In "Great Deeds Against the Dead," three amputated corpses hang from a tree, an updated version of Goya's "Disasters of War" etching.

SENSATION.

An aptly titled exhibition, "Sensation," displayed YBA works at London's Royal Academy in 1997 and at the Brooklyn Museum in 1999. In both venues, public furor at the provocative art was extreme. One of the most reviled works was Marcus Harvey's twelve-foot-high canvas "Myra" (1995), a blown-up mug shot of notorious child murderer Myra Hindley. Individual pixels composing the painted image consist of children's handprints.

The work that brought the wrath of Rudy Giuliani (then mayor of New York) on the Brooklyn Museum was "The Holy Virgin Mary" (1999) by Chris Ofili (b. 1968). Ofili, a British artist of Nigerian descent, decorated his painting of a black Madonna with varnished lumps of dried elephant dung. Ofili uses elephant dung to "incorporate Africa" into his work, which deals with issues of black culture and gender stereotypes.

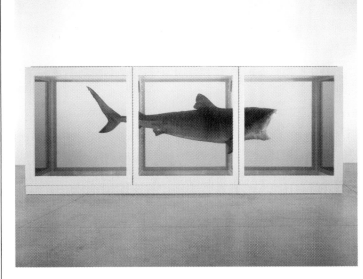

Hirst, "The Physical Impossibility of Death in the Mind of Someone Living," 1991, private collection. Tiger shark, glass, steel, 5% formaldehyde solution. *Damien Hirst, a 1990s Young British Artist superstar, is known for cadavers floating in vitrines of formaldehyde.*

CONCEPTUAL ART CONTINUES

The American artist Sol Lewitt (1928–2007) defined Conceptual art in 1967 as art in which "the idea or concept is the most important aspect of the work . . . and the execution is a perfunctory affair." After its heyday in the '60s and '70s, Conceptual art came roaring back in the '90s, a catchall term for the various forms of art that downplay (or delegate) the physical craft of production. Often involving social or political critiques, Conceptual art may be installations, video, performance, text-based, or hybridized art forms.

CLOWNING AROUND. The Italian-born, New York–based artist Maurizio Cattelan (b. 1960) is one of the best-known practitioners. An avowed prankster, Cattelan devises insubordinate sculptures to stir debate. Cattelan commissions others to execute his ideas. In a work called "Him," a child-sized Hitler kneels in prayer. Cattelan's work is ambiguous, "a perfect balance," he says, "between open and shut."

Gilbert and George, "Down to Earth," 1989, MoMA. *This photo-collage juxtaposes self-portraits sprouting from a cemetery with devouring mouths on floating heads to suggest the cycle of death and rebirth.*

226 x 317 cm

Courtesy of the artists

The British duo Gilbert (b. 1943) and George (b. 1942) have been rejecting traditional techniques as elitist since they began to collaborate as "living sculptures" in 1967. Their "photo-piece" collages attempt to make art a universal language.

California artist John Baldessari (b. 1931) is the Grand Old Man of Conceptual art. At six-foot-seven, he looms over a crowd just as his work towers over "post-studio" art, a field he virtually invented. Constructing new meaning out of familiar fragments, Baldessari says, "I give a few clues and the viewer can fill in the blanks." He recalls with pride a compliment the video pioneer Nam June Paik paid him: "What I like

© Maurizio Cattelan; photo © Touhig Sion/Corbis Sygma

Cattelan, "La Nona Ora," 1999, courtesy of Marian Goodman Gallery, NY. *Cattelan's cheeky sculpture, titled "The Ninth Hour" (the hour of Christ's death), portrays the pope nailed by a meteor, alluding to the death of faith in the modern world.*

AFRICAN ART: THE NEW WAVE

The African avant-garde speaks a global Conceptual language. Best known is South African William Kentridge, whose haunting charcoal drawings and complex narratives explore guilt and repression through fictional characters. Yinka Shonibare, born in Nigeria, stages elaborate scenarios in photographs to examine colonialism. The stitched canvases of Egyptian Ghada Amer have a feminist edge. Zimbabwe's eminent sculptor, Nicholas Mukomberanwa, synthesizes Modernism with the spiritual Shona tradition of stone carving. Photographers such as Malick Sidibé from Mali and Nigerian Iké Udé analyze identity politics through appropriation and installation.

about your work is what you leave out." Baldessari's evocative constructions vacillate between presence and absence "to unsettle," he says, "people's perceptions."

INSTALLATIONS BECOME IMMERSIVE ENVIRONMENTS

In the 1990s, installation art emerged as a major movement. Instead of discrete objects, gallery-goers encountered complex, room-sized environments including sculpture, drawings, paintings, found objects, detritus, ephemera, and often video, sound, lighting effects, and digital media. Installations attempt to overcome the separation between viewer and artwork in an interactive experience that involves multiple senses. These mixed-media environments require the viewer to participate, by connecting what may seem to be random dots into a take-away message.

ART YOU CAN GET INTO. James Turrell (b. 1943) creates installations with light. His 150-foot-long corridor at the Houston Museum of Fine Arts, "The Light Inside" (1999), seems like an infinite journey into space as neon lights transform the passage from pink to crimson, blue, and gold, enveloping the walker in its aura.

Born into a Palestinian family living in Lebanon, Berlin- and London-based artist Mona Hatoum (b. 1952) uses stark industrial materials as a cage metaphor. Her emotionally charged environments, often consisting of metal grids illuminated by moving lights, are both threatening and beautiful. "The Light at the End" (1989) is an iron frame with six electric heating elements installed in a blood-red painted corridor. Its bars glow with searing heat, luring the viewer with their warmth but threatening like a deadly Bug Blaster.

Large-scale installations often seem like a jumble of junk the viewer must mesh into a narrative. Russian artist Ilya Kabakov (b. 1933) creates tableaux of relics from the Soviet era, as a cure for the pain of transition.

TEAMWORK: COLLABORATIVE ART

When the focus in art-making shifted from product to process, an emphasis on collective effort emerged. Mem-

LATIN-AMERICAN ART

Difficult to categorize because of its diversity, Latin American art deals with multiculturalism, postcolonialism, and the relation between past and present. A short list of well-known artists from Central America, South America, and the Caribbean includes the following: Cuban Felix Gonzales-Torres (1957–96), who made "democratic artworks" out of giveaway stacks of paper and carpets of candies. Brazilian Vik Muniz (b. 1961) purposely draws "the worst possible illusion" of famous artworks, rendering an iconic painting such as Leonardo's "The Last Supper" in chocolate syrup, then photographing the image. Colombian sculptor Doris Salcedo (b. 1958) examines violence caused by civil war, crime, and corruption, using such domestic items as furniture and organic material such as bone and hair to address loss, grief, and memory. Mexican Gabriel Orozco (b. 1962) transforms found materials such as a can of cat food to show the value of the discarded and mundane. Cuban José Bedia (b. 1959) shows his passion for Amerindian culture and the Afro-Cuban religion of Santeria. In mixed-media installations and paintings, he explores *de donde vengo* (where I come from). Argentinean Guillermo Kuitca (b. 1961) paints maps, tufted with buttons like a mattress, evocative of home or longing.

bers of art collaboratives replaced the former image of a lone genius suffering in a garret with a group ethos, in which individual identities are sub-

Hatoum, "Light Sentence," 1992, Pompidou Center, Paris. *The installation, resembling a prison, consists of metal racks and a motorized bulb that casts menacing shadows as it rises and falls.*

Kabakov, "The Man Who Flew into Space from His Apartment," 1988, Pompidou Center, Paris. *Satirizing the myth of Soviet supremacy in the Space Race, Kabakov creates a littered cubicle, its walls papered with propaganda. A catapult, which shot the cosmonaut through a hole in the ceiling, suggests the only means of escape from the oppressive, claustrophobic setting.*

Komar and Melamid, "I Saw Stalin Once When I Was a Child," 1981–82, MoMA. *This art-collective duo's painting, in a parody of Soviet Social Realist style, is an example of their Pop Conceptual art.*

Digital image © MoMA/Licensed by SCALA/Art Resource, NY

The artists Christo and Jeanne-Claude (1935–2008) conceived works that required a cast of thousands. Their projects took decades from conception to installation, and the process of working with the public was essential to the final product. "Participation is key," as Jeanne-Claude said.

"The Gates, Central Park, New York City, 1979–2005" required twenty-six years to realize. According to

Photo: Wolfgang Volz

Christo and Jeanne-Claude, "The Gates, Central Park, New York City, 1979–2005." *This mega-public-artwork involved six hundred workers installing 7,500 gates hung with orange cloth throughout Central Park. The rectangular gates echo the street grid around the park, while the free-flowing fabric panels mirror the organic forms of trees and curved paths.*

merged. Although the risk of diluted art-by-committee is present, the younger generation, used to networking, sees the loss of autonomy as a plus rather than a minus.

The team of Komar (b. 1943) and Melamid (b. 1945) worked together for almost thirty years, stating, "We are not just an artist, we are a movement" before separating in 2003. They pioneered what they called multistylistic postmodernism, blending the dissident, anarchic spirit of Dada with Social Realism.

Ever since 1985, an anonymous group of female activist-artists, the Guerrilla Girls, has created posters, billboards, and books attacking institutionalized racism and sexism. Calling themselves "the conscience of the art world," the artists wear gorilla masks when they appear in public to promote their feminist agenda.

Claire Fontaine is a two-artist Parisian collaborative that mounts polemical, political works on ethnic strife and immigration. Anne and Patrick Poirier are a French collaborative couple, and the duo Fischli and Weiss (1946–2012) were Swiss. By far the most common reason for collaborative effort is the scale of public art projects requiring many hands to complete.

CONTEMPORARY SCULPTURE

Grounded in the handmade, new sculpture incorporates found objects with sensual, tactile appeal. The wire, metal, and ceramic sculptures — both delicate and powerful — of American Lee Bontecou (b. 1931) mix organic forms and mechanical structures.

Waxworks by American artist Petah Coyne (b. 1953) hang from ceilings like droopy oriole nests. Her chandelier-like sculptures, covered with dripped wax, seem lacy, bulging with life, yet are frozen in suspended animation. African-American Chakaia Booker (b. 1953) assembles hundreds of rubber tires into massive wall reliefs to comment obliquely on racial identity. The indestructible tires represent, she says, "the survival of Africans in the diaspora." British artist Rachel Whiteread (b. 1963) makes castings in plaster or concrete of spaces linked to working-class life.

British artist Andy Goldsworthy (b. 1956) creates "Land Art" sculptures from found materials such as thorns, twigs, ice, and rock. German-born American sculptor Ursula von Rydingsvard (b. 1942) intuitively sculpts massive chunks of cedar to realize an evolving mental image that looks both natural and manmade. The simple, curved forms with reflective surfaces by London artist Anish Kapoor, born in India (b. 1954), straddle Eastern and Western culture. Chinese artist Cai Guo-Qiang (b. 1957) incorporates traditional feng shui principles to heal human environments, saying it's "necessary to think about the small planet Earth from the angle of the entire universe."

Christo, "Thousands try to stop us. Thousands try to help us." For sixteen days, millions of viewers interacted with twenty-three miles of walkways festooned with saffron-colored fabric panels. "Everybody owns the work," as Jeanne-Claude put it.

RETURN TO FIGURATIVE ART

In the 1990s, painting and figurative art appeared obsolete. But after the turn of the millennium, artists reacted against the pervasive presence of virtual media and returned to both drawing and handcrafted canvases. No single movement or "ism" dominates, but lush, seductive surfaces—in contrast to the sleek, impersonal sheen of digital media—abound. The new painting—whether narrative, figurative, stylized, or decorative—traces a middle path between highbrow and low. As representational painting becomes more widespread, it's a time of refinement more than invention in art.

Among a group rejuvenating Neo-Expressionist techniques were the German Sigmar Polke (1941–2010) and American Robert Colescott, whose deliberately crude applications of paint in assaultive colors satirized race relations in the United States. British artist Peter Doig uses garish color to make realistic landscapes seem hallucinatory. American Julie Mehretu's paintings of exploding lines superimposed on city maps embody urban chaos and dynamism.

Some use figurative imagery to attack social injustice. Kara Walker explores race and gender in cut-paper silhouettes of stereotypes, such as Aunt Jemima. Kerry James Marshall's folk-art–like paintings deal with African-American life in low-income housing projects. Alexis Rockman's ecological concerns shine through in his apocalyptic paintings of the future.

Murray (1940–2007), "Arm-Ear," *1993, Newark Museum. Murray, who loved comics as a child and once wrote Walt Disney asking to be his secretary, adopted the eye-popping color of cartoons, transforming familiar objects, such as stairs and an ear, into her own wacky inventions.*

Richter (b. 1932), "Meadowland," *1985, MoMA. After reproducing a photo in paint, Richter pulls or smears a brush through the paint, creating a diffused blur that calls into doubt the illusion of reality.*

Elizabeth Peyton's intensely colored, fierce portraits, Laura Owens's folksy, fantasy paintings, and works by Amy Sillman, John Currin, and Lisa Yuskavage are notable. Currin's mannered style caricatures Breck girls in almost Norman Rockwell style, glossy and disconcerting. Yuskavage paints big-breasted bimbos like Kewpie dolls, mocking the eroticized *Playboy* aesthetic.

The most celebrated painter is German artist Gerhard Richter, called "the master of the blur," who produces both abstractions and photo-realist paintings. In his fuzzy landscapes based on photographs, Richter tricks the viewer into thinking a scene is romantic but imposes emotional distance by altering the image.

NEW LEIPZIG SCHOOL OF PAINTING

Academic art used to mean staid and stiff, but in the hands of graduates from the Leipzig Academy of Visual Arts in the former East Germany, it means hot and hip. A group of German painters fortified with solid studio skills includes Neo Rauch, Rosa Loy, Matthias Weischer, Tim Eitel, David Schnell, Aris Kalaizis, Tilo Baumgärtel, Martin Kobe, and Christoph Ruckhäberle. Curators and critics laud their paintings, collectively dubbed the New Leipzig School, as "the first bona fide art phenomenon of the twenty-first century."

The Leipzigers tell compelling stories in the old-fashioned medium of paint—but with a twist. Their moody landscapes, urban scenes, and interiors with an unsettling film-noir sensibility, executed with consummate craft, distort realism into a psychedelic zone of surreal angst.

Although the Leipzig painters do not consider themselves a unified movement, their brooding works

Photo: Uwe Walter

© 2007 Artists Rights Society (ARS), New York, VG Bild-Kunst, Bonn

Courtesy Galerie EIGEN+ART Leipzig/Berlin and David Zwirner, New York

Rauch, "*Diktat* (Dictation)," 2004, Rubell Family Collection, Miami. *Rauch's dreamlike scene, with quirky, fungoid shapes in lurid colors, suggests the hybrid creature at left (emblem of the totalitarian state) is dictating ideology.*

display a consistent aesthetic. The paintings vibrate with absence, dislocation, and a psychological state of anomie. They suggest weird narratives, indecipherable but fraught with disturbing implications.

Neo Rauch (b. 1960) is best known and a mentor to the younger generation. His paintings evoke inner conflicts, born during his childhood in Communist East Germany, where the state mandated subject matter for propagandistic, Social Realist art. His

canvases convey not an explicit message but a feeling of living in a failed utopia. He claims his paintings are set in a "strange twilight zone between reason and irrationality where the artist hunts for prey."

The empty rooms of Matthias Weischer (b. 1973), the walls scarred with layers of history, suggest the ghost-town, postindustrial landscape of East Germany after its citizens fled to the West after reunification. The almost photo-realist watercolors of Tim Eitel (b. 1971), in which people fail to make eye contact, convey existential loneliness. David Schnell (b. 1971) uses single-vanishing-point perspective, creating a rational space for his irrational constructs.

Aris Kalaizis (b. 1966) quotes Blaise Pascal's phrase as his motto: "We wish for the truth but find ourselves embedded in uncertainty." His paintings are enigmatic, carefully constructed sets with coded meanings underlying their surface structure. Although a message is implied, it's up to the viewer to puzzle out the plot.

Leipzig School painters use their formidable skills to reinvent realism. As the Austrian writer Thomas Bernhard put it, "The most essential things lie in that which is concealed."

100 x 120 cm on canvas

Kalaizis, "*Das Holzhaus* (House in the Woods)," 2006, Courtesy of Maerzgalerie, Leipzig. *Typical of the Leipzig School is this painting that suggests more than it describes. The furtive figure holds a hose (to refuel, cleanse, irrigate, or commit suicide?), while the eerie light from the window—a void at the heart of the painting—implies both emptiness and a blank slate for a fresh start.*

The Twenty-First Century: State of the Art

Art objects — especially paintings — used to be considered windows into an artist's world. No more. Now art is like a portal inviting viewers to enter and then actively experience and grapple with ideas. Contemporary artwork does not function as an individual object to be passively observed. It's a catalyst enticing viewers to look, feel, think, rethink — and possibly act.

Contemporary work is megahip. Formerly venerated Old Masters are now hopelessly passé for collectors, and even easy-on-the-eye crowd-pleasers like Impressionist paintings aren't sought after like living artists' work. International fairs with bleeding-edge art attract hordes of curious spectators, while contemporary art museums and biennials have proliferated across the globe.

Just as "disruption" is a buzzword in technological innovation, today's inventive art defies traditional genres and the white, male, Euro-American canon that used to dominate. Art is now globalized with no central hub, although cities like New York, Los Angeles, London, Paris, Berlin, Glasgow, and Shanghai still magnetically attract artists.

In many cases, recent art is truly off the wall. Heir to Marcel Duchamp's idea that anything can be art, it's often an assemblage of objects — something immersive that occupies physical and mental space, even cyberspace. Installations, social-practice art, and participatory and performance-based art increasingly usurp galleries. This experiential art is more than an aesthetic encounter: it's a bombardment that elicits intellectual and emotional engagement.

Art both reflects and foreshadows our culture, and diversity is the name of the game. Art today is more than sensory stimulation, narrative allusions, and subjective vision. Rather than illustrating or simulating a version of reality, it confronts high-stakes issues in a quest for meaning in an uncertain time.

Yayoi Kusama, "Infinity Mirrored Room," *2013, David Zwirner Gallery, NY. This experiential work is a room-size installation of LED lights that seem endlessly reflected by mirrors and water.*

The following sections describe the process and goals of some major currents, with the caveat that no art "movement" today is discrete. Artists' concerns and methods are an overlapping mash-up, blending fantasy and fact in a mélange that both conceals and reveals. As Robert Irwin said of his nearly invisible works that glow in the mind's eye, "They have no existence beyond your participation." Art in the twenty-first century is significant not just for what artists see, but also for what they make us see and what we carry with us.

OUTSIDER ART COMES INSIDE THE CANON

Those without formal art school training — mostly African-Americans from the rural South — used to be marginalized as outsider, visionary, or folk artists. Today their works are present in major museums. Their vernacular imagery, often created with scavenged materials, packs a potent punch.

Bill Traylor (1854–1949) is the granddaddy of the bunch. Born into slavery in Alabama, he drew radically simplified forms on discarded cardboard. A former field hand, he produced expressive figures whose dynamic lines bristle with vitality. Clementine Hunter (1886–1988) painted simplified figures, without the illusion of volume, yet her view of life is fully rounded, as in her picture of a joyful wedding atop an image of hard work in a cotton field.

Mose Tolliver (1919–2006) painted dots and lively forms on wood in a magic-realism style. Bessie Harvey (1929–94) used branches and roots of trees, manipulated with paint and extra objects, to create powerful tableaux on Biblical themes. New Orleans artist Herbert Singleton (1945–2007) made jazzy carved reliefs painted with bright enamel on old doors.

The most venerated artist in the field was Thornton Dial, Sr. (1928–2016), revered for massive, dense assemblages of cast-off objects like bones, beer bottles, okra stalks, and buckets. After growing up poor in Alabama, Dial turned to art that references topics like racism, war, natural catastrophes, and the struggle for civil rights.

NEO-POP

1960s Pop Art rebounded in the 1980s as a style more than a movement, slyly satirizing pop icons and materialism. The works are often whimsical in form and candy-bright in color, with an air of false innocence. The current King of Pop Art is Jeff Koons (b. 1955). His "Puppy" (1992), a 40-foot-tall "living" sculpture, combines sentimental symbols of cuteness like flowers and a West Highland terrier.

Dial, "African Jungle Picture: If the Ladies Had Knew the Snakes Wouldn't Bite Them They Wouldn't Have Hurt the Snakes; If the Snakes Had Knew the Ladies Wouldn't Hurt Them They Wouldn't Have Bit the Ladies," *1989, Smithsonian American Art Museum, Washington, DC. Dial's highly expressive style, striking inventiveness, and implicit social commentary demonstrate the originality typical of self-taught artists.*

CALIFORNIA CULTURE

The 2011–12 series of over 60 "Pacific Standard Time" exhibitions highlighting Southern California's postwar art was a game changer. Before this initiative to document West Coast innovations, art history focused on New York, considered the epicenter of avant-garde geniuses. New York was smug; Los Angeles was smog. Now L.A. is an acknowledged cultural capital, its artists recognized for far-reaching influence.

Its *grande dames* are Vija Celmins (b. 1939) and Betye Saar (b. 1926). Celmins specializes in cosmic imagery, making paintings and drawings of oceans, webs, and star-filled galaxies evoking awe and wonder. Saar recycles objects into poetic assemblages, fusing medium (scraps of castaway goods) and message (racial injustice). Her daughter Alison Saar (b. 1956) deals with social issues like gender, race, and the economy in sculptures made from recycled materials trailing clouds of history. "Bareroot" (2007) features a prone nude figure carved in wood and coated in tar, with bronze roots growing from its feet. According to Saar, this piece investigates "how a people who have been consistently uprooted and denied ownership of the land, relate to the land."

Many California artists are well known, such as Ed Ruscha (pronounced Roo-shay; b. 1937), whose views of Los Angeles buildings and the Western landscape seem starkly simple. Yet his billboard paintings with tongue-in-cheek text subvert a literal reading, challenging the viewer to think again. Richard Diebenkorn (1922–93) is renowned for more than 100 luminous abstractions in his "Ocean Park" series embodying what he called "tension beneath calm." Representational paintings of pastries by Wayne Thiebaud (b. 1920) look as luscious as their subject, with juicy daubs of paint thick as frosting on a cake.

A trait of the Light and Space movement is constant change, depending on the angle of viewing and time of day. Robert Irwin (b. 1928) makes nearly invisible hybrid works that play on contingencies of visibility. His pieces use light to dissolve edges, creating transient, shifting, and confusing sensory experiences.

BEAUTY BY THE BAY. The San Francisco Bay Area has contributed notable artists like Ruth Asawa (1926–2013), a sculptor whose crocheted wire, basketlike forms dangle like line drawings in space. Jay DeFeo (1929–89) was a Beat generation painter who mixed plaster and pigment in her most well-known work, the relief-like painting "The Rose," which weighs more than a ton. Bruce Conner (1933–2008) was a beatnik, proto-hippie, quintessential punk, and surrealist artist who pioneered experimental films and conceptual work that crisscrossed mediums and genres. His grisly early work is unforgettable, a curdled mix of Hitchcock's *Psycho* and Dickens's Miss Havisham.

Ruscha, "Hollywood Is a Verb," *1983, MoMA, NY. In this typical "word picture," Ruscha undercuts the pop mythology of Hollywood, distilling it in a cinematic panorama of a lurid sky reddened by decadence and pollution.*

Celmins, "Night Sky #22," *2001, MoMA, NY. Celmins's laborious charcoal drawing on paper captures the mystery of the starry sky.*

Bradford, "Even Change," *2002, private collection. Bradford's collage paintings present an abstracted, almost topographical, version of the chaos and complexity of urban life.*

Mark Bradford (b. 1961) and Diana Thater (b. 1962) are notable artists from a younger generation. Bradford examines issues of class, gender, race, and social justice in Los Angeles using salvaged materials found near his studio. His densely layered, billboard-size works combine torn relics of the real world in a standoff between representation and abstraction.

Multimedia artist Diana Thater creates immersive video, film, and architectural installations. Projecting moving images through colored gels on a wall, she ensures that viewers' shadows interact with the sequences (like video of frolicking dolphins). The kaleidoscopic experience engulfs her audience kinetically, emotionally, and viscerally.

PERFORMANCE AND PARTICIPATORY ART

The idea of art as still life (*nature morte*, French for "dead nature") is hopelessly out of date. Instead of still life, art now embodies moving life.

Artists have become performers enacting live events, like Marina Abramović's "The Artist Is Present" (2010), where she confronted viewers one-on-one. Joan Jonas (b. 1936) is a pioneering figure in this genre, incorporating audio, video, and installations into her theatrical works. Performance, she has said, is "three-dimensional live poetry in space." The New York–based Chinese performance artist Zhang Huan (b. 1965) subjects his naked body to extreme conditions to communicate harsh realities.

Event-centric, participatory works activate not just the artist but also the audience. Art is no longer off-limits, either behind a rope or on a pedestal. It's often made to touch and even take home, like the disappearing heap of candy offered by Felix Gonzales-Torres (1957–96) that represented his partner's body wasting away from AIDS.

Viewers also collaborated in the creation of Olafur Eliasson's 2003 "The Weather Project" at the Tate Modern. Hordes of sun-starved Londoners reclined to bask under an artificial sun. New Yorkers helped realize Ann Hamilton's "the event of a thread" in 2012. Participants swayed on wooden swings suspended from the 80-foot-high ceiling of the Park Avenue Armory. Strings connected to the swings caused sail-like white curtains to billow above them.

Tino Sehgal's performance-based work, which he calls "constructed situations," exists only the moment it happens. He even forbids photographs of the experiences. "This Progress" (2010) consisted of improvised conversations about progress with volunteers, ranging from eight-year-old children to senior citizens. "When you enter my work," Sehgal (pronounced seh-GAHL; b. 1976) has said, "you are also constructing it."

The much-vaunted "sharing economy" is as ubiquitous in the art world as it is in businesses like Uber or Airbnb. Artists want direct engagement with society. Instead of art making as a means of self-definition, with a tangible object that can be observed and acquired, performance and participatory art projects are ephemeral, dematerialized, and democratized. They involve exchange of energy or information in the real world. The ideal is "art for all" (the motto of the singing duo Gilbert and George) — truly populist art.

RELATIONAL AESTHETICS: JOIN THE CROWD. The official label for art that engages the public is Relational Aesthetics — art in which people interact socially. It connotes creating art collaboratively, with the experience itself paramount. Two notable artists whose projects activate viewers in a funhouse social setting are Philippe Parreno and Carsten Höller.

Such sociability is vital for several artists who make art you can literally sink your teeth into. In 2011, Rirkrit Tiravanija (b. 1961) served museumgoers a dish of Thai curry, a form of social sculpture in which the meaning of the work was achieved by sharing. The social conceptualist artist Lee Mingwei (b. 1964) views himself as a catalyst whose medium is hospitality. In 2012, he served homemade meals and conversation to strangers for a work called "The Dining Project." On Chicago's South Side in 2009, Theaster Gates set up a Soul Food Pavilion where he offered traditional down-home food like

Zhang Huan, "Family Tree," *2000, Musée National d'Art Moderne, Centre Pompidou, Paris. Calligraphy gradually covering his face in Zhang Huan's serial self-portrait implies a loss of identity after his emigration to New York.*

THE MEAL AS MEDIUM

A form of social art in which artists prepare and serve food has moved from the art world's back burner to the communal table. The recipe goes like this: Take a scoop of Happenings, a dash of Conceptual Art, and add a dollop of Performance Art. Sprinkle liberally into museums and galleries. Shake. Serve to the masses.

chitlins and watermelon at a communal dinner, spurring discussions of race and inequality.

The Chinese artist-collective Yangjiang Group served tea in a simulated Chinese garden at the Guggenheim Museum in 2016. Visitors measured their blood pressure and heart rate before and after sharing tea to see if socializing has beneficial effects. Since 2002 these artists have invited neighbors to dinner, aiming to build community and commonality.

Interest in such artful networking has expanded like a soufflé since the 1990s. The key to evaluating fellowship as art is to ask the following questions: Does it also provide food for thought? Does it provoke you to see the world differently?

ACTIVIST ART OPENS EYES AND MINDS

Social Practice Art is a new paradigm that's taken off since 2005. Reacting against consumerism, the art market's hierarchical rating system, and skyrocketing prices for contemporary art, many politically progressive artists are lobbying for social justice. Their thought-based works seek to raise awareness, inspiring viewers to improve the world. Publicly engaged art doesn't necessarily go in a gallery; it aims to make a difference in the world.

Some professional artists who devote themselves to the genre include Mary Miss, Tania Bruguera, Mierle Laderman Ukeles, Jackie Brookner (d. 2015), LaToya Ruby Frazier, Suzanne Lacy, and the Russian feminist band known as Pussy Riot.

Tiravanija, "Untitled 1992–1995 (Free/Still)," *1995/1997/1998/ 1999/2003/2007/2011–, MoMA, NY. One of the pioneers of the Relational Aesthetics movement, Tiravanija invited participation and collaboration by serving Thai curry to strangers.*

JUST IMAGINE

For Yoko Ono's "Wish Tree," visitors write a wish and are instructed to "Keep wishing until the branches are covered with wishes." Ono (b. 1933) is a pioneering conceptual and performance artist who has encouraged participatory art since the 1960s.

Rick Lowe's "Project Row House" (1993–ongoing) is a community-based public art project designed to bring social change. Influenced by what the German artist Joseph Beuys termed an "enlarged conception of art" involving "every human action," Lowe rehabs derelict shacks in Houston with volunteers.

The conceptual artist Mel Chin (b. 1951) aims to convert bystanders into collaborators in works that protest the trashing of the natural environment. Art, Chin believes, should infect the bloodstream of the body politic like a virus and replicate itself to bring about a healthy society. His "Revival Field" and "Operation Paydirt" use experimental substances to cleanse soil of toxic metals harmful to children.

Kim Abeles (b. 1952) engages in community art projects on subjects like AIDS and the environment. In "Pearls of Wisdom: End the Violence" (2011), more than 800 survivors of domestic violence collaborated with Abeles to create "pearls" — egg-shaped sculptures made of yarn and painted bandages. Each contains a participant's words, such as a bumpy, lavender pearl by a woman named Kim, which encased her hard-won wisdom: "If he wants you to be perfect, run . . . run now."

The Chinese artist Ai Weiwei (b. 1957) is perhaps the best-known activist artist. On Alcatraz Island in the San Francisco Bay, his site-specific works explored freedom and oppression. In "Trace," more than one million Lego blocks assembled by volunteers formed colorful portraits of political prisoners. "Yours Truly" consisted of a stand of blank postcards addressed to these prisoners. Viewers wrote messages showing solidarity and offering hope. "A small act is worth a million thoughts," Ai Weiwei said.

Ai Weiwei, "Trace," *2014, Installation View, New Industries Building, Alcatraz, California. Ai displayed images of political detainees who are imprisoned and deprived of human rights.*

SWORDS INTO PLOUGHSHARES

Multiplatform artist Pedro Reyes (b. 1972) uses art to reduce gun violence and drug trafficking in Mexico. In "Palas por Pistolas" (2008), he crushed and melted down more than 1,500 guns, converting them into shovels that school children used to plant 1,500 trees. "Disarm" (2012) converted military weapons into instruments like drums, guitars, and marimbas.

INSTALLATION ART

No form illustrates how varied contemporary art has become better than installation art. This multimedia genre recalls the recent buzzword "deskilling" (the erosion or abandonment of traditional mastery of craft). Instead of pursuing artisanal virtuosity, some artists function as accumulators of detritus and set designers. Besides thrift-shop found objects, they might use video, audio, and performance in large-scale installations, arranging everything into a 3-D tableau to convey an idea.

Installations spring from a desire to merge art and life, making art more relevant to a broad audience. The viewer's discovery of meaning in a clue-packed installation is the point — not an overt illustration of an artist's message.

In a geeky extravaganza, Tom Sachs (b. 1966) and his acolytes took over an immense 50,000-square-foot space to present "Space Program: Mars" (2012). Using his bricolage (amateurish tinkering) aesthetic, the team produced sculpted components out of cheap materials like plywood and glue to simulate items for a mission to Mars. His witty panorama included a lunar lander, space suits, and a Darth Vader–shaped refrigerator that held beer.

The Beijing-based collaborators Sun Yuan (b. 1972) and Peng Yu (b. 1974) created a dynamic "Old People's Home" (2008) in which 13 ultrarealistic, life-size sculptures of aged world leaders like Yasser Arafat and Fidel Castro sat slumped in electric wheelchairs. The

chairs buzzed aimlessly around the gallery, occasionally colliding, just as the leaders' political views once clashed.

The French artist Christian Boltanski (b. 1944) presented a mammoth installation consisting of a 25-foot-tall pile of used clothes, lifted and dropped by a 60-foot-high crane. The constantly shifting landscape of rags fluttered down to a throbbing sound track — the pulse of human heartbeats. Visitors could record their own heartbeats to be housed in Boltanski's *Archives du Coeur*, where he's collected more than 40,000.

David Hammons (b. 1943) makes pointed groupings of objects that function as symbols of class, race, and economic disparity. Riffing on African-American life in 2001, he installed three microphone stands, entitled "Which Mike do you want to be like . . . ?" The implied choices were three Michaels who made it big in the worlds of music and sports: Jackson, Jordan, and Tyson. But the mouthpieces were too high to reach.

STREET SMART

Following in the spray can mode of graffiti taggers like Keith Haring, Kenny Scharf, and Jean-Michel Basquiat, artists like Shepard Fairey, Dom Pattinson, and Lari Pittman have appropriated the visual style of posters and street signage. The anonymous British artist Banksy stencils images on city walls to comment on social conditions. In 2008, Banksy painted "One Nation Under CCTV" on a wall near surveillance cameras in London's Oxford Street.

Hamilton, "ONEEVERYONE," *2017, Courtesy of Landmarks public art program at the University of Texas, Austin. These porcelain enamel portraits, installed in a medical school, both reveal and conceal the individual subjects — patients and caregivers who seem to both emerge from and recede into a cloud of common humanity.*

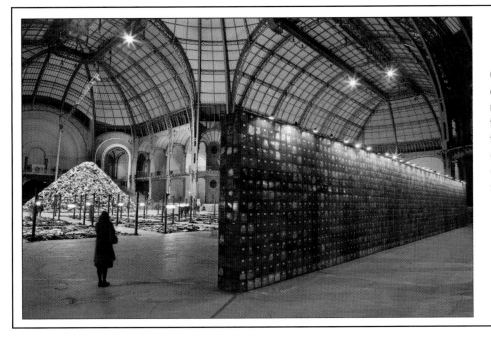

SECOND-HAND CLOTHES FOR FIRST-HAND EMOTION

Christian Boltanski created a landscape of 69 piles of used clothes in a 2010 work. Its title "Personnes" means both "people" and "nobody." A claw, like "the finger of God" as Boltanski said, lifted and dropped rags from a mountain of garments, suggesting the role of chance in life and death. In installation art, the emotional experience is part of the work. You are "not in front of something," the artist explained, "but inside something."

ASIAN ART TAKES THE WORLD STAGE

After a period of economic "opening and reform" in the post-Mao era, a 1985 movement known as the New Wave placed China on the path of contemporary art. More than 2,000 young artists, without institutional support like galleries or museums, began to experiment with conceptual practice, abandoning the agit-prop Socialist Realism that had prevailed. During this great leap forward, avant-garde groups held exhibitions influenced by Western modes. The New Wave artist Gu Dexin summed up the revolutionary spirit: "Except for money and big studios, Chinese artists have everything they need."

One of the most influential artists of the period, Huang Yong Ping (b. 1954) created a replica of a Fujian-style tomb out of washed newspapers. The tomb, shaped like a tortoise (symbol of longevity), represented death, but paradoxically, Huang suggested that out of disorder and demise of the old — the blurred, messy newsprint — comes regeneration. Around 1989, this renaissance of individual freedom faltered when officials crushed a nascent democratic movement in Beijing's Tiananmen Square.

It was a time of incredibly rapid change as the nation mutated from a rural and agricultural economy to an urban and industrial behemoth. Peasants fled the countryside to work in factories. Construction boomed; mega-cities sprouted. Pollution engulfed the landscape, and artists' work reflected the resulting disorientation and tension.

In 2008, at the time of the summer Olympics in Beijing, China became the world's second largest economy while a global recession took hold in the West. Soon China became central, rather than peripheral, to world contemporary art. Using a variety of genres, its artists question the relationship between individual and collective identity, skeptical of both Eastern and Western ideologies.

Conceptual artist Xu Zhen's witty sculptures and installations investigate global culture. This sought-after artist, who was born in 1977 and now calls himself "Madeln Company," straddles history and innovation.

JAPANESE GUTAI MOVEMENT. Just as art practice diversifies, art history is broadening to recognize movements outside the Euro-American orbit. One of the most original post–

THE METROPOLIS IMPLODES

Beijing-based Liu Wei (b. 1972) is a multimedia artist who uses found materials and industrial detritus to satirize urban life, transformed by construction. "Library II" (2013) presents a dystopian city of spiky skyscrapers.

CYNICAL REALISM

Fang Lijun (b. 1963) illustrates the 1990s Cynical Realism movement begun in disillusionment following the crackdown at Tiananmen Square. His woodblock prints show disenchantment with domestic policy. New York–based Zhang Hongtu (b. 1943) paints Pop Art subversions of Chairman Mao's iconic image to criticize the Cultural Revolution.

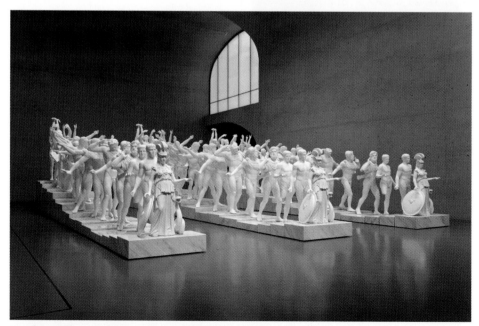

Xu Zhen, "Thousand-Arms Classical Sculpture," *2014–2015, James Cohan Gallery, NY. This hybrid work splices symbols from Chinese and Western culture like a Buddhist thousand-arms statue and Greco-Roman sculptures.*

World War II movements was Gutai (meaning "concreteness") in Japan. From 1954–72, radical artists, reacting against the trauma of war and postwar devastation, jettisoned traditional styles in a performance-based collective movement. Their mantra was "create what has never been done before."

Two of the most original were Sadamasa Motonaga (1922–2011) and Kazuo Shiraga (1924–2008). Shiraga channeled energy into abstract mark-making by using his feet to push paint around a canvas on the floor. The result was an evocation of the horrors of war, which he admitted "became my subjects."

Shiraga, "Chikatsusei Maunkinshi (Golden Wings Brushing the Clouds Incarnated from Earthly Wide Star)," *1960, Art Institute of Chicago. Shiraga's early paintings presented a violent vortex of thickly applied blood-red pigment and flamelike swirls of yellow.*

PHOTOGRAPHY SHINES: FROM ABSTRACT TO EXACT

Photographers Edward Burtynsky and Sebastião Salgado, two of the most brilliant artists working today, construct indelible images of man's impact on the natural environment. The Canadian Burtynsky (b. 1955) has been called the best landscape artist of his generation. He takes large-scale aerial photographs of scenes of destruction, like the BP oil spill in the Gulf of Mexico or ripped-up earth at open-pit copper mines in New Mexico. They

Burtynsky, "Oil Spill No. 4, Oil Skimming Boat, Near Ground Zero," *2010, private collection. "Nature transformed through industry," Burtynsky says, is his constant theme, especially in images dealing with extraction of natural resources, which are like "reflecting pools of our times."*

Salgado, "Untitled (Serra Pelada)" *1986, MoMA, NY. Salgado documents the appalling conditions at a Brazilian gold mine.*

seem like beautiful abstractions — all swirling colors in visually compelling compositions.

Its inventor, Louis Daguerre, called photography "a mirror with a memory." Through the lens of Salgado (b. 1944), it's a medium with a message. The Brazilian photojournalist's black-and-white images are sharply

detailed testimonials of the damage inflicted on the earth and humanity. For his photo-reportage on the plight of refugees, he said, "I photographed it with all my heart. I thought the whole world needed to know. This is our world, and we have to assume responsibility for it."

Photography today splits into two camps: those who document reality and those who manipulate it. Catherine Opie (b. 1961) falls into the tell-it-like-it-is crowd. Subjects range from Malibu surfers to artist friends to gritty portraits of San Francisco's queer subculture. Cuban-born American photographer Abelardo Morell (b. 1948) uses a vintage technique, the camera obscura, to create surprising views. He turns an entire room into a giant camera to capture surreal, inverted vistas of the outside world projected on interior walls.

ABORIGINAL ART

The late critic Robert Hughes called it "the last great art movement of the twentieth century." In Australian indigenous art, people encoded crucial information about their cosmology, ancestors, and survival in geometric "dot" paintings. Paddy Bedford was one of the best. Now a generation of urban, trained Aboriginal artists protest lingering injustices linked to racism through art. No longer confined to ethnographic institutions, Aboriginal art is spotlighted in fine-art exhibitions.

Christenberry, "Red Building in Forest, Hale County, Alabama," *1983, Morris Museum of Art, Augusta, GA. In Christenberry's photographs, sagging but iconic structures in the rural South project an enigmatic aura of memory and myth.*

VISIONS OF THE AMERICAN SOUTH. William Eggleston (b. 1939) made his mark with vibrant color photographs in the 1970s, when only black-and-white prints were considered fine art. "I am at war with the obvious," he declared, an apt credo for his eerily lit tableaux.

Sally Mann (b. 1951) has explored the legacy of the Civil War in brooding, painterly landscapes of her "Antietam" series. William Christenberry (1936-2016) photographed faded buildings in rural Hale County, Alabama, for decades, returning over the years to document their transformation and collapse. "I find beauty in things that are old and changing, like we all are changing," he said in an interview.

Eggleston, "Untitled (Greenwood, Mississippi)," *1973, MoMA, NY. Eggleston pioneered color photography as a respected fine art with his garishly lit scenes of daily life in Memphis and Mississippi.*

STAGING REALITY

Beijing-based Wang Qingsong (b. 1966) highlights the epic transformation of modern China. His large-scale photograph "Follow You" (2013) shows a classroom packed with desks like a factory assembly line. "Artists cannot just make art for art's sake," he has said. "I think it would be absurd for an artist to ignore what's going on in society."

BIG IDEAS: NEW SCULPTURE

Sculpture is no longer a static carved or modeled form on a pedestal. Like the expansion of art practice in general, interdisciplinary methods have broadened its scope both in the studio and in public spaces. Earthworks (interventions in nature), installation, performance, electronic media, and 3-D printing have expanded what constitutes a sculpture. Now a wealth of forms like site-specific work; multiplatform pieces with audio, video, and internet components; and socially engaged interactive and performance-based work activate sculpture.

British sculptor Phyllida Barlow (b. 1944) takes an antimonumental slant in her work. Arranging objects like splintered wood, rags, cardboard, and polystyrene in massive assemblages, she suggests the mess of modern life. Her enormous piles of junk teeter precariously, with entropy and gravity threatening to topple them.

Roxy Paine (b. 1966) also works on a large scale. His "dendroid" sculptures of trees in stainless steel, complete with bare, sprawling branches, are as much as 50 feet tall and weigh more than 16,000 pounds. In 2007, Colombian sculptor Doris Salcedo (b. 1958) made a 550-foot-long crack in the concrete floor of the massive Turbine Hall at the Tate Modern. The plunging chasm beneath the surface suggests underlying dark forces like

Rubins, "Monochrome for Austin," *2015, Courtesy of Landmarks public art program at the University of Texas, Austin. Seventy recycled aluminum canoes strike a balance between delicacy and strength, like an exploding bouquet of flowers.*

Cave, "Soundsuit," *2010, Minneapolis Institute of Arts. Cave began making Soundsuits in response to the police beating of Rodney King in 1991. The idea is to conceal the wearers so the viewer confronts them without judgment as to gender, race, or class.*

A BLAST

This more than 10-foot-tall 2008 sculpture called "The Eye" by David Altmejd (pronounced AWLT-made) references the first nuclear bomb test in 1945. Its dynamic form of shattered mirrors and glass shards, like a frozen explosion, implies both the elegance of scientific breakthroughs as well as their destructive potential.

CLAY HAS ITS DAY

Contemporary artists have reinvigorated an ancient medium: ceramics. The malleability of clay allows the gestural equivalent of expressive painting, resulting in arresting forms. Artists who've reclaimed the material include Eduardo Chillida, Karel Appel, Ken Price, Betty Woodman, Jessica Harrison, Edmund de Waal, Sterling Ruby, Arthur Kern, Kathy Butterly, and Katinka Bock.

colonial oppression. She also makes delicate postminimalist works like the empty shirts of "Disremembered." The woven silk fabric is fragile, embedded with thousands of sharp needles, commenting on the trauma of those lost to political violence.

Figurative sculpture has mutated into hybrid forms. American sculptor Deborah Butterfield (b. 1949) is known for skeletal forms of life-size horses. Constructed out of driftwood, scrap metal, mud, or clay, they resemble 3-D drawings in space. British artist Antony Gormley (b. 1950) creates abstracted sculptures of the human form, often cast from his own body. They stand like silent sentinels, questioning man's role in the cosmos. Jaume Plensa (b. 1955 in Barcelona) makes large public sculptures of metal and fiberglass that resemble monumental heads from Easter Island. American sculptor Nancy Rubins (b. 1952) repurposes industrial objects like water heaters, boats, and airplane parts. She clusters them to create monumental hanging sculptures in tense equilibrium, bristling with energy.

The British conceptual sculptor Richard Long (b. 1945) bases his work on mammoth walks across the countryside. Sometimes his interventions are as unsubstantial as footprints or piles of stones, but he is most known for pieces of slate arranged on the ground in circles, suggesting ancient rituals.

Chicago-based visual artist and former dancer Nick Cave (b. 1959) takes social sculpture to a level of pure joy with his handcrafted Soundsuits, designed to be worn by figures in motion. In 2013, a herd of 30 life-size "horses,"

enacted by two dancers per costume, performed "Heard.NY" in New York's Grand Central Station. They cavorted to lively music accompanied by the sound of swooshing raffia manes, merging colorful sculpture and performance.

FIGURE AND FORM: PAINTING MAKES A POINT

Although mixed-media installation and digital, interactive, and performance art are prevalent, painting still appeals through its power to convey an artist's subjective experience and elicit an emotional response. The "death of painting" — regularly proclaimed — is greatly exaggerated. In a technology-driven world, figurative painting is an expressive medium to communicate humanistic insights.

Figurative painting is more "psycho-realist" than photo-realist, distorting physiognomy to suggest underlying truth. The British painter Lucian Freud (1922–2011) took an intensely unsentimental approach

SITE-SPECIFIC ART: THE DESTINY OF DESTINATION

In site-specific art, the work has an organic relationship to its location, which lends it meaning or contributes to the aesthetic quality. Patrick Dougherty's "Daydreams" (2015), located at Tippet Rise Art Center, Fishtail, Montana, covers a replica of a frontier school with woven willow fronds. It evokes, Dougherty says, children's dreams of the wild when they're shut inside.

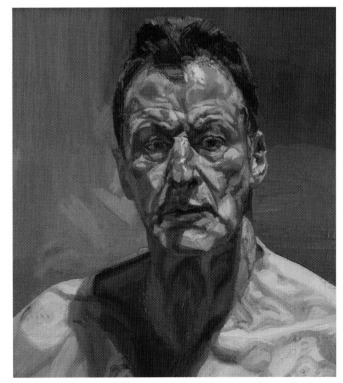

Freud, "Reflection (Self Portrait)," *1985, private collection. By exposing every wrinkle denoting the ravages of time, Freud conjures the emotional life beneath the almost topographical map of his face.*

NUCLEAR WINTER

Using an image from a published photo, Luc Tuymans (pronounced TIE-mans; b. 1958) provides minimal detail in "Nuclear Plant" (2006). Calling his paintings "authentic forgeries" because they refer to memories rather than original content, he often refers to traumatic events like the Holocaust. This blurred, austere image of a top-secret nuclear weapons compound in Israel is nearly monochromatic. The dome and tower recall an Islamic mosque and minaret, implying explosive danger in both radioactive power and regional hostilities.

to portraiture, creating fleshy, brutally frank images. Frank Auerbach (b. 1931), Freud's compatriot in the School of London, also distorts appearance by applying thick masses of heavy, lumpy paint. Together they revitalized portraiture, sparking a renaissance in British figurative art.

Freud and Auerbach painted from live models, but many contemporary artists often base their images on photographs. The South African Marlene Dumas (b. 1953) uses fluid paint that seems to bruise the canvas, presenting floating headshots of subjects who appear in pain, as if suffering from violence or psychological trauma.

Creating still life and landscapes from photographs allows the somewhat retro genre to be provocative rather than regressive. Maintaining an impersonal distance from the subject by using snapshots, cinema, or print media as a source provides freedom. Artists can analyze the omnipresence of visual images that saturate society and convey not so much a likeness but conceptual content.

Dumas, "For Whom the Bell Tolls," *2008, Dallas Museum of Art. This distorted image — a portrait of vulnerability — is based on a picture of the film star Ingrid Bergman, framed in a dramatic close-up to increase its impact.*

ABSTRACT PAINTING:
SCULLY'S WINDOWS ON THE WORLD

If representational painting is consciously artificial and distorted for expressive purposes, abstract painting also uses gestural brushwork and sensual application of paint to communicate without words. The abstract painter Sean Scully (b. 1945) creates large-scale (more than six feet high) canvases with his signature motifs: rectangular blocks of thick paint. In contrast to his limited vocabulary of horizontal and vertical bands, the paintings' tactile surface makes them almost vibrate. They hint of fused opposites like control and chaos, stasis and instability.

NEW ABSTRACTION

Work by artists like Liz Larner, Franz West, Martin Kippenberger, and Rosemarie Trockel keep the genre alive, with both painting and sculpture that engage the viewer, often literally, as in West's grungy sculptures that invite you to sit on them. The Ghanaian El Anatsui (b. 1944), who works in Nigeria, makes metallic tapestries out of flattened liquor bottle caps and seals, linked by copper wire. The nearly 13-by-19-foot "Bleeding Takari II" (2007), with its bloodlike drips, alludes to liquor that was traded for slaves during the colonial era.

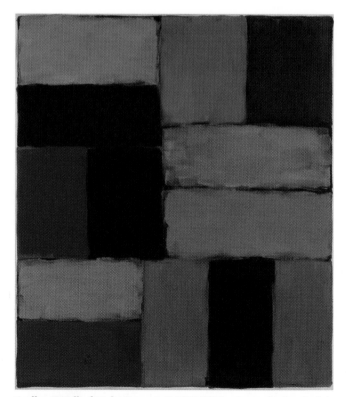

Scully, "Wall of Light Oceanic 7.05" *2005, private collection. Scully's strips of color recall windows and doors embedded in a grid. Underlying glints of color peek through surface layers like light leaking through a cracked wall.*

NEW MEDIA ART: HIGH-TECH TRUMPS HIGH-TOUCH

New Media — as opposed to old media (pure painting and sculpture) — encompasses a broad range of practice. It includes work created with digital and electronic means like video, smartphones, computer graphics, data dives, computer games, apps, robotics, virtual reality, and genomic and GPS technology.

New Media art is interactive, often repurposing items from the internet. It's connected in cyberspace, where it can be infinitely shared and accessible across many platforms. Because it relies on rapidly evolving technology, exhibition and conservation are difficult.

Yet, like traditional art, the genre deals with socioeconomic, political, and cultural issues. Frequently depending on digital code for its production, it seeks to decode the influence and impact of media and technology on our world. Pixel-based New Media has emerged as a tool to criticize the IT revolution. Many artists who grew up with personal computers and video games work in art collectives where appropriation and sampling are common. Copy and paste and drag and drop have replaced paintbrush and chisel.

In Eduardo Kac's "Rara Avis" (1996), visitors control a telerobotic parrot in an aviary. A camera behind the robot's eyes surveys real birds. Cory Arcangel's "Super Mario Clouds" is a nostalgic hack of a classic but obsolescent video game. In "Angry Birds All Levels" (2012), Paris-based Evan Roth converts a video game into inked fingerprints representing swipes on a mobile device.

Ken Solomon freezes scenes from google searches in watercolor images, arresting the constant stream of digitized information. The Serbian artist Dragan Ilic allowed a robotic arm to drag him around a canvas holding paintbrushes to create a picture. The Swiss photographer Daniel Boschung uses a robotic camera to make ultradetailed, 900-million-pixel portraits, an extreme form of photorealism. Laura Poitras makes huge abstract color prints of video-surveillance data from drones.

In all cases, New Media stretches the conventional definition of art. The Dutch-Brazilian artist Rafäel Rozendaal criticizes consumer culture through his websites. "Art is like a sport" that anyone can play, he has said of the democratizing influence of digital tools. Yet he added that only the most passionate professionals play at the top of the game.

POST-INTERNET ART: ON-LINE ART GOES OFF-LINE

The fledgling medium of post-internet art took off after 2010. Net Art, in which the only way to experience a piece was on the internet, mutated into works that use the internet as a tool but also exist as 3-D objects.

Some artists identified with the budding movement include New Yorkers R. Luke DuBois and Seth Price, Berlin-based Oliver Laric, and Petra Cortright in Los Angeles. Cortright's VirtualGirl, digital paintings, video art, and web pages exist online and on YouTube along with collaborative videos and actual clothes done with the designer Stella McCartney.

The Los Angeles–based duo of Lizzie Fitch and Ryan Trecartin (both b. 1981) create elaborately furnished stage sets that viewers enter to watch videos of people enacting narratives within those environments. "Installation Priority Innfield" (2013) consists of four different *mise-en-scène* pavilions, sculptural theaters like a messy mixtape of contemporary culture.

SURROUND-SOUND

In 2008, the Swiss artist Pipilotti Rist (b. 1962) projected a kaleidoscope of high-def color video with a musical score on the walls and ceiling at the Museum of Modern Art. Viewers of "Pour Your Body Out" sprawled on the carpet and a circular sofa in this immersive installation that transformed the giant atrium into a dreamscape.

ECO-ART: IT'S NOT EASY BEING GREEN

Many artists use all formats to reflect the dangers posed by human activity to our natural environment. Pioneered by Helen and Newton Harrison, the Eco-Art movement includes artists like Betty Beaumont and Agnes Denes. Brandon Ballengée's work spans art, field research, and biology. Since 1999, his "Species Reclamation" project has been breeding frogs threatened with extinction.

French artist Pierre Huyghe (pronounced WEEG; b. 1962) has said he wants to create no "autonomous objects," but instead to incorporate things in flux, like living organisms. He's used spiders, dogs, horseshoe crabs, and even live cancer cells to show ecological threats.

Jennifer Allora (b. 1974) and Guillermo Calzadilla (b. 1971), an artist team from Puerto Rico, deal with sociopolitical and environmental concerns. In their dystopian color video "Sweat Glands Sweat Lands" (2006), gruesome footage shows a skewered pig attached to the rear end of a car. It roasts on a spit that speeds up as the car accelerates — a dig at global warming caused by fossil fuels.

Huyghe, "Untitled (Reclining Female Nude)," *2012, MoMA, NY. Huyghe replaces the head of a classical statue, cast in concrete, with a colony of live honeybees to explore the symbiotic relationship between human beings and bees.*

A GLASS ACT

In the twenty-first century, the border between art, design, and technology became permeable, and glass became a medium of choice for large-scale sculptural works. Glassmaking is now aesthetically driven; its objects shine with metaphorical meaning. Dale Chihuly (b. 1941) is the best-known figure in the field of studio glass. His biomorphic pieces, like "Thames Skiff" (2005), are recognizable for their bright colors and curvaceous, ebullient form.

BLACK-OUT

In "Solar Catastrophe" (2011), Allora and Calzadilla made a collage out of broken solar panel fragments. The geometric abstraction, which resembles a modernist painting, transforms a deconstructed emblem of progress into a purely decorative object.

INDEX

Page numbers in italics refer to illustrations.

Abbott, Berenice, 152, 184, *184*
Abeles, Kim, 208
Abramović, Marina, 179, 206
Abstract Expressionism, 23, 128, 158–61, 165–68, 170–72, 174, 177, 193
Adams, Ansel, 185, *185*
African art, 22–23, 130, 137, 198
African Jungle Picture: If the Ladies Had Knew the Snakes Wouldn't Bite Them They Wouldn't Have Hurt the Snakes; If the Snakes Had Knew the Ladies Wouldn't Hurt Them They Wouldn't Have Bit the Ladies, 204
Age of Bronze, The, 13, 110, *110*
Agnew Clinic, The, 86
Aitken, Doug, 195
Albers, Josef, 160, 170, *170*
Allora, Jennifer, 218, *218*
Altamira Caves, Spain, 4
Altmejd, David, 214, *214*
Ambulance Wagons and Drivers at Harewood Hospital, 93
Amer, Ghada, 198
American Gothic, 155, *156*
American Scene School, 155–56
Analytic Cubism, 138, 140
Anatsui, El, 216, *216*
Andre, Carl, 177, 182
Anime, 201
Anthemius of Tralles, 25, *25*
Apollo Conducts the Bride, Beatrice, to Babarossa of Burgundy, 46
Appel, Karel, 214
Appropriation art, 190
Arbus, Diane, 185–86
Arcangel, Cory, 217
Architecture, 14–18, 28–29, 39, 49, 59, 65, 89–90, 126–27, 146–47, 180–83
Arm-Ear, 201
Arneson, Robert, 194
Arnolfini Wedding, 40, 40
Arp, Jean, 148, 148, 164
Arrangement in Gray and Black No. 1, 61, 87, 87
Art Brut, L', 162–63
Art for Art's Sake, 87
Art Nouveau, 91, 127, 182
Arte Povera, 193
Arts and Crafts Movement, 90
Asawa, Ruth, 205
Ashcan School, 141, 154–56
Atelier des Batignolles, L', 99, 99
Arget, Eugène, 152, *152*
At the Moulin Rouge, 113, 115, *115*
At the Time of the Louisville Flood, 184
Auerbach, Frank, 216
Aztecs, 20

Bacchanal of the Adrians, 38
Bacon, Francis, 61, *61,* 163, *163*
Baldessari, John, 178, *186,* 198
Ballengée, Brandon, 218
Balzac, 111, *111*
Banksy, 209, *209*
Bar at the Folies-Bergère, 97, 101, *101*
Barbizon School, 84, 99
Barlow, Phyllida, 213
Barney, Matthew, 195, *195*
Barney, Tina, 196
Baroque period, 46–65
 Catholic, 46
 Dutch, 52–56
 English, 57–59
 Flemish, 50–51
 Italian, 47–49
 Northern, 46
 Spanish, 60–61
Baselitz, Georg, 188–89
Basquiat, Jean-Michel, 189, 209
Bathers, The, 105
Battle of Issus, 25
Baudelaire, Charles, 70, 77, 84, 101, 125
Bauhaus, 146, 170, 180
Baumgärtel, Tilo, 202
Bay, The, 167
Bazille, Jean-Frédéric, 105
Baziotes, William, 161
Bearden, Romare, 86, 156, *156*
Beardsley, Aubrey, 91, *91*
Beaubourg, Paris, 181, *181*
Beaumont, Betty, 218
Beauvais Cathedra, Choir of, *28*
Beaux-Arts style, 126, 181
Becher, Bernd and Hilla, 196
Bedford, Paddy, 212
Bedia, José, 199
Bellows, George, 155, *155*
Bend Sinister, 170
Benton, Thomas Hart, 155, *155,* 161
Berlin Street Scene, 142
Bernini, Gianlorenzo, *48,* 48–49, *49*
Bêtes de la Mer, Les, 135, *135*
Beuys, Joseph, 178–79, 188–89, 208
Bickerton, Ashley, 194
Bierstadt, Albert, 82, *82,* 95
Big Ben, 131
Bingham, George Caleb, 82, *82*
Bird, 21
Bird in Space, 133, 133
Birth of Venus, 33, 33
Black Mountain College, 160, 170
Bleckner, Ross, 194
Bleeding Takari II, 216
Blindman's Meal, The, 136
Blue, Orange, Red, 166
Blue, Red, Green, 171, 171
Blue Knight, 144
Boccioni, Umberto, 139, *139*
Bock, Katinka, 214
Boltanski, Christian, 194, 209, *209*
Bontecou, Lee, 200
Booker, Chakaia, 200
Book of Kells, 27
Borofsky, Jonathan, 178–79, 194
Borromini, Francesco, 49, *49*
Bosch, Hieronymous, 41, *41*
Boschung, Daniel, 217
Botticelli, Sandro, 33, *33*
Boucher, François, 64, 104
Bourgeois, Louise, 165, *165*
Bourke-White, Margaret, 184, *184*
Bradford, Mark, 206, *206*
Brady, Matthew, 93, *93*
Bramante, Donato, 39, *39*
Brancusi, Constantin, 110–11, *133,* *133*
Braque, Georges, 134, 136–38
Breakfast Scene, from Marriage à la Mode, 57, *57*
Breton, André, 128, 149, 151
British Royal Academy of Arts, 59, 68, 72, 80
Brookner, Jackie, 207
Brown, Denise Scott, 182
Bruegel the Elder, 6

Bruegel, Pieter, 41, *41*
Brunelleschi, Filippo, 39, *39,* 180
Bruguera, Tania, 207
Bundestag (Parliament), *196*
Burden, Chris, 178–79
Burgee, John, 180, *180*
Burial of Phocion, 62
Burtynsky, Edward, 211, *211*
Butterfield, Deborah, 214
Butterly, Kathy, 214
Byzantine period, 24–25, 45

Calder, Alexander, 164, *164,* 165
California Aerospace Museum, 182, *182*
Calle, Sophie, 194
Call, I follow; I follow; let me die, 95
Calzadilla, Guillermo, 218, *218*
Cameron, Julia Margaret, 95, *95*
Campidoglio, Rome, 37
Canyon de Chelley, Arizona, 93
Caracalla, Baths of, 17, 25
Caravaggio, *46,* 46–48, 98
Carson-Pirie-Scott Department Store, Chicago, 127, *127*
Cartier-Bresson, Henri, 152, *152*
Casa Milá, Barcelona, 65
Cassatt, Mary, 106, 108, *108*
Castelli, Leo, 102, 173, 177
Cathedrals, Gothic, 28–29
Cattelan, Maurizio, 198, *198*
Cave, Nick, 214, *214*
Cave painting, 4, *4*
Celmins, Vija, 205, *205*
Centre Pompidou, Paris, 181, *181*
Ceremonial sand painting, 20
Cézanne, Paul, 103, 109, 112–13, *113, 116,* 116–17, *117,* 130, 132, 137
Chagall, Marc, 150, *150*
Champollion, Jean-François, 8
Chapman, Jake and Dinos, 197
Charles I at the Hunt, 51, *51*
Charles IV of Spain, 74, *74*
Chartres Cathedral, 29, *29*
Chia, Sandro, 188
Chiaroscuro, 33, 55, 78
Chihuly, Dale, 218, *218*
Chikatsusei Maunkinshi (Golden Wings Brushing the Clouds Incarnated from Earthly Wide Star), 211
Children Playing in Ruins, 152
Chillida, Eduardo, 214
Chin, Mel, 208
Christenberry, William, 212, *212,* 213
Christo and Jeanne-Claude, 200, *200*
Church, Frederic Edwin, 82
Cindy, 191
Cirque, Le, 113, 114, *114*
Citadel of King Sargon II, 6, 6
City Night, 141
Clemente, Francesco, 188–89, *189*
Close, Chuck, 187, *187*
Clos Pegase Winery, California, *14,* 181
Cole, Thomas, 81, *81*
Colescott, Robert, 201
Collaborative Art, 199
Color Field Abstraction, 166–67
Colosseum, 18, *18*
Composition in Red, Blue, and Yellow, 145
Conceptualism, 148, 168, 178–79, 186, 188, 198
Condensation Cube, 179
Conner, Bruce, 205

Constable, John, 79, 79, 80, 102
Constructivism, 139–40
Contemporary art, 168–202
Contemporary sculpture, 200
Contrapposto, 13, 33
Conversion of St. Paul, The, 46, 47–48, 98
Copley, John Singleton, 73, *73*
Corot, Jean-Baptiste-Camille, 78, 84, *84,* 94, 108
Cortright, Petra, 217
Counter Reformation, 45–46, 48
Couple, 23
Courbet, Gustave, 84, *84,* 95, 103, 108, 128
Coyne, Petah, 200
Cow with Subtile Nose, The, 162
Cray chintz, 90
Creation of Adam, 37, 37
Creeley, Robert, 160
Crewdson, Gregory, 196
Crossing the Brook, 80
Crows over Cornfield, 113, 122
Crystal Palace, London, 89, *89*
Cubism, 22–23, 112, 117, 119, 128, 130–31, 134, 136–39, 145–46, 152, 159
Cubi X, 165, 165
Current, 176
Currin, John, 202
Curry, John Steuart, 155, 161
Cuvilliés, François de, 65

Dada, 148–50, 152, 158, 172
Daguerre, Louis-J.-M., 92, *92,* 95, 212
Dalí, Salvador, 149, 151, *151,* 164, 176
Dance (first version), *135*
Das Holzhaus (House in the Woods), *202*
Daumier, Honoré, 83, *83,* 94, 157
David, Jacques-Louis, 68–69, 98
David (Donatello), 33, *33*
David (Michelangelo), 13, 48
Da Vinci, Leonardo, 33, *34,* 34–35, *35,* 96
Davis Stuart, 154, 161
Day One, 166
Daydreams, 215
Death of Marat, 69, 69
Death of Sardanapalus, 77, 77
de Chirico, Giorgio, 149, *149,* 152
DeFeo, Jay, 205
Degas, Edgar, 95, 97, 99, 105, *106,* 106–7, *107,* 108, 115–16
Déjeuner sur l'herbe, Le, 98, 100, 100–101
De Kooning, Wilem, 128, 160, *160,* 172–73
Delacroix, Eugène, 70, 77, *77,* 78, *78,* 95, 173
De Lama Lâmina, 195
Delaroche, Paul, 95
Del Sarto, Andrea, 102
Demuth, Charles, 141
Denes, Agnes, 218
Denis, Maurice, 119
Derain, André, 130–31, *131*
Der Blaue Reiter, 142–43
Descent from the Cross, The, 50, 50
Desmoiselles d'Avignon, Les, 22, 22, 98, 137, 146
De Stijl, 145
de Waal, Edmund, 214
Dexin, Gu, 210
di Corcia, Philip-Lorca, 196
Dial, Thornton, 204, *204*

Die Brücke, 142
Diebenkorn, Richard, 205
Diktat (Dictation), 202
Dine, Jim, 194
Dionysus in a Sailboat, 12
Doherty, Robert J., 153
Doig, Peter, 201
Donatello, 33, 33, 110
Dougherty, Patrick, 215, *215*
Dove, Arthur, 154, 158
Down to Earth, 198
DuBois, Luke, 217
Dubuffet, Jean, 162, *162,* 164, 193
Duchamp, Marcel, 148, *148,* 150, *150,* 152, 173, 203
Dufy, Raoul, 130, 132
Dumas, Marlene, 216, *216*
Durand, Asher B., 81, 102
Dürer, Albrecht, 42, *42,* 43, *43*
Dutch Interior II, 149
Dying Lioness, The, 7, 7

Eakins, Thomas, 86, *86*
Earthworks, *21*
Easter Island, 5
École des Beaux-Arts, 110, 126–27, 132
Ecstasy of St. Theresa, The, 48, *48*
Eddy, Don, 187
Eggleston, William, 213, *213*
Egypt, 8–11
Eiffel, Alexandre-Gustave, 90, *90*
Eiffel Tower, 90, *90,* 181
Eight, The, 141
Eisenstaedt, Alfred, 184
Eitel, Tim, 202
Elegy to the Spanish Republic, No. 34, 161, *161*
Elgin, Lord, 14, 68
El Greco, 45, *45*
Eliasson, Olafur, 206
El Lissitzky, 140
Ensor, James, 142–43
Environmental art, 178
Ernst, Max, 149–51
Eskimo art, 20, *20*
Even Change, 206
Exekias, *12*
Expressionism, 119, 132, 144
 Abstract, 23, 128, 158–61, 165–68, 170–72, 174, 177, 193
 Early, 123–24
 figural, 162–63
 German, 130, 142–44, 188–89
 Neo-, 168, 188–89
Eye, The, 214

Fairey, Shepard, 209
Fallingwater (Kaufmann House), 147
False Mirror, The, 151
Family of Charles IV, 61, 74, *74*
Family Tree, 207
Fanny/Fingerpainting, 187
Fantin-Latour, Henri, 99, *99*
Fauvism, 23, 119, 128, 130–35, 139
Finster, Howard, 163
Fischl, Eric, 192, *192*
Fischli, Peter, 200
Fitch, Lizzie, 217
Flavin, Dan, 177
Flowering Apple Tree, 145
Follow You, 213
Fontaine, Claire, 200
For Whom the Bell Tolls, 216
Fountain, 148
Four Horsemen of the Apocalypse, 42
Fowling Scene, from the tomb of Nebaumun, Thebes, 8
Fragonard, Jean-Honoré 64, 104
Francesco Clemente Pinxit, 189
Frankenthaler, Helen, 167, *167*

Frazier, LaToya Ruby, 207
French Académie Royale, 59, 68, 101–2
French Ambassadors, The, 32, 42
Freud, Lucian, 215, *215,* 216
Friedrich, Caspar David, 76
Frieze, Villa of the Mysteries, *19*
Fur Traders Descending the Missouri, 82
Futurism, 139–40

Gainsborough, Thomas, 58, *58,* 88
Garden of Earthly Delights, The, 41
Garnier, Charles, *126*
Gate, The, 160
Gates, Central Park, New York City, The, 200, *200*
Gaudí, Antonio, 65, *65,* 91
Gauguin, Paul, 23, 108–9, 112–13, *113, 118,* 118–19, *119,* 120–21, 128, 130
Gehry, Frank O., 182, *182*
Gentileschi, Artemisia, 47
Geometric style, Greek, 12, 15
George Reynolds, Pole Vaulting, 86
George Washington (The Athenaeum Portrait), 73, *73*
Géricault, Théodore, x, x–1, 70, 76–77, *77,* 98
Giacometti, Alberto, *23,* 131, 149
Gilbert and George, 198, *198*
Gioconda, La, 34
Giorgione, 38, *71,* 100
Giotto, 26, *26,* 98, 117, 124, 137
Giza, Pyramids of, *7*
Glackens, William, 154
Glass of Absinthe, The, 106, 107
Glass Pyramid, Louvre, *7,* 180
Gober, Robert, 194
Goethe, Johann Wolfgang von, 68, 76
Goldfish and Sculpture, 134
Gold funerary mask, *20*
Goldin, Nan, 196
Goldsworthy, Andy, 200
Golub, Leon, 192
Gonzales-Torres, Felix, 199, 206
Gorky, Arshile, 158–59, *159,* 161
Gormley, Antony, 214
Gothic period, 24, 27–29
 cathedrals, 28–29
 tapestries, 29
Gothic Revival, 76
Gottlieb, Adolph, 161, 166
Goya, Francisco de, 61, *71,* 74, 74–75, *75,* 78, *157,* 175
Graffiti Art, 193
Grande Odalisque, La, 70, *70*
Grape Vine, 91
Graves, Michael, *14,* 181, *181*
Graves, Nancy, 193
Gray Tree, 145
Great Pyramid of Cheops, 10, *11*
Great Serpent Mound, The, 21
Greece:
 architecture, 14–15
 art, 16
 painting, 12
 sculpture, 13
Greenberg, Clement, 98, 159
Greenough, Horatio, 72
Green Stripe, The (Madame Matisse), 134
Gris, Juan, 138
Gropius, Walter, 146
Grosz, George, 144
Group Material and Gran Fury, 194
Guardi, Giovanni Antonio, 38
Guernica, 137, *137, 157*
Guerrilla Girls, 194
Guggenheim Museum, New York City, *147*

Guimard, Hector, *126*
Guo-Qiang, Cai, 200
Gursky, Andreas, 196, *196*

Haacke, Hans, 178–79, *179*
Hadid, Zaha, 194
Hagia Sophia, 25, *25*
Hall of Mirrors, Versailles, *63*
Hals, Franz, 50, 53, *53*
Hamilton, Ann, 206, 209, *209*
Hammons, David, 209
Hampton, James, *162*
Hans Holbein the Younger, *32,* 42–43, 60
Hanson, Duane, 187
Happenings, 173, 176
Hard Edge Abstraction, 168, 170–71, 177
Hardouin-Mansart, François, 63
Haring, Keith, 193, *193,* 209
Harnett, William Michael, 88, *88*
Harrison, Helen, 218
Harrison, Jessica, 214
Harrison, Newton, 218
Hartley, Marsden, 154
Harvey, Bessie, 204
Harvey, Marcus, 197
Hatoum, Mona, 199, *199*
Haymarket, 154
Hay Wain, The, 79
Head Surrounded by Sides of Beef, 61, *163*
Heda, Wilem Claesz, 52, *52*
Heine, Heinrich, 144
Herculaneum, 68
Hill, Gary, 195
Hirst, Damien, 196–97, *198*
Höfer, Candida, 196
Hofmann, Hans, 158–60, *160*
Hogarth, William, 57, *57,* 83, 157
Höller, Carsten, 206
Hollywood Is a Verb, 205
Holzer, Jenny, 178, *178*
Homage to the Square: Ascending, 170, *170*
Homer, Winslow, 85, *85*
Hongtu, Zhang, 210
Hope, 190
Hopi art, 20, *20*
Hopper, Edward, 155–56, *156*
Horn, Rebecca, 194
Horse, cave painting at Lascaux, France, *4*
Horse Fair, The, 83, *83*
Huan, Zhang, 206, 207, *207*
Hudson River School, 81–82
Hunt, Richard Morris, 126
Hunter, Clementine, 204
Hunters in the Snow, 41, *41*
Huyghe, Pierre, 218, *218*
Hyper-Realism, 187

I and the Village, 150
Ia Orana Maria, 113, 119, *119*
Ilic, Dragan, 217
I Like Olympia in Blackface, 71
Immendorff, Jörg, 194
Impression: Sunrise, 96, 102
Impressionism, 96–109, 112, 120, 123
Improvisation 31 (Sea Battle), 143
Industrial Age, 89–90
Infant Mortality, 142
Infinity Mirrored Room, 203
Ingres, Jean Auguste Dominique, 70, *70,* 78, *78,* 106, 160, 173
Interior of My Studio, a Real Allegory Summing Up Seven Years of My Life as an Artist, 84, 84
International Style, 146–47, 180, 182
In the Womb, 35

Irwin, Robert, 204, 205
I Saw Stalin Once When I Was a Child, 200
Isidorus of Miletus, 25, *25*
Itkinos, 14

Jane, Countess of Harrington, 58, *58*
Jefferson, Thomas, *14,* 39, 68, 72
Johns, Jasper, 172–73, *173,* 174
Johnson, Philip, 174, 180, *180,* 181
Jolly Toper, The, 53, *53*
Jonas, Joan, 206
Judd, Donald, 177, *177,* 182
Jugendstil (Youth Style), 91
Justinian and Attendants, 25

Kabakov, Ilya, 199, *199*
Kac, Eduardo, 217
Kagle, 22
Kahlo, Frida, 163, *163*
Kalaizis, Aris, 202, *202*
Kallikrates, *14*
Kandinsky, Wassily, 143, *143,* 144
Kapoor, Anish, 200
Katz, Alex, 194
Kawara, On, 178
Kelley, Mike, 194
Kelly, Ellsworth, 171, *171*
Kentridge, William, 198
Kern, Arthur, 214
Kiefer, Anselm, *157,* 188, *188,* 189
Kippenberger, Martin, 216
Kirchner, Ernst Ludwig, *142,* 142–44
Kitchenmaid, The, 56, *56*
Klee, Paul, 143–44, *144*
Klein, Yves, 177
Klimt, Gustave, 142
Kline, Franz, 158, 160, *160*
Kobe, Martin, 202
Kokoschka, Oskar, 142, 144, 158
Kollwitz, Käthe, 142, *142*
Komar and Melamid, 200, *200*
Koons, Jeff, 204, *204*
Kouros, 15
Krasner, Lee, 161, 167
Kruger, Barbara, 190, *190*
Kuitca, Guillermo, 199
Kusama, Yayoi, 203, *203*
Kwakiutls, 20

La Fontaine, Jean de, 63
Lacy, Suzanne, 207
Lamentation, The, 98
Lange, Dorothea, 153, *153,* 157
La Nona Ora, 198
Large Bathers, 117, 117
Laric, Oliver, 217
Larner, Liz, 216
Lassaw, Ibram, 161
Last Judgment, The (Michelangelo), 37, *37,* 45, 110
Last Judgment, The, Autun Cathedral, 26
Last Supper, The (Da Vinci), 35, *35*
Last Supper, The (Tintoretto), 44
Latin American art, 199
La Tour, Georges de, 62, *62*
Lawrence, Jacob, 86, 156
Le Brun, Charles, 63
Le Corbusier, 146, 182
Leeks, 153
Léger, Fernand, 138, 165
Le Nôtre, André, 63
Levitt, Helen, *185*
Lewitt, Sol, 177
Liberation of the Peon, The, 21, *157*
Library II, 210
Lichtenstein, Roy, 174, *174*
Light Sentence, 199
Lijun, Fang, 210
Lipchitz, Jacques, 117, 133